PHOTO*art*

Photography in the 21st Century

PHOTO*art*

Photography in the 21st Century

EDITED BY UTA GROSENICK AND THOMAS SEELIG

aperture

Front cover: Eve Sussman and Rufus Corporation, *Girls at the Pool*, 2005, production still from *The Rape of the Sabine Women*, photo by Benedikt Partenheimer for Eve Sussman and Rufus Corporation

MANAGING EDITORS
Uta Grosenick, Thomas Seelig

TEXTS
Paolo Bianchi, Reinhard Braun, David Brittain, Florian Ebner, Roy Exley, Uta Grosenick, Felix Hoffmann, Barbara Hofmann-Johnson, Karen Irvine, Martin Jaeggi, Jan-Erik Lundström, Nadine Oloñetzky, Arne Reimer, Manuel Reinartz, Johan Sjöström, Rik Suermondt, Ossian Ward, Grant Watson

EDITOR
Sabine Bleßmann

ASSISTANT
Ina Bierwagen

TRANSLATION FROM DUTCH
Holländer Translations, Rotterdam

TRANSLATION FROM GERMAN
David H. Wilson

DESIGN
Studio Lambl/Homburger: Florian Lambl, Birgitta Homburger, Christian Steubing, Jan-Philipp Hopf

PRODUCTION
Marcus Muraro

REPRODUCTION
GZD Grafisches Zentrum Drucktechnik, Ditzingen

The staff for the Aperture edition of *Photo Art* includes:
Lesley A. Martin, *Publisher, Books*; Susan Ciccotti, *Managing Editor, Books*; Francesca Richer, *Design Director*; Sarah Henry, *Production Manager*

The cover of this Aperture edition was designed by Francesca Richer

Originally published in 2007 by DuMont Buchverlag under the title *Photo Art. Fotografie im 21. Jahrhundert.*

© 2007 DuMont Buchverlag, Cologne
www.dumont-buchverlag.de

First Aperture edition
Printed in Italy
10 9 8 7 6 5 4 3 2 1

Library of Congress Control Number: 2007935224
ISBN 978-1-59711-062-4

Aperture Foundation books are available in North America through:
D.A.P./Distributed Art Publishers
155 Sixth Avenue, 2nd Floor
New York, N.Y. 10013
Phone: (212) 627-1999
Fax: (212) 627-9484

aperturefoundation
547 West 27th Street
New York, N.Y. 10001
www.aperture.org

The purpose of Aperture Foundation, a non-profit organization, is to advance photography in all its forms and to foster the exchange of ideas among audiences worldwide.

CONTENTS

José Antonio Hernández-Diez

Izima Kaoru

Santos R. Vasquez

Guadalupe Ruiz

Anthony Goicolea

Gábor Ösz

Takashi Yasumura

Rut Blees Luxemburg

Adam Broomberg/Oliver Chanarin

Diana Scheunemann

Yang Fudong

Marnix Goossens

Lukas Einsele

Sergey Bratkov

Stephen Gill

Mika Ninagawa

Michael Janiszewski

Jean-Luc Mylayne

Natalie Czech

Arno Nollen

Elina Brotherus

Zbigniew Libera

Jules Spinatsch

Valérie Belin

Martin Polak / Lukas Jasansky

Marco Poloni

Stefan Burger

Kimiko Yoshida

Anuschka Blommers/Niels Schumm

Takashi Homma

Philippe Terrier-Hermann

Florian Maier-Aichen

Marine Hugonnier

Barbara Probst

Bruno Serralongue

Aneta Grzeszykowska

Zwelethu Mthethwa

Lidwien van de Ven

Naoya Hatakeyama

Sanna Kannisto

Rosângela Rennó

Alec Soth

Janaina Tschäpe

Torbjørn Rødland

Juul Hondius

Sabine Bitter/Helmut Weber

Pertti Kekarainen

Annika von Hausswolff

G.R.A.M.

Maria Hahnenkamp

Gonzalo Puch

Jean-Luc Moulène

Dirk Braeckman

Claude Closky

Jochen Lempert

Collectif_fact

Santiago Sierra

Jens Ullrich

Gerard Byrne

Richard Billingham

Sonja Braas

Wangechi Mutu

An-My Lê

Joachim Koester

Ricarda Roggan

Roe Ethridge

Jean-Pierre Khazem

Ann-Sofi Sidén

Charles Fréger

Fabian Marti

Frank van der Salm

Clunie Reid

John Riddy

Kelli Connell

Sze Tsung Leong

Oliver Musovik

Simone Nieweg

Michael Wesely

Luisa Lambri

Xavier Ribas

Shirana Shahbazi

Ruud van Empel

Iosif Király

JH Engström

Nate Lowman

Hellen van Meene

Ana Torfs

Charlotte Dumas

Rinko Kawauchi

Taiji Matsue

Erik Steinbrecher

Paul Albert Leitner

Heidi Specker

Roy Arden

Eve Sussman

Peter Piller

Tacita Dean

Beate Gütschow

Qingsong Wang

Jitka Hanzlová

Olivo Barbieri

Anri Sala

PREFACE

This book is a comprehensive survey of photography in the early 21st century. It is a rich medium which reflects the changes in society like no other, giving visual expression to its commonplaces and peculiarities, its hopes and disappointments, its desires and obsessions. For this reason alone, it seems an indispensable element of our modern culture. Quite apart from the infinite treasure trove of pictures in family albums, newspapers and other forms of print, new means of communication such as the Internet or the mobile phone-cum-camera have led to a positive explosion of photographic images.

Even in this new millennium, however, people are asking the same old questions: Who are we? Where do we come from? Where are we going? The basic questions may not have changed, but our answers may well have. They emerge from changing social conditions that affect individuals, families, nations and indeed the whole of mankind. At the same time photography, which since it was first invented has always been a means of grasping reality, has also changed, adopting new, hybrid modes of narration in order to document the current state of the planet.

This book presents the work of more than one hundred photographers from all over the world and reveals all the innovative and exciting ways in which the photographic medium has developed in recent times. The collection includes enigmatic objects, impressive installations, individual art books or the cheap-looking results of mass production. Normal-sized prints may be stuck on a wall with sticky tape, giant-sized prints may cover an entire surface, newspaper images may be assembled into collages, or sealed in large format behind shining screens of Plexiglas. Technically almost anything is possible. It was only a matter of time before this vast potential found its way into new concepts of art.

Profiles of 112 artists are listed in alphabetical order and accompanied by typical examples of their work. The selection, which even after intensive research must still remain subjective, focuses on the most striking

current trends in the market and in exhibitions which are becoming increasingly global. It includes the most important innovators, but leaves enough room for the traditional exponents of the art. The photographs are accompanied by short, informative commentaries written by critics or curators. Completing this photographic panorama are a clearly structured essay by Paolo Bianchi and a uniquely comprehensive glossary of contemporary terms, compiled by Florian Ebner, Arne Reimer and Manuel Reinartz, which make this an indispensable work of reference for anyone interested in or working with photography. There is also plenty of opportunity to explore these photographers further on the websites of the artists themselves or their galleries which invariably feature additional information about exhibitions, biographies and bibliographies. Web addresses are included in the profiles.

We are deeply grateful to the artists and their galleries for their willing and productive cooperation, and to the following authors for their expert commentaries: Paolo Bianchi, Reinhard Braun, David Brittain, Florian Ebner, Erik Eelbode, Roy Exley, Felix Hoffmann, Barbara Hofmann-Johnson, Karen Irvine, Martin Jaeggi, Jan-Erik Lundström, Nadine Olonetzky, Arne Reimer, Manuel Reinartz, Johan Sjöström, Rik Suermondt, Ossian Ward and Grant Watson.

We also extend our thanks to Ina Bierwagen, who put her heart and soul into this project and whose help was indispensable, especially in the acquisition of the pictures; to the editor Sabine Bleßmann, who checked all the texts with scrupulous efficiency and also coordinated all the translations; to the designer Florian Lambl and his assistants Jan-Philipp Hopf and Christian Steubing, who gave the book its beautifully symmetrical layout; and finally to our publisher Marcel Hartges, whose love of photography was an inspiration to all of us.

UTA GROSENICK AND THOMAS SEELIG
COLOGNE AND WINTERTHUR
OCTOBER 2007

ACKNOWLEDGMENTS

Uta Grosenick, Thomas Seelig and DuMont Buchverlag
would like to thank the following people, galleries and
studios for providing information and photographs.
Without their generous support, the publication of this
book would not have been possible.

303 Gallery, New York, Barbara Corti
Air de Paris, Paris
Galerie Akinci, Amsterdam, Leylâ Akinci
Alia Al-Senussi
Andréhn-Schiptjenko, Stockholm, Ciléne Andréhn,
 Marina Schiptjenko
Galerie Paul Andriesse, Amsterdam,
 Milka van der Valk Bouman
Galerie Anhava, Helsinki, Piia Oksanen, Satu Oksanen
Olivo Barbieri Studio, Daria Menozzi
Galerie Anita Beckers, Frankfurt am Main,
 Tasja Langenbach
Galerie Albert Benamou, Paris
Galería Elba Benítez, Madrid, José Castañal
Blum & Poe, Los Angeles, Renée Martin
Dirk Braeckman Studio
Brancolinigrimaldi, Florence/Rome, Kate Collins
Kate Bush
Carlier | Gebauer, Berlin, Bimal Saha
Gloria Chalmers
Galerie Mehdi Chouakri, Berlin, Mehdi Chouakri
Cinémathèque de Tanger, Tangier, Simona Schneider
Galería Pepe Cobo, Madrid, Claudia Rodríguez-Ponga
Sadie Coles HQ, London, Katy Reed
Galerie Chantal Crousel, Paris, Karen Tanguy
Galerie Claudia Delank, Cologne
Deweer Art Gallery, Jo Coucke

Markus Dreesen
Régis Durand
EIGEN + ART, Berlin/Leipzig, Ulrike Bernhard
Galerie Luciano Fasciati, Chur
Galerie Ulrich Fiedler, Cologne, Nadine Müseler
Flatland Gallery, Utrecht, Marije Oostindie
FOIL Co. Ltd., Tokio Masakazu Takei
Galeria Fortes Vilaça, São Paulo, Marcia de Moraes
Galerie Fotohof, Salzburg, Rainer Iglau
Frehrking Wiesehöfer, Cologne, Markus Frehrking
Christine Frisinghelli
Frith Street Gallery, London, Dale McFarland
Frits Gierstberg
Stephen Gill Office, London, Richard Green
Gladstone Gallery, New York, Jessie Green
Galerie Laurent Godin, Paris, Isabelle Chen
Marian Goodman Gallery, New York, Catherine Belloy
Green On Red Gallery, Dublin, Karen Tierney,
 Aoife Cassidy
Studio Guenzani, Milan, Luciana Rappo
Murray Guy, New York, Janice Guy
Haunch of Venison, London, Jade Awdry,
 Clare Walsh
René Hauser
Hauser & Wirth, Zurich, Isabelle von Meyenburg
Michael Hue-Williams Fine Art Ltd, London
Marine Hugonnier Studio, Rachal Bradley
William M. Hunt
Rebecca Ibel Gallery, Columbus
Michael Janiszewski Studio, Michael Michlmayr
Johnen + Schöttle, Cologne, Manuel Miseur
Kesselskramer, Amsterdam, Kyra Müller
Kicken, Berlin, Mareike Stoll

Galerie Peter Kilchmann, Zurich, Annette Amberg,
 Cynthia Krell, Annemarie Reichen
Christine König Galerie, Vienna, Martina Weiss
Tomio Koyama Gallery, Tokyo, Tomoko Omori
Andrew Kreps Gallery, New York, Liz Mulholland
Galerie Krobath Wimmer, Vienna
Kuckei + Kuckei, Berlin, Ben Kuckei, Hannes Kuckei
Kudlek van der Grinten Galerie, Cologne,
 Franz van der Grinten
L. A. Galerie, Frankfurt am Main, Lothar Albrecht
Lisson Gallery, London, Justyna Niewiara
Gallery Luisotti, Santa Monica, Alex Weber
Maccarone Inc., New York, Risa Needleman
Mai 36, Zurich, Gabriela Walther
Ricco Maresca Gallery, New York, Frank Maresca
Galerie Metropolis, Paris, Marie Guilhot-Voyant
Galerie Mezzanin, Vienna
Yossi Milo Gallery, New York, Mia Khimm,
 Alissa Schoenfeld
Galerie Edward Mitterrand, Geneva
MKgalerie, Rotterdam/Berlin, Emmo Grofsmid
Multiplicity Studio, Milan, Anniina Koivu
Galerie Bob van Orsouw, Zurich, Eveline Baumgartner
Galerie Priska Pasquer, Cologne, Ferdinand
 Brüggemann
Galerie Polaris, Paris, Bernard Utudjian
Galerie Poller, Frankfurt am Main
Marco Poloni Studio, Geneva, Winfried Heininger
Produzentengalerie, Hamburg
Galeria ProjecteSD, Barcelona, Silvia Davdé
Raster, Warsaw, Jakub Antosz
Anthony Reynolds Gallery, London, Nadine Lockyer,
 Maria Stathi

Yancey Richardson Gallery, New York, David Carmona,
 Tracey Norman
Ritter/Zamet, London, Marcus Ritter
Galerie Jette Rudolph, Berlin
The Rufus Corporation, Brooklyn, Catherine Mahoney
Kunstraum Marion Scharmann, Cologne
Galerie Aurel Scheibler, Berlin, Marie Graftieaux
Sabine Schmidt Galerie, Cologne
Inka Schube
Jack Shainman Gallery, New York, Katie Rashid,
 Judy Sagal
ShanghART Gallery, Shanghai, Chen Yan
Alec Soth Studio, Saint Paul, Eric William Carroll
Sperone Westwater, New York, Jennifer Burbank
Urs Stahel
Stampa, Basel
Standard, Oslo, Petter Snare
Jiri Svestka Galerie, Prague, Filip Polansky
Galerie Wilma Tolksdorf, Berlin, Katharina Blanke
Torch Gallery, Amsterdam, Adriaan van der Have
TZR Galerie, Düsseldorf, Kai Brückner
Union Gallery, London, Maja Grafe
Van Horn, Düsseldorf, Daniela Steinfeld
Galeria Vermelho, São Paulo, Marcos Gallon
Susanne Vielmetter Los Angeles Projects, Culver City,
 Gosia Wojas
Galerie Anne de Villepoix, Paris, Alex Dibie
Galerie Nicolai Wallner, Copenhagen,
 Sidsel Kjærulff Rasmussen
Max Wigram Gallery, London, Lisa Carlson
Zeno X Gallery, Antwerp, Frank Demaegd
Van Zoetendaal Gallery, Amsterdam,
 Willem van Zoetendaal

THE AESTHETICS OF PHOTOGRAPHY

Paolo Bianchi

This is a book about photography and about photographers. The medium was born in 1839, a product of the *Zeitgeist* of the Industrial Revolution. More than any other technical invention of the modern age, it has evolved continuously in a manner that has permanently changed our perception, study and knowledge of reality.

The discovery of photography might be linked to the formula that there is no revolution in the means of presentation without a revolution in the means of production. At the turn of the 20th century, almost every modern, middle-class family had a camera. This perfect piece of technology was easy to use and fascinating at the same time. Some people earned millions just through the sale of cameras and film. But, more than mere technology to produce pictures, photography is also a medium of intellectual perception. Today, in the hands of the masses, it has become a mirror image of our own realities, a means of capturing and even fashioning our own world in pictures. Photography has become an aesthetic force, which in this book is quite clearly linked to the world of art.

This essay maps out a possible training ground for sharpening visual awareness of different realities, and in so doing it makes the imaginative machinery of photography into a model for the production of such realities. Silvio Vietta's book *Ästhetik der Moderne* ('Aesthetics of the Modern World') offers a typology – here revised and reclassified, as follows – of five kinds of photography:

1. Photography of the imagination
2. Photography of emotion
3. Photography of memory
4. Photography of association
5. Photography of sensation

Vietta argues that through recognition of the artwork as a composition and a product of subjectivity, there has been a Copernican shift in perception. He quotes the American philosopher Richard Rorty, who perceived the emergence of a new world view through the clash between an ossified vocabulary that has become inhibiting and annoying, and a new vocabulary that is as yet only half formed and offers vague promises of great things to come. The five sections that follow deal with the shift in metaphors and patterns of meaning, in which context this book does not mark a photographic end, but a turning point in the perception and expression of reality through photography.

1. PHOTOGRAPHY OF THE IMAGINATION

Photography is generally regarded as a medium for which visual reality provides the material that is to be given form. If in the process of photographic appropriation, reality and the visual image coincide, the photographer's field of activity is reduced to whatever is available to him in his immediate surroundings. He can only capture on film what he can see with his own

eyes. This concept, however, offers a very restricted view of the medium itself. It is much more rewarding to recognize that photography is also highly imaginative, and capable of producing its own realities, which in turn may be related to other imaginary worlds. Photography of the imagination creates a duplication of reality in which the photograph always has the status of a sign of signs.

FANTASY TOTALIZES

The flood of images in this age of information overwhelms the individual's capacity for perception to such a degree that there is simply no respite for the imagination. Pictures may be illustrations, but they may also be products of the imagination, which transforms 'felt images' into something visual, thus producing new forms of appearance. The human imagination may create images that the inner eye can grasp only as shadows, whereas photography can represent them in a totally visual form.

The photography of the imagination is clearly dominated by fantasy. The Greek term *phantasia* is linked etymologically to the verb *phainesthai* (to appear), and its original meaning refers to the inner realization of a perceivable object without its actual presence. The photography of the imagination allows for fantasy as an independent poetic force, in some ways reminiscent of Goethe's Prometheus as the prime symbol of man blessed with a creative imagination. As opposed to the claims of the intellect, the imagination may be seen as the mental process best able to bring forth reality.

Photography works on the basis that the imagination is the faculty that analytically divides the visible world up into a store of images from which it synthetically produces a new world, together with a sense of the unusual. Analysis and synthesis enable the poetic imagination to create or develop these images. 'We may lay it down that a happy person never fantasizes, only an unsatisfied one': but photography of the imagination transcends Freud's rigid distinction with its playful delight in the act of creation. Even the state of happiness will transport a photographer to the gates of fantasy, where the imagination can run free.

Fabian Marti's photographs show on the one hand just what photography is: the construction and imagination of a reality. On the other, their view of distant galaxies also illustrates the sheer power of fantasy. 'Fantasy turns all parts into a whole…it gives completeness even to the infinite universe,' as Jean Paul put it in his *School for Aesthetics* (1804). Ana Torfs' key work *La Narration (une histoire extraordinaire)* (2000) takes as its subject an 'extraordinary' and fantastic tale, which unites six females on a sofa, ranging from child to grandmother. It is not a 'rejection of reality' that is presented in this personal composition. On the contrary, it is a 'further development of reality' – a permanent projection of fantasy, without a beginning and without an end.

PHANTASTOPOLIS

Pertti Kekarainen's interior photographs show men and women going up or down stairs, groups of people or individuals in rooms, or completely empty interiors. If the dramatic shadows are reminiscent of German Expressionism, then it is worth remembering that the Expressionist artists did not take things or take photographs of them, but created a fantastic, visionary counter-world to that of their times. With Florian Maier-Aichen's skies and seas turning into menacingly empty spaces as the settings for apocalyptic events, we reach an apogee of imaginative photography situated somewhere between an attack on civilization and a vision of the end of the world.

Valérie Belin's portraits and photographs of everyday objects – like car wrecks, bags of crisps or discarded electrical items – transcend their subjects and take them beyond our normal, familiar concepts of reality, and in so doing transform their plasticity, their hyper-reality, their illusionism into key elements of fantasy. Rut Blees Luxemburg's imaginative photography dissolves the great metropolis of London into a megalomaniac construct: Phantastopolis. In this case, she takes existing places, but with glowing colours she distances these forgotten, neglected areas from reality.

The photography of the imagination can make a city or megacity into a total fantasy that has no connection with traditional concepts of space. Modern cities serve as screens onto which the unbounded imagination may project its dreams, as in the hubristic efforts to glorify Berlin and Moscow during the 20th century. Aglaia Konrad has travelled around the world – to Tokyo, Shanghai, Cairo, Chicago, Beijing, Mexico City, Brussels, Paris, etc. – taking photographs from the plane, the road or from bridges, establishing her own kind of logic as she moves through the urban spaces. Her ever alert imagination enables her to discover the lifelessness, the emptiness, the nothingness that lies behind the glittering, heavily made-up façades.

Olivo Barbieri favours the bird's-eye view for his large-format colour photographs of Beijing, New Delhi, Shanghai, Las Vegas and Los Angeles, in order to convey the impossibility of grasping such urban centres. The pyramids, palaces and road junctions in these photographs seem like architectural models that stem not from reality but from the creative powers of the imagination. Here the photographer functions as his own architect who, like Baudelaire in *Les Fleurs du Mal*, can say that he built this world of magic.

The realism of this kind of phantastopolis lies in the fact that it shows the modern age itself to be the product of a size-obsessed fantasy. Taiji Matsue's photographs are also taken from a bird's-eye view. At the beginning of the 21st century one might have the feeling that aerial photography is seen as somewhat old-fashioned, but it is worth taking a second look because, although these urban views are sharply detailed, one finds that there is nothing for the eye to fix on. Whatever the imaginative photographer depicts becomes a vision. This seems to be confirmed by the work of Sabine Bitter and Helmut Weber, which shows

that the global transformation of the world bears within itself the potential of another giant-sized piece of fantasy.

2. PHOTOGRAPHY OF EMOTION

In the photography of emotion, it is of course the expression of human feelings in the widest sense that comes uppermost, with each one functioning as a kind of 'neurotransmitter' that sends its subjective, emotional message out into the photographic image. Psychology recognizes the triad of anger, fear and love, together with all their many nuances. In gauging the full range of human emotions it is vital, however, not to separate them from processes of cognition but to ascribe all of them together to the phenomenon of consciousness. 'The soul cognizes that it senses,' said Johann Gottfried Herder as long ago as 1780.

THE DRAMA OF IDENTITY

The photography of emotion creates its own space-time narrative out of the feelings experienced by its subjects. When Yto Barrada focuses on the African migrants who set out from Tangier to try to reach the Spanish coast, the pictorial language conveys not just the people but also their myths, songs and rituals. For those leaving, one cannot say as in earlier times that they are 'migrating'; now they are 'burning' because they burn their papers and they burn their past. But the drama of identity is only the beginning of their ordeal on the Continent, assuming that their boat even survives the crossing.

The most influential German text dealing with Romantic emotion is Goethe's *The Sorrows of Young Werther* (1774), whose title already suggests its emotional content. 'How glad I am to have come away! Dearest friend, what is the human heart!' The question concerning the heart, and the logic underlying universal emotions like suffering, pleasure, betrayal, is also reflected in the work of An-My Lê, who fled Vietnam for the USA as a political refugee in 1975, and in 1999 began to visit training camps in South Carolina, where Americans were spending their weekends re-enacting incidents from the Vietnam War for fun. In their reconstruction of battles and day-to-day living in a state of war, they were 'playing' both sides, the Viet Cong and the American forces. The horrors of this bloodbath, particularly through the aesthetics of cruelty as encapsulated in *Apocalypse Now*, have found their way into the leisure culture of thrill-seeking amateur actors – war cheerfully translated into gaudy, theatrical performance.

Kelli Connell describes the drama of the self by way of a female figure who plays both roles in a lesbian relationship, thus indulging in a narcissistic love: two women go into a bar, squat down on a toilet, have sex, and one of them gets pregnant. As sex and gender come into question through the reflection of autobiography, we see how the ego, which lives out its emotions, remains trapped in the confines of the self.

Lukas Einsele complements his portraits of landmine victims with their stories, which he combines with drawings and descriptions of these explosive devices. Thus, the overall picture is intensified to a state of fear and despair that recalls Martin Heidegger's words in *Being and Time* (1927), in which he says that fear is afraid of naked existence as something cast into the unknown. Countless victims of political persecution in the 20th century never knew who was persecuting them, or why. Just like Kafka's K in *The Trial*, they only knew that they were being hounded. The group collectif_fact creates scenes that are derived from real terror attacks, but hover between virtual and actual reality, as if between aesthetics and morality.

TYPOLOGY OF PLACES

The photography of emotion focuses on the self and on personal worlds with all their attendant relationships and problems. It also entails a very individual typology of places and driving forces that underlie human emotions: moonlit night scenes, ruins, graves and parks were the typical backgrounds to the emotional literature of the 18th century. Contemporary photography picks out other sites and settings. Derelict apartment blocks, patches of light on wooden panels, creased wallpaper, a sea of flowers, broken windows, bullet holes: these are Natalie Czech's images of loss, pain and grief.

In her cityscapes, Beate Gütschow combines – to quote Martin Engler – 'the joyous, optimistic euphoria of a gigantic building site with the traumatic stillness of a ruined town'. In her landscape photographs, she reconstructs two paintings called *The Jewish Cemetery* (1668) by Jacob van Ruisdael, to give an emotional charge to her perception of nature and art. Justine Kurland visited rural communes in the USA which had adopted utopian lifestyles in their search for peace, harmony and love. She also visited a girls' boarding school in New Zealand, depicting the girls as fugitives from the repressive structures of school life, and running free in Romantic natural settings, happily indulging in their fantasies and in all the life-enhancing joys of youth. Here, the logic of the heart is translated into images of an allegorical landscape that corresponds to the uninhibited dreams of freedom as *joie de vivre*.

At first sight, Hellen van Meene's pictures seem to be little more than portraits of pubescent children with all the psychological and physical problems of adolescence. But emotionally charged backgrounds such as the Dutch marshlands or Japanese cherry trees give these photographs an additionally dreamlike or fairytale charm. Sonja Braas constructs models to create traumatic images of natural violence: her thunderous waterfalls, foaming waters and crumbling cliffs immediately draw us into the pictures. Drifting snow is shown as a kind of steam, and the contrast between hot and cold directly appeals to our emotions.

If the epistolary novel, diary and autobiography are typical literary genres for the expression of emotion, then Dirk Braeckman's pictorial diary, with portraits of himself and other people from his immediate circle,

provides an exemplary form of emotional exploration, ranging from concealment to revelation. Jens Ullrich, who was born in Tanzania, takes his inspiration from his own life story, documenting the 'direct action' of his peace-activist parents, but altering the slogans on the placards of the demonstrators. Elsewhere, he takes newspaper photographs of everyday scenes in Africa, and sticks photographs of traditional African masks over all the faces. The autonomy of human feelings is articulated through copied patterns, copied emotions and copied lives. Outside influences have such a lasting effect on this particular photography of emotion that the mixed codes may be said to have generated a new form of image.

3. PHOTOGRAPHY OF MEMORY

Forming the basis of the photography of memory are the impressions, perceptions and experiences that have been stored in the mind. The German word for memory is *Erinnerung*, derived from the old high German *inne*, meaning inside. In these times of high-speed activity, the cultural function of memory is more important than ever, especially since our current state of knowledge may change from one minute to the next and may even disappear completely. The media theorist Hans Ulrich Reck writes: 'Precisely because it is recorded, remembering changes into forgetting and becomes transient. Conversely, memory can only re-emerge out of the transition from blind forgetfulness to a culture of remembering forgetfulness. What remain are gestures, ritual passages, crossings: transitory turbulence.' Metaphors for memory are linked to buildings, like stores, temples or libraries, to labyrinths, or to writings such as books, palimpsests or hieroglyphics.

TRANSITORY TURBULENCE

Gábor Ösz's seemingly Romantic camera obscura view of the sea starts at the Nazis' Atlantic Wall and its innumerable bunkers, as 'temples without a culture' (Ösz's phrase), together with the Prora holiday camp in Rügen, built in 1936, with its slogan Strength Through Joy. Both places experienced 'transitory turbulence' in all senses of the term. Meanwhile, collectors like Ohio, Peter Piller and Rosângela Rennó are on their way to setting up a universal archive, whose content gives presence to the past. Their eye for the seemingly unobtrusive, insignificant trivia of everyday life lifts them out of their humdrum context and creates new tales to be told in the mass media. The material collected by Rennó since 1992 from private homes and photography studios, or the picture archives of anonymous professional photographers, local newspapers and businesses discovered by Piller, give rise to a world of memory whose openness, dynamism and transience create a potential representation of their time.

Roy Arden's works form what he calls 'allegories of reality'. They provide visual references to the apparently insignificant remains of an urban aesthetic,

disregarding the officially documented archives of Canadian history, and focusing instead on transitory places and actions: wasteland, overgrown garages and gravel paths, discarded rubbish, parks where the homeless bed down for the night. For Hans Ulrich Reck, turbulence opens the way to a theory of transience, creating space for the minutiae that once were available and now have disappeared: 'Only in this phase of decay does turbulence open up as a specific form that reflects the far distant foundations of memory processes.'

Tacita Dean's photographs also give expression to memory. She takes slow-motion films, recalls a shipwrecked round-the-world sailor, or shows the TV tower in Berlin's Alexanderplatz and contrasts it with a picture postcard from 1972. For her, photographic archives provide a storehouse of history in which experience of time, of past and present, becomes hazy, so that time seems to be endowed with a kind of elasticity.

A different feeling of temporality is conveyed by Arno Nollen's faded-looking portraits and by his study of the sexuality of girls and young women. He finds them in transitory urban spaces like streets, bars and discos, and persuades them to let him photograph them within the illuminated confines of a hotel room or a changing room. The point of this kind of memory photography is that it does not set out to fascinate us with individual stories, but simply provides clear images to create a cultural memory of the female body. As soon as a space changes into a setting for memory – as in Ricarda Roggan's photographs – chair, table and bed from a socialist world of life and work begin to assume an identity as relics of a generally accepted past. This past is no longer visible to our eyes, but it unfolds before our mind's eye as a subjective process of remembering events and emotions.

LIVING MEMORY CULTURE

In Barbara Probst's photographic series of people *Exposure* (since 2000), the title refers to the revelation or opening-up that occurs when the self succeeds in accomplishing metamorphoses within its world of memories. When Anuschka Blommers and Niels Schumm take half-length portraits of young Londoners, remove them from their own reality and transport them back with blow-dried hair into the 1980s, we experience a subjective feeling along the lines of 'it all comes back to me now'. Elina Brotherus reconstructs classical motifs from the world of painting, always incorporating herself into the picture, so that the memory of art history, for instance Caspar David Friedrich's *The Wanderer* (1818), is supplemented in pictorial form by her desire to depict her own existence.

In these three different approaches, the self is energized as part of a living process of remembering. Memory comes to light from the deepest recesses of the mind. In this context, the photography of memory is not just a regression into childhood recollections or classical settings for art, but is itself a dynamic release mechanism for whole worlds of memory that produce the illuminating power which is so indispensable for the actuality of photography.

Charlotte Dumas' photographs of horses, wolves and tigers are like paradigms for the life of the artist. According to Dumas, painters such as Delacroix and Géricault put their own souls into the animals they portrayed. Charles Fréger's pictures of people in uniform – the royal guards in European palaces, foreign legionnaires, the Swiss Guard at the Vatican, and also portraits in the classical style of the Flemish school, with Buddhist monks, sumo wrestlers, actors at the Peking Opera, water polo and ice-hockey players, sailors and policemen – even while remaining bound to a traditional memory culture, surprise us in their choice of subjects.

Memory culture in Takashi Yasumura's photographs reflects the traditional way of life of his parents, as well as the erosion of their values by the ghettoblasters, plastic cruets and similar manifestations of westernization. Qingsong Wang combines traditional Chinese folk art with aspects of western art history and with the rampant consumerism in his country, as typified by international brands like Marlboro, Coca-Cola and McDonald's. But no matter how impressive the artist's social criticism may be, one can sense all too clearly that nothing can reverse these developments.

Janaina Tschäpe's photographs, taken in her own garden, bear witness to the important function of place in memory. She expresses visually what John Hanson Mitchell describes in writing as a 'ceremonial time' of place, which unlike human beings cannot die. Man can burn until all traces of his existence have disappeared, but even a burned place will still retain its coordinates. It may even take on a new value as a site of memory.

4. PHOTOGRAPHY OF ASSOCIATION

The photography of association denotes the impetus that triggers creative processes in the mind of the observer. Associations should transcend feelings of time and space, should break the chain of cause and effect, and should promote ideas that have no equivalent in the reality we have experienced. They remain fragmentary, and lead to experimental work. The form of associative image production and reflection is reminiscent of Roland Barthes' *Death of the Author*, in that the author withdraws and leaves the initiative to the images or words themselves, forming chains of association that lead to obscure frames of reference.

STREAM OF CONSCIOUSNESS

Roe Ethridge's still lifes, landscapes and portraits all attest to the neutrality, the expressionless indeterminacy that is the hallmark of the absent author. The demands made by his work are always the same, whether it is for a magazine, an exhibition or an advertising agency. The idea that the best form of expression for the release of associations is the monologue corresponds to a statement made by Kimiko Yoshida: 'My aim was to present this [*Lonely Brides*] series as an inner monologue

– the stream of consciousness in James Joyce's *Ulysses*. It is in this stream of consciousness that subjective space and time take on a concrete form.' In most of her photographs, the lonely bride is covered by a cloth, blanket, veil or chador.

In his cycle on the death of the model, the former fashion photographer Izima Kaoru actually seems to be leaving it to the models themselves to decide what image they should make of their own death. It is noticeable that the women always choose haute couture for the final moment of departure. It is the principle of similarity that provides the fuel to ignite and drive the associations, and to set in motion the whole process of image production. Jean-Pierre Khazem deliberately focuses on the similarity between a model and the Mona Lisa, or, in his portraits of *First Ladies*, between Nancy Reagan, Pat Nixon, Betty Ford and Laura Bush, in order to disturb the 'female models' pattern of association.

Ruud van Empel looks for alienation effects with his photographs, using various fragments and leftovers to compose his works on the screen. When he first presented a series that consisted of nothing but blonde-haired, blue-eyed white girls, he was accused of racism. To this unjustified misrepresentation of his work, the artist responded immediately with a series of pictures showing black children against a background of tropical vegetation, as in the jungle paintings of Henri Rousseau, thereby opening up the field of associations in exactly the opposite direction. In this manner, he expanded the associative range of his actual theme 'the innocent child', which in art history had been illustrated only with white children, by giving it a black counterpart.

DREAM MATRIX IN A FLASH

Rinko Kawauchi's photographs use scraps of pictorial material to form associations between animals, people, plants, birth and death, creating instant visual links. It is not by chance that she uses flash. The photography of association breaks the unity of action, space and time, and creates a range of interlinking images and reflections which, in the work of Gonzalo Puch for instance, produces a system of references related to philosophy and the natural sciences.

Some people would say that Juul Hondius' photographs avoid associations. However, on closer inspection, one becomes aware of the inner world of his characters. Dreams, sleep and daydreams stimulate associations that undermine the logic of one's conscious, waking hours.

Erik Steinbrecher's eye-level views of people sleeping in municipal parks typifies his artistic approach, which relies on the associative power of images. This also applies to the Dutchman Marnix Goossens' nature photography, for in his country nature always means visualizing an image as one's starting-point, because everything has been artificially designed and laid out by human hand.

In Alec Soth's *Sleeping by the Mississippi*, in which planks and pieces of corrugated iron lie scattered around as if there has been some natural catastrophe,

and in which beds, mattresses and sofas are recurrent themes, it seems that sleep is the only possible escape from the misery of daily life in this region. Another step along the path of associations leads to Heidi Specker and her dematerialized pictures of towers, banks and apartment blocks, and grilles, mosaics and patterns on the façades of buildings in Berlin. These pictures are like a dream matrix for architects.

5. PHOTOGRAPHY OF SENSATION

The photography of sensation refers to perception through all five human senses. Whatever we see, hear, taste, smell or touch will be perceived either favourably or unfavourably – our responses will oscillate between the poles of pleasure and disgust. When Johann Gottfried Herder writes in his *Journal meiner Reise* (1769) that he wants someone to use all of his senses, it implies that sensory perception has been cooled and placed under emotional control. For Novalis the functioning of the senses is not a passive process but an active, conscious one: a product of the mind. This shift in art theory led from a purely receptive faculty to one of production and projection, and it ended the period of mimetic aesthetics, ushering in a new aesthetics of expression. From mere perception, art became active interpretation, no longer asking the question whether perception was true-to-life, but instead seeking to fasten onto and convey a meaning.

AGAINST TABOOS

The action artist Santiago Sierra is famous, if not notorious, for his shock tactics, as in the photographic documentary *245 Cubic Meters*, in which he used plastic hoses to direct carbon monoxide from the exhausts of six cars into the former synagogue at Pulheim-Stommeln, near Cologne. Visitors could – at their own risk – enter the room wearing gas masks and, accompanied by a fireman, spend a few minutes in the midst of this deadly environment. The artist's intention was to try to 'counter the "trivialization of our memory of the Holocaust".' Although the Central Council of Jews in Germany called the project *niveaulos* (mediocre or mindless), it gave people the chance to feel the horror for themselves – an extraordinary example of sensory perception and interpretation.

With their series *Paparazzi*, the G.R.A.M. group of artists play with sensation, voyeurism and taboo to trivialize glamour. Stephen Gill's predilection for dirt and rubbish gave him the idea to bury his photographs in the ground and leave them to the ministrations of rain and microbes. The resultant stains and holes create an impression of age and decay, which enhances the sensual charm of the pictures. For Jochen Lempert it is German glow worms and Italian seawater that leave their mark on the photographic paper, creating a sensual interplay between nature and culture. Lempert goes to the very limits of the permissible by questioning the myth of the artist-genius and creative spirit, preferring to celebrate nature as the great artist-creator. Maria Hahnenkamp devotes her art to the role

and stereotypical images of women. She cuts or embroiders the photos, violently deforming the bodies to show how sexual identity is shaped by social sanctions and taboos. Wangechi Mutu makes collages out of photos from fashion magazines, *National Geographic* and books on African art, in order to draw a contrast between western prejudices about Africa and rich and colourful images drawn from ancient tradition and the promise of a flourishing future. Luc Delahaye's tableaux illustrate current conflicts, clashes and wars – the dead Taliban soldier lying in the street shows us the horror of war directly and yet with detachment. Perception here is cold, critical, impersonal, despite the close-up perspective. By using straightforward photography, Delahaye avoids interpretive representation and simply creates images that will call forth their own response, thus raising sensory perception to a different semiotic level. He argues that in war one must be capable of feelings both in and around one's own body.

FOR SYMBOLS

In his pictures of Tokyo's canals, Naoya Hatakeyama observes certain details of the city that symbolize the anonymity and rootlessness of modern city-dwellers. His view of Tokyo's innards takes us on a ceaseless trail of sensory impressions. Takashi Homma's coolly detached chronicle of his native Tokyo and its local youth culture leads, in Martin Jaeggi's words, to 'allegories that point to the uncertain future of people in the highly technologized big cities'. Martin Polak and Lukas Jasansky's photographs show the shabbiness of

Czech houses, villages and landscapes, making them into symbols for the instability of these Eastern European regions.

Frank van der Salm would never take a photo of the Eiffel Tower, because then everyone would know that it was of Paris. His photographs remain anonymous, in the sense that we are never told where they have been taken. His passion lies in the architecture of big cities, and sometimes he shows us high-rise buildings at night looking like radiant icons.

Annika von Hausswolff has women lying lifeless on the ground in the midst of idyllic Nordic landscapes, abused and faceless objects that have become symbols of sexism. Zwelethu Mthethwa shows us indigenous peoples going about their daily business in the townships and hinterland of Cape Town. The dialogue between photographer and observer, and model and subject is almost like a visual training school, for it demands an eye that can really see.

These examples of the photography of sensation need sharp-eyed vision as the driving force of perception. The views of town, country and people, regardless of the choice of subject, make 'seeing sight' into a theme of its own. Even though the focused gaze of the photographer may release the poetic imagination, nevertheless the latter remains attached to the long lead of vision. The French photographer Robert Doisneau, who in 1950 made his name with a photograph of a kissing couple on the pavement outside the City Hall in Paris, should have the last word on this subject: 'There are days when one feels the simple fact of seeing to be true happiness.'

ROY ARDEN

born in 1957 in Vancouver, Canada
lives and works in Vancouver

WWW.ROYARDEN.COM

The central theme of Roy Arden's work is urban and public environments, and the wide variety of features that reveal themselves as 'allegories of reality', as he describes them, particularly in the seemingly trivial. Since the late 1970s, he has put together collections of works based on this concept. In the early 1980s, he used colour photographs to document experiences in the series *Fragments*. Towards the end of the decade he turned his attention to historical records with the collection *Abjection*, in which he reproduced pictorial archives of Canadian history and combined them with black, monochrome surfaces. These blank spaces act as a visual metaphor by masking the moment recorded in the photograph, thus highlighting its limitations in conveying information about social changes.

The flip side of urban development, as epitomized by an increasingly prosperous social and architectural environment, is always to be seen in its byproducts, such as piles of refuse, derelict houses and overgrown patches of land. These themes are explored in *Landscape of the Economy*, which Arden began in 1991. His colour photographs show fragments of landscape with empty houses, overgrown garages and gravel paths, and rubbish tips. One example is *Railway Yard, Vancouver, B.C.* (1999). This picture is clearly divided into three sections. In the foreground is a mass of rubbish on asphalt, the remains of a demolished building with sheets of blue plastic, shards of broken glass and pieces of panelling. Behind this urban no-man's-land, identified only by the title of the picture, and separated from it by a fence, is a strikingly colourful landscape of containers. This is reflected, almost like a painting, in a large puddle between it and the fence. One of these containers bears the company name, Uniglory, an apt expression of the global economy's self-confidence, while behind the fence we see the rubbish that completes the landscape.

In his black-and-white series *Terminal City* (1999), Arden again turns to the unpresentable aspects of the urban landscape. Wasteland, overgrown garages and paths, rubbish, an old typewriter, a wooded area where the homeless bed down for the night: they all take on an allegorically focused aestheticism. '*Terminal City* is a view of the city from the bottom...from the position of the discarded or rusticated citizen. However it is also figuration of the slide from Constable to Wols – the rustication of art.' With his slide projection *The World as Will and Representation: Archive* (2004), which takes its name from the work by Arthur Schopenhauer, Arden expanded his analysis of the visible world by means of a new form of photographic record. Here, the artist's archive of some 10,000 photographs is combined with pictures from the Internet.

BARBARA HOFMANN-JOHNSON

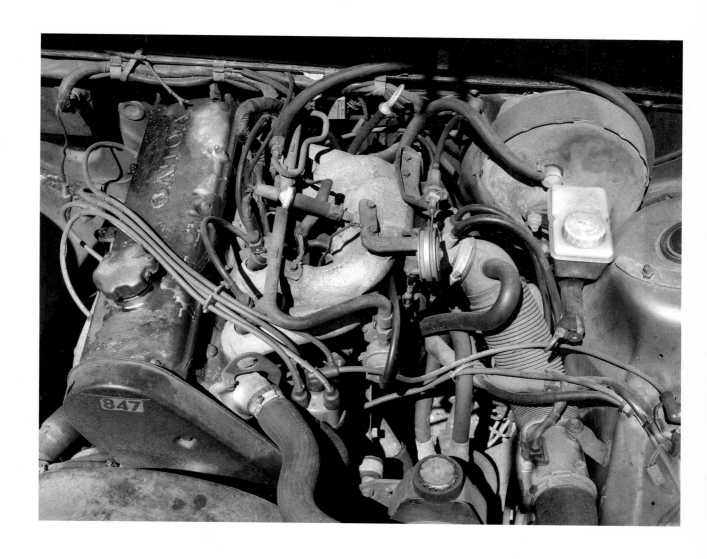

VOLVO ENGINE, 2000
GELATIN-SILVER PRINT
51.3 X 66.7 CM (20¼ X 26¼ IN.)

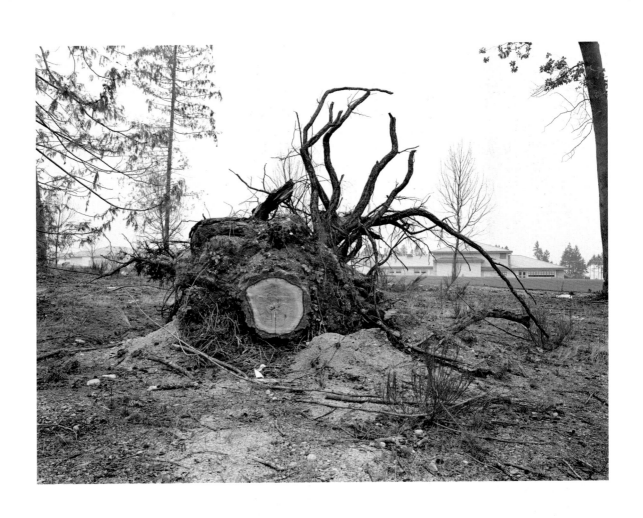

TREE STUMP, NANAIMO, B.C., 1991
INKJET PRINT, 104.1 X 130.3 CM
(41 X 51¼ IN.)

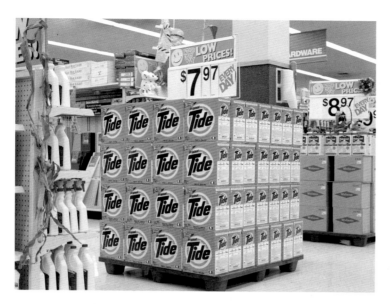

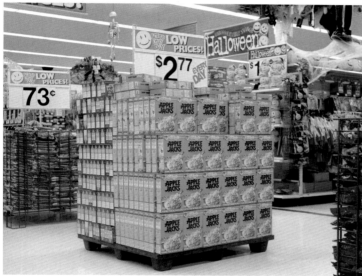

WAL-MART STORE (TIDE), BURNABY, B.C., 1996
INKJET PRINT, 106 X 130.3 CM (41¾ X 51¼ IN.)

WAL-MART STORE (APPLEJACKS), BURNABY, B.C., 1996
INKJET PRINT, 106 X 130.3 CM (41¾ X 51¼ IN.)

THE ATLAS GROUP/
WALID RAAD

founded in 1999 by Walid Raad

born in 1967 in Chbanieh, Lebanon

lives and works in New York, USA

WWW.THEATLASGROUP.ORG

Walid Raad's eclectic, distinct artistic practices, realized through the Atlas Group project, deal with the documentary genre and the archive which he reassesses and refashions as paths towards information, knowledge and truth. Neither ironic nor nihilistic, yet successfully sidestepping issues of realist representation, Raad augments and recasts the possibilities and potential of knowledge, mixing memory with invention, recollection with fantasy, observation with re-creation, in a series of drily sophisticated meditations centred around issues of absence, presence, displacement and submission. The Lebanese civil war (1975–90) is the primary source for the work. By inserting fiction, narrative, storytelling and fantasy into a documentary framework, Raad is able to address the inexplicable: the loss, pain and trauma experienced by people caught up in the conflict.

With the overarching notion of the archive holding all the various elements of the Atlas Group together, the project (which includes films, photographs, documents, objects, but also performances, lectures and essays) catalogues particular elements of the war and effectively forms a repertoire of violence. *Already Been in a Lake of Fire*, which comprises cut-out photographs of cars with accompanying texts, aims to list all the types of vehicle used as car bombs during the civil war, along with information about the type of bomb and the impact of the explosion.

The Atlas Group is formally and explicitly established as a research foundation with the purpose of investigating and preserving recent Lebanese history. The meticulously detailed works in the project suggest an artistic practice of collaboration and sharing knowledge – the promotion of public space for public discourse. This focus on excavating and preserving the memory of the war as a real, historical concern is coupled with the realization that the actual experiences documented in the archive are in a certain sense inaccessible: to tap into the memory of what has passed is to reinvent the war and replay its wounds as stories, to make it up, and yet this process teaches us the difficulty or impossibility of remembering and understanding, and of healing the wounds of war.

Raad's sophisticated artistic practice is complemented by his support of other archives and works, such as the Arab Images Foundation, an informative and well-managed archive of historical photographs from the Arab world. *Mapping Sitting* (in collaboration with artist and filmmaker Akram Zaatari) explores genres and historical practices of portraiture in the Middle East.

JAN-ERIK LUNDSTRÖM

MIRACULOUS BEGINNINGS AND NO, ILLNESS IS NEITHER HERE NOR THERE, 1993
TWO-CHANNEL VIDEO, 1:43 MINUTES

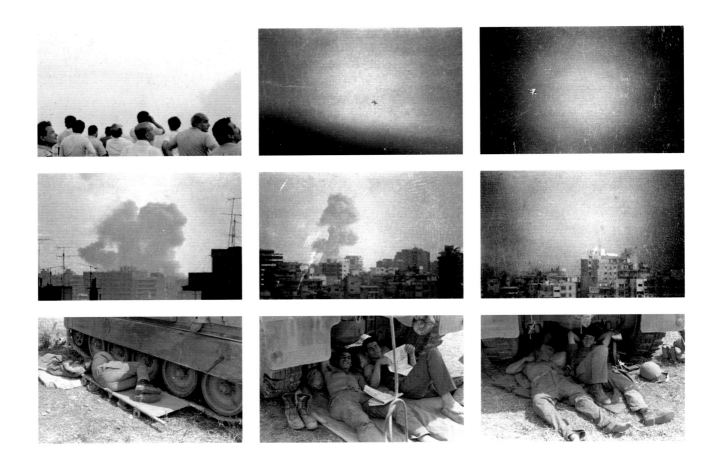

FROM THE SERIES **WE DECIDED TO LET THEM SAY 'WE ARE CONVINCED' TWICE**, 2002
24 COLOUR PHOTOGRAPHS, EACH 111 X 180 CM (43¾ X 70⅞ IN.)

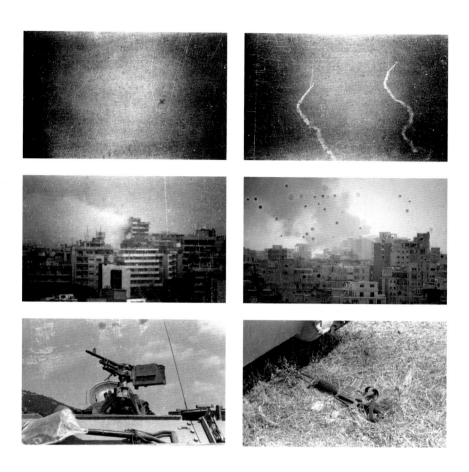

SEUNG WOO BACK

born in 1973 in Taejon, South Korea
lives and works in London and Seoul

WWW.GANAART.COM

Working on many pictorial levels simultaneously, Seung Woo Back focuses primarily on aspects of cultural identity and the related perception of real-life contexts. In a country such as South Korea, changes in living conditions, which oscillate between history and tradition on the one hand, and the economic and social structures of the globalized western world on the other, are evident in the complex and rapid reorientation of the culture. The immediate proximity of Communist North Korea confronts the people not only with a regimented model of society but also with a potential military threat. Back's encounter with western urban culture in London was a defining moment in his life.

In various series of pictures, using all the means at his disposal, Back subtly delves below the surface of the different levels of reality. These pictures provoke us through the use of documentary techniques or their staging and composition. They make us question the kinds of truth that may be conveyed by photographs which refer to some outer, concrete reality in order to produce personal, artistically independent realities, or interpretations of social contexts.

In the series *Blow Up* (2001), the photographs are based on miniatures taken in Pyongyang, North Korea. Their original contexts – 'real' situations or staged political 'theatre' – are no longer distinguishable in the enlarged and doctored details. By working on these pictures, Back interprets not only the particular fragments of the image but also Pyongyang's own image of itself. As in Michelangelo Antonioni's film of the same title (1966), photography is used as a means of tracking complex, real-life connections.

In the collection *Real World* (since 2003), Back reveals aspects of the search for cultural identity. Taken in the Aiinsworld theme park of miniature replicas, South Korea, the landscapes use a clear, documentary language of homogeneous colours to capture subjects such as the Eiffel Tower, a flotilla of traditional Korean boats against the skyline of Manhattan's Twin Towers, or the Leaning Tower of Pisa. While such architectural reference points are in the foreground, the skyscrapers of the city of Bucheon form the background. Taken from a slightly lowered vantage point, the photographs are deceptive in their dimensions, and their patchwork landscapes suggest the possibility that they might be real. 'I have been working steadily on the in between of reality and unreality, or staged borders of ambiguity,' Back writes of his photographs. This is also apparent in his series *Real World II* (since 2005). Almost imperceptibly, these pictures show universal, urban landscapes being invaded at night by miniature toy soldiers. With this allegorical allusion to the sense of danger hanging over life in the city, the documentary style of the pictures proves to be anything but objective, as in fact it is used to convey a deliberately staged, subjective reality.

BARBARA HOFMANN-JOHNSON

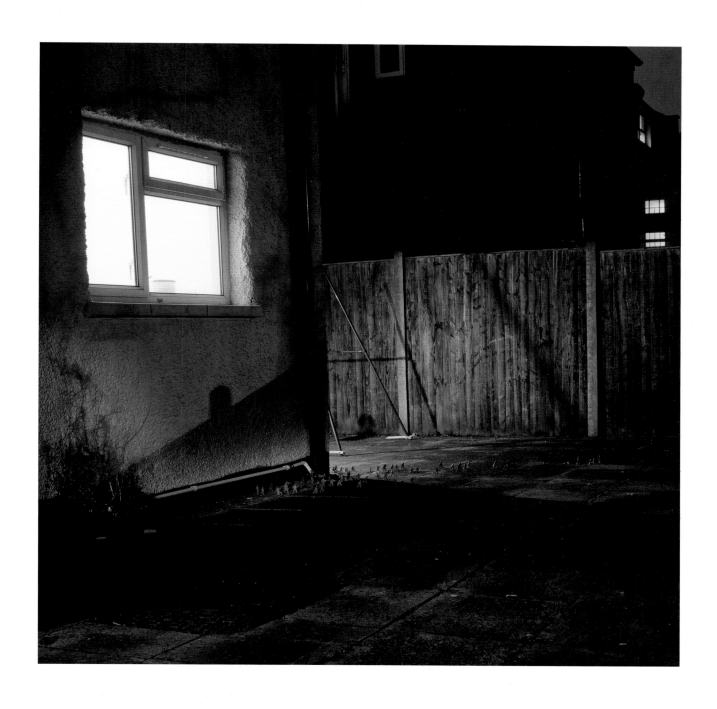

REAL WORLD II #14, 2005–6
DIGITAL C-PRINT
180 X 230 CM (70⅞ X 90½ IN.)

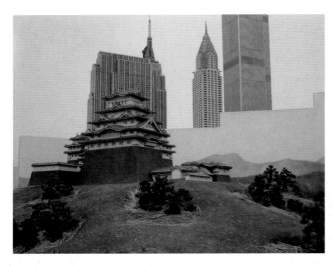
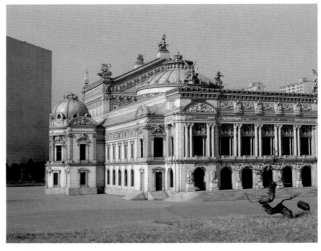
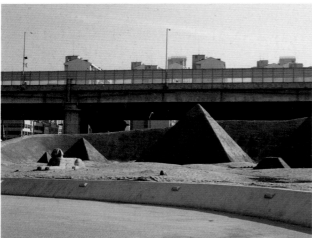
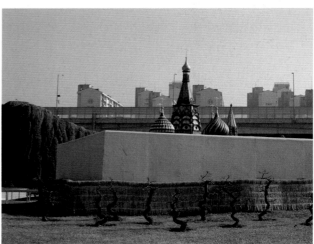

REAL WORLD I #02, 2003–5
DIGITAL C-PRINT
128 X 165 CM (50⅜ X 65 IN.)

REAL WORLD I #04, 2003–5
DIGITAL C-PRINT
128 X 165 CM (50⅜ X 65 IN.)

REAL WORLD I #15, 2003–5
DIGITAL C-PRINT
128 X 165 CM (50⅜ X 65 IN.)

REAL WORLD I #09, 2003–5
DIGITAL C-PRINT
128 X 165 CM (50⅜ X 65 IN.)

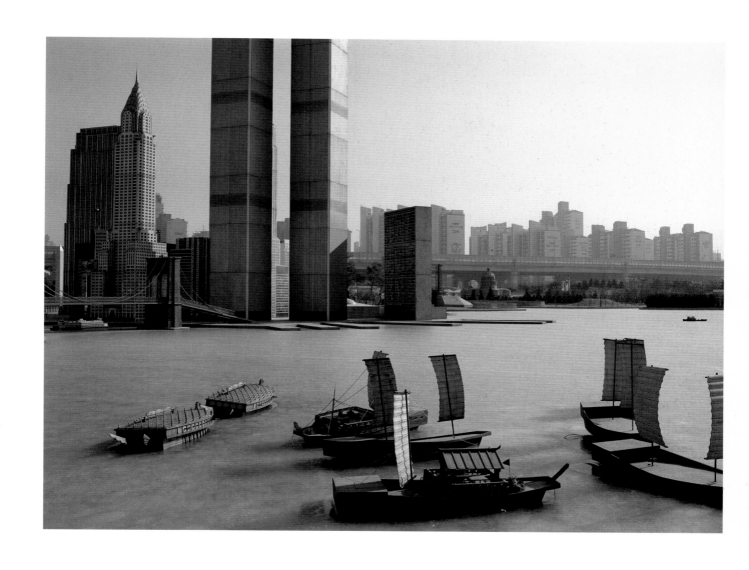

REAL WORLD I #01, 2003–5
DIGITAL C-PRINT
128 X 165 CM (50⅜ X 65 IN.)

OLIVO BARBIERI

born in 1954 in Carpi, Italy
lives and works in Carpi

WWW.BRANCOLINIGRIMALDI.COM

Since the 1980s, Olivo Barbieri has used colour photographs and video to focus on the urban environment, which has become one of the fundamental themes of contemporary landscape photography. Initially, he concentrated on the historical cities of his homeland, such as Siena, Rome and Venice, as well as some of the smaller towns. In these pictures Barbieri presents the characteristic features of these places – already firmly anchored in our visual memory – but uses the formal possibilities of the photographic medium to give them an individual interpretation. He makes creative use of film material, special lenses and digital processes in the development of his work to produce particular effects of colour, distortion and indistinctness which are in direct contrast to the conventional, documentary view of such places. The result is almost painterly. The photographs of Venice under the title *Canaletto* (2002) derive from the *vedute* of the famous 18th-century artist, not only in their title but also through the selection of detail.

In recent years, Barbieri's interest in cultural and global changes has also led him to expand his horizons beyond the towns of Italy to the urban environments of the modern megacities. In *Site Specific*, he produces views of such great metropolises as Beijing, New Delhi, Shanghai, Las Vegas and Los Angeles, often taking the photographs from a helicopter. This bird's-eye view suggests an apparently objective panorama of each city, but Barbieri's large-scale colour photographs deliberately lay emphasis on individual features. Through digital manipulation and the use of lenses that can be moved or tilted in order to adjust the plane of sharp focus, he is able to create striking colour effects and distortions. Often the salient architectural features emerge from the artistically indistinct urban landscapes, making the picture seem like a photographic model of a city. In *Site Specific*, Barbieri is not interested merely in recording the facts; he seeks, rather, to capture a visually atmospheric idea of the place.

BARBARA HOFMANN-JOHNSON

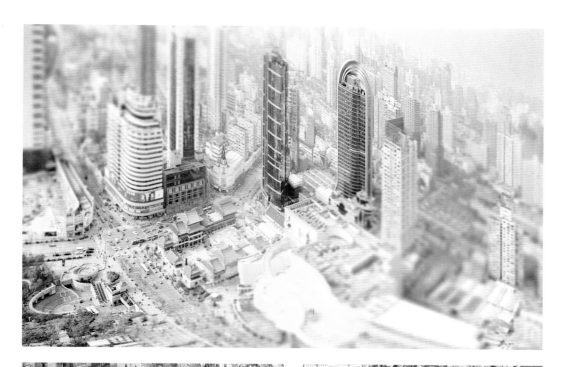

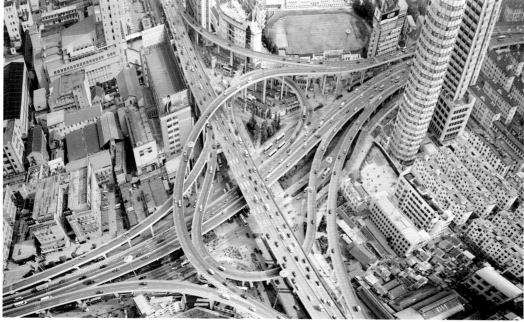

SITE SPECIFIC_SHANGHAI 04, 2004
INKJET PRINT, 111 X 164 CM (43¾ X 64⅝ IN.)

SITE SPECIFIC_SHANGHAI 04, 2004
INKJET PRINT, 111 X 164 CM (43¾ X 64⅝ IN.)

SITE SPECIFIC_LASVEGAS 05, 2005
C-PRINT, 122 X 169 CM (48 X 66½ IN.)

SITE SPECIFIC_LASVEGAS 05, 2005
C-PRINT, 122 X 169 CM (48 X 66½ IN.)

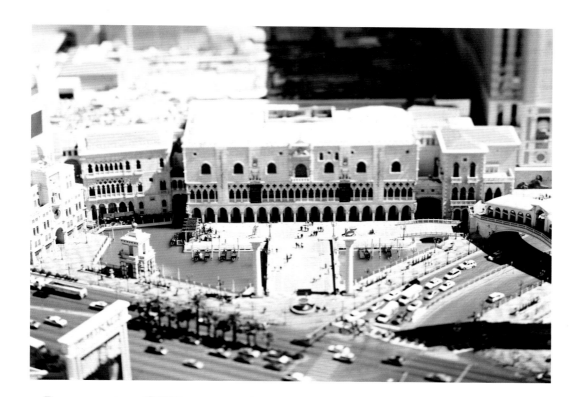

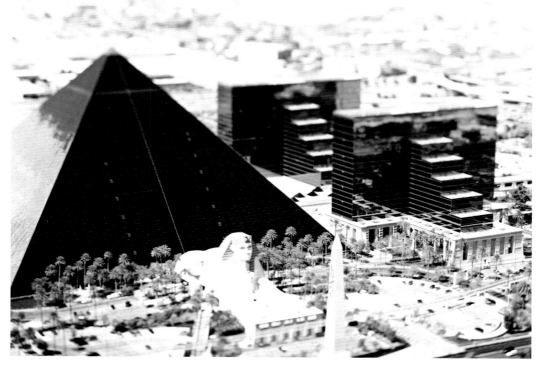

SITE SPECIFIC_LASVEGAS 05, 2005
C-PRINT, 122 X 169 CM (48 X 66½ IN.)

SITE SPECIFIC_LASVEGAS 05, 2005
C-PRINT, 122 X 169 CM (48 X 66½ IN.)

YTO BARRADA

born in 1971 in Paris, France
lives and works in Paris and Tangier, Morocco

WWW.GALERIEPOLARIS.COM

Yto Barrada's most comprehensive photographic project takes as its focus the Strait of Gibraltar, which separates Spain from Morocco. *A Life Full of Holes: The Strait Project* (1998–2004) concentrates on this symbolically charged stretch of water, where many people have made dangerous journeys from North Africa to Europe, often in makeshift and overloaded boats. The Strait is approximately 60 kilometres long, between 14 and 44 kilometres wide, and up to one kilometre deep in places. South of the Strait, in Morocco, lies a patch of European territory on African soil: the autonomous Spanish city of Ceuta.

Here, people come from all over Africa, fleeing war and poverty, and meet the Wall of Shame – an 8-kilometre-long and 3-metre-high double barrier financed by the European Union and fortified with barbed wire, motion sensors, CCTV and armed guards. The first nine months of 2004 witnessed around 9,000 attempted breaches, and the Spanish Guardia Civil reports an average of two successful attempts every night. Meanwhile, overseas routes from Africa to the EU are used by people smugglers, who charge refugees shameless prices for hazardous journeys in unpredictable conditions.

The photographs in *The Strait Project* were taken in Tangier, Morocco. They are about distance, home, exile, and the alluring but treacherous attempts to make the dream a reality: everyday cityscapes featuring streets and walls, sometimes momentary snapshots, at times lingering and empty. Taken individually, the images are strangely quiet and clear, often with an elegiac and melancholy undercurrent. Seen together, they flow into one another and become a muted explosion – a critique of civilization, colonialism, language and nature. Barrada helps us to listen. Suddenly we hear the constant grinding of borders being shifted all over the world.

JOHAN SJÖSTRÖM

CONTAINER 1, 2003
C-PRINT, 60 X 60 CM (23⅝ X 23⅝ IN.)

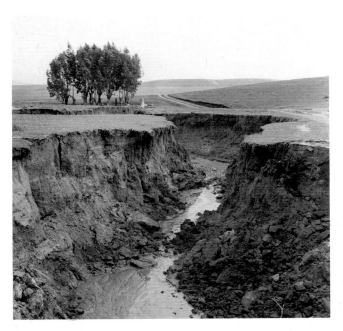

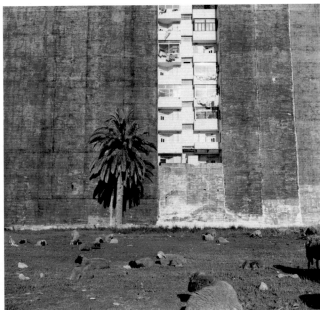

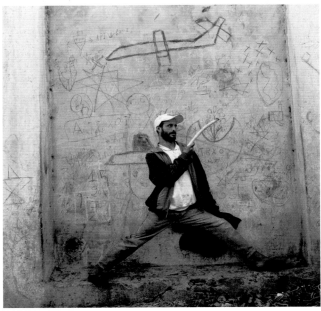

LANDSLIP, 2001
C-PRINT, 60 X 60 CM
(23⅝ X 23⅝ IN.)

MAN WITH STICK, 1999
C-PRINT, 103 X 103 CM
(40½ X 40½ IN.)

VACANT PLOT, 2001
C-PRINT, 60 X 60 CM
(23⅝ X 23⅝ IN.)

ADVERTISEMENT LIGHTBOX, 2003
C-PRINT, 60 X 60 CM (23⅝ X 23⅝ IN.)

VALÉRIE BELIN

born in 1964 in Boulogne-Billancourt, France
lives and works in Paris

WWW.VALERIEBELIN.COM

In her generally large-format series, Valérie Belin confronts the observer with multiple aspects of physical reality and their abstraction in an artistic and meaningful context. This thematic interest can be traced back to her early study of sculpture and art theory: groups of works were conceived to explore a particular subject and, through the medium of photography, were given a two-dimensional form.

In one of her first series, from the early 1990s, the theme was crystal, and so we see black spaces filled with vases, lamps, mirrors and other glass objects. Illuminated by a number of spotlights, the glass – whose immaterial effect is an integral part of its nature – seems to dissolve in the reflections of the light on its surfaces and on the dark areas around it.

In her later, predominantly black-and-white photographs (although more recently she has also explored colour) on the subject of portraiture, Belin has turned her attention with hyper-real aesthetic precision to different facets of physical reality and the possibilities of its depiction. In her *Portraits* series, the young models are deprived of any recognizable context, and pose in their flawless perfection against a black or white background, which is reminiscent of classical sculpture. Other series show display dummies, car wrecks, slices of meat, dogs and bodybuilders. Some were taken at a recycling plant – impressive, graphically precise compositions of pallets containing discarded electronic equipment, such as old computers and monitors. In another series taken in 2006, the entire surface of the pictures is covered with crisp wrappers. The bags, bearing a rich variety of typography, seem almost like watercolours, but Belin's black-and-white photography removes them from time and from their usual colour context, endowing them with a two-dimensional abstract life of their own.

As in the crystal series, the even lighting and the reflection of the light on people and objects play a vital role in these works, combining with sharpness of perspective and precision of detail to bring out both the physical and the formal structures of their subjects. Surface textures, graphic features, variations in light and shade, transparency and brilliance seem to be enhanced in these various series, so that we are made to see the chosen themes outside of their normal contexts, as exaggerated, illusory abstractions.

BARBARA HOFMANN-JOHNSON

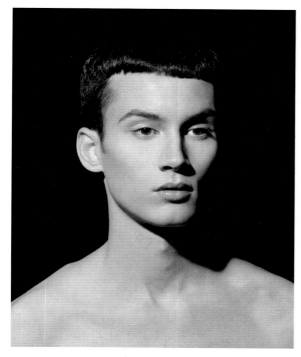

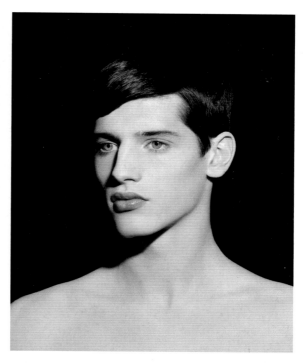

UNTITLED, 2006
FROM THE SERIES **PORTRAITS**
INKJET PRINT, 125 X 100 CM
(49¼ X 39¾ IN.)

UNTITLED, 2006
FROM THE SERIES **PORTRAITS**
INKJET PRINT, 125 X 100 CM
(49¼ X 39¾ IN.)

UNTITLED, 2006
FROM THE SERIES **PORTRAITS**
INKJET PRINT, 125 X 100 CM
(49¼ X 39¾ IN.)

UNTITLED, 2006
FROM THE SERIES **PORTRAITS**
INKJET PRINT, 125 X 100 CM
(49¼ X 39¾ IN.)

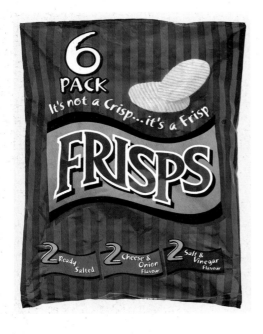

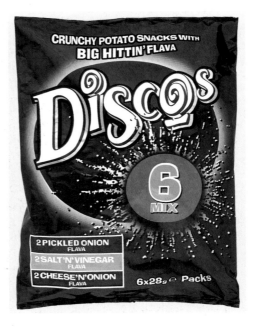

CHIPS, 2004
FROM THE SERIES CHIPS
GELATIN-SILVER PRINT
166 X 125 CM (65⅜ X 49¼ IN.)

CHIPS, 2004
FROM THE SERIES CHIPS
GELATIN-SILVER PRINT
166 X 125 CM (65⅜ X 49¼ IN.)

CHIPS, 2004
FROM THE SERIES CHIPS
GELATIN-SILVER PRINT
166 X 125 CM (65⅜ X 49¼ IN.)

CHIPS, 2004
FROM THE SERIES CHIPS
GELATIN-SILVER PRINT
166 X 125 CM (65⅜ X 49¼ IN.)

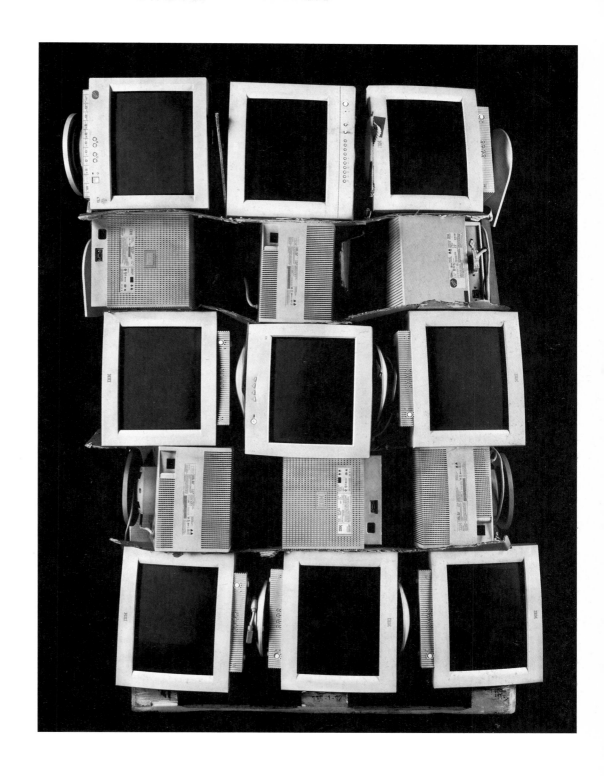

RICHARD BILLINGHAM

born in 1970 in Cradley Heath, UK
lives and works in Brighton

WWW.ANTHONYREYNOLDS.COM

British artist Richard Billingham could be described as a portraitist, landscapist, anthropologist or zoologist. His largely documentary photographic practice is, however, rooted in an appreciation of painting and its somewhat traditional notions of pictorial beauty, balance and atmosphere. This painterly quality might not be immediately evident in the series *Ray's A Laugh* which made Billingham famous in the 1990s. These unflinching portrayals of his working-class family earned him not only a place in Charles Saatchi's 'Sensation' exhibition, but also the inaugural Citibank Photography Prize in 1997 and a Turner Prize nomination in 2001. Centred around his alcoholic father Ray and his chain-smoking, overweight mother Liz, as they eat, sleep and brawl inside their tower block home in Birmingham, the images are not simply vicarious shots of life below the poverty line. Many of the works are saturated in bright colours, adding a glow of vitality and radiance to the otherwise grim scenes and squalid living conditions. They can be tender, too, showing a son's grudging respect for his parents' self-destructive tendencies, as well as a hint of sorrow at their rough, inescapable lives.

Perhaps as a reaction against this personal outpouring, Billingham subsequently turned his lens towards nature, first in his series of rural English idylls – cows grazing in fields and Romantic woodland vistas – and then in nocturnal suburban landscapes around his hometown of Cradley Heath in the West Midlands, where deserted street corners and verges are artificially lit by the sulphurous glow of street lights. The medium-format pictures are love letters to Romantic landscape painting and the specifics of living in the so-called Black Country of England, but they are also totally devoid of human life and so, as Billingham says, 'embody that longing and sense of immanent loss' that people associate with childhood memories of growing up.

The most recent series of photographs and films taken in zoos throughout the world, from Buenos Aires to Tel Aviv, reveals a new sort of empathetic loneliness, that of the caged animal. Taking visual cues from the prison-like compositions of Francis Bacon and behavioural models from the writings of John Berger, Billingham presents the incarcerated lions, elephants and penguins as both physically trapped and psychologically 'owned' by human beings and our incessant gaze. *Zoo* combines the interior logic of his early family photographs with the natural concerns of his later landscape pictures, but adds a layer of unsettling, repetitive drama through his filming of the understimulated animals. For example, a large kea parrot paces the length of its cage, tilts its head back before running back the other way, while a tapir rhythmically sways its head to simulate the walking motion denied to them by the size of their enclosure. 'If you saw a lion in the wild it would look back at you and probably want to eat you, but a lion in captivity would just look through you,' says Billingham.

OSSIAN WARD

BEACH IN KARACHI, 2001
DIGITAL C-PRINT, ALUMINIUM
123.8 X 142.6 CM (48¾ X 56¼ IN.)

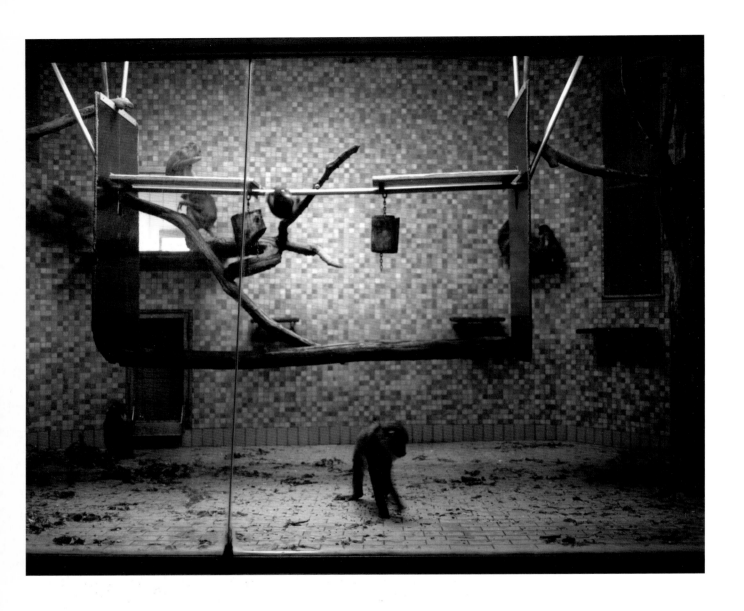

BABOONS, 2005
COLOUR PHOTOGRAPH
165.5 X 205.5 CM (65⅛ X 80⅞ IN.)

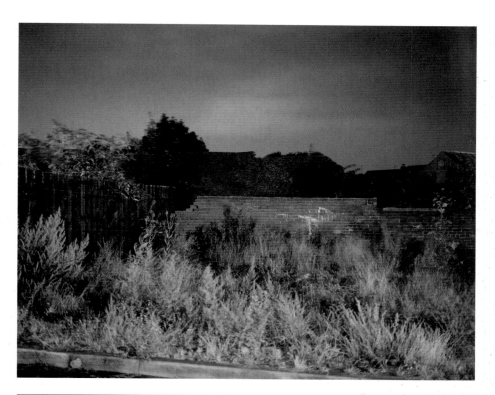

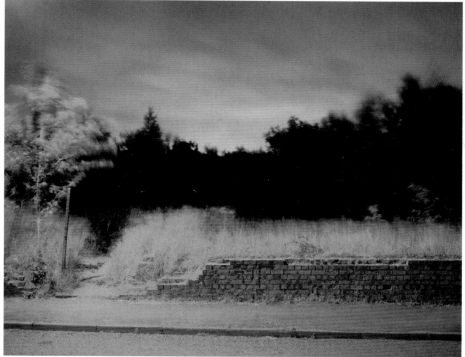

UNTITLED #2, 2003
FROM THE SERIES **BLACK COUNTRY**
DIGITAL C-PRINT, 111 X 136 CM (43¾ X 53½ IN.)

UNTITLED #8, 2003
FROM THE SERIES **BLACK COUNTRY**
DIGITAL C-PRINT, 111 X 136 CM (43¾ X 53½ IN.)

SABINE BITTER/
HELMUT WEBER

S.B. born in 1960 in Aigen, Austria

H.W. born in 1957 in Dorf/Pram, Austria

live and work in Vancouver, Canada, and Vienna, Austria

WWW.LOT.AT

Sabine Bitter and Helmut Weber have been working together since 1993, focusing mainly on urban spaces, areas of development and typical architectural ensembles. They see these urban phenomena as the products of political and economic structures, and as environments architecturally marked by cultural and political conflicts – divisions in society, race and class. For Bitter and Weber, photography offers a means of identifying these divisions in visual form. Their work reproduces the socio-cultural hegemony to which urban life itself is subject. Through this medium, the two artists can formulate their critique, combining view, image, architecture and power.

In the series *Caracas, Hecho en Venezuela* (2003–5), Bitter and Weber apply this complex network of space, image, politics and architecture to a situation of social upheaval. They record the changes in the relationship between all these factors, and their photographs cancel out the stereotypical links between urban spaces and social structures. In the series *Bronzeville* (2005), they again reconstruct the political aspects of modernist architecture that are omitted from architectural histories as well as from conventional illustrations. Mies van der Rohe's Illinois Institute of Technology in Chicago is given as an example of architecture as a social Utopia which is essentially founded on exclusion and oppression. To create this complex, a whole area of the city had to be demolished which in the 1960s had been a centre of emancipatory African-American culture.

By darkening their photographs through solarization, Bitter and Weber are able to incorporate this history of architectural oppression visually. In their *Recent Geographies* series (2007), they put together post-Socialist New Belgrade, Ricardo Bofill's postmodern Parisian suburb, and Ceausescu's palaces in Bucharest in a context that reveals the switch from modern promises of Utopia to a postmodern Utopia of global exchange and the limitless circulation of political power. Thus the photograph becomes a vehicle for cultural and political criticism.

REINHARD BRAUN

PARQUE CENTRAL, VIEW OF THE CITY AND LANDSCAPE PROJECTS
IN THE CENTRE OF CARACAS
FROM THE SERIES **CARACAS, HECHO EN VENEZUELA**, 2003–5
42 C-PRINTS, EACH 50 X 34 CM (19⅝ X 13¾ IN.) (DETAIL)

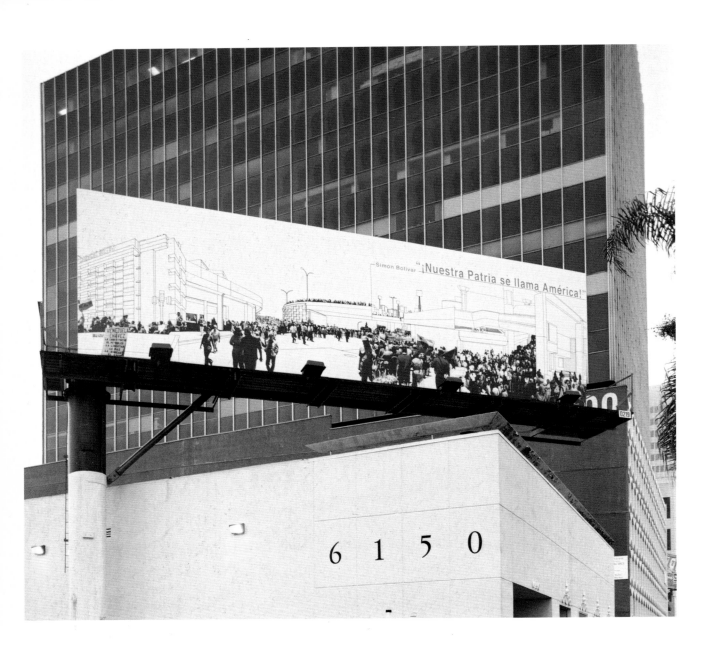

SUPERCITIZENS, 2004
PUBLIC SPEAKING, CLOCKSHOP, WILSHIRE BOULEVARD 6150, LOS ANGELES, 2004–5
BILLBOARD, DIGITAL PRINT ON CANVAS, 4.27 X 14.6 M (14 X 47⅞ FT)

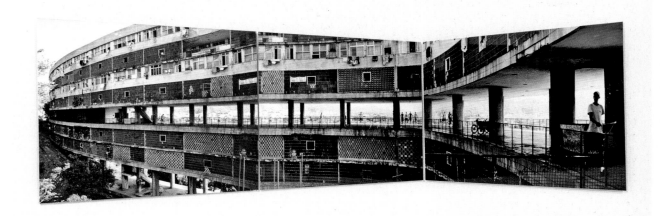

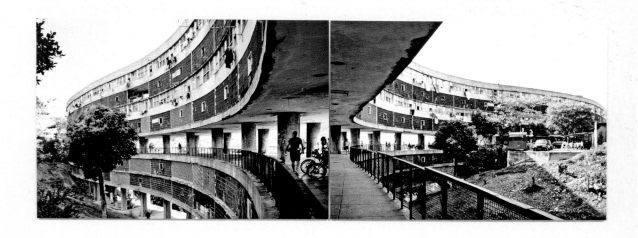

FROM THE SERIES **LIVE LIKE THIS! DID THAT BUILDING DO THAT TO YOU? OR DID YOU DO THAT TO THE BUILDING?**, RIO DE JANEIRO, 2000
7 COLOUR PHOTOGRAPHS, ALUMINIUM, 50 X 70 CM (19⅝ X 27⅝ IN.), 50 X 70 CM (19⅝ X 27⅝ IN.),
50 X 80 CM (19⅝ X 31½ IN.) (COMBINATION 1)

FROM THE SERIES **LIVE LIKE THIS! DID THAT BUILDING DO THAT TO YOU? OR DID YOU DO THAT TO THE BUILDING?**, RIO DE JANEIRO, 2000
7 COLOUR PHOTOGRAPHS, ALUMINIUM, 50 X 70 CM (19⅝ X 27⅝ IN.), 50 X 66.5 CM (19⅝ X 26⅛ IN.)
(COMBINATION 2)

RUT BLEES LUXEMBURG

born in 1967 in Leimen, Germany
lives and works in London

WWW.UNION-GALLERY.COM

Rut Blees Luxemburg is a tireless investigator of the city, whether it be London, Paris or Dakar. She leaves those urban areas that you might find on a tourist board in favour of the forgotten interstices, pockets of the city that have been bypassed by planners and developers, and have fallen into neglect. Neglect is as much a part of a city as development; over time dilapidation and dereliction become an integral element of urbanization. Most of us see such places as ugly eyesores, and tend to ignore or actively avoid them. Blees Luxemburg nevertheless cajoles and entices to the surface an oblique beauty in her photographs of these places. This alternative reality subverts the ordered, planned and designed environment in which we presume to live, revealing those little glitches that sneak in uninvited, those chance anomalies that occur in unguarded corners and neglected spaces as nature erodes the man-made veneer of the cityscape. Blees Luxemburg obliges us to look at these dingy spaces with new eyes. We begin to question why these spaces are as they are. These photographic forays into the liminal spaces of the city are nocturnal: this is the side of the city that a clubber might see on the way to a venue, but miss in a euphoric, narcotic haze. Blees Luxemburg senses the surreal or fantastic qualities of these spaces. Using the available light from sodium or mercury-vapour streetlights, these places are given an eerily beautiful cast.

Much of Blees Luxemburg's work is concerned with the relationship between photography and time. The long exposures required to capture those nocturnal images of the city suggest a prolonged but intangible passage of time whose only indication, as in the series *London: A Modern Project*, is a barely perceptible skein of ghostly traces left by the lights of passing traffic. With this series, Blees Luxemburg burst onto the contemporary photography scene in 1997. Each image in the series depicts an area of the city as a site of menace and as an arena for a potential encounter. The lack of human presence makes it difficult to construct a narrative and opens up the possibility of endless interpretations of the work. *A Modern Project* was followed by *Liebeslied* (1997–2000), a series of fourteen photographs. These images, subtly influenced by the work of the 19th-century German poet Friedrich Hölderlin, are more lyrical and abstract, creating beauty from abject scenes of decay and neglect, but still referencing the forgotten corners of London at night.

ROY EXLEY

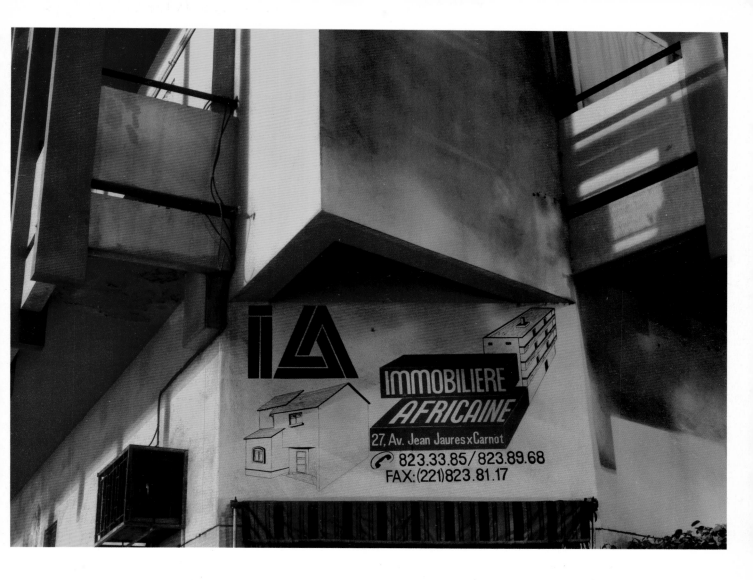

IMMOBILIERE, 2003
C-PRINT, ALUMINIUM
90 X 115 CM (35³⁄₈ X 45¹⁄₄ IN.)

THE KISS, 2003
C-PRINT, ALUMINIUM
140 X 180 CM (55⅛ X 70⅞ IN.)

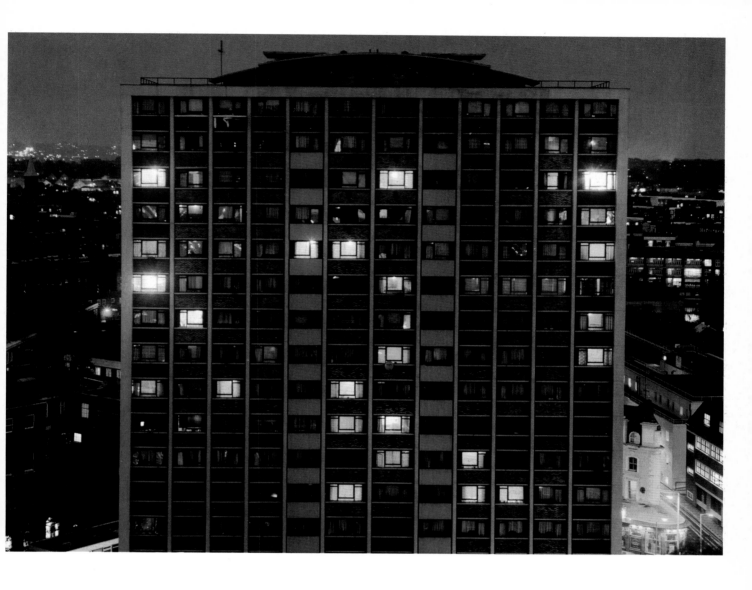

TOWERING INFERNO, 1996
C-PRINT, ALUMINIUM
61 X 76 CM (24 X 29⅞ IN.)

ANUSCHKA BLOMMERS/ NIELS SCHUMM

A.B. born in 1969 in Purmerend, Netherlands

N.S. born in 1969 in Naarden, Netherlands

live and work in Amsterdam

WWW.BLOMMERS-SCHUMM.COM

Anuschka Blommers and Niels Schumm have been working in partnership since they graduated from Amsterdam's Gerrit Rietveld Academy in the 1990s. In recent years, they have become known for their unusual photographs in the fields of fashion and portraiture, which flout the conventions by dispensing with the elaborate and largely expensive practices of the trade. Instead of flying top models to exotic beaches or the great cities, or placing them in luxurious, artificial interiors to create an illusory world in which fashion is associated with some longed-for exclusivity, Blommers and Schumm often use models from their own circle of family and friends, against everyday domestic or landscape backgrounds. Only by means of lighting and emphasis, though sometimes also by exaggerating the pose, do they formalize their compositions to achieve a hyper-realism that lifts their photographs out of the everyday realm.

This is also true of their pictures of objects – for example, a pencil standing upright on a table, balanced on its point, or a glass of water 'caught' just as it is about to topple off the edge of the table. In keeping with these two images, they sometimes go to the extreme in their choice of subject-matter.

In their series of half-length portraits, *Class of 1998* (1998), Blommers and Schumm placed very young models from a London agency against a monochrome blue background. Brightly lit, and with blow-dried hairstyles that are exaggeratedly reminiscent of the 1980s, these young models seem somehow divorced from reality. Their facial expressions are naive and aimless, while the static, disciplined poses make the photographs seem almost like a pastiche of conventional fashion and hairstyle advertisements. Strangely, however, the aura of innocence enables each of these girls to make her own personal impact. This is what indirectly exposes the experienced artificiality of conventional fashion photography and makes these photographs genuine portraits. Other series explore aesthetic formalism and individual auras in the field of portraiture, and their many-layered subtlety gives them a special place not only in applied photography, but also in the context of art.

BARBARA HOFMANN-JOHNSON

WE, 2002
C-PRINT, 125 X 150 CM (49¼ X 59 IN.)
RE-MAGAZINE #23, 'IT'S SPRING TWO THOUSAND SEVEN', SPRING 2002, P. 166; MODEL: BAS

WE, 2002
C-PRINT, 125 X 150 CM (49¼ X 59 IN.)
RE-MAGAZINE #23, 'IT'S SPRING TWO THOUSAND SEVEN', SPRING 2002, P. 168; MODEL: MAARTEN

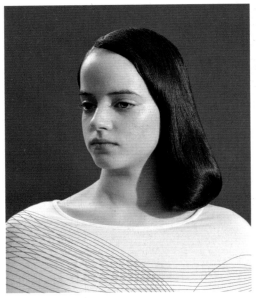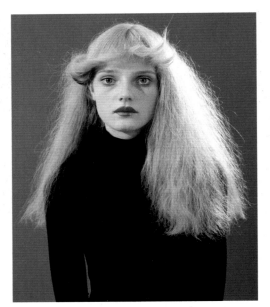

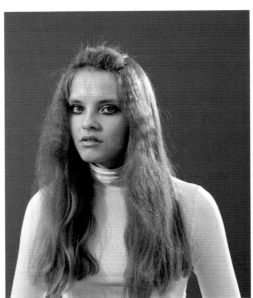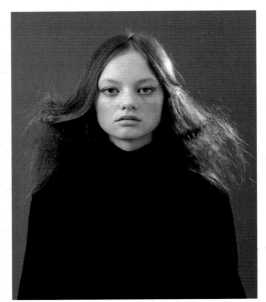

CLASS OF 1998, CIARA, 1998
FROM THE SERIES **SELF SERVICE #8**
C-PRINT, 60 X 50 CM (23⅝ X 19⅝ IN.)

CLASS OF 1998, LAURA, 1998
FROM THE SERIES **SELF SERVICE #8**
C-PRINT, 60 X 50 CM (23⅝ X 19⅝ IN.)

CLASS OF 1998, SUSAN, 1998
FROM THE SERIES **SELF SERVICE #8**
C-PRINT, 60 X 50 CM (23⅝ X 19⅝ IN.)

CLASS OF 1998, MICHELLE, 1998
FROM THE SERIES **SELF SERVICE #8**
C-PRINT, 60 X 50 CM (23⅝ X 19⅝ IN.)

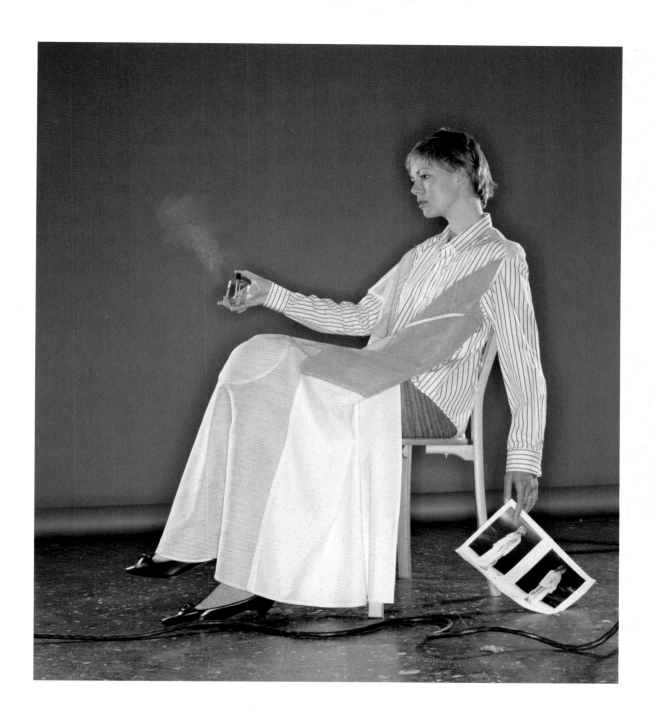

PURPLE #2, 1998–99
C-PRINT, 150 X 125 CM (59 X 49¼ IN.)
MODEL: VIVIANE SASSEN

SONJA BRAAS

born in 1968 in Siegen, Germany
lives and works in New York, USA

WWW.SONJABRAAS.COM

Sonja Braas could best be described as a visual poet, but instead of the sylvan scenes of Romantics such as Wordsworth, Byron or Keats, she creates dramatic and turbulent landscapes, the bubbling white waters of mountain torrents, the icy crags of inhospitable mountain peaks, with their attendant avalanches, or the looming funnels of deadly and unpredictable tornadoes. Her work could be better aligned with the sublime poetry of Coleridge or the hyperbolic paintings of Philippe-Jacques de Loutherbourg or John Martin. In her scenes of nature in the raw, however, very little is actually natural. These cleverly constructed photographs of a rampant and destructive nature are the fruits of Braas' vivid imagination.

Despite the fact that the simulation of nature in Braas' images is an almost faultless deception requiring very little suspension of disbelief, we begin to question their veracity simply because of Braas' apparently reckless, repeated exposure to catastrophic events. Her serial encounters with the deadly forces of nature make her seem at the very least indestructible and possibly even immortal. These skilfully wrought images, based on models painstakingly constructed in her studio, ultimately question the concept of truth. Where are we to place truth among the plethora of cultural way-markers in a rampantly digital civilization? Instead of seeking the truth, we seem to be manufacturing it; instead of pinning it down, we seem to be stretching it out through ubiquitous electronic ether. So, just as climbers strive to conquer mountains because 'they are there', perhaps digitally manipulated images are created simply 'because it is possible'.

However, Braas' intimidating landscapes fly in the face of these trends as they are not digitally generated, but only suggest this. They are, in fact, created the hard way – manually. This turns out to be a mentally strenuous and exacting stretching of the truth that navigates all those mutable interstices between reality and fantasy, the fruits of symbiotic observation and imagination. In her series *Forces* (since 2002), we are at first overwhelmed by the tumultuous actions of nature, but as we struggle to get some idea of the scale of these events, which is veiled by a visual ambiguity, we begin to detect tiny flaws in the credibility of Braas' images: the way the light works, the incongruous vegetation in the foreground, the snow flurries that look a bit like steam or mist. Her visual trickery, such as the seamless merging of images of nature and studio-built models, begins to lose its subliminality and slip slowly but surely into the realm of conscious and analytical perception – the cover has been blown, the artifice exposed, and our relationship to these images makes a radical shift like that of moving from one aspect of a gestalt image to the other in the blink of an eye.

ROY EXLEY

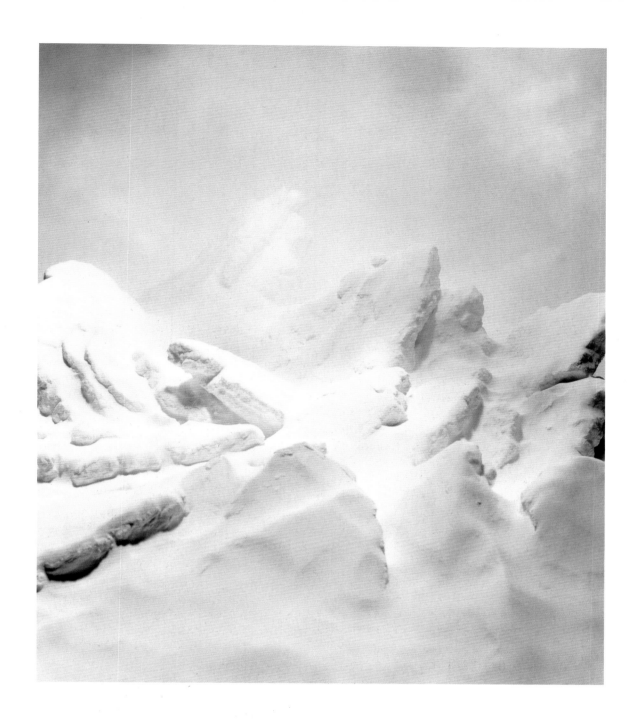

FORCES #3, 2002
C-PRINT, DIASEC
170 X 150 CM (66⅞ X 59 IN.)

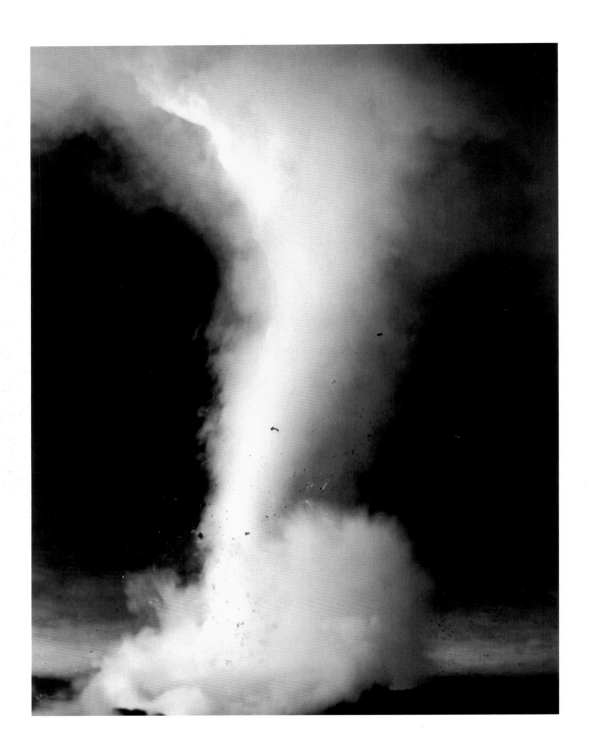

TORNADO, 2005
FROM THE SERIES **THE QUIET OF DISSOLUTION**
C-PRINT, DIASEC, 185 X 140 CM (72⅞ X 55⅛ IN.)

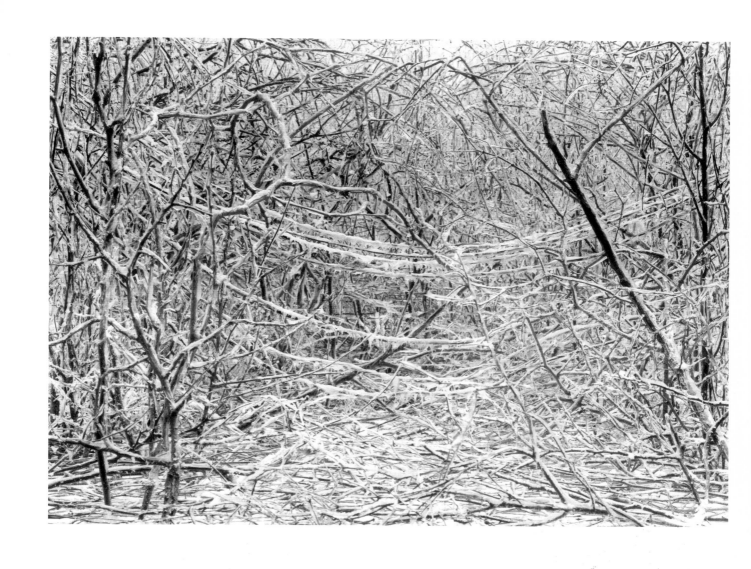

ICE STORM, 2005
FROM THE SERIES **THE QUIET OF DISSOLUTION**
C-PRINT, DIASEC, 160 X 207 CM (63 X 81½ IN.)

DIRK BRAECKMAN

born in 1958 in Eeklo, Belgium
lives and works in Ghent

WWW.BRAECKMAN.BE

Like an action painter, Dirk Braeckman rubbed his early works – including self-portraits – with developer on baryta paper. The emotional tension and concentrated power of expression, with the intuitive combination of concealment and revelation, ensure that the later portraits too represent a purely personal world through what seem like fragments of a highly selective pictorial diary. He chooses them in his darkroom, where he works on them and watches over them. They are brutally direct, generally life-size, consisting of claustrophobic details and veiled in a dull, dark silver-grey which is like a transparent screen that binds things together rather than concealing them. It is a sometimes confusing, uniform grey – in the words of fellow photographer Marc Trivier: 'This muted, dull light...sucked in by the objects.' There are never any noticeable contrasts, and yet the pictures are far from cold, expressionless or detached in their indistinctness, for the photographer is never far away. He is a part of his photographs. The special, or maybe even unique attention with which Braeckman composes the structure of his pictures is always in the foreground.

In later portraits, first of all the eyes disappear from view, either hidden by long wafting hair or because the model's back is turned to us. The direct look proved to be too determinate according to Braeckman, and so he deliberately dispensed with it. Strangely enough, this literal loss of (eye) contact does not result in soulless portraits. Quite the contrary. By the mid-1990s, however, the figure itself had virtually disappeared. Apart from a few 'naked key figures', what we now see are mainly places, empty spaces, uninspiring scenes – a deserted hotel lobby with a veil of lit chandeliers, a monolithic bench in a waiting area, a blank television screen, or the surprising and confusing image of a pale stretch of mountain. This is one of the first photographs in which the reflected flash points directly to the presence of the photographer. Any trace of sensation, attraction or charm is deliberately avoided or eliminated. Themes seem to be a secondary consideration, and the pictures become increasingly free, because what takes place before the camera is a means and not an end. The dominant square format changes into a less restrictive rectangular shape, while the image is no longer central but functions more as a support. The gaze now is not in but behind the picture, invisible yet at the same time more concrete.

'I don't search for such places,' says Braeckman. 'They are my surroundings, my territory. Somewhere within this décor I myself am to be found. These are places where I feel that I am in the right spot.' In this sense, he is still continuing to make portraits. The range encompasses a tiled bathroom wall, a frosted window, foaming surf, and a beacon in the City of London – photographed in Shanghai. The long list of successful one-man and group exhibitions, for which Braeckman continually renews the dialogue between his colossal works, is supplemented by a number of striking commissions and installations. In this context, too, one might describe him as an intuitive conceptual artist, for whom the potency of a picture is more important than all the theoretical footnotes put together.

ERIK EELBODE

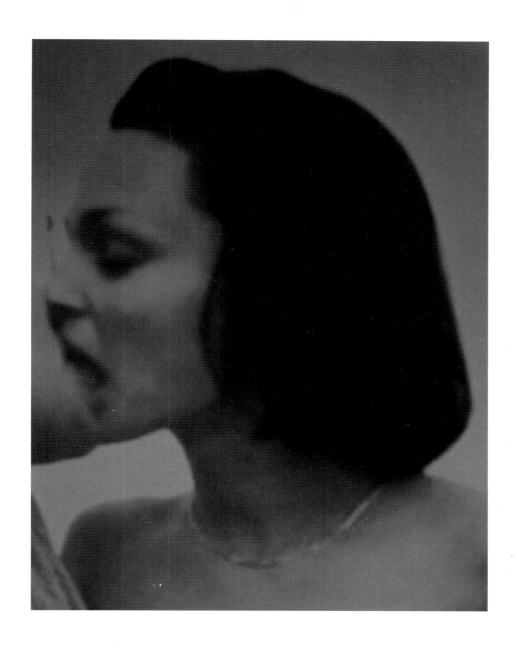

N.P.-I.K.-04, 2004
GELATIN-SILVER PRINT, ALUMINIUM
57 X 43 CM (22½ X 16⅞ IN.)

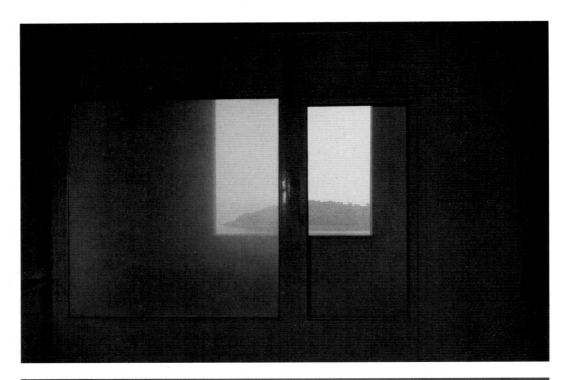

N.P.-E.D.-04, 2004
GELATIN-SILVER PRINT, ALUMINIUM
120 X 180 CM (47¼ X 70⅞ IN.)

B.E.-L.Y.-96, 1996
GELATIN-SILVER PRINT, ALUMINIUM
80 X 120 CM (31½ X 47¼ IN.)

HINGE #1, 2006
ULTRACHROME, INKJET PRINT
49 X 36 CM (19¼ X 14⅛ IN.)

SERGEY BRATKOV

born in 1960 in Charkov, Ukraine
lives and works in Moscow, Russia

WWW.GALERIE-BECKERS.DE WWW.REGINA.RU

Sergey Bratkov belongs to the current generation of artists who, through the medium of photography, have adopted an ironic, critical stance in regard to the changes that have taken place in post-Communist Russian society. His installations incorporate videos as well as photographs. A decisive influence on his development as an artist has been his experiences in his hometown of Charkov, an industrial town with extremes of poverty, prostitution, alcoholism and unemployment. This is where Bratkov, after an initial foray into painting, began to train his photographic lens on social realities, both during and after the Communist era. During the 1960s, a radical underground art movement formed in Charkov with a view to depicting social realities and the needs of individuals, in opposition to the representative, pro-government art of Socialist Realism. One member of this movement was Boris Mikhailov, whose nudes had already antagonized the regime and who since the 1990s has also documented the reverse side of society after the dissolution of the Socialist government. With his stark portraits of the homeless, alcoholics and prostitutes, he continues to turn a critical eye on the social realities in Russia that have followed on from the socio-political upheavals.

Just like Mikhailov, who is more than twenty years his senior, Bratkov was a member of the Fast Reaction Group in Charkov during the 1990s. From this starting-point, he developed his own photographic view of individual identity and the current state of society in his country. His most recent collections consist of snapshots of social and urban realities in Russia, and Moscow in particular, just as his portraits of children, sailors, soldiers, prostitutes or secretaries posing as pin-up girls convey the atmosphere of a present that is still suffused with the history of the Socialist era. This forms the background against which society and the individual must find a new direction, with the restrictions and obligations imposed by the former regime having now been replaced by the equally intrusive clichés of apparent self-determination imposed by the consumer society of the west. In addition to various series of portraits, Bratkov has more recently composed an almost surreal collection of bedroom scenes under the title *Dream Rooms* (2006). These include furniture, personal effects and even photographs of photographs, giving visual form to a subjective, poetic reflection on time and the products of its changeability.

BARBARA HOFMANN-JOHNSON

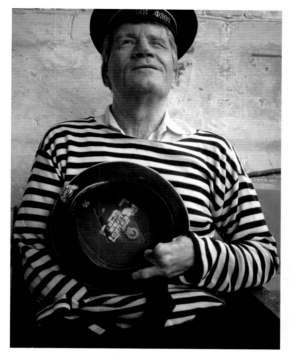

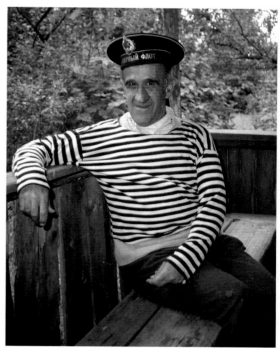

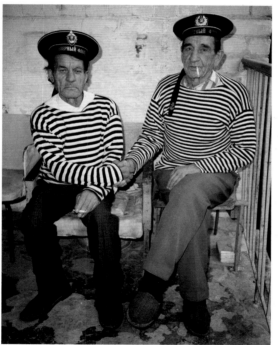

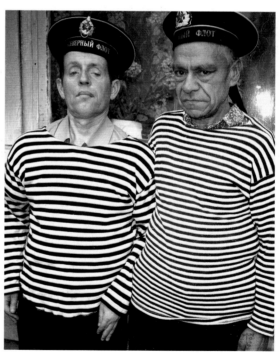

UNTITLED, 2001
FROM THE SERIES **SAILORS**
COLOUR PHOTOGRAPH
85 X 60 CM (33½ X 23⅝ IN.)

UNTITLED, 2001
FROM THE SERIES **SAILORS**
COLOUR PHOTOGRAPH
85 X 60 CM (33½ X 23⅝ IN.)

UNTITLED, 2001
FROM THE SERIES **SAILORS**
COLOUR PHOTOGRAPH
85 X 60 CM (33½ X 23⅝ IN.)

UNTITLED, 2001
FROM THE SERIES **SAILORS**
COLOUR PHOTOGRAPH
85 X 60 CM (33½ X 23⅝ IN.)

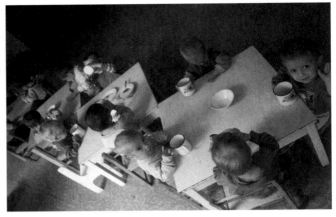

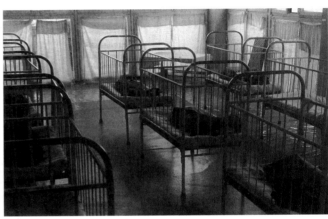

UNTITLED, 1997
FROM THE SERIES **ORPHANAGE**
BLACK-AND-WHITE PHOTOGRAPH
45 X 70 CM (17¾ X 27⅝ IN.)

UNTITLED, 1997
FROM THE SERIES **ORPHANAGE**
BLACK-AND-WHITE PHOTOGRAPH
45 X 70 CM (17¾ X 27⅝ IN.)

UNTITLED, 1997
FROM THE SERIES **ORPHANAGE**
BLACK-AND-WHITE PHOTOGRAPH
45 X 70 CM (17¾ X 27⅝ IN.)

UNTITLED, 1997
FROM THE SERIES **ORPHANAGE**
BLACK-AND-WHITE PHOTOGRAPH
45 X 70 CM (17¾ X 27⅝ IN.)

UNTITLED, 1997
FROM THE SERIES **ORPHANAGE**
BLACK-AND-WHITE PHOTOGRAPH
45 X 70 CM (17¾ X 27⅝ IN.)

UNTITLED, 1997
FROM THE SERIES **ORPHANAGE**
BLACK-AND-WHITE PHOTOGRAPH
45 X 70 CM (17¾ X 27⅝ IN.)

UNTITLED, 2001
FROM THE SERIES GLUE SNIFFERS
COLOUR PHOTOGRAPH
100 X 90 CM (39⅜ X 35⅜ IN.)

ADAM BROOMBERG/ OLIVER CHANARIN

A.B. born in 1970 in Johannesburg, South Africa
O.C. born in 1971 in London, UK
live and work in London

WWW.CHOPPEDLIVER.INFO

Combining a straightforward, hands-on journalistic aesthetic with sophisticated and complex conceptual structures, Adam Broomberg's and Oliver Chanarin's photographic explorations produce unexpected juxtapositions, bringing together a wide scope of images. *Trust* (2000) centres around the human face, but throughout the project the viewer is confronted with expressions of people whose attention appears to be elsewhere or who seem to have been hypnotized or anaesthetized. In these photographs the face is naked to the camera. The project is both a counterpoint to and at the heart of Broomberg and Chanarin's practices, where the relationship between photographer and subject is always a concern.

When Broomberg and Chanarin were given the task of restructuring Benetton's *COLORS* magazine in 2000, they shifted editorial policy towards commissioning rather than purchasing photographs. They also framed a policy whereby anonymous subjects were not accepted, and direct contact between photographer and subject was promoted. Broomberg and Chanarin took the lead in generating work that followed this policy, including *Ghetto* (2005). Twelve contemporary 'ghettos' are represented in images and texts, each a subculture or miniature society outside dominant culture: a Roma community in Macedonia, a Cuban mental hospital, a Tanzanian refugee camp, a high-security prison in South Africa. Having spent a month in each location using the same approach, venturing nearness but not intimidation, the relations between photographer and subject are animated: portraits are frank but respectful. Short narratives accompany each photograph, rendering the larger issues through personal stories.

For *Mr. Mkhize's Portrait* (2004), Broomberg returned to his native South Africa with Chanarin to document living conditions and emotional landscapes ten years after the end of Apartheid. Again, personal narratives, portraits, still lifes and landscapes together map and address the larger issues facing South Africa in the 21st century: violence, AIDS, poverty, class divisions.

In *Chicago* (2006), contemporary Israel is scrutinized from a number of perspectives, revealing a thoroughly militarized and paranoid nation, where myth, reality, illusion and image constantly shift; whatever anything seems to be is seldom the case. At the heart of this project is 'Chicago', an artificial Arab town, complete with mosques, shops and housing, and built by the Israeli Army for rehearsing urban warfare. Another central sequence is devoted to 'Mini Israel', a touristic and peaceful miniature model of the Israeli nation. Put together, *Chicago* is a compelling and stark visual analysis of a conflicted nation and its people.

Continuing a photographic practice of tracing increasingly complex narratives and connections, their recent work *Fig* (2007) brings together issues of photographic history, the colonial impulse to collect and map, and the larger framework of imperialism, through portraits, still lifes and landscapes.

JAN-ERIK LUNDSTRÖM

MANDELA, CAESAR'S PALACE CASINO, 2003
C-PRINT, HANDMADE PRINT
102 X 76 CM (40⅛ X 29⅞ IN.)

THE RED HOUSE 6, 2005
C-PRINT, HANDMADE PRINT
25 X 20 CM (9 ⅞ X 7 ⅞ IN.)

THE RED HOUSE 4, 2005
C-PRINT, HANDMADE PRINT
25 X 20 CM (9 ⅞ X 7 ⅞ IN.)

THE RED HOUSE 5, 2005
C-PRINT, HANDMADE PRINT
25 X 20 CM (9 ⅞ X 7 ⅞ IN.)

THE RED HOUSE 7, 2005
C-PRINT, HANDMADE PRINT
25 X 20 CM (9 ⅞ X 7 ⅞ IN.)

CHICAGO 7, 2006
C-PRINT, HANDMADE PRINT
50 X 60 CM (19⅝ X 23⅝ IN.)

ELINA BROTHERUS

born in 1972 in Helsinki, Finland
lives and works in Paris, France

WWW.WILMATOLKSDORF.DE

During the late 1990s, the photographic work of Elina Brotherus charted a particular late-postmodern terrain grounded in the staged photograph, with the artist as protagonist, and with specific but open-ended biographical references. As Brotherus herself has stated, she made 'wedding photographs' when she got married, and 'divorce photographs' when she got divorced. But autobiography was always source material, not the outcome, as each photograph quickly left its autobiographical demarcations behind to enter into the general realm of human experience: How do we live in this world? How is it possible to continue living? What, if anything, might link 'I' and 'we'? How do we cope with this loneliness? All this is spoken through compelling, attractive and resourceful photographs.

Staged photography, with the artist as protagonist, remains key to Brotherus' image repertoire, but the biographical references move to the background in order to make space for investigation of the multiple deployments of the human figure in the landscape. Here, Brotherus more directly engages historical genres of art and visual expression, in particular the self-portrait and the landscape. And here, the body of the artist discretely exists in the mental landscape of the self, in melancholic enquiries of the psyche, only to be recast in a more formal investigation of body and nature, physical presence and landscape, intimately and creatively reworking a range of formal issues in art history – even reproducing a number of keynote paintings in the Brotherus style. Classicism is home turf in her oeuvre, but is always slightly deformed, upturned, ironically treated, or simply spiced with the particular self-consciousness of her visual world.

The enchanted, and simultaneously troubled, photography of Brotherus insists on an existential core. Regardless of the formalist impulses that could be taken as sources of a photograph, the Brotherus image quietly but quickly and determinedly moves towards a doubling or breaking down of these very references. In the end, the photographs re-emerge as commentary and manifestations of representation. Who masters this parallel world of the image? What is representation all about? Do we ever close the gap? Brotherus' series of photographs *Suites françaises 2* (1999), with words written on Post-it notes and attached to the objects they represent, summarizes in a warmly eclectic or slightly quirky manner the artist's intuitive ability to expose the faultlines in the attempts of representations to approach the real. In a Brotherus photograph, peace, harmony and the presence of history remain attached to doubt, enquiry and the implosion of discourse.

JAN-ERIK LUNDSTRÖM

VUE 2, SOIR, 2003
C-PRINT, 80 X 101 CM
(31½ X 39¾ IN.)

VUE 2, NUIT, 2003
C-PRINT, 80 X 101 CM
(31½ X 39¾ IN.)

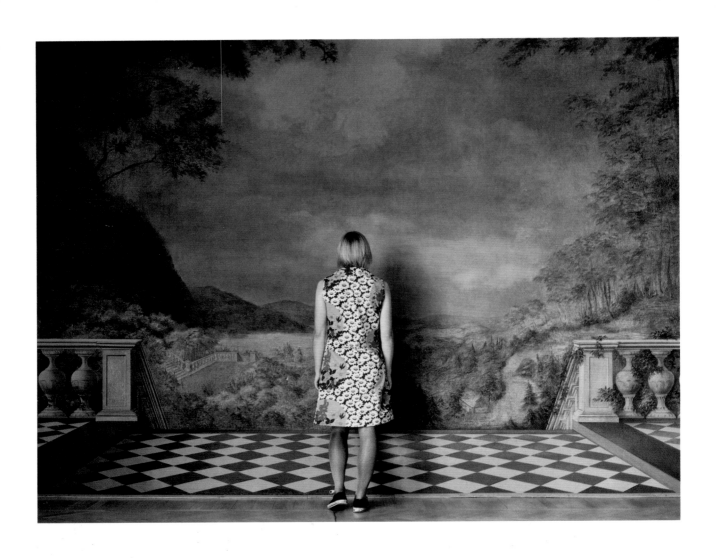

DER WANDERER 5, 2004
C-PRINT, 105 X 136 CM
(41 3/8 X 53 1/2 IN.)

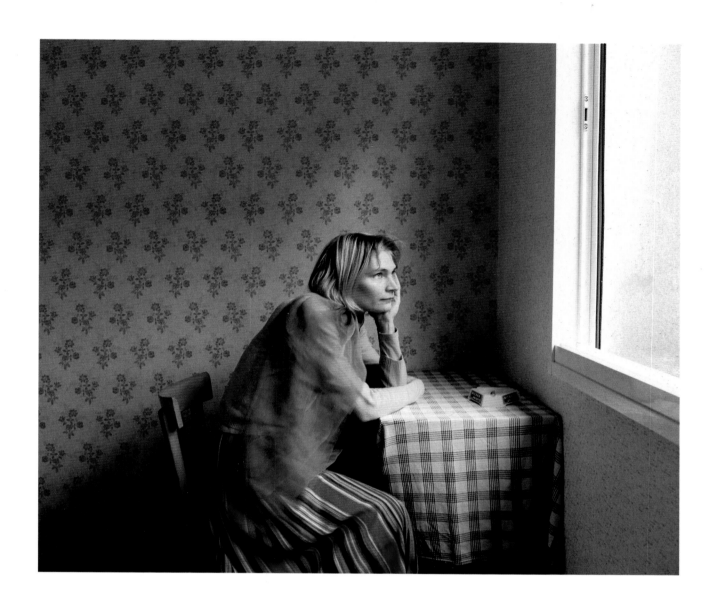

LE PRINTEMPS, 2001
C-PRINT, 70 X 80 CM
(27³⁄₁₆ X 31½ IN.)

STEFAN BURGER

born in 1977 in Müllheim (Baden), Germany
lives and works in Zurich, Switzerland

WWW.STEFANBURGER.CH

Stefan Burger's photographs are an experimental exploration of the frontiers of art, photography and the pictorial image. They may be interpreted as ironically playful reflections on the loss of natural self-assurance which has been the hallmark of art in modern times and has shown itself in the ceaseless quest for definitions and redefinitions. Closely connected with this is the question of whether and under what conditions photography may be regarded as an art – a question that only received a clear, affirmative answer during the final decades of the 20th century. This precarious status does not, however, lead Burger to any dry theoretical considerations; instead, he explores it with entertaining but also thought-provoking 'picture games', in the spirit of Ludwig Wittgenstein's 'language-games'.

A good example of Burger's approach is his *1,5 Jahre Nadelfilz im Fotohof*. In 2004 the Fotohof Gallery in Salzburg, an important exhibition centre for photography, replaced the carpet in its reception area. Burger decided that this carpet represented an important piece of photographic history, and so he invited different photographic institutions to acquire it for their collections. He enclosed a report by the artist and critic Georg Winter, who testified to the importance of the carpet for the history of photography and for the broader concept of the medium. The correspondence that arose, together with the carpet in its wooden setting, now forms part of the artwork. What may at first sight seem like a light-hearted enterprise in fact throws up crucial questions concerning the definition of art and photography, which becomes clear when one reads the correspondence.

This same double-edged wit and analytical selectivity also reveals itself in Burger's titles, which often hold the key to the works themselves. The picture of a man hurtling down from a high-rise building, in front of numerous witnesses standing on their balconies, only takes on its implications as an allegory for the artist through its title, which in translation reads *Leap into the Void Assessed by a Commission of Experts* (2006), an echo of Yves Klein's *Leap into the Void* (1960). In series such as *Innenparasiten des Menschen* (2006), translated as 'Internal Parasites of Man', Burger again combines still-life installations, travel pictures, photographs from scientific and commercial publications, and linguistically clever titles to produce poetic meditations on art with allusions to biology. He flits between playfulness and reflection, between poetic absurdity and sharp-eyed observation, and the result is cunningly composed works of art that invite the observer to delve deep below the surface.

MARTIN JAEGGI

HYPOCHONDER 1, 2006
POSTER ON WOODEN PLANKS
185 X 140 CM (72⅞ X 55⅛ IN.)
INSTALLATION VIEW

IL MUSEO È CHIUSO, 2006
WOOD, ACRYLIC ON CARDBOARD
27 X 19 X 14 CM (10⅝ X 7½ X 5½ IN.)
INSTALLATION VIEW

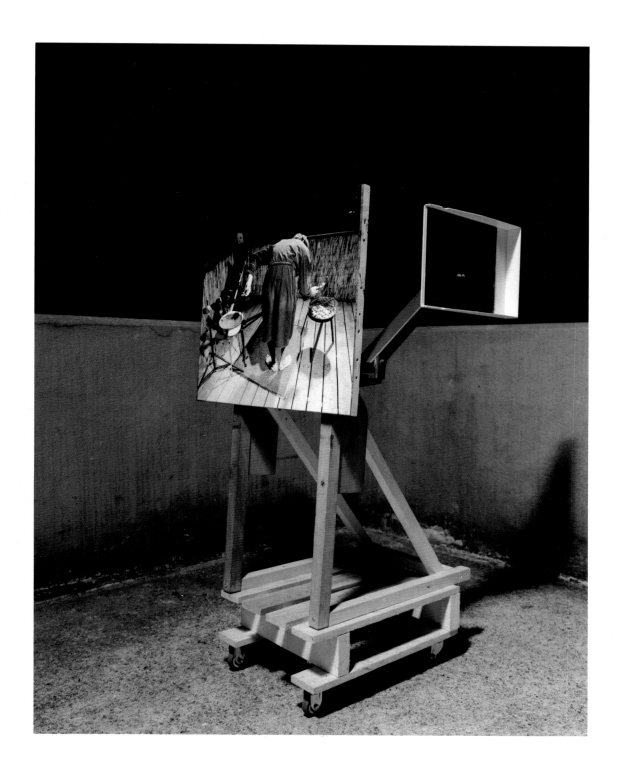

WURST/APPARAT/SETZLING, 2003
MIXED MEDIA
160 X 90 X 50 CM (63 X 35⅜ X 19⅝ IN.)
INSTALLATION VIEW

GERARD BYRNE

born in 1969 in Dublin, Ireland
lives and works in Dublin and New York, USA

WWW.GREENONREDGALLERY.COM WWW.LISSONGALLERY.COM

The way that the viewer interprets the information contained in a photograph is, of course, determined by how it is presented: where it sits on the page or on the wall, the caption that runs beneath it and its institutional setting. As author Richard Bolton put it, the truth of a photograph 'is established through interpretative conventions that exist outside of the image – conventions that are socially and institutionally constructed'. For Gerard Byrne, these conventions and the systems that surround and shape the transmission of information, of narratives, of cultural forms, provide a rich seam of material that he works through in his photographs, his films and, to a lesser extent, in performances and installations.

In two films *Why it's Time for Imperial Again* (1999) and *New Sexual Lifestyles* (2003), Byrne takes a found text as his starting-point and then puts it through a number of transitions. In the first film, a fictional conversation between Frank Sinatra and Lee Iacocca, which once graced the pages of *National Geographic* magazine as an advertisement, is brought to life by actors who are filmed against what looks like a post-industrial American heartland setting. In the second, actors perform the role of swingers discussing the pros and cons of the sexual revolution: here, the artist used a transcript from a 1972 copy of *Playboy*. These texts are not only displaced in time but also in tone. The actors in the first bring a level of 'realness' to what was obviously a constructed conversation, and in the second, the quality of the acting brings a stilted feeling to what was once presumably real.

The theatre, more generally, provides an interesting milieu for Byrne to explore questions of presentation and reception. A series of photographs of the empty set of *Twelve Angry Men*, shot in Andrew's Lane, Dublin, demonstrates how various vantage points and framing devices produce different effects. Close-up and cropped gives the impression of a real, or at least plausibly atmospheric space, while panned out to include the bare bones of the auditorium reveals the framing of the space in which the willed illusion of the play will occur.

A group of photographs that come under the collective title of *In the News* (since 2001) considers the question of topicality, meaning and genre as it is defined by the different sections of the newspaper (sport/news/politics/culture/lifestyle), a printed environment where photographs often encapsulate a story or set the tone. In *Sold Out* (2004), which is part of this series, a gang of teenagers spray-paint a construction site hoarding in Dublin's Smithfield Market. The title refers both to the apartment blocks, which have just been completed, and to the action of the group, whose graffiti seems to be a condoned, perhaps even orchestrated element in the gentrification process. Another in this series, *Alexandra Horgan drawing at the Natural History Museum, on November 2001*, shows a woman sketching between antique cabinets of museum specimens. The people presented in these images seem to be in the news but not making the news, because both photographs frame their subject's small expressive gestures as structured and channelled by the public spaces in which they occur – the institutional and civic spaces that define the way we act and how our actions are perceived.

GRANT WATSON

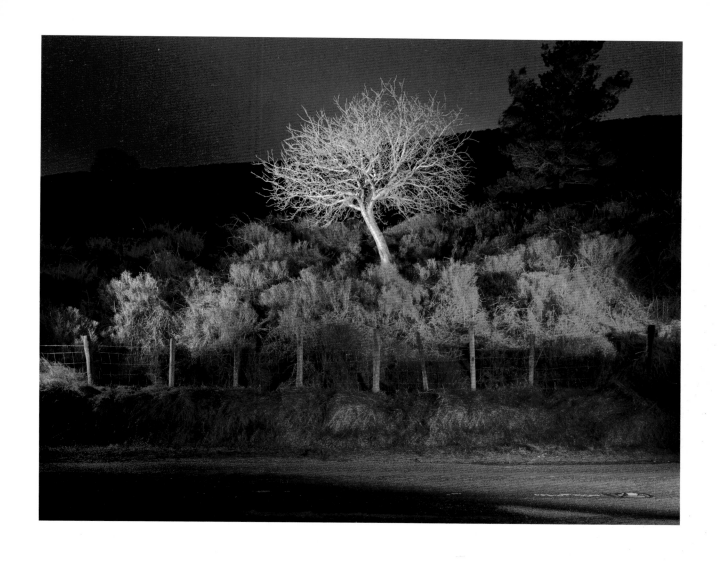

A COUNTRY ROAD. A TREE. EVENING. THE ROAD TO GLENCULLEN BETWEEN
GLENDOO AND TIBRADDEN MOUNTAIN, DUBLIN MOUNTAINS, 2005-7
INKJET PRINT ON FUJI CRYSTAL PAPER, 80 X 110 CM (31½ X 43¼ IN.)

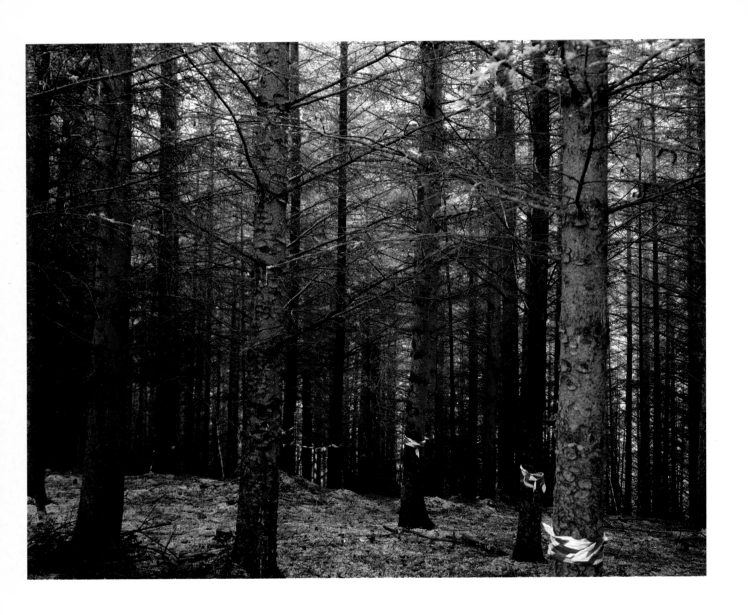

LN 1901, 2002
INKJET PRINT ON FUJI CRYSTAL PAPER
53.5 X 63.5 CM (21 X 25 IN.)

UNTITLED (#807), 1999
INKJET PRINT ON FUJI CRYSTAL PAPER
67 X 99 CM (26³⁄₈ X 39 IN.)

CLAUDE CLOSKY

born in 1963 in Paris, France
lives and works in Paris

WWW.CLOSKY.INFO

With Claude Closky one can have a good laugh – in the gallery, in the museum, and also at home in front of the box. Nevertheless, you can be sure that he himself doesn't find the world funny at all. What lies behind each liberating smile and each loud laugh is a deadly earnest melancholy. It was not for nothing that, in 2005, he was awarded the Marcel Duchamp Prize.

Together with Pierre Huyghe, Closky attended the École Nationale Supérieure des Arts Décoratifs in Paris, and in the early 1980s he became a member of the neofigurative group of painters Les Frères Ripoulin. Nowadays he uses every conceivable medium for his plastic art, ranging from photography and wallpaper design right through to websites.

Closky concentrates on everyday things: 'I'm stimulated by the everyday,' he says. 'Reflection is important. Sometimes it seems that the work of art already exists inside the material I'm using. All I have to do is separate one area…. And it's precisely this new standpoint that emerges from my direct reaction to my everyday life.' Thus, for example, in his video 200 Mouths to Feed (1994), there is a collage of TV adverts showing people eating. The succession and constant repetition of these perfectly natural actions turn them into a bizarre, artificial and, at times, downright unappetizing spectacle.

Even in his earlier works, Closky also set out to organize chance, which determines our everyday chaos, and somehow subject it to systems. But he often allows this category of work to spill over into absurdity, for example in 1000 premiers nombres classés par ordre alphabétique ('1000 prime numbers classified in alphabetical order') or in Osez ('dare'), in which he organizes a thousand advertising slogans by length: from 'Apprenez à faire deux choses à la fois' ('Learn to do two things at once') to 'Osez'…. Everything he uses or reuses is perfectly familiar to us; he never shows us anything new. He uses only materials that we know from everyday communications (films, magazines, the Internet) and there is absolutely nothing 'magic' about any of his pictures, but his logical taxonomy and indefatigable lust for collecting and rationalizing undermine our normal vision of these 'non-pictures'. He reduces the grammar of the common objects all around us to zero. As a consequence, we come to see them – perhaps for the very first time – in all their fullness.

However, Closky is no cool deconstructionist, and he is neither a know-it-all moralist nor an earnest Situationist. With his elegant, sophisticated wit he often has a great deal more to offer than simple irony or loud social criticism. As Lynne Cooke has observed, he feels as much at home with such precursors as Marcel Broodthaers and Ed Ruscha as he does with Minimal Art and Concept Art. Sometimes surprisingly and always disarmingly he continues to develop his cult of absurdity. He does so methodically and laconically, continually bringing new energy to one of the most vital driving forces of modern art: the action of planting doubt.

ERIK EELBODE

AOÛT 1999 #7, AOÛT 1999 #8, AOÛT 1999 #9, 1999
C-PRINTS, EACH 40 X 50 CM (15¾ X 19⅝ IN.)
INSTALLATION VIEW

BOURG LA REINE, 2000–1
C-PRINT, ACRYLIC, DIASEC
150 X 225 CM (59 X 88⅝ IN.)

GENTILLY, 2000–1
C-PRINT, ACRYLIC, DIASEC
150 X 225 CM (59 X 88⅝ IN.)

500 € 1000 €

500 EUROS, 2002
COLOUR PHOTOGRAPH, FELT TIP
32 X 24 CM (12⁵⁄₈ X 9¹⁄₂ IN.)

1000 EUROS, 2002
COLOUR PHOTOGRAPH, FELT TIP
32 X 24 CM (12⁵⁄₈ X 9¹⁄₂ IN.)

COLLECTIF_FACT

founded in 2002 in Geneva, Switzerland, by Annelore Schneider, Swann Thommen and Claude Piguet

WWW.COLLECTIF-FACT.CH

The city as a forest of signs is the subject-matter explored by the multimedia artists of collectif_fact – Annelore Schneider (b. 1979), Swann Thommen (b. 1979) and Claude Piguet (b. 1977). They often start with photographs which they work on digitally and combine with computer-generated images. They also frequently present computer images as photographic prints. In their representations of urban space they dispense altogether with the superficial realism of traditional photography. One of their earliest works was given the almost programmatic title of *datatown* (2002). For this project they dissected a town, splitting it into abstract elements, signs (including posters and road signs) and photographic fragments of reality which they divided up on the computer and then reassembled in different combinations, creating new architectural models and apocalyptic simulations.

For the video projection *Circus* (2004), collectif_fact took precise, detailed photographs of a square in Geneva. These pictures were put together in a projected computer animation which continuously split the square into individual elements and reassembled it. Thus, an urban area is literally taken to pieces in a manner that directly confronts the senses but at the same time also appeals on different levels to the intellect. It is reminiscent of both a smart architectural presentation and a trip on LSD.

The same principle of spatial dismemberment can be seen in one of the group's most recent works, *Enterraum* (2006), a three-dimensional installation for the entrance to the art museum in Thun which is reminiscent of a computer-drawn explosion. For this project collectif_fact photographed architectural details of the space and hung them as cut-outs at different levels all around the entrance hall. In its rejection of any linear reference to the reality it illustrates, this model installation sharpens our focus on the space itself and extends the photographs into the third dimension.

Collectif_fact use these computer-aided images not only for model-like reductions of spaces but also for simulations to extend reality. The five-part photographic work *No Comment* (2006) shows pictures of grey areas suffused with pink-coloured smoke. Allusions to actual terrorist attacks (Oklahoma City, World Trade Center, the Paris metro, Bali) invoke frightening scenarios that hover between reality and computer games, between politics and Hollywood. Collectif_fact extend the range of photography through the infinite possibilities of digital picture-making, in order to show a living world in which the borders between virtuality and reality are becoming increasingly blurred, and which can no longer be grasped by the medium of conventional photography.

MARTIN JAEGGI

WIREFRAME 3, 2002
LAMBDA PRINT, ALUMINIUM
75 X 100 CM (29½ X 39⅜ IN.)

NO COMMENT 1, 2006
LAMBDA PRINT, BLACK PVC, ACRYLIC
200 X 75 CM (78¾ X 29½ IN.)

NO COMMENT 2, 2006
LAMBDA PRINT, BLACK PVC, ACRYLIC
200 X 75 CM (78¾ X 29½ IN.)

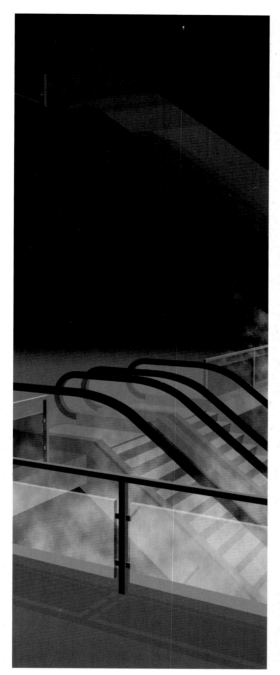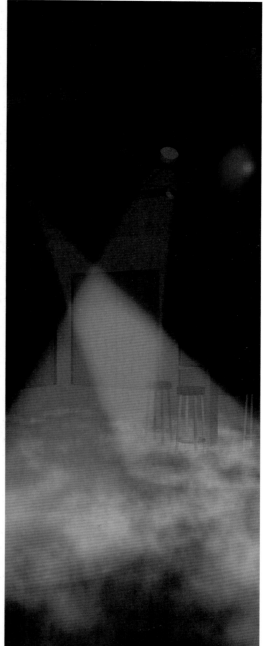

NO COMMENT 3, 2006
LAMBDA PRINT, BLACK PVC, ACRYLIC
200 X 75 CM (78¾ X 29½ IN.)

NO COMMENT 4, 2006
LAMBDA PRINT, BLACK PVC, ACRYLIC
200 X 75 CM (78¾ X 29½ IN.)

KELLI CONNELL

born in 1974 in Oklahoma City, USA
lives and works in Chicago

WWW.KELLICONNELL.COM

Kelli Connell received her Master of Fine Arts from Texas Women's University in 2003 with a body of work called *Double Life*, for which she gained immediate recognition. The series, begun in 2002 and still ongoing, depicts various moments in a fictitious relationship between two women. Provocatively, one model, seamlessly placed in the images using Photoshop, plays both characters. The appeal of the series is manifold: Connell uses digital technology in an intriguing, conceptual way to explore concepts of doubling and narcissism, she speaks to identity politics in her investigation of a homosexual relationship, and she explores universally poignant themes of love, lust and companionship.

Although she relies on digital tools to create her images, Connell begins her process in an analogue manner. For each picture, expressions and poses have to be carefully planned, and she sometimes uses parts of herself to stand in for the other woman. Connell has cheap, drugstore-quality prints made, which she cuts up and combines manually to plan her final compositions. These small collages are roughly taped together, and are interesting in their own right, but are not as compelling as the illusion of having two versions of the same person in the same photograph. Although we know better, we still enjoy the idea that a photograph can be confused for reality.

In her tableaux Connell weaves together an open, cinematic narrative about a young lesbian couple who seem to be generally enjoying each other and the world around them. Sometimes the situations are banal: the couple go on road trips, stop for coffee and cigarettes, have picnics and share quiet moments. Other times, the events are more dramatic: the women go out to a bar, sit pale and hungover at the base of a toilet at 5 a.m., get into fights, have sex; one of them even becomes pregnant, although we never meet her baby (or, for that matter, its father). Each picture offers a glimpse into the women's relationship, but provides neither a clear, linear narrative nor the visible existence of other characters. Connell's choice to have each of the women interact with her double signals an interest in narcissism and vanity in relationships. It also raises questions: To what extent do we look for ourselves in our partners? And to what degree do we give our partners what they are looking for in us? Connell's pictures invite us to explore the fantasy of having to interact with ourselves in a romantic relationship. They also hint at the particular loss of identity that a relationship requires.

The title of the series, *Double Life*, suggests the sharing of one life by two people as well as the polarities of identity, such as feminine and masculine, that comprise the self. On a more political level it hints at the schism between private and public identities that homosexuals experience when they feel pressure from society to conform. For Connell, the series represents an autobiographical questioning of sexuality and gender roles that shape identity in intimate relationships.

KAREN IRVINE

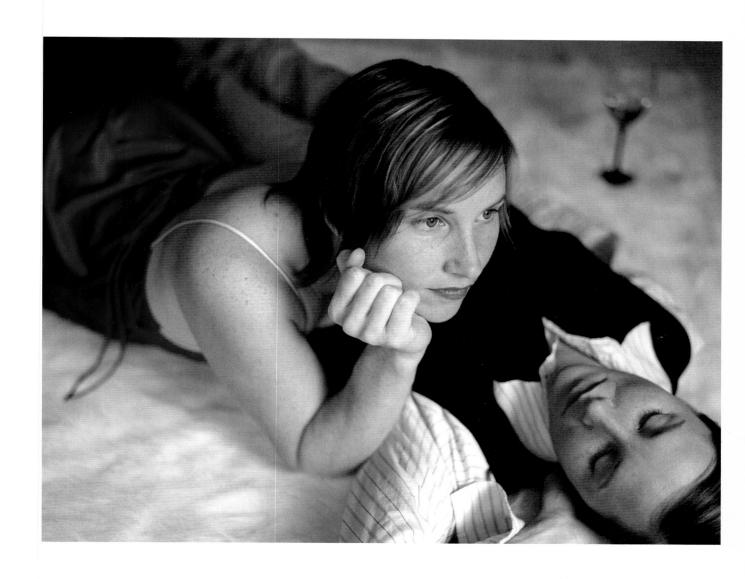

REVERIE, 2006
DIGITAL COLOUR PHOTOGRAPH
76.2 X 101.6 CM (30 X 40 IN.)

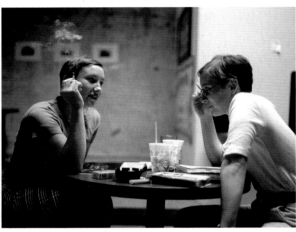

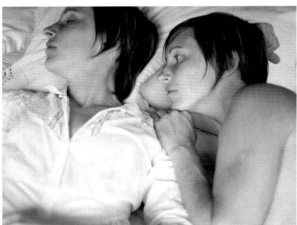

CARTALK, 2002
DIGITAL COLOUR PHOTOGRAPH
76.2 X 101.6 CM (30 X 40 IN.)

BRICKHAUS CAFE, 2002
DIGITAL COLOUR PHOTOGRAPH
76.2 X 101.6 CM (30 X 40 IN.)

CARNIVAL, 2006
DIGITAL COLOUR PHOTOGRAPH
76.2 X 101.6 CM (30 X 40 IN.)

MAYBE, 2006
DIGITAL COLOUR PHOTOGRAPH
86.4 X 101.6 CM (34 X 40 IN.)

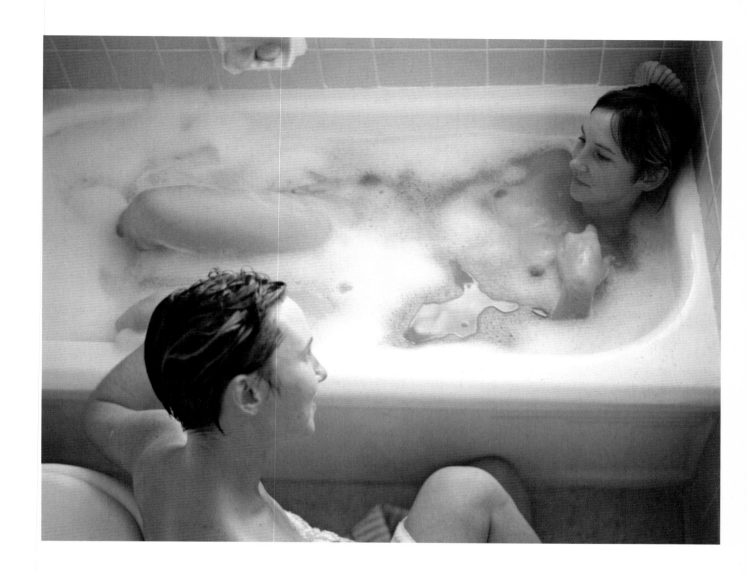

BUBBLEBATH, 2002
DIGITAL COLOUR PHOTOGRAPH
76.2 X 101.6 CM (30 X 40 IN.)

NATALIE CZECH

born in 1976 in Neuss, Germany
lives and works in Cologne

WWW.NATALIECZECH.DE

Natalie Czech's photographic montages are drawn from archives and databanks of images. She sorts through their motifs and arranges them into groups by similarity. Her *Blattschnitte* series (since 2002) – beautiful, semi-abstract aerial photographs of urban and industrial complexes – are based on images taken by government survey offices to help make maps. Czech digitally layers aerial photographs of the same place on top of each other to produce pleasing geometric patterns that titillate the eye while presenting irrefutable evidence of man's incursions upon the natural surface of the earth. Precisely documenting the traces of change in the urban architecture, Czech's long-running photographic project neatly exposes the extent to which the process is transforming the earth's surface.

In her *anderswo* series (1998–2001), Czech explores the desecration brought upon entire villages by the expansion of brown coal opencast mining operations at the Garzweiler II mine in Germany. Family homes have been reduced to shattered hulks, abandoned after the forced evacuation of their occupants. Wallpaper hangs in shreds, and once colourful carpets lie faded and rotting. The light shadows left on wooden panelling, where photographs and pictures have been taken down, are ghostly traces of the lives that used to fill these spaces.

Press photos documenting war, terror, catastrophes and accidents form the basis of the *Daily Mirror* series (since 2005). Filled with intricate detail, these images are photo-collages of scenes, including a sea of flowers of mourning and memorial (*Sea of Flowers*, 2005) stretching into the infinite distance, a levelled swathe of seemingly endless wreckage (*Aftermath*, 2006) created by a haphazard disaster, a claustrophobic vision of intricately interwoven police 'exclusion zone' tapes (*Keep Out*, 2006) which fill the picture frame with their oppressive presence, and a concrete wall riddled with bullet holes (*Riddled*, 2005) which is reminiscent of scenes from Beirut, Sarajevo or Baghdad. These darkly satirical images speak many pain-filled words through their terse silences. Here, there is no plot – just the arrested traces of one, which lose their individuality in the mass condensation of equals. *Daily Mirror* is based on the artist's idea of what makes an image current, how long it remains in our memory, and when it is replaced by another image of an apparently similar kind.

In her digital photo-collages, Czech not only flattens the picture plane, but abbreviates the signatures of time that inhabit her images. History is inscribed in them, and yet they are hermetically caught in the interplay of difference and repetition, which constitutes the reason for their selection. Although the individual photographs show things that have taken place at separate points in time, the montage develops a disturbing simultaneity which does not refer to any distinct experience.

ROY EXLEY

RIDDLED, 2005
FROM THE SERIES **DAILY MIRROR**
LAMBDA PRINT
170 X 127.4 CM (66⅞ X 50⅛ IN.)

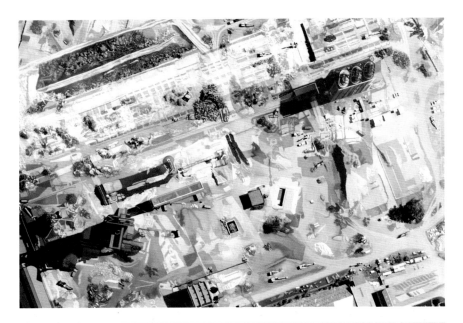

BLATTSCHNITTE 13, 2004
FROM THE SERIES **BLATTSCHNITTE**
LAMBDA PRINT, 100 X 141.7 CM
(39 ³/₈ X 55 ¾ IN.)

BLATTSCHNITTE 16, 2004
FROM THE SERIES **BLATTSCHNITTE**
LAMBDA PRINT, 100 X 135.1 CM
(39 ³/₈ X 53 ⅛ IN.)

WIN OR LOSE, 2005
FROM THE SERIES DAILY MIRROR
LAMBDA PRINT, 205 X 153 CM
[80¾ X 60¼ IN.]

TACITA DEAN

born in 1965 in Canterbury, UK
lives and works in Berlin, Germany

WWW.TACITADEAN.NET

Tacita Dean works in various media including 16 mm film, photography, installation, drawing and sound. Photography appears in her practice as one phase within a larger project, as an archive of images to be worked with, or occasionally as a surface on which to make drawings and notations. The element of time in Dean's practice has been written about extensively, often in relation to the slowed-down quality of her films, where the work unfolds for the viewers who are prepared to give it their unbroken attention. Dean also explores other aspects of time, such as calendar time and its relation to space, a construct that is often out of kilter with our own experience of the world. Her interest in time also extends to the way in which the residue of history survives in the present, often presenting us with a layered and porous sense of temporality.

Dean's photographs in the book *Teignmouth Electron* (1999) show a boat of this name washed up on Cayman Brac island in the Caribbean. They recall the tragic tale of Donald Crowhurst (an entrant in a single-handed round-the-world race) who attempted to fake his progress by sending home false location reports before finally vanishing at sea. While documenting this boat and its island setting, the artist noticed a weirdly futuristic abandoned building, which the locals call Bubble House. She subsequently shot footage of this grandiose ruin, producing a counterpoint of two relics from the recent past, both heavy with the melancholy of human aspirations that remain unrealized. The 16 mm film *Fernsehturm 2001: Back to the Future*, which

was shot in the rotating café at the top of the Fernsehturm in Berlin's Alexanderplatz, portrays this place as it is today, while a small black-and-white postcard from 1972 (part of the artist's collection) shows how this tower was perceived at the time – as a triumphant icon of state socialism.

The photographic archive as a repository of history is also the material source for a number of works. *The Russian Ending* (2002) reproduces images from found postcards, depicting morbid or catastrophic scenes, as photogravures on which the artist then makes notations, while *Czech Photos* (1991/2000) salvages and reworks Dean's own material by developing and printing a forgotten reel of black-and-white film shot in Prague ten years earlier. The ubiquity of photography, and its inherent promise to present the whole of life, is touched upon in the book *Floh City* (2001), which contains hundreds of found images arranged in no apparent sequence. One of them, a bird's-eye view of an ice rink, shows from a great height skaters forming elliptical patterns on the ice. Each tiny figure leaves behind a trail which attests to the moment that has just passed, so that the picture contains the experience of time as duration by capturing several of these moments at once. Although not taken by the artist, this image is indicative of a practice in which the experience of temporality and of past and present is blurred and liable to elasticity, highlighting the confusion and gaps that more accurately describe our experience than, for example, the regularity and passing of time on a clock.

GRANT WATSON

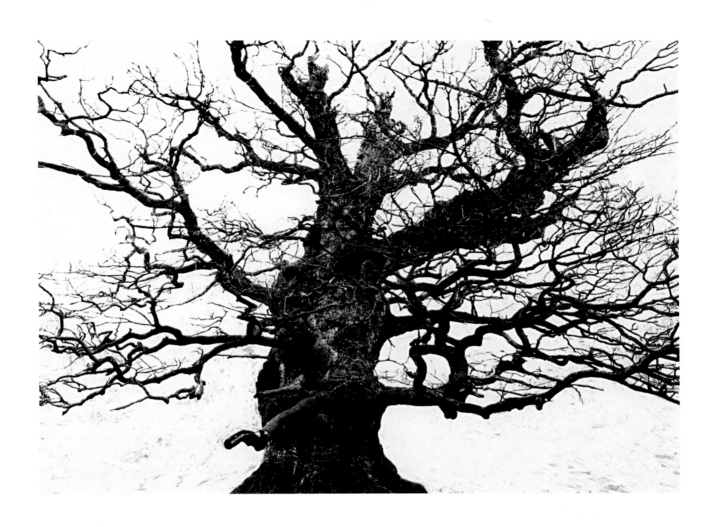

MAJESTY, 2006
WATERCOLOUR ON PHOTOGRAPH, PAPER
300 X 420 CM (118⅛ X 165⅜ IN.)

BOOTS, 2003
FILM STILL

LUC DELAHAYE

born in 1962 in Tours, France
lives and works in Paris

WWW.RICCOMARESCA.COM

In 2003, after years of war reporting, Luc Delahaye suddenly announced that he was an artist and not a photojournalist, quitting the respected photo agency Magnum a few months later. The photographic essay remains his medium, but his duty to document has since become blurred by his desire to subvert and explore. His first considered projects were in Russia and Paris in the late 1990s, where he spent long periods of time taking portraits of anonymous, homeless or destitute people, in a process of human gathering akin to August Sander's *People of the 20th Century* or the hidden-camera subway shots by Walker Evans.

After covering war zones in Lebanon, Romania, Haiti, Kuwait, the former Yugoslavia and Rwanda, Delahaye began to produce increasingly ambivalent war photographs taken in conflict-ridden Bosnia, Chechnya and Afghanistan. Images of a boy soldier staring at himself unselfconsciously in a mirror, or of a cloud of dust thrown up by a mortar shell, speak not so much of the horror of combat, but of its matter-of-fact reality. Illusory spaces and landscapes often accompany Delahaye's central figures and heighten his quest for human drama. His most famous image, *Taliban* (2001), from the *History* series, depicts a dead fighter in a ditch, staring up from his makeshift, shallow grave, having had his shoes, wallet and seemingly his soul removed. The work stirred controversy not only for its blunt frontality but also for its outsized format and high-definition detail, which dwarfs the average reportage image found in newspapers or on websites. It also invited comparison with other monumentally scaled art photography by Andreas Gursky or Jeff Wall.

The use of medium- and large-format images imbues his panoramic interiors of the UN or the US Security Council with epic significance, mirroring art's traditional infatuation with weighty subjects of historical import or compositional grandeur. By pulling back his focus from the specifics of a speech by George Bush or Colin Powell say, to give the overall picture, Delahaye deviates from the norm of journalistic intent, lending his topical scenes an air of detachment usually associated with the impartial observer, not the embedded journalist. Delahaye himself describes it so: 'There is the refusal of style and the refusal of sentimentalism, there is this desire for clarity, and there is the measuring of the distance that separates me from what I see.' Despite his self-proclaimed Road to Damascus conversion to art, he still spends months at a time travelling and engaging with his subject-matter like an investigative journalist. His implicit involvement is reflected in the work and invites viewers to take his place behind the lens, in close proximity to current affairs. Perhaps his work confronts us with something far too present and troubling, because as T. S. Eliot pointed out, 'human kind cannot bear very much reality'.

OSSIAN WARD

TALIBAN, 2001
C-PRINT, 111 X 237 CM (43¾ X 93¼ IN.)
EXHIBITION VIEW, MAISON ROUGE, PARIS, 2005–6

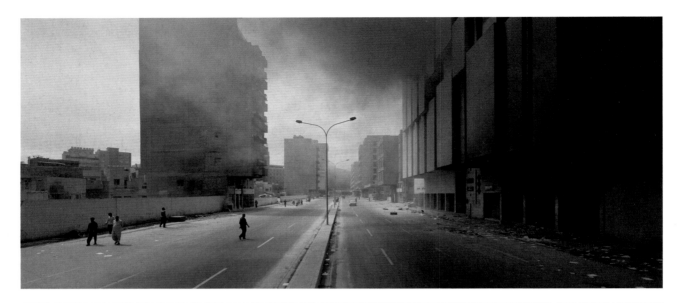

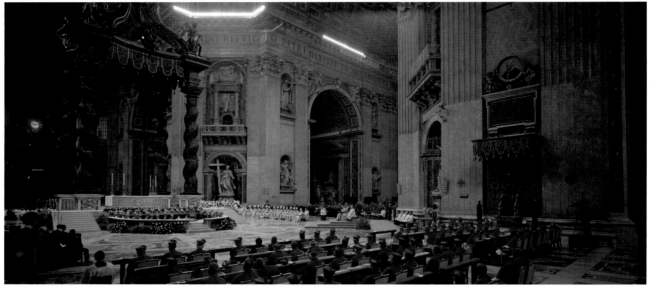

BAGHDAD IV, 2003
C-PRINT, 111 X 240 CM (43¾ X 94½ IN.)

ORDINARY PUBLIC CONSISTORY, 2003
C-PRINT, 111 X 240 CM (43¾ X 94½ IN.)

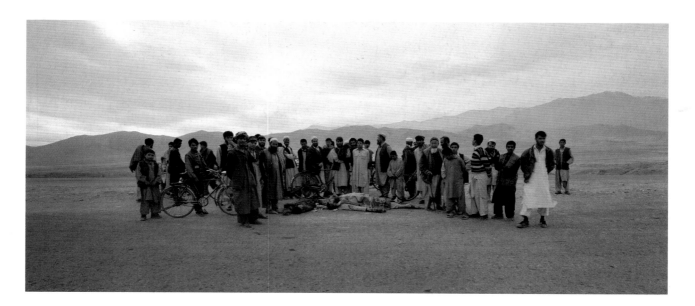

KABUL ROAD, 2001
C-PRINT, 111 X 240 CM
[43¾ X 94½ IN.]

SEPTEMBER 11 MEMORIAL, 2002
C-PRINT, 111 X 240 CM
[43¾ X 94½ IN.]

CHARLOTTE DUMAS

born in 1977 in Vlaardingen, Netherlands
lives and works in Amsterdam

WWW.CHARLOTTEDUMAS.NL

Horses, wolves, tigers – Charlotte Dumas photographs them all, and not just for *National Geographic*. She makes portraits of them, and has been doing so ever since she finished training at the Gerrit Rietveld Academy in Amsterdam. It all began with the horses of the Dutch mounted police, and later those of the carabinieri in Rome. In the series *Day is Done* (2004), she shows the horses of the Roman police looking strangely vulnerable in their stables at night. In the more recent collection entitled *Reverie* (2006), she has adopted a more traditional, art-historical style of portrait.

In an interview, Dumas has spoken in this context of her admiration for the painting *Horse Attacked by a Lion* (c. 1842) by Eugène Delacroix: 'According to my theory, artists like him and Géricault, who often did paintings on commission, projected their own souls into the animals they portrayed. Because that was the point where they could enjoy artistic freedom. People had to look authentic. But they could depict a horse in whatever way they liked. I'm convinced that the painters endowed these animals with a great deal of their own character.... This is not just an illustration. Something is actually happening here – there is action. And what I also like very much is the eyes. Sometimes they are like portraits of humans.' And just like Delacroix, Dumas tries to immerse herself as deeply as possible in her subject. 'He must certainly have sat for hours in the stable observing the horses. His style of painting reveals a fast tempo. A photo is also done

quickly. But in order to photograph in the same way as a painter paints, one must choose just one image out of many. One must know one's subject inside out – just as an actor has to enter fully into his role.'

Dumas' first animal photos were of police dogs biting the protective clothing of their trainers. She chose to show only the dogs themselves and the bite – in other words, these were pictures of violence, aggression and cruelty. Then came the horses, inspired by Isaac Babel's *Red Cavalry* war stories, which he based on his experiences in the Russian–Polish war. Dumas tells how she was deeply moved by the role and the fate of the horses he describes there: 'They are tragic creatures: on the one hand proud and strong, and with a natural dignity; on the other, so willing and obedient. In the First World War, for instance, hundreds of thousands of them were sacrificed.' Initially, Dumas took photographs of horses in action, especially police horses doing spectacular things. But then gradually the portraits became gentler and more intimate. Wolves too, which act almost as opposites to the obedient horses – beasts of prey versus domesticated animals – look especially 'restrained'. Dumas explains this: 'Yes, here it's a kind of passive aggression. All these animals are in captivity. And wolves are only half wild anyway. They live in fenced-off enclosures or rescue centres. What strikes you immediately – what simply cries out to you is: "Here is the animal, and the animal wants to break free."'

ERIK EELBODE

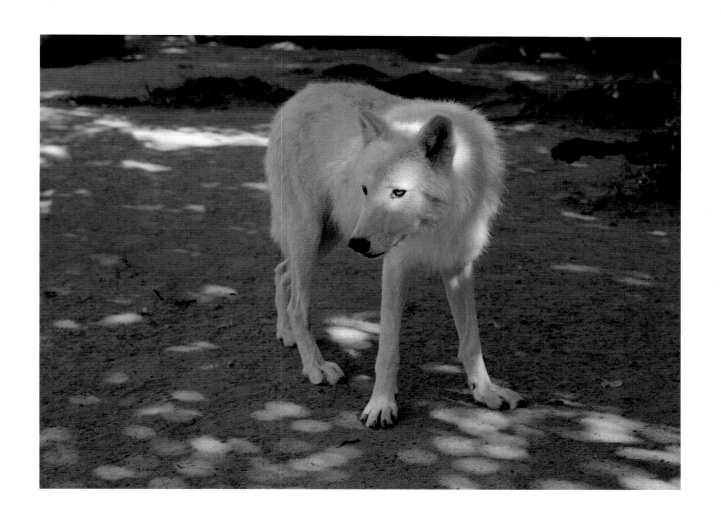

UNTITLED (ATKA), 2005
C-PRINT, 60 X 80 CM
(23⅝ X 31½ IN.)

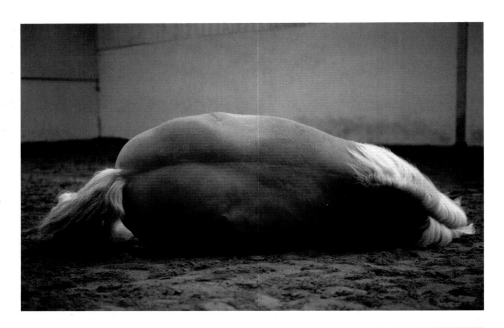

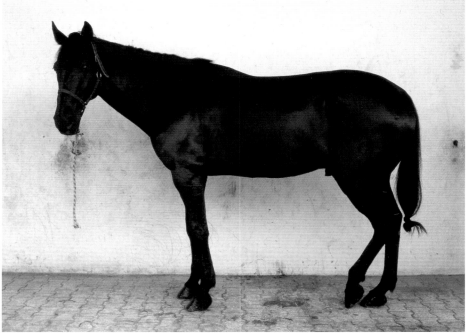

UNTITLED, 2002
C-PRINT, 100 X 154 CM
(39 3/8 X 60 5/8 IN.)

UNTITLED, 2004
C-PRINT, 115 X 154 CM
(45 1/4 X 60 5/8 IN.)

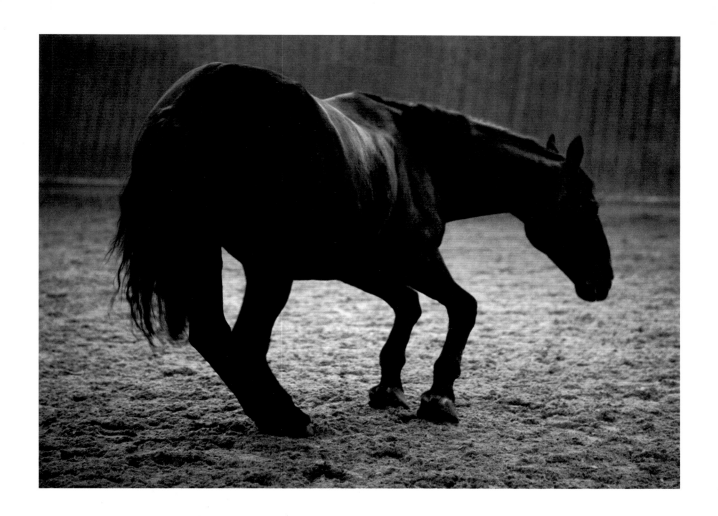

UNTITLED (DAVID), 2002
C-PRINT, 28 X 40 CM
(11 X 15¾ IN.)

LUKAS EINSELE

born in 1963 in Essen, Germany
lives and works in Berlin and Mannheim

WWW.ONE-STEP-BEYOND.DE

Lukas Einsele's *One Step Beyond: The Mine Revisited* (since 2002) explores the global affliction of landmines in the four worst affected countries: Afghanistan, Angola, Bosnia-Herzegovina and Cambodia. According to the UN, between 15,000 and 20,000 people in some sixty countries are wounded or killed by landmines each year. Civilians account for 96 per cent of the victims, and one quarter are children below the age of fifteen. The estimated total number of people who have survived mine explosions is between 300,000 and 400,000. Most of these require continual medical care and various kinds of social and economic support, which often are unavailable in the poor countries where they live.

In this extensive project, Einsele interviews and photographs victims of landmines. Their memories and stories form the basis of the exhibition. In the interviews, those who have stepped on mines try to describe the circumstances and experiences surrounding the accident itself. Some of the interviewees draw pictures of what happened. Einsele then takes photographs of those interviewed, and each participant gets to keep a portrait. In the installation, which is the end result, these portraits are presented along with interviews, drawings and small maps of how they walked and moved up to the point when the mine exploded. Photographs of the regions themselves also form an important part of the project, as there are often more mines than people there. Through landscape photographs and accounts of mine clearing, we are shown the difficult task of removing the mines one-by-one to make the landscape habitable once again. Several pictures in *One Step Beyond* also depict the recovery and readjustment after a mine accident. Large parts of Kabul's infrastructure and roads have been destroyed or are in a very bad state, and one striking photograph of Afghanistan's capital shows a group of rehabilitated mine victims who are today successfully working as bicycle messengers.

Einsele's photographs are characterized by a delicate balance between the documentary and the existential. Sharp analysis and humanitarian sympathy make it possible for him to avoid the sensational and spectacular, and instead the images bring out the human beings, the memories and the experiences behind the sad statistics. 'Certain photographs I neither could nor wanted to take,' says Einsele. 'Pictures with horrible contents taken in far-away places often have a dulling effect on us. I wanted to show people with an identity who had experienced something horrible. That is an entirely different starting-point. Instead of being anonymous victims, those portrayed have become individuals, with a name, a nationality and a face.'

JOHAN SJÖSTRÖM

LANDMINE IMPACT SURVEY, BOSNIA, 2003
DIGITAL C-PRINT, 180 X 150 CM (70⅞ X 59 IN.)
CI HANDCIC AND NIAZ NEMIC ON A HILL NEAR SARAJEVO

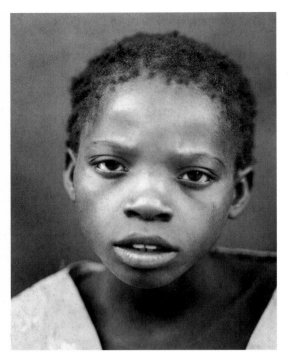 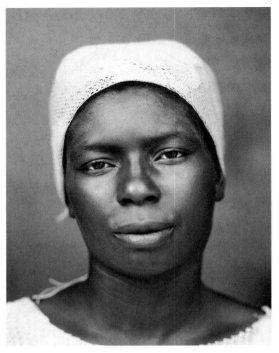

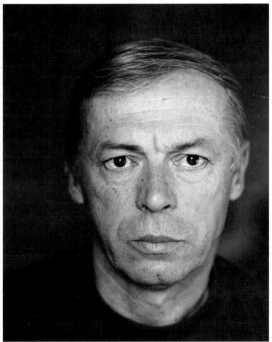 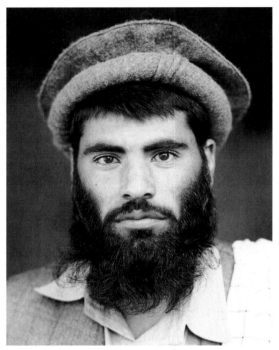

REBECCA MUJINGA, ANGOLA, 2001
INKJET PRINT, BETWEEN 40 X 30 CM AND
50 X 40 CM (15¾ X 11¾ IN. AND 19⅝ X 15¾ IN.)

ROSA MUFUCA, ANGOLA, 2001
INKJET PRINT, BETWEEN 40 X 30 CM AND
50 X 40 CM (15¾ X 11¾ IN. AND 19⅝ X 15¾ IN.)

ALIJA IBRAHIMPASIC,
BOSNIA-HERZEGOVINA, 2003
INKJET PRINT, BETWEEN 40 X 30 CM AND
50 X 40 CM (15¾ X 11¾ IN. AND 19⅝ X 15¾ IN.)

ABDUL AZIZ, AFGHANISTAN, 2002
INKJET PRINT, BETWEEN 40 X 30 CM AND
50 X 40 CM (15¾ X 11¾ IN. AND 19⅝ X 15¾ IN.)

TMRP-6, FORMER YUGOSLAVIA, 2004
C-PRINT, DIMENSIONS VARIABLE
TYPE: ANTI-VEHICULAR MINE
EFFECT: MISZNAY-SCHARDIN

PMN, FORMER USSR, 2004
C-PRINT, DIMENSIONS VARIABLE
TYPE: ANTI-PERSONNEL MINE
EFFECT: EXPLOSIVE

M18 A1, USA, 2004
C-PRINT, DIMENSIONS VARIABLE
TYPE: ANTI-PERSONNEL MINE
EFFECT: SHRAPNEL

V-69, ITALY, 2004
C-PRINT, DIMENSIONS VARIABLE
TYPE: ANTI-PERSONNEL MINE
EFFECT: SHRAPNEL

RUUD VAN EMPEL

born in 1958 in Breda, Netherlands

lives and works in Amsterdam

WWW.RUUDVANEMPEL.NL

Dutch artist Ruud van Empel has taken the digital manipulation of photographs to a new level. His colourful images are synthesized from a myriad of elements, manipulating their fragments and traces rather like an artist uses paint. With digital software he creates complex and exotic images, sometimes spending months working on the synthesis of a particular photo-derived scenario. Van Empel does not pretend to represent the truth or convey reality, but so seamless is his work that the eye is unwittingly coaxed into believing in the reality of a total fantasy world.

Beginning his career in theatre before moving on to graphic design and filmmaking, van Empel entered the world of photography in the early 1990s at the commercial end of the spectrum. Initially working in black and white, creating photo-collages of scenes from the natural world, he quickly graduated to colour photography and soon the enhanced opportunities offered by digital manipulation presented him with a whole new palette of possibilities. Since the mid-1990s, he has devoted all his time to art photography. When van Empel exhibited his work at a gallery in 's-Hertogenbosch in the Netherlands, he showed a series of images depicting blonde, blue-eyed girls and

was both shocked and dismayed when he was labelled a racist and a Nazi for displaying images solely of white girls. This prompted his most distinctive series of images. In a riposte to his critics, he created *Moon, World, Venus*, depicting the innocence of childhood through a series of images mostly of black children. These portraits of children surrounded by lush tropical vegetation are as contrived as the famous jungle paintings of Henri Rousseau, who derived his images from plants sketched in the Tropical House of the Jardin des Plantes, Paris. His work methods are complex but, typically, van Empel will photograph four or five agency models in his studio, and then take a series of detailed shots of leaves, flowers, plants and insects. After collecting hundreds of images, he carefully selects those images that can best achieve the required effect. These artificial paradises of van Empel's appeal, of course, to our romantic sentiments and are a hair's breadth from outright kitsch, executed with such skill and aesthetic sensibility that the visual impact eclipses the satirical message. It is this threshold between the original and the rhetorical that van Empel adroitly navigates in the creation of his ultimately seductive images.

ROY EXLEY

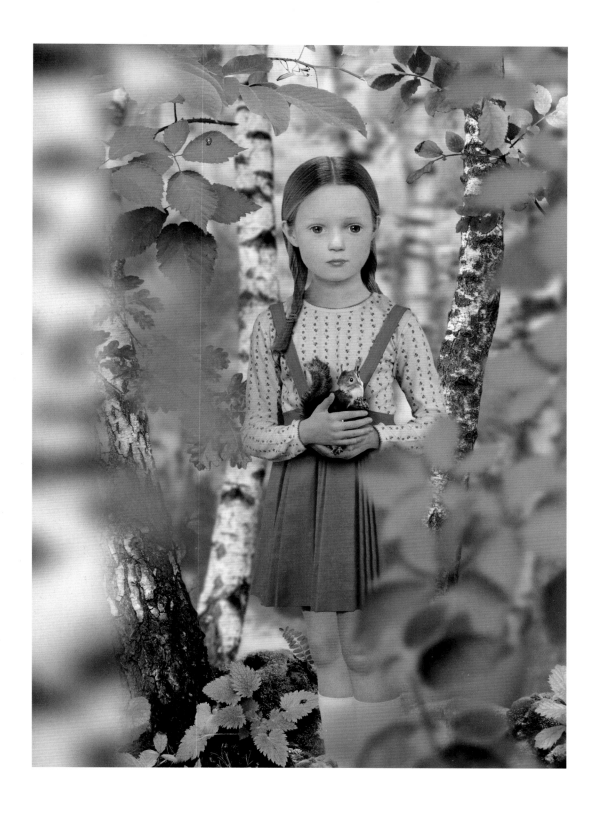

UNTITLED #5, 2004
ILFOCHROME
42 X 30 CM (16½ X 11¾ IN.)

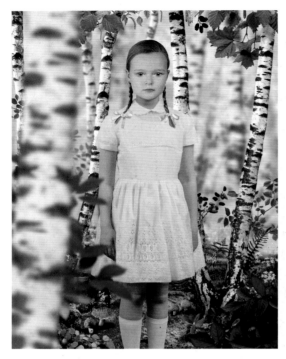

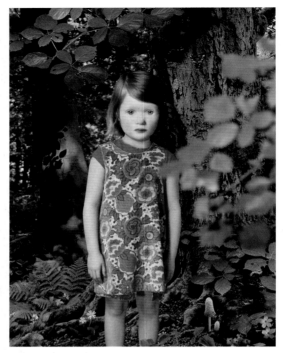

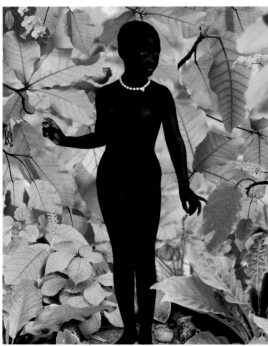

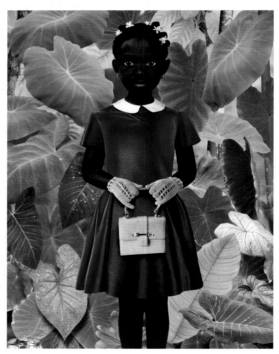

UNTITLED #1, 2004
ILFOCHROME
118.9 X 84.1 CM
(46⅞ X 33⅛ IN.)

VENUS #1, 2006
ILFOCHROME
118.9 X 84.1 CM
(46⅞ X 33⅛ IN.)

STUDY IN GREEN #2, 2003
ILFOCHROME
118.9 X 84.1 CM
(46⅞ X 33⅛ IN.)

WORLD #19, 2006
ILFOCHROME
84.1 X 59.4 CM
(33⅛ X 23⅜ IN.)

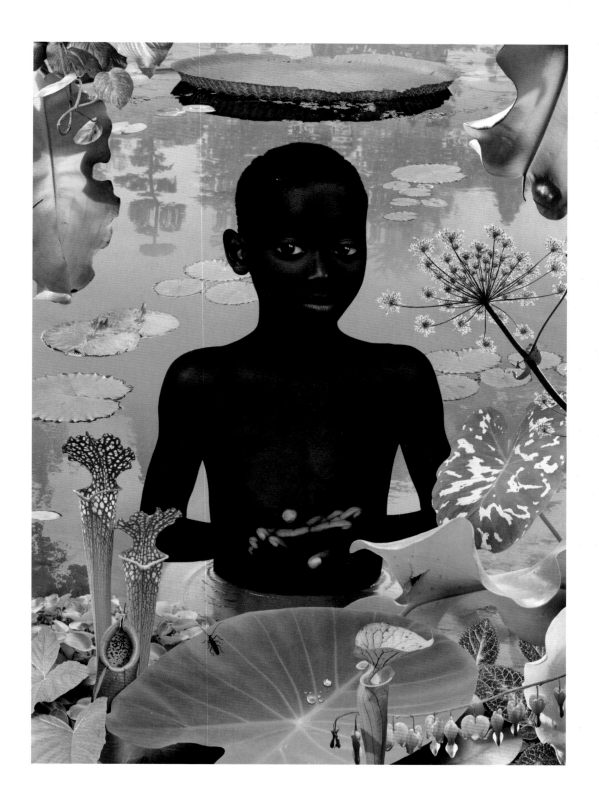

WORLD #13, 2006
ILFOCHROME
118.9 X 84.1 CM
(46⅞ X 33⅛ IN.)

JH ENGSTRÖM

born in 1969 in Karlstad, Sweden
lives and works in Södra Åby

WWW.JHENGSTROM.COM

JH Engström constructs photographic stories. Placed in sequence, displayed in books and arranged in grids and constellations in the gallery, he persuades the viewer to piece together a sense of the work as a whole, rather than take it one image at a time. Typically, within these groupings the artist juxtaposes diverse subject-matter and perspectives: close up with far away, fragment with overview, tender and poetic with shocking. This eclectic approach makes the viewer defer judgment, because while one particular image might be considered sentimental, the next will be raw. And yet despite this eclecticism, like reading a novel in which the writer breaks the temporal sequence into fragments by switching between times and places, we are somehow able to construct a narrative, albeit one that is loose, inconclusive and open to flights of fancy.

A man lies on a bed, his hands clasped tightly together, his face tilted to one side, his eyes closed – is he dead or is he asleep? A tumbledown clapboard house with a sagging porch looks like it might be haunted. A white plastic garden table and chairs stand deserted in the long grass. These scenes, coming as they do from a series called *Haunts*, suggest the spectral or the uncanny. They produce poetic correspondences and allude to the presence of others. Some of the links and connections that can be intuited from the work come from its semi-autobiographical nature, which portrays the artist's milieu as it is defined by the people and places with which he comes into contact. This is

particularly true of *Trying to Dance*, a series that includes the portraits, self-portraits, landscapes and still lifes that Engström began to produce when he moved to Brooklyn in 1998. In this series, as elsewhere in his work, minor details open up onto a world. The ephemera of lived experience, such as the informality of the dinner table with its debris of dirty plates and glasses, or a screen of dried plants close-up through which you can see the rolling ocean, imply the human presence and the human gaze.

An early project saw the artist spending two years taking photographs in a hostel for homeless women, an experience that resulted in his first book *Shelter* (1997). Here, without glossing over the sometimes grim reality of these women's experiences, he manages to salvage intimacy, companionship, humour and even moments of glamour from what are otherwise hard lives. Then there are the straightforward nude portraits of what look like friends photographed in their apartments and elsewhere, his black-and-white portraits that develop the relationship between figure and ground in more abstract terms. In one, a woman (or is it a man?) bends down to look out of the window, while the sun pours into the room, casting deep shadows and delineating the subject's muscular body in a play of tonal qualities. Here, in a rather classical manner, the human figure is arranged as a formal element in the overall composition of light and shade.

GRANT WATSON

FROM THE BOOK **TRYING TO DANCE**, JOURNAL, 2004
C-PRINT, 90 X 120 CM (35³⁄₈ X 47¹⁄₄ IN.)

FROM THE BOOK **TRYING TO DANCE**, JOURNAL, 2004
GELATIN-SILVER PRINTS, 120 X 90 CM AND 50 X 60 CM
(47¹⁄₄ X 35³⁄₈ IN. AND 19⁵⁄₈ X 23⁵⁄₈ IN.)

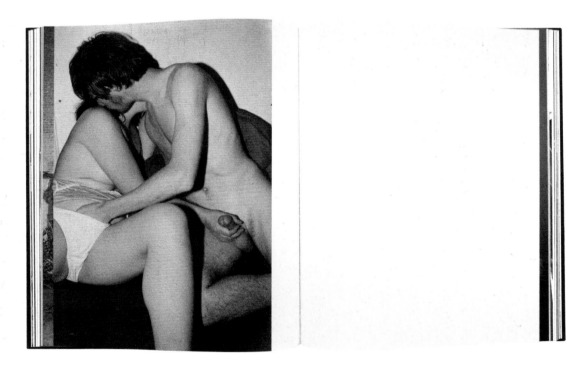

FROM THE BOOK **HAUNTS**, STEIDL, 2006
C-PRINT, 72 X 95 CM (28⅜ X 37⅜ IN.)

FROM THE BOOK **HAUNTS**, STEIDL, 2006
C-PRINT, 95 X 72 CM (37⅜ X 28⅜ IN.)

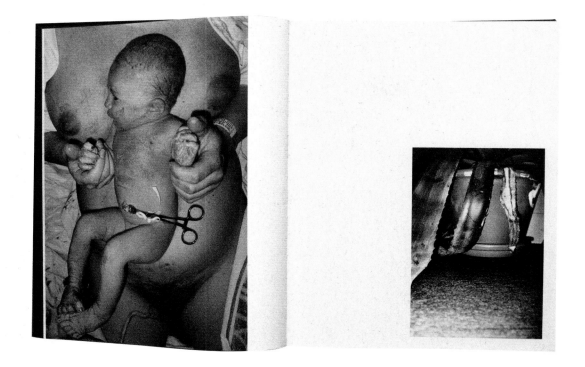

FROM THE BOOK **HAUNTS**, STEIDL, 2006
C-PRINT AND GELATIN-SILVER PRINT
40 X 30 CM AND 95 X 72 CM
(15³⁄₄ X 11³⁄₄ IN. AND 37³⁄₈ X 28³⁄₈ IN.)

ROE ETHRIDGE

born in 1969 in Miami, USA
lives and works in New York

WWW.GAGOSIAN.COM WWW.ANDREWKREPS.COM

With their technical perfection and complete neutrality, Roe Ethridge's photographs seem totally impersonal – they could be pictures taken from the stock of some agency. And yet it is precisely this indeterminacy that inspires Ethridge's fascination with photography: 'It's the same image whether it's illustrating a text or has a caption, on the walls or on a bus stop. I like the fact that photography is ubiquitous and polymorphic, that it can be for the specialist or the dilettante or sometimes both at the same time…. The ability of photographs to function in different contexts becomes almost like a little bit of the burden of photography. It's great that it can do that, but sometimes it's hard to make judgments about images because they're so contextual. It's a nebulous area.'

Ethridge's photographs fulfil completely the criteria for universal application: they have the same impact whether they are used for editorial purposes in a magazine, as exhibits in a gallery or as advertisements. In keeping with this universality is the fact that he generally works in the classical genres – still lifes, landscapes and portraits. He produces series of pictures which he puts together in new combinations for different exhibitions. For instance, in the exhibition 'County Line' (2005), he juxtaposed illuminated signs from shopping precincts in the suburbs of Long Island and Atlanta with pictures of the Canadian Rockies. The contrast between the two groups of photographs raises all kinds of questions, perhaps concerning the conflict between nature and civilization, although there is nothing explicit to guide the observer. These are simply statements in an empty space, and they could also be taken to denote the basic indeterminacy of photography in general.

The very absence of expression sometimes endows Ethridge's work with a photographic beauty of its own – an aesthetics of the punctum, or to quote Roland Barthes: 'this element which rises from the scene, shoots out of it like an arrow, and pierces me.' A slightly irregular double row of pearls on a model or a picture on a refrigerator of a lady wearing old-fashioned sunglasses somehow creates a touching presence precisely because Ethridge does not insist on pointing these details out to us. The neutrality of the photographs makes them seem cosmopolitan – a kind of astonished and astonishing perception whose only message is: 'Look, there's all this to see.'

MARTIN JAEGGI

DUNWOODY MALL SIGN, 2005
C-PRINT, 127 X 101.6 CM
(50 X 40 IN.)

SARAH BETH WITH PIPE, 2006
C-PRINT, 83.2 X 66 CM (32¾ X 26 IN.)

FISH GUTS, 2004–6
C-PRINT, 66.7 X 82.6 CM
(26¼ X 32½ IN.)

CHARLES FRÉGER

born in 1975 in Bourges, France
lives and works in Rouen

WWW.CHARLESFREGER.COM

People in uniform are the living embodiment of the ambivalent and often tense relationship between the individual and society, the member and the group, the will and the function. This is the focal point of Charles Fréger's work. Since 1999 he has travelled the world photographing different categories of people who wear uniforms and whose appearance is prescribed for them: royal guards at different European courts, foreign legionnaires, Swiss Guards, Buddhist monks, sumo wrestlers, the heavily made-up actors at the Beijing opera, water polo and ice-hockey players, schoolchildren and students, scouts, sailors, policemen, etc.

Fréger is particularly interested in the relationship of body to group – how the group inscribes itself into and onto the body, and how bodies amalgamate into a group. He himself has described what fascinates him about this subject: 'In French we speak of a *corps d'armée*, an expression that denotes the fact that a group of soldiers merges into a single body. The individual soldier becomes part of a collective body. Two wrestlers fighting each other produce a similar effect, merging into a single strange, mobile creature. Every sumo wrestler in turn is part of a training community (*heya*).

The changes in his body, which becomes increasingly bulky, are a result of this group activity. Belonging to such a group demands total abandonment of the self, and this is shown by the changes in the body.'

This dynamic tension between group and individual is reinforced in Fréger's work by his references to the iconography of classical portraiture, particularly that of the Flemish School. Historically, this genre marked the ascendance in early modern times of the urban middle classes, with their humanistic and individualistic ideals. However, the people photographed by Fréger have no link with these ideals, which traditionally find their expression in the language of the portrait, because they have temporarily or even permanently sacrificed their individuality. The vulnerability and uniqueness of each face competes for the attention of the observer with the decorative splendour of the uniform. With their subtle aesthetic hyperbole and the absence of any moralistic commentary, these photographs are an elegant way of questioning certain basic elements of human existence, and they show how photography may be used as a kind of poetic anthropology.

MARTIN JAEGGI

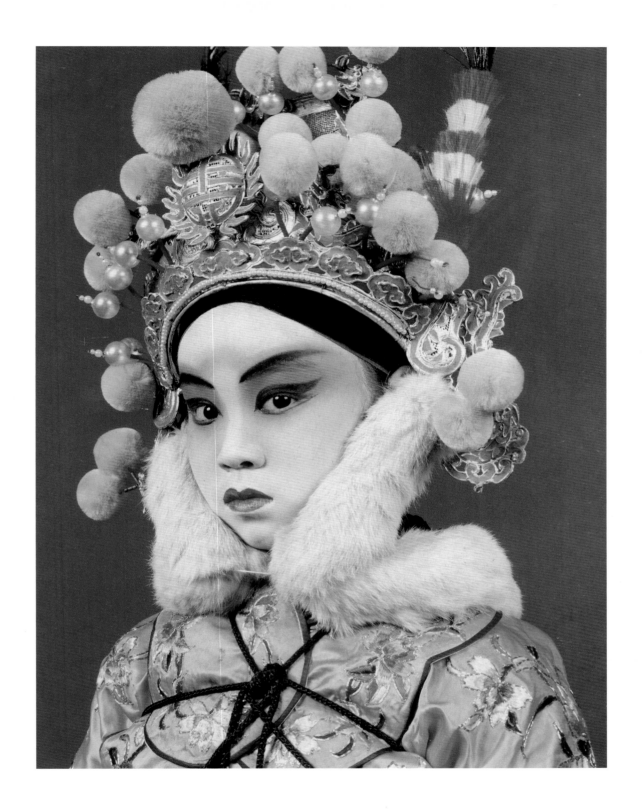

OPERA 30, 2005
FROM THE SERIES OPERA
C-PRINT, 93 X 58 CM
[36⅝ X 22⅞ IN.]

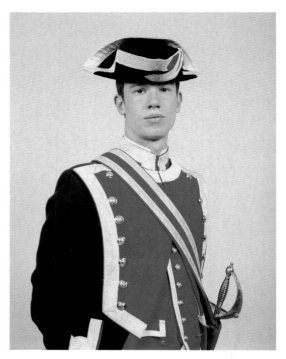

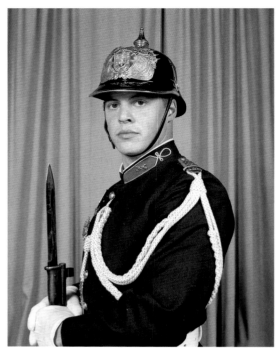

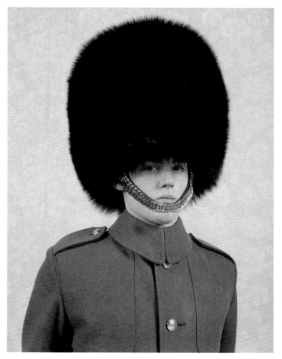

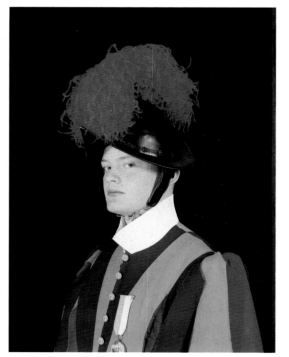

GUARDIA REAL 3, 2004–6
FROM THE SERIES EMPIRE
C-PRINT, 93 X 58 CM
(36⅝ X 22⅞ IN.)

GRENADIERS 12, 2004–6
FROM THE SERIES EMPIRE
C-PRINT, 93 X 58 CM
(36⅝ X 22⅞ IN.)

GNR 2, PORTUGAL, 2004–6
FROM THE SERIES EMPIRE
C-PRINT, 93 X 58 CM
(36⅛ X 22⅞ IN.)

VATICAN 1, 2004–6
FROM THE SERIES EMPIRE
C-PRINT, 93 X 58 CM
(36⅝ X 22⅞ IN.)

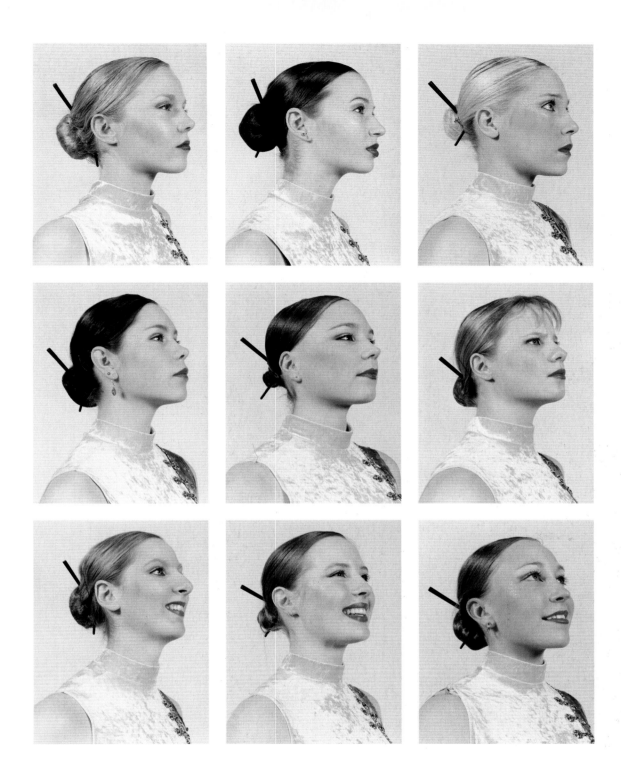

FROM THE SERIES **WINNER FACE**, 2002
C-PRINT, 93 X 58 CM (36⅝ X 22⅞ IN.)

WINNER FACE 1	WINNER FACE 2	WINNER FACE 3
WINNER FACE 4	WINNER FACE 5	WINNER FACE 6
WINNER FACE 9	WINNER FACE 13	WINNER FACE 14

STEPHEN GILL

born in 1971 in Bristol, UK
lives and works in London

WWW.STEPHENGILL.CO.UK

Whether they are portraits, landscapes, cityscapes or still lifes, photographs interpret and conserve aspects of the three-dimensional world in two-dimensional form. With the passage of time, the picture ages, and this changes its significance. In his series *Buried* (2006), Stephen Gill accelerates this process. He buries the photographs in the earth – picture by picture, either singly or in pairs – and waits until rainwater and micro-organisms have stained the surfaces. Like the series *Hackney Flowers* (2004–7) and *Hackney Flower Portraits* (2007), taken in Hackney Wick, England, the photographs become dirty and ragged, and what had once been whole and wholesome is now riddled with decay. What effect does this destructive process have on the subject-matter? Is its authenticity, its 'magic' enhanced or reduced? Whatever the result, the artificial ageing process makes us directly conscious of the picture as a picture, something transient that represents only one of many possible ways of seeing.

Gill seems to have a predilection for mucky, messy things. With *Billboards* (2002–4), he focuses not on the advertisements themselves but on the hidden areas 'backstage', where litter and rubbish and car wrecks and all of society's forgotten or abandoned bits and pieces lie rotting. The forgotten are also the subject of *Invisible* (2004–6), in which we see people peering down drains or into space. These are the refuse collectors, the builders, etc., who all perform an important role in the everyday life of the city but are rarely acknowledged or even noticed. And during their brief photographic moment centre-stage, they see something that the observer doesn't: they remain excluded.

Refuse collectors at work, commuters in their trains (*Day Return*, 2001), old women with shopping trolleys (*Trolley Portraits*, 2000–3), people who have lost their way (*Lost*, 2003) or are listening to music (*Audio Portraits*, 1999–2000): Gill captures them all in his photographic study of the British way of life. These are not reportages in the true sense of the term, but gentle, slightly melancholy pictorial essays on living conditions that are not exclusive to his native land. His mode of unobtrusive intrusion is particularly striking in his series *Birds*: here the photographs show us crossroads and pavements, houses in towns and cities, rows of terraced houses, railway bridges, electrical wires, street lights and telephone booths, and somewhere in the picture you will find the tiny figure of a bird – a robin or a sparrow, for example. These birds are living in what we call civilization. It must be a hard life.

NADINE OLONETZKY

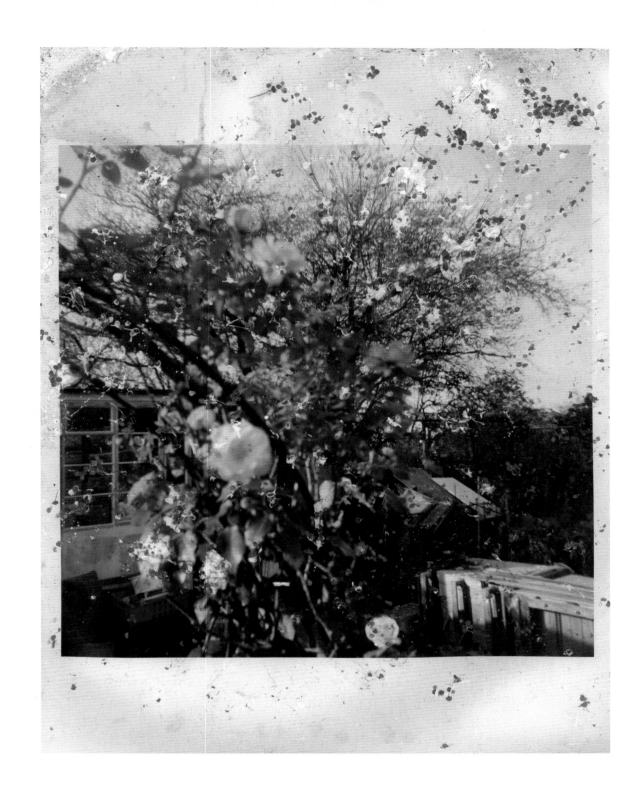

UNTITLED, 2006
FROM THE SERIES **BURIED**
C-PRINT, BURIED FOR A CERTAIN PERIOD IN HACKNEY WICK
30.4 X 25.4 CM (12 X 10 IN.)

UNTITLED, 2003
FROM THE SERIES **LOST**
C-PRINT, 30.4 X 25.4 CM
[12 X 10 IN.]

UNTITLED, 2003
FROM THE SERIES **LOST**
C-PRINT, 30.4 X 25.4 CM
[12 X 10 IN.]

UNTITLED, 2003
FROM THE SERIES **LOST**
C-PRINT, 30.4 X 25.4 CM
[12 X 10 IN.]

UNTITLED, 2002–5
FROM THE SERIES **HACKNEY WICK**
C-PRINT, 50.8 X 40.6 CM (20 X 16 IN.)

ANTHONY GOICOLEA

born in 1971 in Atlanta, USA
lives and works in New York

WWW.ANTHONYGOICOLEA.COM

At first sight, Anthony Goicolea's photographic landscapes and interiors could be real, with their scenes of mostly uniformed teenagers in pairs or in groups, in the army, at leisure, in their college summer camps, or simply at home. A closer look, however, reveals that these settings have been staged. They have been created with all the tricks of digital technology, and with a multiplicity of aesthetic and narrative detail they confront us with various aspects of homosexual and androgynous sexual identification and experience. We can sense both the isolation and the group dynamics. In some of Goicolea's series, nature appears as a metaphor for the imponderable and the unpredictable, in the form of a surreal landscape or in the construction of shelters, as in the series *Shelter* (2004–5).

Since his early self-portraits and a series of fairytale figures, the artist has continued to make frequent appearances as the main character in his now mostly large-scale pictures, which occupy a territory that lies halfway between real memory and dreamlike imagination. 'Cloning' himself repeatedly in these photographs, with a variety of wigs, college uniforms and other accoutrements, he represents facets of the self in its experience of a hybrid, adolescent identity. In the series *Summer Camp* (2001), college students

(alias Goicolea) appear in erotic, homosexual poses as uniformed pairs sitting in rowing boats, or reading in a forest hut. Likewise, in another picture in the series, a single male figure without a uniform is sitting in a boat, and the seat next to him is vacant; he looks frightened, and – as is often the case in a social context – clothing functions as an indicator of 'belonging' to a group, which means that others are excluded. This aspect of society is also to be found in Goicolea's *Ash Wednesday* (2001) from the *Detention Series* (2001–2), where a group of young men are out on a nocturnal stroll in the forest and appear to have captured another young man, whom they are carrying tied to a branch, like a dead animal. While everyone else is wearing the same yellow waterproof jacket, the 'victim' is not.

'Many of the scenes,' Goicolea writes of his landscapes, 'are staged or constructed and then further altered through digital manipulation to create a world anchored in reality but predicated on fantasy, fairytales, fables, mythology and other narratives.' It is an approach which gives rise to poetic, sometimes strange and evocative pictorial worlds, and which also finds expression in the artist's drawings and videos.

BARBARA HOFMANN-JOHNSON

UNDER III, 2002
C-PRINT, ALUMINIUM
51 X 40.1 CM (20⅛ X 15¾ IN.)

AFTER DUSK, 2001
C-PRINT, ALUMINIUM
101.6 X 256.5 CM (40 X 101 IN.)

BRUSH FIRE, 2002
C-PRINT, ALUMINIUM
56 X 210.8 CM (22 X 83 IN.)

MARNIX GOOSSENS

born in 1967 in Leeuwarden, Netherlands
lives and works in Amsterdam

WWW.MARNIXGOOSSENS.COM

Since completing his studies in 1996 at the photography department of the Hogeschool voor de Kunsten in Utrecht, Marnix Goossens has worked within a wide variety of genres: staged self-portrait, landscape, still life and erotic nude. In all these fields he combines a remarkable eye for beauty and estrangement of simple objects and situations with a dry humour and a feel for the anecdotal. There is always a visual discovery to be made in his multi-layered images, a pun that is the result of intense and concentrated looking. His reference is not so much the photographic medium as the formal qualities of painting and sculpture. The tension between the flat surface and three-dimensional space, and the rich scale of tonal nuances of objects and places, deepens our insight into our daily surroundings.

Goossens' self-portraits in empty and barely decorated interiors stand in line with the Dutch tradition of genre painting by masters such as Vermeer. In these pictures self-mockery mixes with a camp feeling for the absurd and the cosiness of the interior: a man lying on a carpet beside a gas heater, staring at the flames, for example, or a man sitting on a couch, smiling with a mouth full of broken teeth and holding his breast. In portraits of close friends and relatives, Goossens is also attracted by their disfigured faces: the yellow, brown and red coloured skin of Bart after he was beaten up; a famous Dutch cabaret performer with traces of a harelip, and the eyes of a girl filled with tears, carrying a plate of watermelon.

A more documentary approach appears in Goossens' publication *Regarding Nature* (2001), a close study of the planned landscape around the young city of Almere, built in the 1970s on land that used to be sea. The pinpoint-sharp pictures, made with a Linhof Technika 4 x 5 inch camera, show small forests, grassland, ditches and reeds as a structured unity, changing its identity with the seasons. Nature seems artificial and mystical at the same time. The photographer himself plays a part in the landscape. He poses anonymously, sitting on a traffic sign with a helmet on (*Driver*, 2000), or has left a towel with the head of a tiger on a tree-branch for drying (*Hangout*, 2000). The influence of painting, stimulated by a further study at Ateliers in Arnhem and the Rijksacademie in Amsterdam, is visible in Goossens' masterly eye for the different nuances of green in the landscape. While travelling in Asia, he discovered new dimensions of nature in archetypal scenes of jungle. In a picture of a group of palm trees, with one palm lacking its branches, he accentuates the mortal and bizarre beauty of the rainforest. The bare tree is a folly of nature. It looks like the extended trunk of an elephant, crying out for help.

As a member of the Dutch photo agency Solar, Goossens also uses his characteristic style in editorial commissions for magazines and advertising companies. In 2006 the different artistic qualities of his work were combined in the publication *Deep Light*.

RIK SUERMONDT

SURFERS PARADISE, 2007
ILFOCHROME, DIASEC
160 X 140 CM (63 X 55⅛ IN.)

YONDER COMES A SUCKER, 2005
KODAK ENDURA PRINT
170 X 140 CM (66⅞ X 55⅛ IN.)

VERTILIGO, 2005
KODAK ENDURA PRINT
170 X 140 CM (66⅞ X 55⅛ IN.)

G.R.A.M.

founded in 1987 in Graz, Austria, by Günther Holler-Schuster, Ronald Walter, Armin Ranner and Martin Behr

WWW.CHRISTINEKOENIGGALERIE.COM

G.R.A.M. is a group of artists concentrating primarily on the visual politics of the mass media. Voyeurism, sensationalism, the cult of celebrity, and also the cheap and banal pleasures of pop culture form the background to their strategies of appropriation and deception. By imitating the pictorial language of the tabloid press, they appear to endow trivial situations with profound significance. Are we looking at stars we don't know at an event of major interest, or is it the photographs that give status to what we're seeing? Could this be a demystification and a trivialization of glamour? In the series *Paparazzi* (since 1996), G.R.A.M. has been addressing these questions, focusing on mass-media–style pictures and their ways of constructing reality. However, these images are not just a superficial critique of modes of representation or a cheap game of confusion. G.R.A.M.'s work presents these modes in such a way that they themselves become the subject of representation. By playing with sensation and deception, voyeurism and taboo, and by directing their gaze to the borders between privacy and public life, the group reveals all the basic mechanics of picture production.

The series *Nach Motiven von...* ('Based on Motifs from...', 2001) operates by appropriating pictures that now form part of the collective memory of the western world: the shooting of Benno Ohnesorg in 1967, the arrest of Ulrike Meinhof in 1972, John Lennon and Yoko Ono at their 1969 sleep-in – images that characterize a time, a particular historical situation, a turning-point in international politics, or a cultural icon of the 20th century. The G.R.A.M. artists twist these images even to the point of absurdity, even though they cannot bring about any fundamental change to their significance. What these photographs do is draw our attention to the power of pictures to enter our collective memory; we become aware of their potential to act as guidelines, signposts and interpreters in the realms of history, politics and culture. The photographs show the extent to which image and reality are intertwined, and that it is not just a matter of producing counter-images to destabilize this relationship, but that the question of how pictorial cultures construct realities can only be answered through the pictures themselves.

REINHARD BRAUN

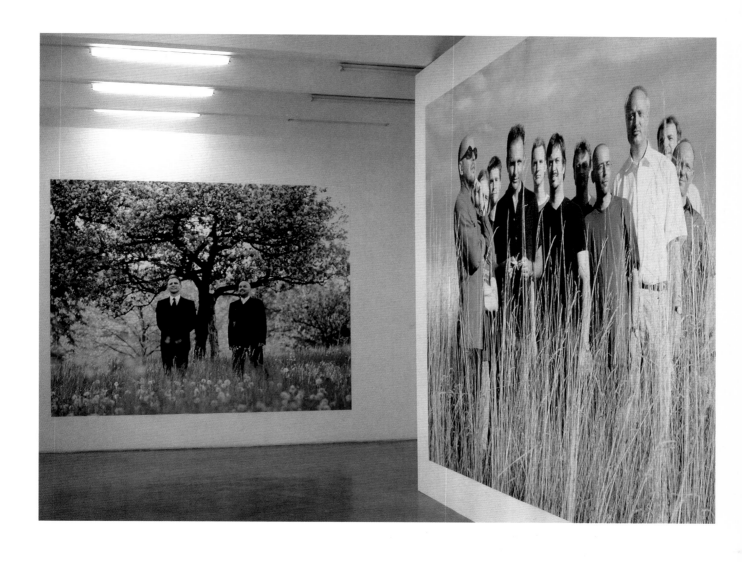

EXHIBITION VIEW OF **GLOBAL PLAYER**,
GALERIE CHRISTINE KÖNIG, VIENNA, 2006

LEFT: **KIM IL-SUNG, KIM JONG-IL:
'ETERNAL LEADERS' OF NORTH KOREA**, 2006
DIGITAL PRINT, 317 X 440 CM (124¾ X 173¼ IN.)

RIGHT: **ONCE AGAIN NORTH KOREA MAKES
HEADLINES: SHOWN IN THIS PROPAGANDA PHOTO
IN A WHEAT FIELD WITH REPRESENTATIVES OF
THE PEOPLE, THE DICTATOR KIM JONG-IL BOASTS
POSSESSION OF AN ATOMIC WEAPON**, 2006
DIGITAL PRINT, 287 X 358 CM (113 X 141 IN.)

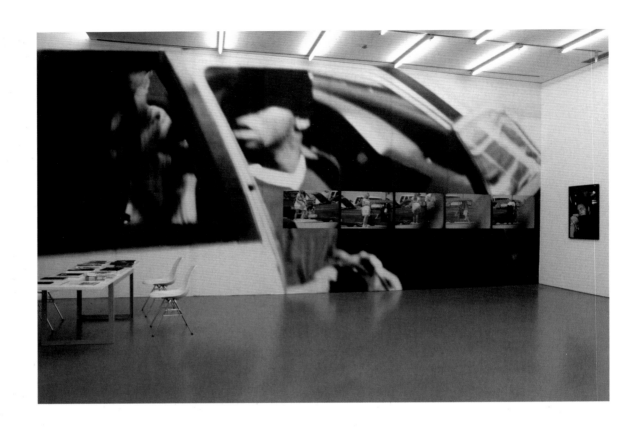

INSTALLATION VIEW OF **KNOWING YOU, KNOWING ME**,
CAMERA AUSTRIA, GRAZ, STEIRISCHER HERBST, 2006

IN THE INSTALLATION VIEW:
LARGE IMAGES **PAPARAZZI (L.A.)**, 1997/2006
WALLPAPER, DIMENSIONS VARIABLE

SMALL IMAGES: **PAPARAZZI (L.A.)**, 1997
PHOTOS BEHIND PLEXIGLAS, 5 PARTS,
EACH 60 X 80 CM (23⅝ X 31½ IN.)

FAR RIGHT: **PAPARAZZI (MUHAMMAD ALI)**, 2006
BLACK-AND-WHITE PHOTOGRAPH
120 X 90 CM (47¼ X 35⅜ IN.)

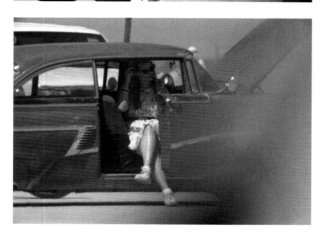

PAPARAZZI (L.A.), 1997
PHOTOGRAPHS, PLEXIGLAS, 5 PARTS,
EACH 60 X 80 CM (23⅝ X 31½ IN.)

ANETA GRZESZYKOWSKA

born in 1974 in Warsaw, Poland
lives and works in Warsaw

WWW.RASTER.ART.PL WWW.ROBERTMANN.COM

Sometimes on a flight, when you've just taken off and the plane is climbing over houses, you wish the roofs would disappear so that you could see inside other people's homes. It would be like looking into dolls' houses – you would see tiny lamps, sofas and armchairs, encapsulating the contemporary history of home life. But of course this is only a dream, even in the photographs of the Polish artist Aneta Grzeszykowska, who works in partnership with Jan Smaga (b. 1974). For what we see in the compositions that make up the series *Plan* (2003) – a bedroom and a kitchen complete with fruit dish, spoon and teacup, etc., accurate down to the last detail as if the roof had been spirited away – are in fact computer-generated constructions made up of individual photographs of furniture, objects and flooring. Hovering somewhere between model architecture and visual sociology, these pictures – composed by two artists who trained at the Art Academy in Warsaw (and both appear themselves in the photographs) – offer an artificial view of real life, and one feels all the pleasure of the voyeur enjoying a glimpse of someone else's private habits and predilections. Seen from above, however,

these detailed images can induce a kind of vertigo in the viewer, for between the carefully placed items of furniture, one's gaze is suddenly plunged into disorientating depths.

The more recent works *Album* (2006) and *Untitled Film Stills* (2006–7) take a different view of the interplay between appearance and reality. In *Album* we see photographs of people 'just like you and me', but they are not what they seem. Once again they are composed of isolated fragments joined together; they are not portraits of real men, women, children, but are invented faces – the staging of virtual identities. With her coloured *Untitled Film Stills*, Grzeszykowska uses settings and clothes from modern Warsaw to recreate the famous black-and-white *Untitled Film Stills* (1977–80) by the American photographer Cindy Sherman. With this simple repetition of what was a milestone in art history, though it may also be seen purely as a homage to the great artist of roles and identities, Grzeszykowska once again reflects on the nature of the medium and the language of staged photography. Nothing is what it pretends to be.

NADINE OLONETZKY

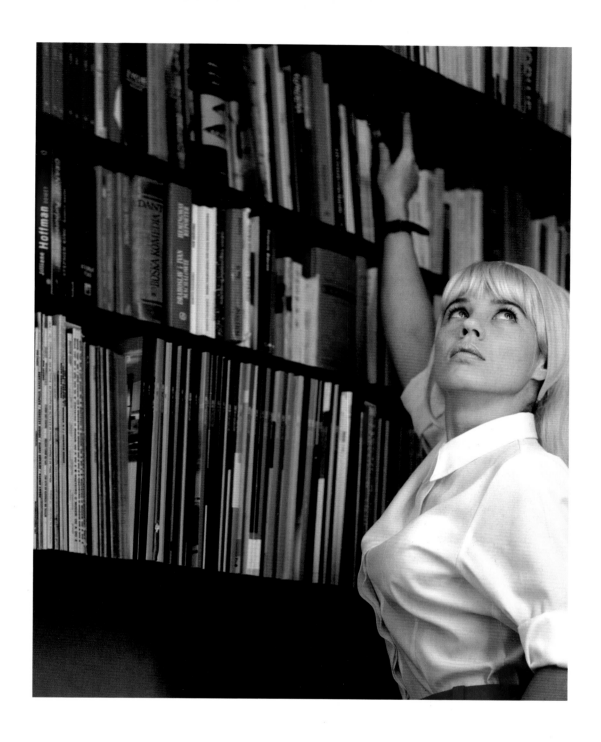

UNTITLED FILM STILLS #13, 2006–7
C-PRINT, 25 X 20 CM (9⅞ X 7⅞ IN.)

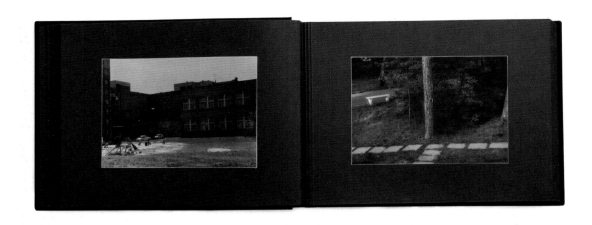

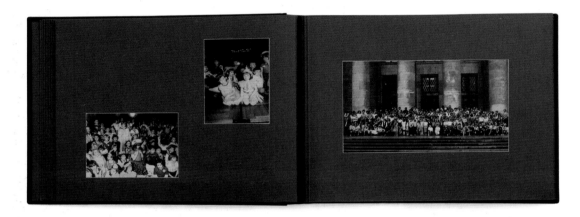

ALBUM, 2005
203 PHOTOGRAPHS IN AN ALBUM (DETAIL)
29 X 40 X 9 CM (11 3/8 X 15 3/4 X 3 1/2 IN.)

ALBUM, 2005
203 PHOTOGRAPHS IN AN ALBUM (DETAIL)
29 X 40 X 9 CM (11 3/8 X 15 3/4 X 3 1/2 IN.)

ALBUM, INSTALLATION VIEW, WARSAW, 2005

ALBUM, 2005
203 PHOTOGRAPHS IN AN ALBUM (DETAIL)
29 X 40 X 9 CM (11⅜ X 15¾ X 3½ IN.)

BEATE GÜTSCHOW

born in 1970 in Mainz, Germany
lives and works in Berlin

WWW.PRODUZENTENGALERIE.COM

Landscape photography is the chosen genre of surprisingly few contemporary photographers, so when one comes across a series of landscape photographs such as those of Beate Gütschow, one always suspects a hidden agenda, or some oblique motive on the photographer's part which might undermine the initial impact of their work. And indeed, there is a subtle strategy employed by Gütschow to achieve these images. In her *LS* series, Gütschow uses a digital montage process to imitate 17th- and 18th-century landscape paintings, patching together elements from an extensive suite of her photographs of northern Germany. These montages are relatively seamless but contain clues that betray the flawed veracity of the images. For instance, highlights and shadows seem to contradict each other, inferring a collection of suns in different parts of the sky. Far from the apocalyptic scenario that this might suggest, however, there is something of an unsettling quiescence about these photographs.

Nineteenth-century landscape painters such as Claude Lorrain and Nicolas Poussin included figures in the landscape, which afforded an element of scale to their scenes. Gütschow's, on the other hand, are deserted. The configurations of landscape features and vegetation come close to the original genre, although the aged varnish is not simulated, but it would have been anathema to these painters not to have included figures in their scenes. Consequently, in viewing Gütschow's photographs we find ourselves imagining what type of people we might come across in these ultimately strange landscapes. Should we imagine peasants in 17th-century garb resting from their toils, or walkers clad in all-weather gear, strolling across some part of a national park during a public holiday? What degree of fantasy can we justify if this is a 21st-century reinvention of a 17th-century painted scene? In the final analysis, these works demand some work on the part of the viewer, who knows instinctively that they are just too simple, too prosaic to be matter-of-fact landscape scenes. Close visual analysis or picture research might be relevant responses here.

In her video diptych *R#1 + R#2* (2007), Gütschow sets out to simulate two paintings by Jacob van Ruisdael, both entitled *The Jewish Cemetery*. After locating and photographing the actual Jewish cemetery that Ruisdael used in his painting, she then undertook some photo shoots in the New Forest and other areas of southern England, including Corfe Castle, seeking out vistas with an ambience sympathetic to Ruisdael's landscapes. She then completed the images in her studio using digital software. These images are not, of course, simply an exercise in creating authentic imitations, but explore how the passage of time influences our perception and its connotations for the gradual transformation of historical events. Memory, the relentless passage of time, loss and our compensations for that loss, are all phenomena subtly addressed in Gütschow's photographs.

ROY EXLEY

LS #13, 2001
C-PRINT, 108 X 85 CM
(42½ X 33½ IN.)

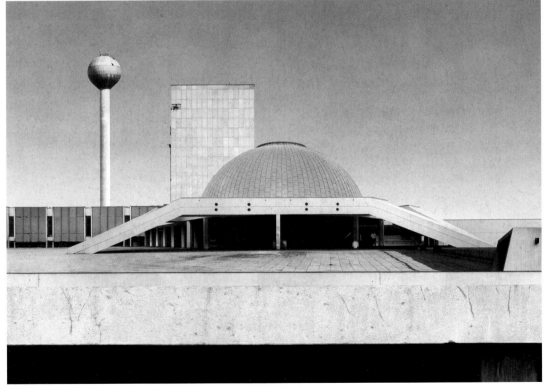

S #14, 2005
LIGHT JET PRINT
180 X 267 CM (70⅞ X 105⅛ IN.)

S #11, 2005
LIGHT JET PRINT
180 X 232 CM (70⅞ X 91⅜ IN.)

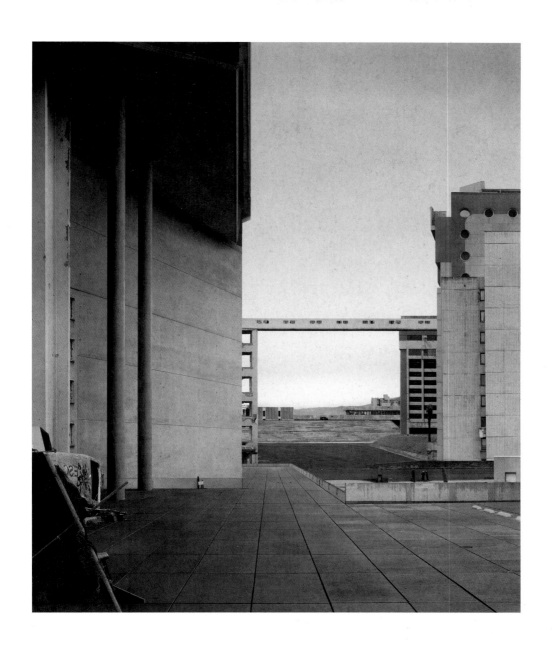

S #16, 2006
LIGHT JET PRINT
142 X 122 CM (55⅞ X 48 IN.)

MARIA HAHNENKAMP

born in 1959 in Eisenstadt, Austria
lives and works in Vienna

WWW.KROBATHWIMMER.AT

Since the late 1980s, the Austrian artist Maria Hahnenkamp has focused mainly on social attitudes towards the female body, its cultural attributes and the related repertoire of stereotypes concerning roles, rituals, gestures and especially images. All of this is conveyed by recurrent forms of female representation which form a critique of the cultural text that is always inscribed in the female body. In *Text/Ornament* and *Cut Out* (both 2007), Hahnenkamp shows this text applied quite literally to the bodies. But even before this, in works such as *Geschmirgelte Fotoarbeiten* ('Sanded Photographs', 1991–99), she had removed the images themselves and sanded the photographs down to their base. By this means she eliminated the 'story' of the picture, at the same time creating a vacant space for projections. Through this action she rejected the actual production of images, which in the case of the obliterated pictures were of a female model at the hairdresser's, or having a pedicure, or having her hair styled – all stereotypical images of the female. Hahnenkamp's next logical step, in the mid-1990s, was to stop taking photographs herself, and thus to disappear as an author.

With these works, Hahnenkamp transfers the conflict to the image itself. She does not deal in counter-images in order to articulate a critical commentary on pictorial politics, but makes the picture itself the setting for the clash. She shows that images always emerge from a cultural network which is marked by power, exclusion and repression. She also shows that such networks inscribe themselves into the image, because the pictures themselves as cultural technology are bound up with the structure of this power.

Since her series *Körper-Diskurse* ('Bodies-Discourses', 2005), she has been using fragments of texts by Judith Butler, one of the most important feminist theorists of the 1990s, once more demonstrating that the female body is an effect of linguistic processes, i.e. a cultural product. By superimposing ornaments – a motif that Hahnenkamp has used since her embroidered photographs of the 1990s, based on religious pattern books – the artist further emphasizes the artificiality of these picture-languages describing the female body. Ultimately, her work shows clearly that a picture is always more than just a visual form.

REINHARD BRAUN

UNTITLED, 2001
FROM THE SERIES **ZWEI FRAUEN**
C-PRINT, ALUMINIUM
93 X 73 CM (36⅝ X 28¾ IN.)

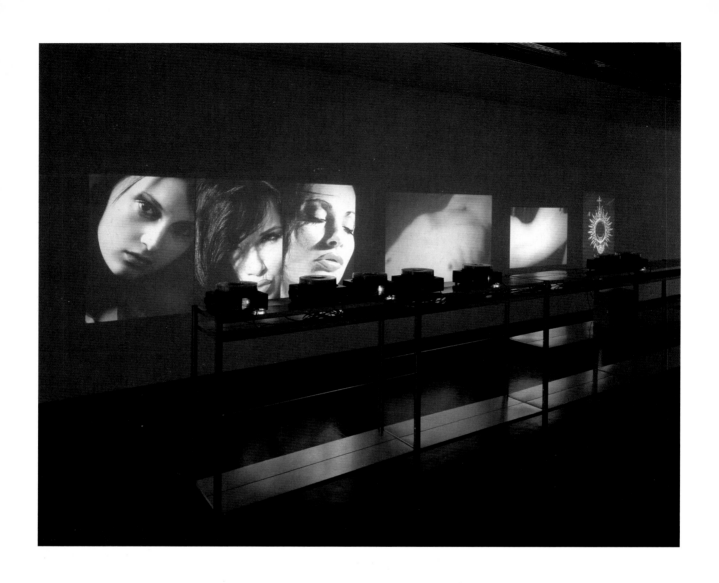

TRANSPARENCY, 2002
INSTALLATION WITH 9 SLIDE PROJECTORS, COMPUTER-CONTROLLED
IN TOTAL 729 SLIDES WITH C. 410 DIFFERENT IMAGE SEQUENCES
INSTALLATION VIEW, MAK-GALERIE, VIENNA

UNTITLED, 2005
FROM THE SERIES **KÖRPER-DISKURSE**
C-PRINT, ALUMINIUM
93 X 123 CM (36⅝ X 48⅜ IN.)

UNTITLED, 2005
FROM THE SERIES **KÖRPER-DISKURSE**
C-PRINT, ALUMINIUM
93 X 123 CM (36⅝ X 48⅜ IN.)

JITKA HANZLOVÁ

born in 1958 in Náchod, Czech Republic
lives and works in Essen, Germany

WWW.JIRISVESTKA.COM

Jitka Hanzlová studied photography at the University of Essen. She first gained critical attention for her documentary photographs, *Portrait of a Village* (1990–94), which were taken in Rokytnik in the Czech Republic over repeated visits. Writing of these warm and compelling portraits of adults and children, *Creative Camera* described the project as a meditation on 'the disparities between reality and memory and the nature of remembering'.

For her next series, Hanzlová focused on the place where she lived: a housing project in Essen that was originally built for working-class families. The photographs of her neighbours became part of a larger series on urban life, *Bewohner* (1994–96). Hanzlová frequently stays in the Belgian town of Vielsalm, which lends its name to a series from 1999. *Female* (1997–2000) comprises fifty-three individual portraits: subjects were photographed in European and North American streets, in squares, in gardens or in landscapes. These projects helped identify Hanzlová with others, such as Rineke Dijkstra, who were working in a mannered, spare style of portraiture. Both photographers adopt an unsentimental approach to address such themes as identity and belonging in the wake of the fall of Communism in Europe.

Hanzlová's acclaimed photographic series, *Forest* (2000–5), took her back to the Moravian landscape of her youth. The series continues her exploration in and around the village where she grew up, but it eschews the portraiture of her earlier work for quiet scenes of enshrouded woods, and exchanges the documentary style for an overtly symbolic one. Each atmospheric picture shows a different view of the forest. Time is complex and multi-layered in such a fecund place. Seasons impose themselves in the light that reaches the ground, filtered through layers of boughs, or in the lushness or sparseness of foliage. Traces of the passage of animals, or maybe people, register in soft grasses or snow or the pattern of broken twigs. In one picture small pines resemble the fully mature trees that dwarf them, primeval ferns stretching into the darkness thrive, probably much as they always have done.

The forty-five photographs that comprise *Forest* were published in 2006 with an essay by John Berger. Berger understands Hanzlová's photographs to be about the alternative time of the forests that is counter to the concept of time linked with modern capitalism. The photographs speak to him of 'events' that result from the merging of the many time scales, energies and exchanges that occur within the forest and defy measurement. 'We feel them occurring, we feel their presence, yet we cannot confront them, for they are occurring for us, somewhere between past, present and future,' says Berger.

Jitka Hanzlová was awarded the Otto Steinert Photography Prize in 1993 and the European Photography Prize in 1995, and was shortlisted for the Citibank Private Bank Photography Prize in 2000 and 2003.

DAVID BRITTAIN

BUTTERFLY, QUEENS, 1999
FROM THE SERIES FEMALE
C-PRINT, 30 X 20 CM
(11 ¾ X 7 ⅞ IN.)

MOONSHINE, 2000
FROM THE SERIES **FOREST**
C-PRINT, 27 X 18 CM (10⅝ X 7⅛ IN.)

TIGHTROPE WALKER, 2002
FROM THE SERIES FOREST
C-PRINT, 27 X 18 CM (10⅝ X 7⅛ IN.)

NAOYA HATAKEYAMA

born in 1958 in Iwate, Japan
lives and works in Tokyo

WWW.LAGALERIE.DE WWW.TAKAISHIIGALLERY.COM

Naoya Hatakeyama's photographs in the series *River* (1993–94) are in vertical format, like a Japanese hanging scroll, and are divided horizontally in the middle. In the lower half we see water flowing along a canal and reflecting the light from windows of the houses that rise up in the top half of the picture. A patch of sky – either day or night – can be seen above the roofs, and there is an occasional tree reaching across the canal. Each setting is perfectly balanced within the format. The pictures, 100 x 49 cm, reveal a delicate sensitivity to form, colour, perspective, horizontal and vertical lines, foreground and background – all combined to convey an extreme sense of composition.

Hatakeyama is not, however, simply focusing on some picturesque feature of Tokyo. The atmosphere of the canal is in stark contrast to what lies beyond its banks, where one knows for a fact that there are hundreds of thousands of people rushing around, each with his or her own desires and aims and obligations. Down here in the canal, where the photographer wades through the shallow water, the hustle and bustle of the outside world is shut out. It's almost like a modern Japanese version of the Styx, the river of Greek mythology across which the souls of the dead were ferried; the canal leads to the underworld of the city, to the unconscious, suppressed realms of society.

Hatakeyama studied at the School of Visual Art & Design in Ibaraki, has had his work acclaimed at international exhibitions, and has won several awards, including the Higashikawa Domestic Photographer Prize in 2000. He focuses mainly on the fragile beauty of urban and industrialized places. In such series as *Lime Hills* (1986–91) and *Lime Works* (1991–94), he looks for the marks that man leaves on and directly beneath the skin of the earth; he is not interested in man himself. The series *Untitled* (1989–97) shows the city as a sea of concrete boxes divided up by the lines of its streets, as do the *vedute* photographed in Osaka in 2002. The Moloch of Osaka, though created by humans for humans, is shown by Hatakeyama as an 'all-over' composition – a structure in which humans in fact are a minor consideration. In *Underground/River (Tunnel*, 1999), he burrows deep down below the city, using lamps to light up the pitch-dark world of the sewers and their brackish water. In Hatakeyama's painterly use of light and shade, the three-dimensional, geometric shapes of the concrete drains are turned into a contemporary Hades.

NADINE OLONETZKY

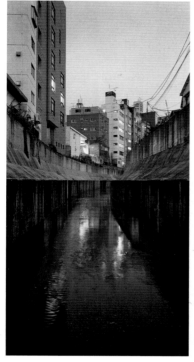
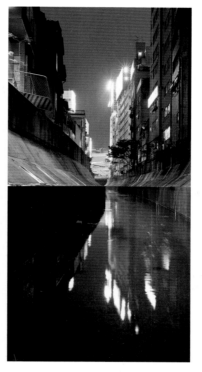
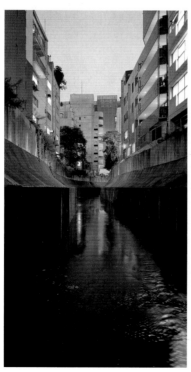
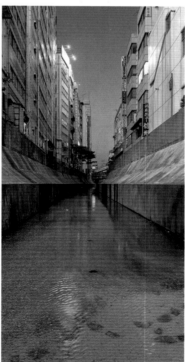

RIVER 5, 1993–94
FROM THE SERIES RIVER
C-PRINT, ALUMINIUM
100 X 49 CM (39³⁄₈ X 19¹⁄₄ IN.)

RIVER 7, 1993–94
FROM THE SERIES RIVER
C-PRINT, ALUMINIUM
100 X 49 CM (39³⁄₈ X 19¹⁄₄ IN.)

RIVER 8, 1993–94
FROM THE SERIES RIVER
C-PRINT, ALUMINIUM
100 X 49 CM (39³⁄₈ X 19¹⁄₄ IN.)

RIVER 4, 1993–94
FROM THE SERIES RIVER
C-PRINT, ALUMINIUM
100 X 49 CM (39³⁄₈ X 19¹⁄₄ IN.)

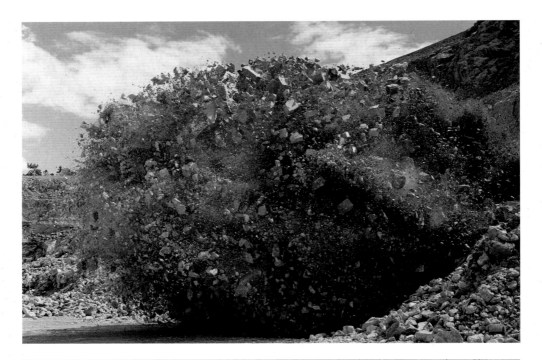

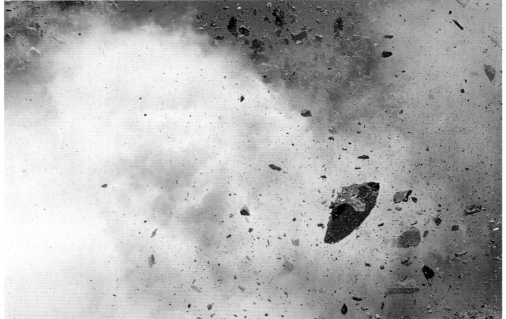

BLAST, SINCE 1995
C-PRINT, 38 X 57 CM
(15 X 22½ IN.)

BLAST, SINCE 1995
C-PRINT, 38 X 57 CM
(15 X 22½ IN.)

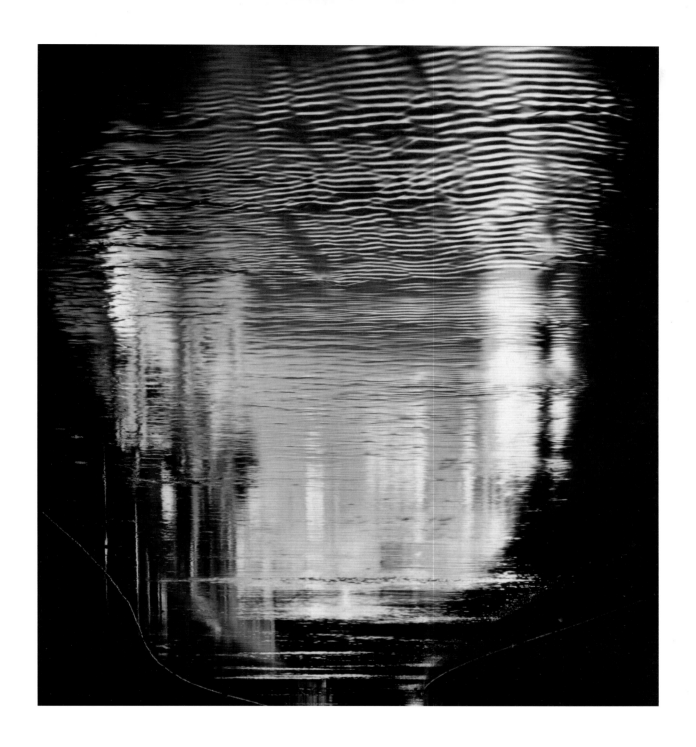

SHADOW #79, 2002
FROM THE SERIES RIVER
C-PRINT, 54 X 49 CM (21¼ X 19¼ IN.)

ANNIKA VON HAUSSWOLFF

born in 1976 in Gothenburg, Sweden
lives and works in Stockholm

WWW.ANDREHN-SCHIPTJENKO.COM

Annika von Hausswolff's early, large-format work from the mid-1990s, such as *Back to Nature* (1992–93) or *Hey Buster! What Do You Know About Desire?* (1995), addresses issues of gender, desire, violence and power in meticulously composed photographic tableaux. *Back to Nature* restages and subverts selected moments from patriarchal art history: a female nude playing at the water's edge is, in the artist's photographs, replaced by a seemingly dead body, floating face-down in the water. The grim double irony of the title of these disturbing images plays out clearly: the woman is identified with nature, not culture, whether dead or alive. An ability to impregnate images with a layered narrative momentum has remained a central feature of her work, allowing the particular instant of the still photograph to be opened outward into more complex territories. The theme of violence spills over into other bodies of work engaging with and making visible issues of self-identity, or its absence. The pitiless self-portrait *As Death Prolongs Laughter* (1995) shows a face split in two by a cut through its middle, and with a grin so wide that it disrobes the body, displaying, so to speak, the skeleton beneath the skin.

The awkwardness of this grin or the naked corpse upsetting the safe confines of art history reveal typical ingredients of von Hausswolff's photographs – imagery resolved to remind us of the abyss that awaits us, even in the most ordinary of moments. Indeed, the domestic sphere is stage to – and agent for – much of von Hausswolff's work. In the series *Spöke* (2000) and works such as *Now You See It, Now You Don't* or *Everything Is Connected – He, He, He* (both 1999), for example, household and family micro-dramas are played out in bedrooms, living rooms, porches and lawns, and situations of unclear origin or future resolution are preserved and commemorated.

Using a limited repertoire of objects and actions – clothes (which may not protect the body, but hinder, block or even strangle it), flower pots, curtains, carpets, doors, acts of leaving, returning, encountering, touching and tidying, all in the midst of frustrated desires – von Hausswolff's imagery has the uncanny ability to double as both realist representation and allegory. Sometimes a situation is what it is, sometimes it is symbolic of a proposition, memory or feared possibility. In this artist's hands, the photograph is never neatly categorized, but slips easily out of reach, while effecting the most powerful of emotions with the simplest of means.

JAN-ERIK LUNDSTRÖM

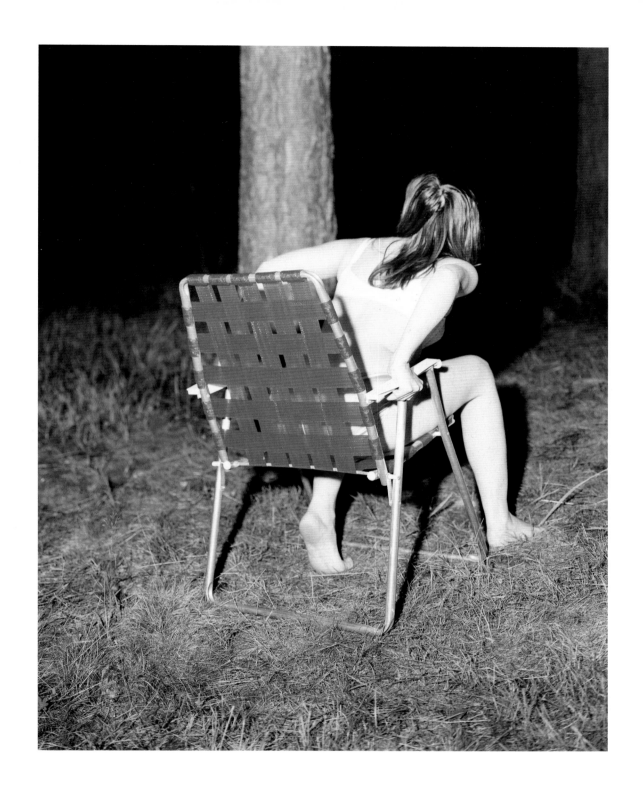

EVERY MOTION BEARS ITS OPPOSITE, 2002
C-PRINT, PLEXIGLAS, 152 X 120 CM (59⅞ X 47¼ IN.)

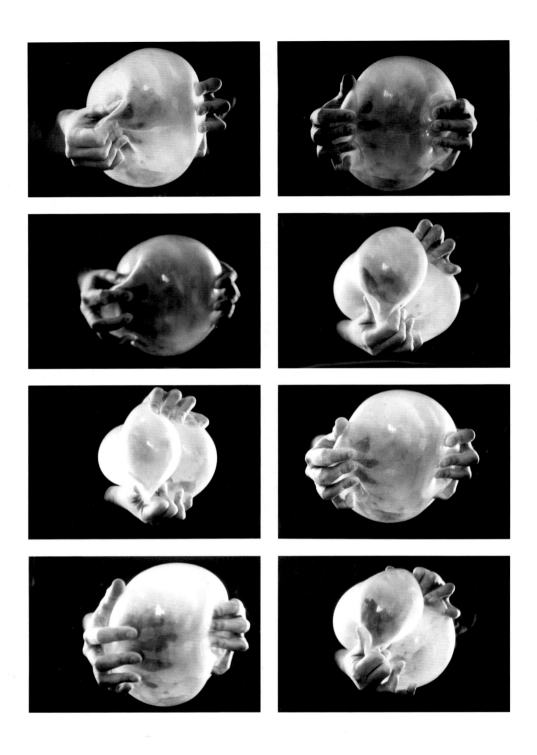

UNTITLED, 2006
8 BLACK-AND-WHITE PHOTOGRAPHS,
EACH 60 X 90 CM (23⅝ X 35⅜ IN.)

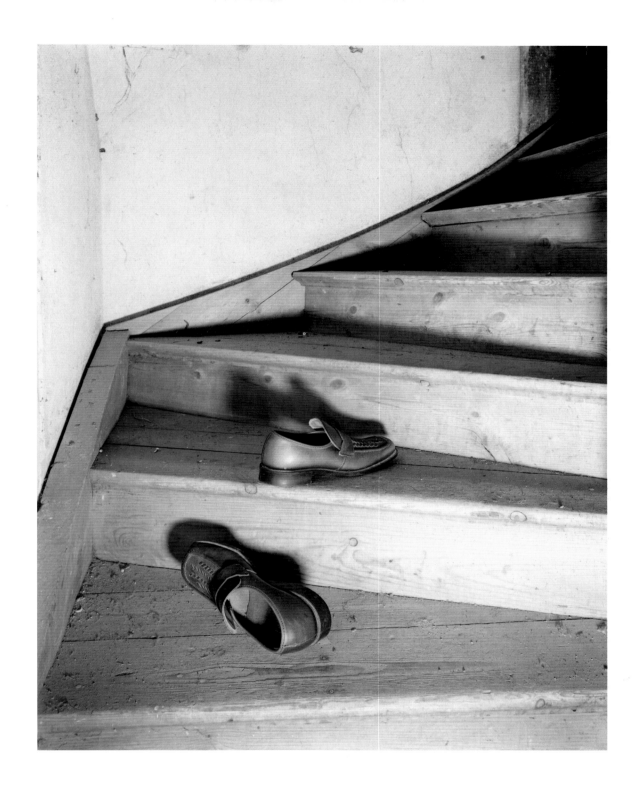

FROM THE SERIES **SPÖKE**, 2000
C-PRINT, PLEXIGLAS (DETAIL)
157 X 123 CM (61¾ X 48⅜ IN.)

JOSÉ ANTONIO HERNÁNDEZ-DIEZ

born in 1964 in Caracas, Venezuela
lives and works in Barcelona, Spain, and Caracas

WWW.ELBABENITEZ.COM WWW.FORTESVILACA.COM.BR

The best word to describe the fascinating work of the filmmaker and video artist José Antonio Hernández-Diez is 'candid', with all its implications of open-mindedness, honesty, naturalness and avoidance of artifice. A candid camera may be hidden, but it can spontaneously capture spontaneity. Hernández-Diez's multimedia installations are also poetic, disturbing, irreverent, witty and sometimes biting. His work draws its inspiration both from the culture and traditions of his homeland and from the worlds of science, religion, domesticity and leisure, and it is a (sometimes very cynical) commentary on the contradictions and absurdities that arise from globalization. In concrete terms, this means that one may be confronted in his videos, video stills or C-prints with a stuffed dog (which you can touch with rubber gloves beforehand in a glass container), a skateboard in and made of pig fat, sneakers, a billiard table or outsized artificial fingernails.

Right from the start, Hernández-Diez has twisted familiar vocabulary such as Pop Art and Minimal Art, plundered it and exploited it in such a way that he has created a kind of counterbalance to the stereotypical western concept of Latin-American art. We expect the latter to be bright, hyper-sensual and baroque, but Hernández-Diez sees it differently: with subtle, often witty variations of form borrowed from contemporary art, he offers us different ways of looking at things, thus making us think twice about the nature of consumerism, globalization, technology, religion and identity. Works that at first sight appear uncomplicated serve to unmask the contradictions and complexities inherent in the systems of power that govern our lives.

The gigantic artificial fingernails are a good example. In the sculptural series S & M (Ella Perdió un Dedo/She Lost A Nail) (1998), these nails, which are as big as the artist, are presented by the gallery or museum in a white space with different installations – as would-be Minimal Art sculptures, combined for example with a blow-up of a nail buffer, file or drier. This concentrated form opens up a wide range of possible contexts: the star of Spanish B-films in the 1960s (referred to, among others, in the title), the stereotypical icons of the mass media, Venezuela's Catholic culture, vanity as one of the Seven Deadly Sins. All of these find expression in the artificial fingernails, as does the contradiction inherent in a patriarchal culture that simultaneously worships and oppresses its (beautiful) women. But such isolated examples can hardly do justice to the wide (though conceptually consistent) variety of Hernández-Diez's work.

ERIK EELBODE

CUIDADOS 2, 2004
INKJET PRINT ON COTTON PAPER
145 X 112 CM (57⅛ X 44⅛ IN.)

FREUD, 2005
C-PRINT
230 X 140 CM (90½ X 55⅛ IN.)

JUNG, 2000
C-PRINT
210 X 160 CM (82⅝ X 63 IN.)

HUME, 2000
C-PRINT
210 X 160 CM (82⅝ X 63 IN.)

HEGEL, 2001
C-PRINT
250 X 160 CM (98⅞ X 63 IN.)

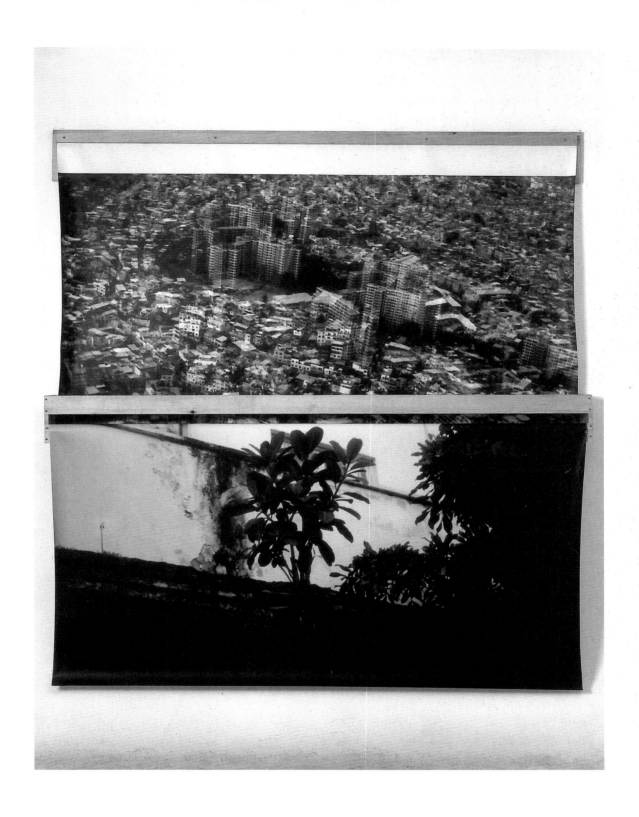

ENTRE DOS AGUAS, 2003
INKJET PRINT ON BOX OF WOOD AND VINYL
PRINT: 250 X 240 CM (98⅜ X 94½ IN.)
BOX: 240 X 25 X 25 CM (94½ X 9⅞ X 9⅞ IN.)

TAKASHI HOMMA

born in 1962 in Tokyo, Japan
lives and works in Tokyo

WWW.DELANK.COM

Takashi Homma is a coolly detached chronicler of his hometown, taking pictures of the present in which one can already detect the outlines of a disquieting future. Between 1989 and 1994 he lived in London, where he worked for *Lifestyle Magazine* and *i-D*. After his return to Japan, he continued to publish his photographs in art and fashion magazines, as well as in his own magazine *Landscape*, but also began to show and publish his own independent works.

Homma's major breakthrough came with his book *Tokyo Suburbia* (1995–98), a massive tome the size of a telephone directory, in which he juxtaposed photos of the tiny prefabricated houses, the gigantic blocks of flats and the chain restaurants of Tokyo's suburbs with pictures of the teenagers who are growing up there. The photographs convey an atmosphere of emotionless sterility, reminiscent of the American painter Edward Hopper. Homma does not pass judgment; he simply makes a statement. It is only the accumulation of images that creates the feeling of oppression and emptiness, which characterizes the youngsters in these gigantic urban jungles that seem to have sprung up almost overnight. These grim perspectives, which are in stark contrast to the apparent objectivity of the presentation, are reinforced by the introductory essay, in which the Japanese sociologist Shinji Miyadai tells

the story of a 14-year-old boy from the suburbs who beheaded an 11-year-old, stuck the head on a pole, and became a cult figure among his suburban peers.

In his next book, *Tokyo Children* (2001), Homma portrays the children with the same detached attitude. They make no attempt to flirt with the camera, but neither do they try to avoid it; they merely look at it without emotion or expression. There is not the tiniest hint of sweetness, and the observer cannot make out whether they are threatening or threatened. They are, however, allegories that point to the uncertain future of people in the highly technologized big cities. In more recent works, he offers a more personal approach to the question of how children may be marked by their city upbringing. These are assembled in *Tokyo and My Daughter* (2005–6), in which he juxtaposes his usual objective town pictures and interiors with quite openly affectionate photographs of his daughter. In his own words: 'I love my daughter very much. I love Tokyo very much.' In the exhibition 'Photographs of the Torahiko Mountains' (2006), Homma turned to a new subject. His cool, impersonal gaze focused on the shimmering, steel-blue mountains which, in their own indifferent monumentality, are reminiscent of his pictures of Tokyo.

MARTIN JAEGGI

UNTITLED, 2005–6
FROM THE SERIES **TOKYO AND MY DAUGHTER**
C-PRINT, 100 X 80 CM (39³⁄₈ X 31¹⁄₂ IN.)

UNTITLED, 2005–6
FROM THE SERIES **TOKYO AND MY DAUGHTER**
C-PRINT, 120 X 150 CM (47¼ X 59 IN.)

UNTITLED, 2005–6
FROM THE SERIES **TOKYO AND MY DAUGHTER**
C-PRINT, 79 X 100 CM (31⅛ X 39⅜ IN.)

UNTITLED, 1996
C-PRINT, 150 X 120 CM
(59 X 47¼ IN.)

JUUL HONDIUS

born in 1970 in Enschede, Netherlands
lives and works in Amsterdam

WWW.AKINCI.NL

What we see in Juul Hondius' photographs is recognizable and commonplace. At first sight, they might seem like bright, well-made press photos of refugees in the forest, or a body in the river, a petrol pump, the large, wet, spinning wheels of an HGV, or three black men in the back seat of a shiny new car. But Hondius did not come across any of these images by chance, as is the case with 'true' documentary photographers. In all respects, he made them himself: every single event and situation, right down to the last detail, has been staged by him. His starting-point, however, is always journalistic photography and film and, as he cannot resist occasionally alluding to classic examples from the history of photography, it becomes increasingly confusing. Titles such as *Man, Wheels, Richie* or *Bus* also bear no relation to the explanatory captions we expect to find below normal press photos. Our uncertainty becomes even more pronounced. Furthermore, his unmistakably aestheticized colour photographs are presented in monumental format which makes them seem independent of one another and detached from any overriding theme; they become an end in themselves, with no link to any narrative or documentary reality.

The jury of the Aanmoedigingsprijs Fotografie AFK (2002) described Hondius' work as follows: 'In this way, every association as found in illustrative work, in which objects are named, given a place, and – in certain respects – rendered harmless, is strictly avoided.

This absence of information makes the images seem strangely threatening, as if they belong to a world that refuses to divulge its meaning and thus remains uncontrollable.' The fact that these pictures are not 'really' snatched from life in the raw does not make them any less critical. There is not one single work in which we see the glamorous side of life, although this would lend itself particularly well to such stagings and such a format. Nothing could be further from Hondius' mind. In the dramatic constructs of his photos, we are continually confronted with the fate of illegal immigrants, social injustice, civil war and racism.

In the 1990s, Hondius attended a practical course in Prague, where he put together a particularly striking portrait series of gypsies. He printed the photos in superposter format and hung them up around the streets of Prague to give these people a visible profile. No sooner had they been hung than they were torn, covered in dirt or smeared with racist slogans. He then photographed the posters again, and these 'after' pictures form an integral part of the project. However, he stresses that his prime concern is to be a photographer and not a political activist. His particular focus on a problem is therefore the exception rather than the rule. He is more interested in finding universal, critical ways of grasping both our deteriorating world and, above all, our highly conditioned way of seeing it.

ERIK EELBODE

RICHIE, 2006
C-PRINT, DIBOND, PERSPEX
124 X 157 CM (48¾ X 61¾ IN.)

A COMPLEX NEWSPAPER, 2002
OFFSET, 60 X 44 CM (23⅝ X 17¼ IN.)
8 PAGES (DETAIL)

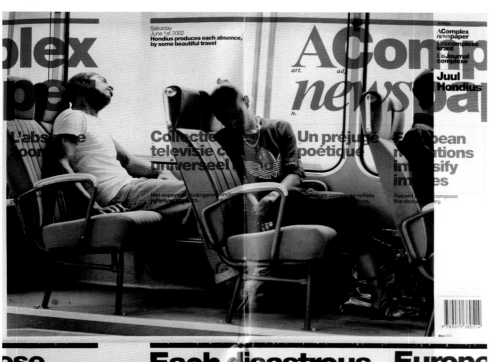

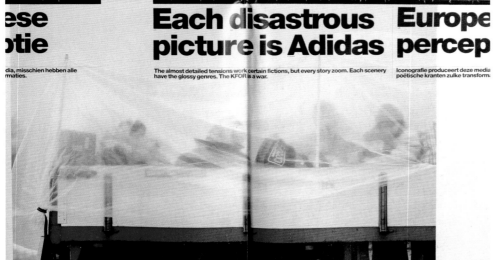

A COMPLEX NEWSPAPER, 2002
OFFSET, 8 PAGES (DETAIL)
60 X 44 CM (23⅝ X 17¼ IN.)

ABOVE: BUS, 2001
C-PRINT, 125 X 160 CM (49¼ X 63 IN.)

BELOW: PLASTIC, 2001
C-PRINT, 125 X 160 CM (49¼ X 63 IN.)

MARINE HUGONNIER

born in 1969 in Paris, France
lives and works in London, UK

WWW.MAXWIGRAM.COM

In film and still photography, Marine Hugonnier presents landscapes as shaped by ideology, power and history. The self-reflexive storylines often halt, sidestep and fold upon themselves, being engaged with what Hugonnier calls a 'politics of vision', how structures of beliefs or values – or how images and perspective itself – frame the perception and experience of spaces and landscapes. Hugonnier continually demonstrates the very specificity of every vantage point as seen through the camera lens. Her recently completed film trilogy focuses on failed utopias and lost paradises. In *Ariana* (2003) we follow a film crew as it journeys to Afghanistan to shoot the legendary Panjshir Valley, which has been associated with the Garden of Eden since the Middle Ages and, in more recent times, was a stronghold of resistance against Soviet, Taliban and US occupation. The film crew's desire for a panoramic shot of the valley is, however, thwarted after they are prohibited access to the planned, ultimate vantage point. Returning to Kabul, filming ruins and renovations, the film subtly transforms into a meditation on the panoramic shot as a symbol of power. When permission is finally granted, the film crew decides to quit, recognizing the panorama as a perspective of military origin.

The Last Tour (2004) is a work of fiction. 'Everything has been seen, there is an image of everything; the only fantasy which remains is that of being the last person to see something,' says Hugonnier. In the film, the Swiss Alps are to be permanently closed off to the public to prevent their destruction through exploitation and overuse. A last voyage by balloon is undertaken, while, in parallel, the film investigates the story in reverse, describing the path that led to the current state of affairs. With the closing of the region, the Alps are left to become myths, legends, fiction, guesswork, fading memories. The meta-filmic perspective reoccurs in *Travelling Amazonia* (2006) where, again, a film crew is followed in pursuit of a particular shot. This time the setting is the Trans-Amazonian highway, a colossal project that was never completed but was initiated by the Brazilian government in the 1970s (during dictatorship) to establish a route through the entire Amazon region, connecting the Atlantic and Pacific coasts. To represent this nationalistic project, the filmmaker attempts to produce a travelling shot, using tracks and a dolly made from the same local natural resources – rubber, wood, metal – that were employed in the highway project. In the end, achieving this linear filmic sequence becomes less central to the film than telling the story of a double failure, of the unfinished highway and the collapsed dictatorship. Other films by Hugonnier, such as *Death of an Icon* and *Territory* (both 2004), continue her engagement with contested territories and with the geography of political conflicts.

JAN-ERIK LUNDSTRÖM

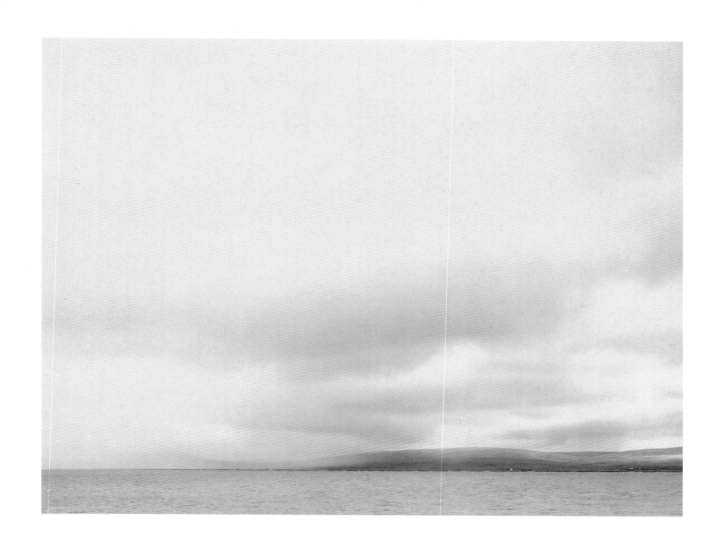

TOWARDS TOMORROW (PANDJSHÊR VALLEY, AFGHANISTAN), 2003
LAMBDA PRINT, ALUMINIUM, 126.4 X 133.3 CM (49¾ X 52½ IN.)

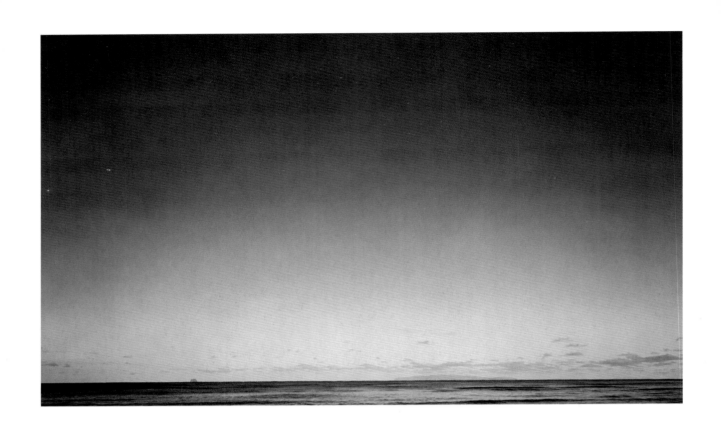

TOWARDS TOMORROW (INTERNATIONAL DATE LINE, ALASKA), 2001
LAMBDA PRINT, ALUMINIUM, 120 X 160 CM (47¼ X 63 IN.)

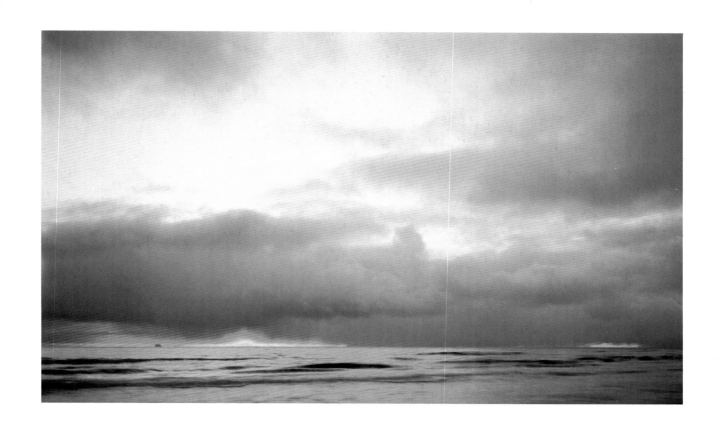

TOWARDS TOMORROW (INTERNATIONAL DATE LINE, ALASKA), 2001
LAMBDA PRINT, ALUMINIUM, 130 X 200 CM (51⅛ X 78¾ IN.)

MICHAEL JANISZEWSKI

born in 1957 in Berlin, Germany
lives and works in Munich

WWW.DRISSIEN-GALERIE.COM

Michael Janiszewski had no formal art training, but studied German and law at the Ludwig-Maximilians-Universität in Munich. Shortly after graduating in 1987, he began to collaborate with Bernhard Johannes Blume, and from 1989 until 1994 he worked in his own studio with the actor Hansjörg Föhse as his permanent model. According to Manisha Jothadi in *Camera Austria*, Janiszewski has been developing a very personal form of action art since the beginning of the 1990s. No one ever gets to see the action itself, because there is nothing but photographs of it. And these are not documentary records, such as the 'performances' of the 1960s. Janiszewski's actions serve the purposes of the photograph, and not the other way round. Is it really photography as such? He prefers not to categorize his work in this way: 'They are pictures, because the medium of photography, with all its technical possibilities, doesn't actually interest me very much.'

For this reason, perhaps, the photos themselves are not particularly professional; indeed, Janiszewski's working methods are deliberately amateurish. In contrast to traditional performance artists, he himself never appears in his pictures. He prepares the scene,

directs it and records it with a 35 mm camera. Until 1994 he worked with Föhse, and between 1997 and 2003 with a life-size display dummy. During the three intervening years, he put his art on hold, in memory of a close friend who committed suicide. Since 2004 he has again been working with an actor.

'Provokation? I (Gesellschaftliche Verweigerung)' ('Provocation? I – Social Rejection') is not just the title of Janiszewski's exhibition in Vienna's Fotogalerie, (2007) but includes key terms that run throughout his work, along with alienation, staged sexuality and dreamlike (or nightmarish) scenarios. His images disrupt our visual conventions as well as our expectations of pictorial art. This is also the view of the Austrian virtual platform for cultural networking, a.c.t.i.o.n.: 'Janiszewski confronts the social, political and religious norms that govern the outer world with a provocative inner life. The protagonist acting in this inner world, and continually threatening to lose himself in a variety of grotesque roles, at the same time becomes recognizable as a distorting mirror which unmasks the reverse side of the things that govern us.'

ERIK EELBODE

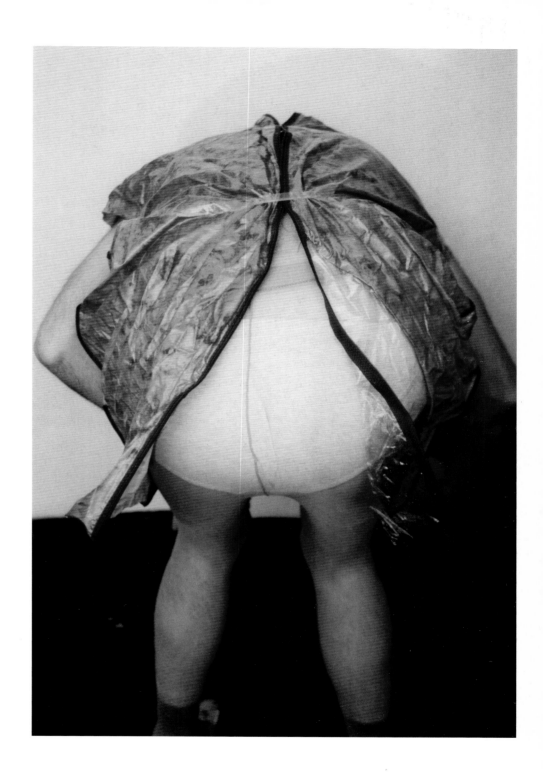

GEOMETRISCHER UNFALL, 2005
C-PRINT, 40 X 27 CM
[15¾ X 10⅝ IN.]

WIDERSTAND DURCH ERSCHÖPFUNG, 2005
C-PRINT, 40 X 27 CM (15¾ X 10⅝ IN.)

LUDWIG VAN BEETHOVEN, 14. SINFONIE 'NOSFERATU'
FÜR GASTROMBONE UND ZITTERKLAVIER, 2005
FROM THE SERIES BEETHOVENS KOMPOSITIONEN AUS DEM JENSEITS
C-PRINT, 40 X 27 CM (15³/₄ X 10⁵/₈ IN.)

SANNA KANNISTO

born in 1974 in Hämeenlinna, Finland
lives and works in Helsinki

WWW.SANNAKANNISTO.COM

In a self-portrait from 2000, we see Sanna Kannisto sitting at a table in a dark wooden house. She is looking into a brightly lit display cabinet which contains a toad, or maybe a large frog. The back of the cabinet is lit up but its sides are covered in black, which makes it look like a stage, with the artist watching the performance. She in turn is being photographed from one side by a camera on a tripod. As a composition, its dense atmosphere and reference to science are reminiscent of genre painting. Here, as in Vermeer's *The Geographer* (1669), the scene takes place against a curtain in a stage-like room. If this were indeed a genre work, one could well imagine it having a title like *The Scientist*, and indeed this would tie in with Kannisto's other photographs.

'My work,' she writes, 'explores the relationship between nature and culture…. I aim to study the methods, theories and concepts through which we approach nature in art and in science. As an artist I am attracted by the idea that when I am working in a rain forest I am a "visual researcher".' In order to translate her approach into pictures, Kannisto has been on several expeditions to Latin-American rain forests. The result was various landscape motifs and photographs of strange scenes of scientific experimentation, as well

as odd-looking research stations. A good example is *65 Bats* (2000). Other photographs show snakes, frogs and tropical plants taken out of their environment and set against a white background, or graph paper, or next to measuring instruments in a display cabinet.

Kannisto's compositions are like a theatre for science, but although the scientific name of each species is given in the title, the artist is not interested in delivering objective knowledge by way of systematic taxonomy. Science, too, is subject to changeable perceptions, and the study of nature remains just as open-ended as it ever was. Reflecting this, Kannisto's photographs always lay emphasis on a vividly subjective approach to methodology, and in this manner she creates her own pictorial worlds. This is particularly clear in the series *Act of Flying, Amazilia tzacatl* (2006). A colourful tropical humming bird, photographed in flight, is shown in individual pictures against a white background. The focus again is not on a study of movement, which is a common subject in scientific photography, but on the aesthetic momentum brought about by the interplay of the flight of the bird and the artistic process that has captured it.

BARBARA HOFMANN-JOHNSON

PRIVATE COLLECTION, 2003
C-PRINT, 130 X 161 CM
(51 ⅛ X 63 ⅜ IN.)

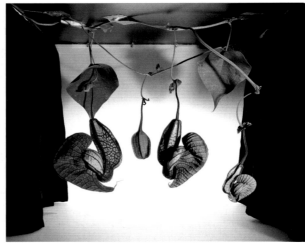

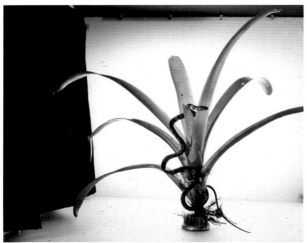

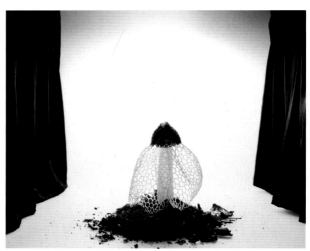

LEPTOPHIS AHAETULLA, 2006
C-PRINT, 76 X 94 CM (29⅞ X 37 IN.)

SIBON NEBULATUS, 2003
C-PRINT, 75 X 92 CM (29½ X 36¼ IN.)

ARISTOLOGIA GORGONA, 2003
C-PRINT, 76 X 94 CM (29⅞ X 37 IN.)

DICTYPHORA INDUSIATA, 2003
C-PRINT, 75 X 94 CM (29½ X 37 IN.)

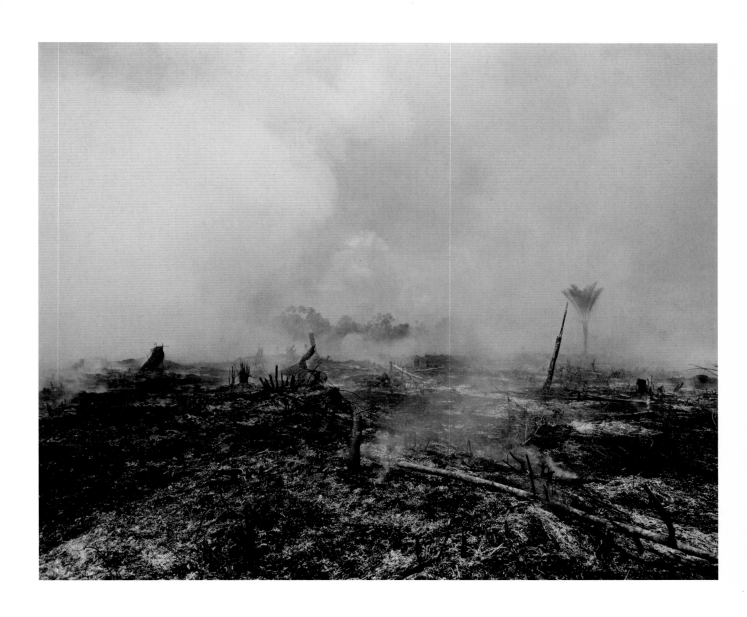

FOREST FIRE 2, 1998
C-PRINT, 103 X 130 CM
(40½ X 51⅛ IN.)

IZIMA KAORU

born in 1954 in Kyoto, Japan
lives and works in Tokyo

WWW.KUDLEK-VANDERGRINTEN.DE

Feeling restricted by the formulas and the expectations of the fashion photography industry, Izima Kaoru made the firm decision to step sideways into the world of contemporary art in order to give himself the freedom he needed. His origins as a professional fashion photographer are clearly seen in his work. Through the skilful use of colour and an adroit choice of locations, Kaoru creates stunningly beautiful images, even if it is an ironic beauty. *Landscapes with a Corpse* (since 1993), for example, presents the 'corpses' of beautiful fashion models in *haute couture* clothing. These are, essentially, exotic murder scenes in which Kaoru's *modus operandi* is to take a sequence of images of the same scene. Starting from a distance, usually from a bird's-eye view, where the presence of the body is virtually indistinguishable from the surrounding landscape, he gradually moves closer until finally the gruesome corpse dominates the foreground of the final image in the sequence.

Bittersweet is perhaps the best word to describe Kaoru's work, which is riddled with contradictory elements. The victims – the models – are actually given a choice as to how they would like to die, so they are involved in setting the scene and in depicting the mode of their death. In effect they are happy about their deaths. Black is the colour generally associated with death, but Kaoru's colour-saturated C-prints fly in the face of this tradition. Colour plays a major role in these carefully constructed images. This is styling on a grand scale: not only are the appearance of the location, its ambience and its visual impact carefully chosen, but also its complementary colour palette. Vast sweeping landscapes, iconic contemporary architecture and imposing civil engineering works, as settings, make grand gestures that at first overwhelm the crime scenes, but become progressively diminished as Kaoru's camera zooms in for the kill.

With titles like *Igawa Haruka Wears Dolce & Gabbana* (2003), *Koike Eiko Wears Gianni Versace* (2004) and *Erin O'Connor Wears Vivienne Westwood* (2006), we are drawn into the world of fashion. The photographs, far from glamorizing murder or aestheticizing death, actually give us pause for thought, imposing that sobering realization that the line between life and death is fine indeed. Just as beauty is only skin deep, death hovers above our often superficial daily lives. Although staged fakes, by taking on the aesthetic of the big screen these cinematic images are irresistibly appealing and achieve a greater impact through this subtle association, without becoming hyperbolic or overblown. Kaoru achieves the fine balance between an emotively powerful edge and the quasi-kitsch eye-candy of fashion photography, and in a gestalt way the viewer can flip almost seamlessly from one persona of the image to the other. It is this phenomenon that gives his photographs a compelling, magnetic quality.

ROY EXLEY

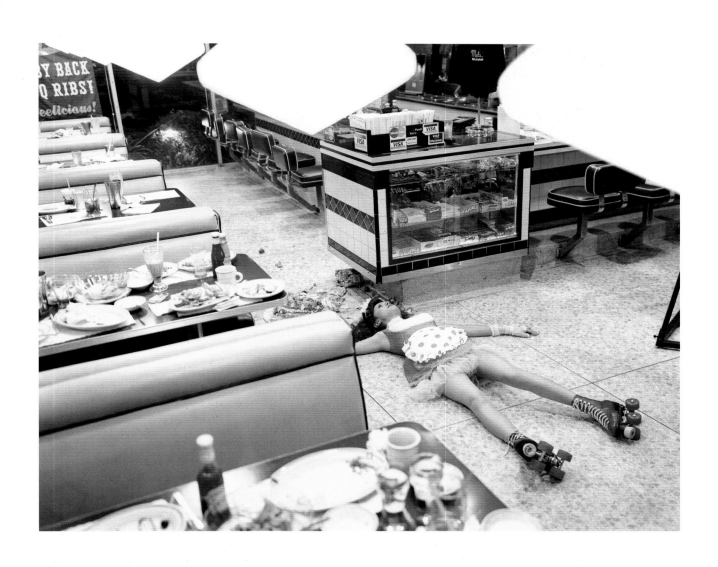

HASHIMOTO REIKA WEARS MILK, 2006
C-PRINT, DIASEC, 180 X 220 CM (70⅞ X 86⅝ IN.)

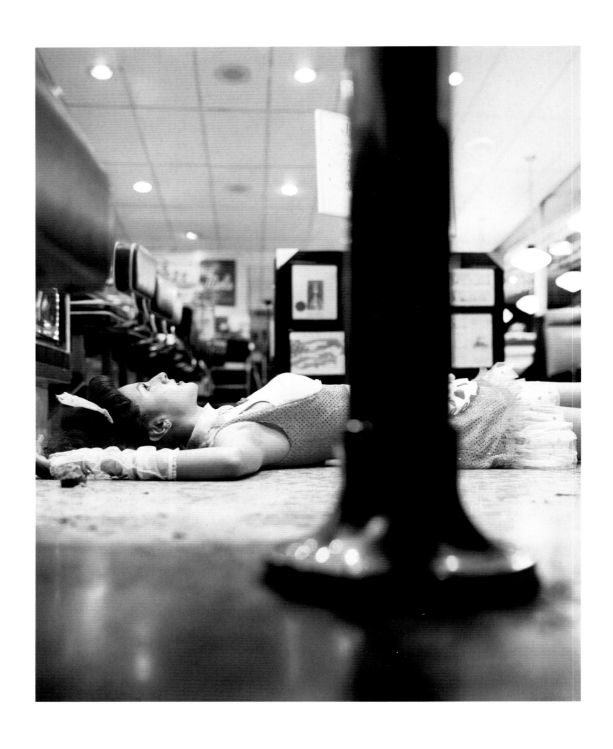

HASHIMOTO REIKA WEARS MILK, 2006
C-PRINT, DIASEC, 180 X 150 CM (70⅞ X 59 IN.)

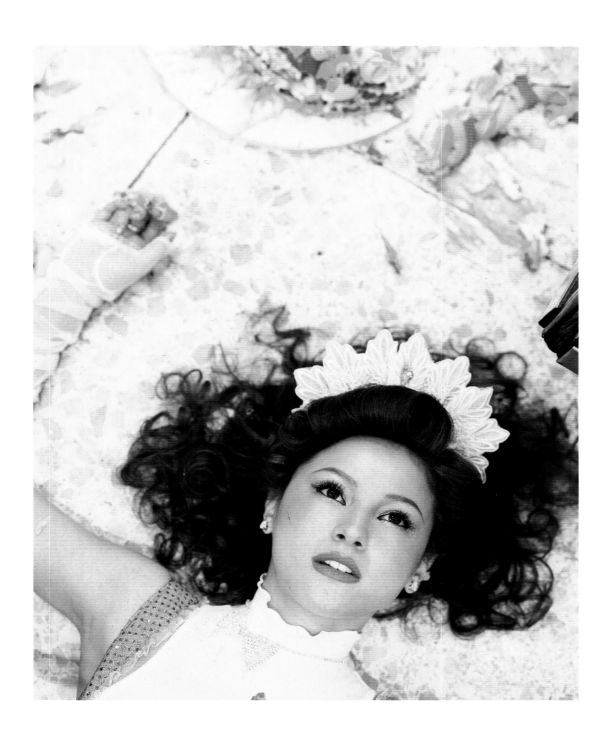

HASHIMOTO REIKA WEARS MILK, 2006
C-PRINT, DIASEC, 180 X 150 CM (70⅞ X 59 IN.)

RINKO KAWAUCHI

born in 1972 in the Shiga Prefecture, Japan
lives and works in Tokyo

WWW.COHANANDLESLIE.COM WWW.PRISKAPASQUER.DE

With her poetic photographs of different aspects of everyday life, Rinko Kawauchi combines commonplace situations, people, animals, objects, landscapes and the urban environment with atmospheric lighting to create subtle narrative patterns. She enhances the narrative impact with unconventional scenes and objects, dynamic perspectives, and transparent, almost paint-like colours. Like the pieces of a puzzle, each with its own contribution to the whole, the photos created by this internationally acclaimed photographer and filmmaker accumulate to produce thematic series conveying a fragile, transient beauty.

Aila (2004) is one such series – a melodious word which is Turkish for family. Like a diary, the interlinked photographs depict various aspects of life detail by detail – people and animals, plants, birth and death – establishing a melancholy sense of the passing of time and the transience of all things. The experience of nature always plays an important role in Kawauchi's work, and this series is no exception. One of the motifs is an impressive pattern of lightning bolts in the sky which, seen from below, take up the right half of the

picture. They look as if they are about to snake their way into a building (a tower and a round structure) which soars from the bottom left-hand corner of the picture into the sky. This building is probably a factory, although it looks more like a modern fortress. One of the bolts seems to hit the roof of the round structure, and the light from the windows gives the impression that it may have penetrated inside too. Removed from the flow of time, this single shot becomes a metaphor for the power of nature, and for the interplay of the concreteness of things and the vagueness of the senses. These features, which are often found in Kawauchi's pictures, can be seen in another photo from the Aila series in which a child 'emerges' as a half portrait – seen from below and gazing upwards – entranced by the infinity of the sky. One might take this as a metaphor for all questions in life: the child becomes a kind of screen on which nature projects itself, bearing within itself – as it so often does in Kawauchi's pictures – an archaic symbolic power that is given presence by its contact with everyday life.

BARBARA HOFMANN-JOHNSON

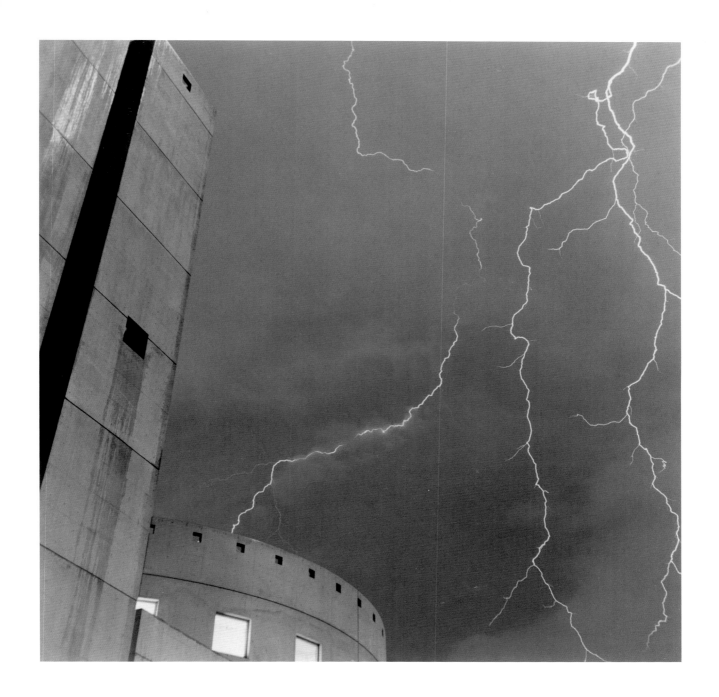

UNTITLED, 2004
FROM THE SERIES **AILA**
C-PRINT, 25.4 X 30.5 CM (10 X 12 IN.)

UNTITLED, 2004
FROM THE SERIES **AILA**
C-PRINT, 101 X 101 CM (39½ X 39½ IN.)

UNTITLED, 2004
FROM THE SERIES **AILA**
C-PRINT, 101 X 101 CM (39½ X 39½ IN.)

UNTITLED, 2001
FROM THE SERIES **UTATANE**
C-PRINT, 101 X 101 CM (39½ X 39½ IN.)

UNTITLED, 2004
FROM THE SERIES **AILA**
C-PRINT, 101 X 101 CM (39½ X 39½ IN.)

UNTITLED, 2004
FROM THE SERIES **AILA**
C-PRINT, 101 X 101 CM (39½ X 39½ IN.)

PERTTI KEKARAINEN

born in 1965 in Oulu, Finland
lives and works in Helsinki

WWW.ANHAVA.COM

Neither motif nor temporality are central in the work of Pertti Kekarainen. Rather, both are peculiarly secondary in his phenomenologically charged imagery. In fact, a particular displacement of motif and deferral of time are at the core of Kekarainen's work. Not that it is necessarily difficult to describe what a Kekarainen photograph depicts or what is happening in front of his camera. Most of his photographs record everyday interior spaces – staircases, lounges, hallways, libraries, galleries, as well as details such as a door frame or a segment of a wall. Yet, his imagery remains anonymous and suggestive, rather than explicit and articulate. Edging towards abstraction and reduction, Kekarainen's photographs are, somehow, slightly disinterested in their subject-matter, and the few people who do make an appearance lack a direct relationship with the camera, seemingly unaware of or unconcerned with being photographed. Space, motif and subject all remain effectively unresolved in these photographs.

Over the past few years, Kekarainen has been working on two major series, *Tila* and *Density*, each including almost one hundred images. These two series are not held together by a particular theme. Motifs come and go. A selection of photographs might be linked by a specific colour, a particular place or

an optical intervention, but no single property characterizes the entire series. Instead, viewers are asked to use their imagination to make the link. The idea of physical or optical interventions is a central element of Kekarainen's art. In each photograph in these two series there is a disturbance to the field of vision of some kind – a filter, a membrane, a coloured patch, a mask, opaque layers of assorted colours, a milky pane across the line of vision, or even additional lenses that repeat the photographic act within the image.

In Kekarainen's work, sight is not taken for granted. The acts of seeing and photographing are conceived as uncertain, perceptually and emotionally complex, indecisive and changeable. Photography, with its privileged position in mankind's search for mimesis, proves a reliable and seductive performer. Kekarainen uses the camera to think and to undermine vision. His art is a phenomenological laboratory where everyday life is opened up to the visual abyss of the technological sublime. The end result is a series of visual explorations of how light shapes the world, upturning the age-old distinction between image and idea, so that the image becomes the idea.

JAN-ERIK LUNDSTRÖM

TILA (MOVING DOTS), 2005
C-PRINT, FOREX, DIASEC
60 X 48 CM (23⅝ X 18⅞ IN.)

TILA (PASSAGE II), 2006
C-PRINT, DIASEC
195 X 125 CM (76¾ X 49¼ IN.)

TILA (PASSAGE VI), 2007
C-PRINT, DIASEC
195 X 125 CM (76¾ X 49¼ IN.)

JEAN-PIERRE KHAZEM

born in 1968 in Paris, France
lives and works in Paris

WWW.SPERONEWESTWATER.COM WWW.BILLCHARLES.COM

Combining performance and photography, Jean-Pierre Khazem's spirited portraits hide their true identity beneath the false skin of prosthetics and plastic surgery. His perfect female specimens stride through nature or stand rigidly still in the gallery like shop-dummies or mannequins, defiantly returning the viewer's gaze. Yet there is something wholly unnatural about their smooth, unblemished faces and their tight, featureless, Botoxed expressions. Khazem employs his models and muses to wear highly finished facial masks, before photographing them in a carefully constructed set or gallery. Sometimes he asks them to perform live and perhaps even naked, apart from their mask.

Like Yasumasa Morimura's self-portraits before him, Khazem appropriated the familiar visage of Leonardo's enigmatic Mona Lisa for a series of photographs and sculptural performances entitled *Mona Lisa Live* (2003). The model's uncanny likeness to the painted features of La Gioconda and the strong overhead spotlight distract from her nakedness and from her human presence, as though the model had been replaced by a silent, unmoving automaton. Her statuesque pose and stillness, mirroring the stasis of the resulting photographs, again removes her from the land of the living into a dream state or a hyper-real fantasy world. Indeed, Khazem has occasionally placed his doll-faced figures in leafy, pastoral idylls, positing both an Edenic world of origin and its opposite, a future world of robotic clones. The lineage of art-historical

nudity is also reinforced in Khazem's unachievable visions of beauty, created by the finest wig-makers, silicone rubber specialists and false eye manufacturers. Unlike Cindy Sherman's reinterpretation of the female face as mask, Khazem's beauties refuse any notions of identity or emotion, reducing femininity to a construct or a *tabula rasa*. This could be a comment on how bland and meaningless the world of commercial and fashion photography has become – a world through which, ironically, Khazem first made his name.

Khazem's early work included men and women adorned with outlandish animal masks such as lion or llama heads, lost in their own aimless activity of work or leisure. He also collaborated with other artists, first with the Belgian Eric Duyckaerts for *The Dummy's Lesson* (2000), and then with Maurizio Cattelan for an oversize puppet-like Picasso head, which greeted gallery-goers in New York.

More recently, Khazem has personalized his work further, creating a series of recognizable portraits of seven *First Ladies* (2004): Nancy Reagan, Lady Bird Johnson, Pat Nixon, Betty Ford, Rosalynn Carter, Barbara Bush and Laura Bush. Each is surrounded by the trappings and regalia of the Oval Office but wears the vapid, surgically precise stare of a trophy wife, an empty vessel. Khazem reveals the mask to be an entirely appropriate response to the 21st-century identity crisis facing us all.

OSSIAN WARD

UNTITLED MARILYN 5, 2007
C-PRINT ON FUJI FLEX PAPER
120 X 220 CM (47¼ X 86⅝ IN.)

UNTITLED MARILYN 1, 2007
C-PRINT ON FUJI FLEX PAPER
120 X 220 CM (47¼ X 86⅝ IN.)

UNTITLED MARILYN 4, 2007
C-PRINT ON FUJI FLEX PAPER
120 X 220 CM (47¼ X 86⅝ IN.)

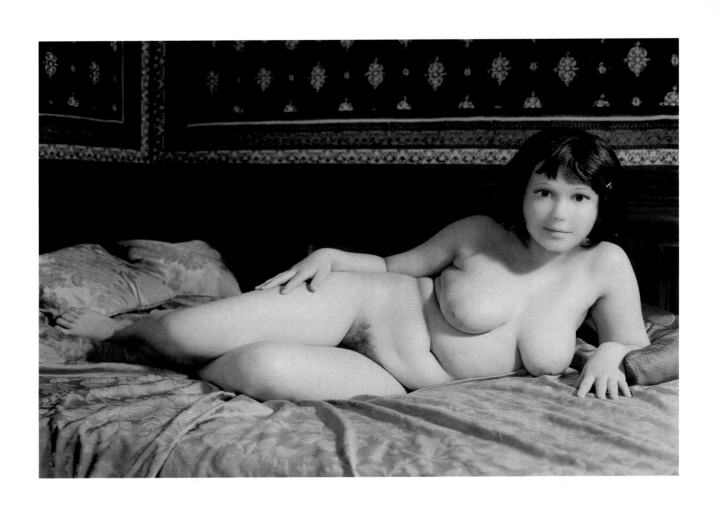

VOLUME 3, 2000
C-PRINT, 100 X 140 CM
(39 3/8 X 55 1/8 IN.)

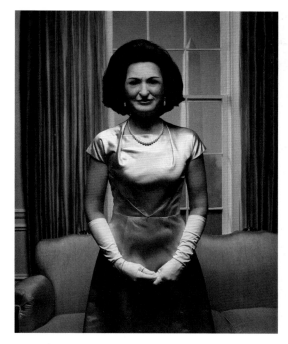

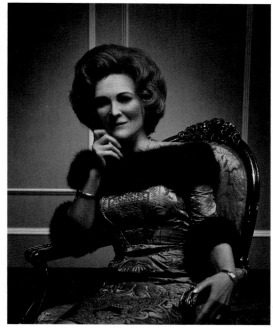

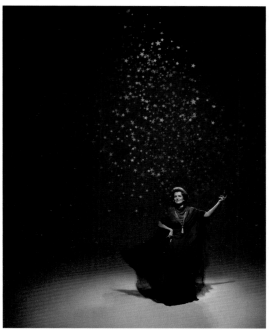

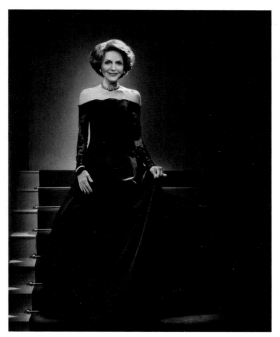

FIRST LADIES: BIRD, 2004
C-PRINT ON FUJI FLEX PAPER
157.5 X 121.6 CM (62 X 47⅞ IN.)

FIRST LADIES: BETTY, 2004
C-PRINT ON FUJI FLEX PAPER
157.5 X 121.6 CM (62 X 47⅞ IN.)

FIRST LADIES: PAT, 2004
C-PRINT ON FUJI FLEX PAPER
157.5 X 121.6 CM (62 X 47⅞ IN.)

FIRST LADIES: NANCY, 2004
C-PRINT ON FUJI FLEX PAPER
157.5 X 121.6 CM (62 X 47⅞ IN.)

IOSIF KIRÁLY

born in 1957 in Timisoara, Romania
lives and works in Bucharest

WWW.IOKIRA.COM

For Iosif Király, photography is a medium of memory – a Proustian technique for capturing lost time. This may well be due to his photographic beginnings. In the 1980s he concentrated mainly on installations and performances. As it was virtually impossible under the Communist dictatorship to show his works publicly, he performed them mostly in front of the camera – the only way he could create a small audience for himself beyond his immediate circle of friends. For him, photography was a means of removing the restrictions of time and place on his work, and rendering them accessible to memory. This idea of access also makes itself felt in *Indirect*, a work that Király began in 1990, initially in black and white but since 1998 in colour. It is a diary-like collection of atmospheric photographs, the motivation for which he describes as follows: 'A doubt in my own ability to perceive, understand or enjoy things at the moment of their happening. Often in my life events, words or even meaningful looks have had a different significance from what I first thought. Photography for me is the art form that lets me say "Stop!" to time.'

Photography as a memory medium is also to be found in Király's *Reconstructions*: pictures composed of countless photos taken from the same vantage point but at different times (minutes, days, months, even years later). The images, which combine spatial continuity with temporal discontinuity, give visual expression to the work of the memory, as it combines individual impressions into a synthesized whole. Other series deal with the passage of historical time and the social changes that have taken place in post-Communist Romania, especially noticeable in architecture. *Tinseltown* (2000–1) shows the picturesque and unconventional architecture and way of life in the new estates built for gypsy settlers; we see how the forms traditional to these people have been translated into a new architectural aesthetic which incorporates their memories of life on the move. In *Triaj (The Marshalling Yard)* (2005), a project on which he collaborated with the architects Mariana Celac and Marius Marcu Lapadat, Király uses multi-perspective photographs to trace how the appearance of housing estates has changed since the end of the Communist dictatorship. This project extends the private memory processing of *Reconstructions* into an historical context, and helps to make his work into a survey of the different forms of memory to be found in post-Communist Eastern Europe.

MARTIN JAEGGI

RECONSTRUCTIONS_BUCHAREST_POLIZU, 2006–7
DIGITAL C-PRINT, 42 X 150 CM (16½ X 59 IN.)

RECONSTRUCTIONS_MOGOSOAIA 2A_LENIN AND GROZA, 2006
DIGITAL C-PRINT, 63 X 183 CM (24¾ X 72 IN.)

RECONSTRUCTIONS_TURNU SEVERIN_1, 2005
DIGITAL C-PRINT, 86 X 300 CM (33⅞ X 118⅛ IN.)

RECONSTRUCTIONS_YAZD_2, 2005–6
DIGITAL C-PRINT, 53 X 126 CM (20⅞ X 49⅝ IN.)

JOACHIM KOESTER

born in 1962 in Copenhagen, Denmark
lives and works in New York, USA

WWW.JANMOT.COM WWW.NICOLAIWALLNER.COM

History as a conversation, as a set of musings that ramble between fact and fiction. History as a partially buried object, a powerfully felt psychic charge or a low murmur – or as an exchange that takes place between an individual and a site, between an artist and an audience. Most of Joachim Koester's recent work deals with historical data in one or other of these ways. It charts a course between the documentary and the imagined, often allowing the fantastic and the mundane to butt up against one another in a manner that attests to the presence of the extraordinary in the everyday. Often there is a play between the macro and the micro, or between what happens in the mainstream (on the stage of history for example) and the details of a specific place and the intricate, often hidden narratives that are connected to it. *Resolute* (1999), the title of one of his works, refers to an obscure town of only 200 people somewhere in the Canadian Arctic, and yet this place has been witness to a sequence of events that link it to more worldly currents, including the search for the Northwest Passage, Cold War politics, the relocation of the Inuit people in the 1950s, and the development of an unrealized plan to build an 'ideal city' in the Arctic.

The status of the photograph as an individual document that can contain a set of ambiguities is evident in a series called *In Day for Night* (1996). Depicting the famous social experiment and free town of Christiania in Copenhagen, the images in this series are shot with a blue filter (normally used for representing night scenes during the day), tilting the work towards a kind of fiction. At the same time, the titles are split and allude to both the town's erstwhile military history and to its subsequent occupation by squatters, its current inhabitants.

Another project that examines a type of multiple habitation in time, *The Kant Walks* (2003–4), is based on research into the elliptical perambulations of philosopher Immanuel Kant through his hometown of Königsberg. Here, the process of tracing the philosopher's path through a severely broken-up terrain requires the juxtaposition of two different maps, pointing to the abrupt about-turns of history and to the record of this which is inscribed in the landscape. Königsberg, a cosmopolitan town that once held Germany's largest bookstore, was in 1938 the scene of arson, killing and book-burning. Then in 1945 it was flattened by Allied bombs and subsequently renamed Kaliningrad by the Soviets who annexed the city. Fragments of this story litter the path that Kant once took and force their way into the consciousness of anyone wishing to literally follow in his footsteps. Here, as elsewhere in Koester's practice, layers of history rise to the surface and become materialized in the present, with the artist catching the physical texture of time (and its scrambling) from a past that exists as a rich terrain of associations, encapsulated in the objects and places that constitute his site of field work.

GRANT WATSON

THE MAGIC MIRROR OF JOHN DEE, 2006
GELATIN-SILVER PRINT, 59 X 47 CM (23¼ X 18½ IN.)

ROW HOUSING #3, 1999
FROM THE SERIES ROW HOUSING
C-PRINT, 68.6 X 88 CM (27 X 34⅝ IN.)

BEECHEY ISLAND #1, 1999
FROM THE SERIES ROW HOUSING
C-PRINT, 68.6 X 88 CM (27 X 34⅝ IN.)

ED RUSCHA, 6565 FOUNTAIN AVE, 2003–5
FROM THE SERIES **HISTORIES**
GELATIN-SILVER PRINT, EACH 17.7 X 21.2 CM
[7 X 8⅜ IN.] [DIPTYCH]

ROBERT ADAMS, DARWIN PLACE, 2003–5
FROM THE SERIES **HISTORIES**
GELATIN-SILVER PRINT, EACH 17.7 X 21.2 CM
[7 X 8⅜ IN.] [DIPTYCH]

AGLAIA KONRAD

born in 1960 in Salzburg, Austria
lives and works in Brussels, Belgium

WWW.FW-GALERIE.DE

For years Aglaia Konrad has been tracking modernism. In the course of her quest, she has travelled to countless cities and mega-cities all over the world, exploring and documenting their structure, as well as the architectural and planning concepts of modernism as a global form of combining space and society. The result is a massive archive of photographs that she has assembled to convey the visual topology of each specific urban landscape. For her many exhibitions, she covers walls with large-format pictures from her archive, sometimes even creating a kind of wallpaper of the collections. By this method, and by expanding her pictures into installations or other large-scale forms, she recreates a physical sense of these structures, reproducing and conveying the power of the built-up environment within the framework of the exhibition.

The systematization of collective living and potential for action that is embodied in the modernist town is an experience of space, rather than a subject for aesthetic 'consumption'. Konrad transplants this experience into a new spatial context in order to avoid any sort of stylized, autonomous, ahistorical, apolitical representation. She shows clearly in her work that the photograph is not a medium for documenting reality, but a vehicle for the analysis and interpretation of that reality. By means of her unconventional formats, the visual structure of duplications and series, fragmentations and false connections, she undermines the conventional view of photography as a documentary form. As with architecture, she shows that the photograph is a medium for the appropriation and control of space and society. In her installations, she strategically moulds this spatial 'control' of space, interweaving picture, space and architecture into a complex network which, on the one hand, reinvents architectural photography, and on the other bids farewell to photography as an iconography of the world.

REINHARD BRAUN

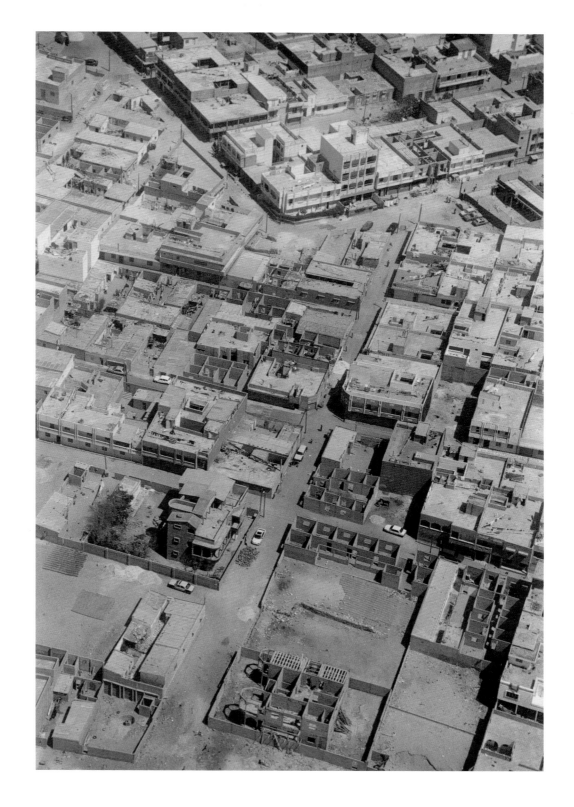

DAKAR, 2002
VARIOUS TECHNIQUES, VARIOUS DIMENSIONS

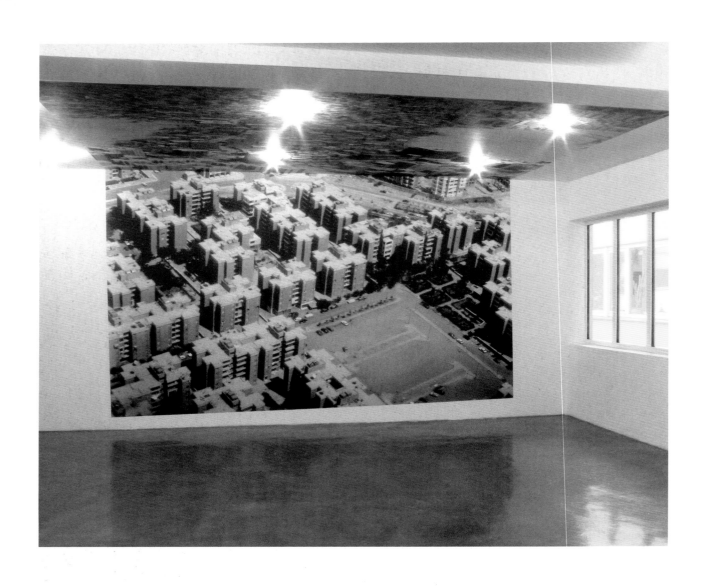

HER CITY
EXHIBITION VIEW, FREHRKING WIESEHÖFER, COLOGNE, 2005

MEXICO CITY, 1995
VARIOUS TECHNIQUES,
VARIOUS DIMENSIONS

CHANDIGARH, 1994
VARIOUS TECHNIQUES,
VARIOUS DIMENSIONS

SHANGHAI, 2000
VARIOUS TECHNIQUES,
VARIOUS DIMENSIONS

JUSTINE KURLAND

born in 1969 in Warsaw (New York), USA
lives and works in New York

WWW.MIANDN.COM WWW.TORCHGALLERY.COM

Combining elements of make-believe and other (real and imagined) social worlds, Justine Kurland's photographs often highlight the potentiality (and mythic reality) of matriarchal or exclusively female communities. Staged in an intense, dense and sometimes overwhelming nature which is rendered in exquisitely rich detail, Kurland removes the enacted photographs from everyday society. She focuses on a female collectivity, powerful and determined, where the community has replaced the family, where association and togetherness are by affiliation rather than filiation, and where traditional behavioural patterns are eclipsed: Edenic settings where man is again hunter-gatherer rather than urban animal. Closer to the pastoral rather than the sublime, these photographs insist on an unforeboding, romanticist universe that is saturated with dreams of something else, of escaping from and disturbing normality. Her chosen heroines pursue this with grand self-assurance and exquisite self-absorption, never doubting their goal.

The photographer's early work featured girl groups, pre-adolescent minor collectives, determinedly occupying and performing in nature. As the artist herself has indicated, these groups are girl versions of Huckleberry Finn, but with fewer sinister undertones (they are non-hierarchical); the girls shepherd, bathe, hunt, play and chat in the wild, in magnificent settings that are reminiscent of a Romantic frontier landscape

and only occasionally reference suburban borders. Autobiographical elements are betrayed – or, rather, an adamant elimination of the borders between life and art. In interviews, Kurland has often referred to both life-style issues (how her photographs emerge out of extended road trips scouting locations for photographs and finding subjects to photograph) and her personal background (having grown up in post-hippie bohemian communities, where she was often on the road). However, personal experience is never the meaning behind her photographs.

After her work with female adolescents, Kurland returned to particular fringe communities and collectives in the Appalachian South. In group portraits, Kurland created a challenging mix of documentary and fiction, photographing people from these communities in everyday contexts pursuing everyday activities, but often in the nude – on the edge of something else, and yet an existing reality. Similarly, *Of Woman Born* (2006) replaces the girls or outskirt collectives with groups of pregnant women with small children and babies, again set in pastoral surroundings, simply hanging out together in the woods or on the beach. Sometimes ritual charges these images, and sometimes they refer to the everyday, in the crossover that is so typical of Kurland's work.

JAN-ERIK LUNDSTRÖM

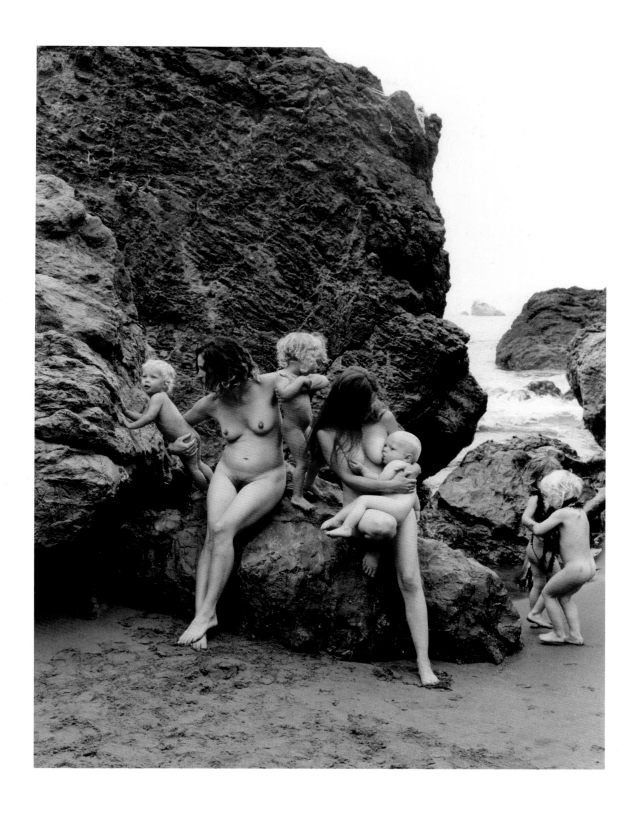

THE MILK SUCKER, 2006
C-PRINT, 101.6 X 76.2 CM
[40 X 30 IN.]

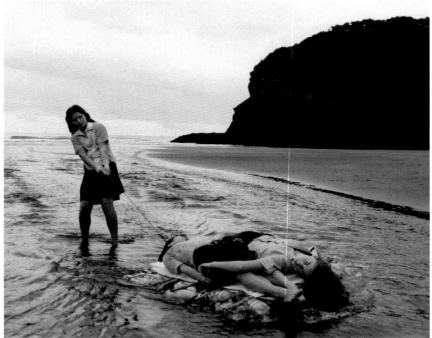

SUNSET, 2000
C-PRINT, 76.2 X 101.6 CM (30 X 40 IN.)

RAFT EXPEDITION, 2001
C-PRINT, 75.9 X 102.1 CM (29⅞ X 40⅛ IN.)

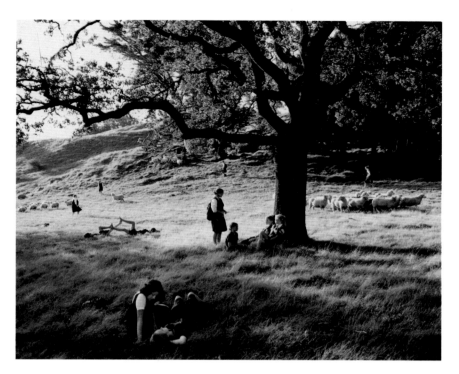

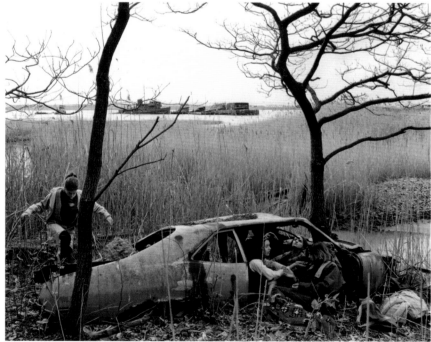

SHEEP WRANGLERS, 2001
FROM THE SERIES **GIRL PICTURES: NEW ZEALAND**
C-PRINT, 76.2 X 101.6 CM (30 X 40 IN.)

SHIPWRECK, 2000
COLOUR PRINT ON SINTRA
78.5 X 103.5 CM (30⁷⁄₈ X 40³⁄₄ IN.)

LUISA LAMBRI

born in 1969 in Como, Italy
lives and works in Milan

WWW.LUHRINGAUGUSTINE.COM WWW.STUDIOGUENZANI.IT

The images of architectural interiors that form the basis of Luisa Lambri's impressive body of work are but an armature for something altogether more esoteric: there is more to these images than meets the eye. These photographs of iconic modern buildings are neither arbitrary nor aesthetically driven; they are an expression of the symbiotic relationship between the deliberate intentions of the architect, as expressed in those spaces, and Lambri's own perception in her exacting and intense contemplation of those spaces. She is not attempting to document the shrines of modern architecture, but is using photography to explore her responses to the spaces. Each photo shoot enables her to discover something new about herself and to leave subliminal imprints of those discoveries in the images; we are able to sense her presence without being able to pin it down. This is more than style, more than idiosyncrasy, which are the fruits of contingency or wilfulness; this is a symbiosis fuelled by Lambri's passion for this architecture and the results of her consequent interactions with it. Through her lens, these sometimes austere spaces are transformed into something entirely personal, something fresh and unique; they shed the straitjacket of their iconic identity to somehow take on an anonymous role.

Lambri's early work focused on the architecture of such modern masters as Le Corbusier, Ludwig Mies van der Rohe, Alvar Aalto and Louis Kahn, looking at communal spaces such as foyers, corridors, hallways and stairways, which seem all the more poignant without their transient users. Like the shadows on the cave wall in Plato's allegory of the cave, we are led to question the 'reality', or rather the 'ontology', of these spaces that Lambri has reinvented.

More recently, Lambri has concentrated on the work of a younger generation of architects such as Richard Neutra, Oscar Niemeyer, Peter Zumthor and Kazuyo Sejima. There has also been a shift of emphasis in her photographs. There is something much more intimate about these images: we are closer to the subject and, instead of being transient, impersonal spaces, there is a sense of occupation here. Utilitarian fittings feature more frequently – cupboards, shutters, screens or blinds appear in varying degrees of openness or closure. These are lived-in or worked-in spaces and, as observers, we are brought closer to the absent occupants through these objects. The ambience of these spaces now transcends their architectural significance as Lambri explores the changes of light. Rooms become almost like cameras, with their adjustable shutters and apertures. The early photographs, which showed buildings as conduits of light along passageways and corridors, have been superseded by images of interiors as infinitely changeable vessels of light.

ROY EXLEY

UNTITLED (PALÁCIO DA INDÚSTRIA, #03), 2003
LASERCHROME, 105 X 92 CM (41³/₈ X 36¹/₄ IN.)

UNTITLED (STRATHMORE APARTMENTS, #05A), 2002
LASERCHROME, 110 X 130 CM (43¼ X 51⅛ IN.)

UNTITLED (STRATHMORE APARTMENTS, #46), 2002
LASERCHROME, 110 X 130 CM (43¼ X 51⅛ IN.)

AN-MY LÊ

born in 1960 in Saigon, Vietnam
lives and works in New York, USA

WWW.MURRAYGUY.COM

An-My Lê is a documentary photographer who approaches her subjects obliquely. Born in Vietnam, Lê came to the United States as a refugee in 1975 during the height of the Vietnam War. After graduating from Yale in 1993 with a Master of Fine Arts in photography, she decided to return to Vietnam to explore the landscape of her childhood. There she took large-format pictures of both the natural and built environments, and the people she met along the way. According to Lê, these pictures are 'a direct extension of a life in exile. The sense of home has to do with the importance of food and location, and it is all connected to the land.' Interestingly, because the war took place almost entirely on Vietnamese soil, and because the country's recent history has been dominated by the conflict, there is a tendency to view all images of Vietnam in terms of the war.

Lê created her next series, *Small Wars* (1999–2002), to explore 'the Vietnam of the mind', as she calls it. In these pictures she documents men – most of them history buffs with no combat experience – re-enacting the war in Vietnam on weekends in North Carolina and Virginia. Sensitive to the fact that what motivates them is a complex web of psychological need, fantasy and a passion for history, Lê does not make fun of their hobby. Instead, she photographed the re-enactors to explore the cumulative effect that various accounts of war – history books, television, movies, etc. – have on memory, both individual and collective, and how these sources affect the ways in which we imagine and glorify war.

Lê's ongoing series 29 *Palms* (since 2003) extends her investigation of war by documenting the military base of the same name in the California desert, where soldiers train before being deployed to Afghanistan or Iraq. Like the Vietnam re-enactments, and Hollywood just 150 miles away, 29 *Palms* is a place where fictions are performed. Lê feels that the presence of her camera feeds the artifice by encouraging the men and women to pose as what they think a Marine looks like. She has even heard the soldiers quoting scenes from war movies to one another during training. Lê recently complemented her still photographs from 29 *Palms* with a double-screen video projection of the same name. The soldiers and tanks seem toylike in the vast desert landscape, reminding us of the distance from which most of us experience war.

By taking a documentary approach to both rehearsal and re-enactment of war, Lê extends and complicates the tradition of war photography. Her pictures do not show us the effects of war, but they do contribute to our understanding of war in a new and compelling way. By bringing a new resonance to the phrase 'the theatre of war', Lê asks us to reconsider the fictions that influence the ways in which conflict is reported, experienced and remembered. By extension, the ambiguity of Lê's work raises questions over the reliability of seemingly objective historical accounts.

KAREN IRVINE

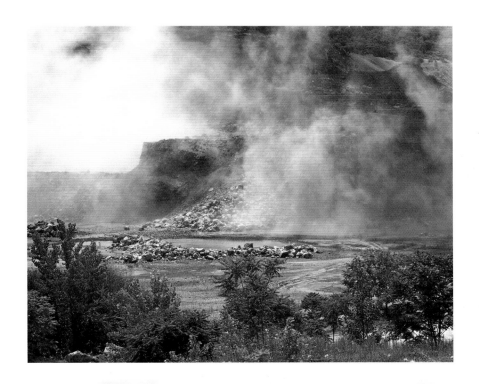

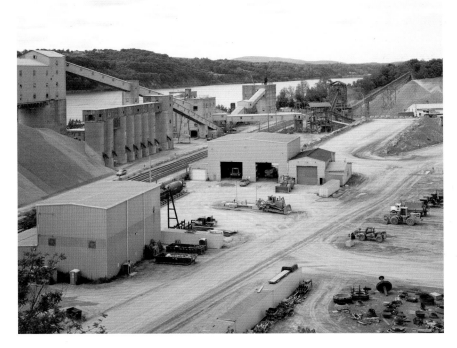

TRAP ROCK (SHOOT II), 2006
INKJET PRINT, 66 X 95.3 CM (26 X 37½ IN.)

TRAP ROCK (PARTS DEPOT), 2006
INKJET PRINT, 66 X 95.3 CM (26 X 37½ IN.)

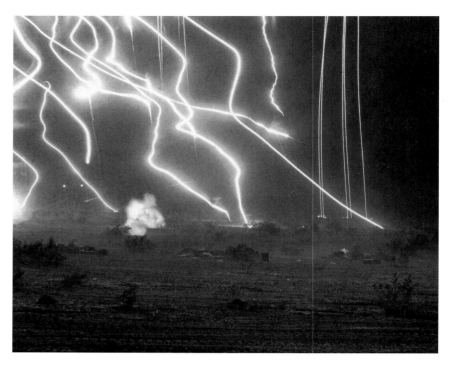

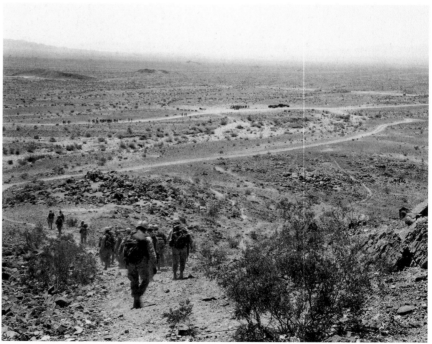

29 PALMS: NIGHT OPERATIONS III, 2003–4
GELATIN-SILVER PRINT, 66 X 95.3 CM (26 X 37½ IN.)

29 PALMS: INFANTRY PLATOON, RETREAT, 2003–4
GELATIN-SILVER PRINT, 66 X 95.3 CM (26 X 37½ IN.)

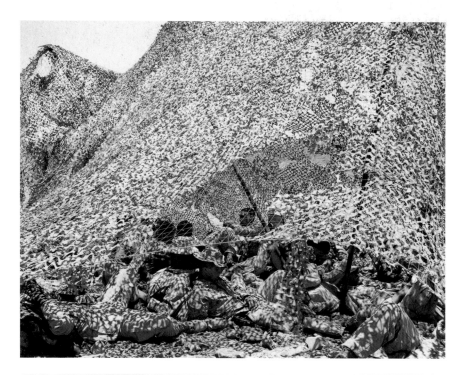

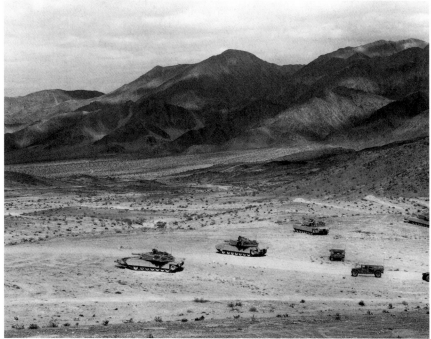

29 PALMS: INFANTRY PLATOON, ALPHA COMPANY, 2003–4
GELATIN-SILVER PRINT, 66 X 95.3 CM (26 X 37½ IN.)

29 PALMS: MECHANIZED ASSAULT, 2003–4
GELATIN-SILVER PRINT, 66 X 95.3 CM (26 X 37½ IN.)

PAUL ALBERT LEITNER

born in 1957 in Jenbach, Austria
lives and works in Vienna

WWW.FOTOHOF.AT

The central theme of Paul Albert Leitner's projects is undoubtedly travel. As a wanderer and a tracker, he is constantly on the move with a camera in hand, indefatigably collecting images which he later arranges and combines. For Leitner, the borders between documentation and autobiography become blurred: to a certain extent, the object of study is the artist himself, as he incorporates himself into the pictures and at the same time reaffirms his own life through them. Leitner prefers towns to countryside and generally begins his 'photo tour' in a town centre, moving outwards to its periphery. In his exhibitions and especially in his books, however, this geographical coherence disappears, and the photographs are linked through a topological system that transcends locality: self-portraits in hotel rooms, the theme of the 'passage' in different forms of traffic, *objets trouvés*, nightlife, interiors, right down to dead animals lying in the street. The connection between images lies in their subject-matter; the original context is dissipated, creating a visual study whose focus lies on the nature of experience, its specificity and its arbitrariness.

Leitner's interest lies not in the actual city but in everything that he finds there, and in everything that goes to make up its cultural and political contrasts. He wants nothing to do with the touristic view, and he does not stay long enough to immerse himself in the cultural, social and economic differences. As a nomad, he is much more interested in constructing images of everyday life, which can be observed everywhere in general and nowhere in particular. In the substantial publication *Städte: Episoden* ('Towns: Episodes', 2005), the system changes into one of associative combination, with even greater emphasis on the subjectivity of the arrangements. A narrative begins to unfold, in which Leitner himself plays the lead, so that the book appears to revolve around a (naturally fictional) autobiography. However, the artist renounces all documentary pretensions, and shifts the art of photography into a strange, intermediate zone where its documentary status becomes uncertain, but its ability to display and record personal experience appears to become equally dubious.

REINHARD BRAUN

INSTALLATION VIEW OF PAUL ALBERT LEITNER'S **KUNST UND LEBEN: EIN ROMAN**
THE 2ND INTERNATIONAL FESTIVAL OF PHOTOGRAPHY, 'PRO VISION'
INTERNATIONAL EXHIBITION CENTER, NIZHNY NOVGOROD, 2002

CAFÉ 'BEIGNET STATION', SLIDELL TRAIN STATION, LOUISIANA, 2004
FROM THE STUDY GROUP **STILLLEBEN**
C-PRINT, 31.3 X 47 CM (12⅜ X 18½ IN.)

ILE DE GORÉE (DAKAR), SÉNÉGAL, 2000
FROM THE STUDY GROUP **STILLLEBEN**
C-PRINT, 31.3 X 47 CM (12⅜ X 18½ IN.)

RIVIERA, CALLE 23, HAVANA, 2001
FROM THE STUDY GROUP '0–24' – SIGNS AND ADVERTISEMENTS (ON PROGRESS)
C-PRINT, 31.3 X 47 CM (12⅜ X 18½ IN.)

SHIRAZ, IRAN, 2005
FROM THE STUDY GROUP '0–24' – SIGNS AND ADVERTISEMENTS (ON PROGRESS)
C-PRINT, 31.3 X 47 CM (12⅜ X 18½ IN.)

JOCHEN LEMPERT

born in 1958 in Moers, Germany
lives and works in Hamburg

WWW.PROJECTESD.COM WWW.SABINESCHMIDT.COM

Jochen Lempert is a biologist, but found his way into photography via filmed experiments. In his work he focuses on aspects of the relationship between humans and nature – our perception of the natural world, our attempts to read the 'book of nature', to understand it and to represent it. His black-and-white, often coarse-grained photographs are far removed from those hi-tech images that claim to show an unmediated, totally objective piece of reality. Lempert foregrounds the pictorial, material elements of his subjects, in order to underline the fact that there can be no serious study of nature that is not at the same time a study of perception and representation. He plays games with the general inclination to see natural phenomena as readable signs, revealing similarities that are only superficially significant. Thus in his *Physiognomische Versuche* ('Physiognomical Experiments', 2002), he juxtaposes portraits of animals with 'faces' that appear to be outlined in violet, a car radiator and a house, drawing attention to our constant attempts to project human images onto natural phenomena. In *Schwärme* ('Flocks', 2005), he photographs flocks of birds in flight – their formations appearing to us to take on particular patterns.

In Lempert's photograms, animals themselves create symbolic pictures. *Luciola* (2001) shows the punctuated tracks left behind on light-sensitive paper by Italian glow-worms, while *Leuchtkäfer* ('Glow-Worms', 1991) shows the net-like tracks of one of their German brethren. In another of his works, Lempert poured seawater onto a 35 mm film and then enlarged the tracks of the plankton, which reacted to the movement by emitting a glow that was caught on the film. Elsewhere, his starting-point is the human depiction and cultural distortion of nature itself. *The Skins of Alca impennis* (begun in 1995) shows different preserved examples of an extinct bird, the Great Auk, which died out more than 150 years ago. The specimens were sourced from various scientific collections in this quest for a creature that now exists only in museums. *365 Tafeln zur Naturgeschichte* ('365 Plates on Natural History', 1989–2004) combines pictures of live and preserved animals, sculptures and cuddly toys in a complex system of signs which alludes to the tradition of encyclopedic comparative nature studies, such as Erich Häckel's *Kunstformen der Natur* ('Art Forms of Nature'), and which questions human interpretations of nature that are heavily influenced by our ideas of control and form. Lempert's work lays great emphasis on the fact that any truly profound reflection on nature must always raise questions about the images with which we represent it.

MARTIN JAEGGI

OISEAUX – VÖGEL, 1997
12 GELATIN-SILVER PRINTS ON BARYTA PAPER
TOTAL DIMENSIONS 175 X 210 CM (68⅞ X 82⅝ IN.)

O.T. (SEEANEMONE), 2005
GELATIN-SILVER PRINT ON BARYTA PAPER
30 X 24 CM (11¾ X 9½ IN.)

O.T. (WEISSER HUND)
FROM **PHYSIOGNOMISCHE VERSUCHE**, 2002
17 GELATIN-SILVER PRINTS ON BARYTA PAPER,
EACH 24 X 18 CM (9 1/2 X 7 1/16 IN.) (DETAIL)

SZE TSUNG LEONG

born in 1970 in Mexico City, Mexico
lives and works in New York, USA

HOMEPAGE.MAC.COM/SZETSUNGLEONG

One of the most significant global developments of our time has been the transformation of China from an isolated, relatively impoverished agricultural society to an industrial powerhouse. As the Chinese government has moved to a more market-driven economy and focused on foreign trade as a primary vehicle for economic growth, an ensuing economic boom has changed the landscape of the country in dramatic ways. Sze Tsung Leong's series *History Images* (2002–5) explores the effects of this rapid growth on China's cities by documenting the quickly changing built environment. Leong studied architecture at Harvard and the University of California at Berkeley. In 2001 he set off for China to record the large-scale levelling of existing cities and the construction of residential mega-developments, or new cities, which are taking their place. Unfortunately, the destruction of the old cities erases the strata of building styles that reflect various stages in Chinese history.

Leong is well aware that, throughout history, city planning has been ideologically driven on the whole. From the imperial dynastic rulers who planned cities to reflect social hierarchies, to the Communists who built uniform concrete housing blocks to equalize economic disparity, power has always been reflected in architecture. 'The tradition of authoritarian power that enabled the uniform construction and ordered layouts that once defined Chinese cities is also the tradition enabling their destruction,' Leong explains. In his pictures, he captures the chaos that ensues as one planned city is replaced by the next. While Edward

Burtynsky uses the massive scale and repetition of the development in China as a symbol of regimented, homogeneous growth, Leong seeks out haphazard views. In his pictures, new residential buildings rarely look attractive and cheerful; more often they are captured mid-construction, sometimes obscured by scaffolding or surrounded by construction debris. Old buildings appear as half-standing ruins. All of the scenes exist underneath the same eerie, cloudless white sky, enveloped in fog that obscures the distance, perhaps as a metaphor for the shortsightedness of rapid urban development. In comparison to the massive built environments, people are always very small or absent. Destruction and construction appear equally ill-fated.

Since *History Images* Leong has been working on two series, both of which are still in progress. *Cities* (since 2002) extends his investigation of urban development to varied locations around the world, from Lincoln, Nebraska, to Osaka, Japan. *Horizons* (since 2002) offers panoramic views of landscapes, from Paris to Inner Mongolia, each with the horizon line in the same position in the composition, approximately one third of the way up the image. When the images are seen side-by-side, the lines visually connect to one another. In both of these series, Leong maintains his signature muted earth-toned palette and hazy, white skies. These projects expand his observations in *History Images* into global concerns, implicating all of us in the shared responsibility of our world.

KAREN IRVINE

TIANANMEN SQUARE, BEIJING, 2002
C-PRINT, 182.9 X 222.3 CM (72 X 87½ IN.)

BEICHENG XIN CUN, PINGYAO, SHANXI PROVINCE, 2004
C-PRINT, 182.9 X 222.3 CM (72 X 87½ IN.)

PINGYAO, SHANXI PROVINCE, 2004
C-PRINT, 182.9 X 222.3 CM (72 X 87½ IN.)

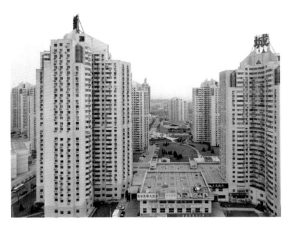
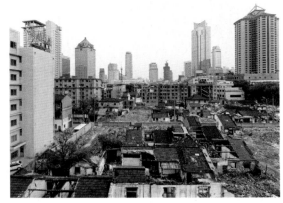
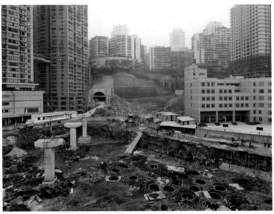
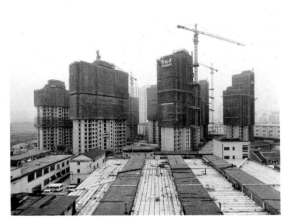

WANGJING XINCHENG, CHAOYANG DISTRICT, BEIJING, 2003
C-PRINT, 182.9 X 222.3 CM (72 X 87½ IN.)

YIHAOQIAO, YUZHONG DISTRICT, CHONGQING, 2002
C-PRINT, 182.9 X 222.3 CM (72 X 87½ IN.)

XINJIEKOU, XUANWU DISTRICT, NANJING, 2004
C-PRINT, 182.9 X 222.3 CM (72 X 87½ IN.)

MOGANSHAN LU, PUTUO DISTRICT, SHANGHAI, 2004
C-PRINT, 182.9 X 222.3 CM (72 X 87½ IN.)

ZBIGNIEW LIBERA

born in 1959 in Pabianice, Poland

lives and works in Warsaw

WWW.RASTER.ART.PL

Zbigniew Libera belongs to the so-called lost generation of Polish artists who experienced the grim reality of martial law during the 1980s. His earliest work saw him producing posters and leaflets in protest against the conditions and events taking place in Poland, but in 1982 he was arrested and sentenced to one and a half years in prison. Throughout his heterogeneous oeuvre, this autodidact, iconoclast and resolute anti-authoritarian has maintained a particular focus on identity formation and the social conditioning of individuals in his attempt to identify and expose the processes of governmentality and the disciplining of individuals. The result is a thematic prism which includes state oppression and its methods; socialization and power, primarily explored within a domestic context; the forces of consumerism and commercialism; the impact and power of media; and the hierarchical games of the art world itself, such as in Libera's *Masters* series (2004).

In the 1980s, as a member of the artistic community at the Strych (The Attic) in Lódz, Libera pioneered a form of low-tech video art based on kitchen-sink realism. Primarily using footage of interactions with his own family, he was able to orchestrate issues of social and gender conditioning, power and intimacy in videos such as *How to Train Girls* (1987) or *Playing With Mother* (1987). In the disarming, empathetic and provocative work *Intimate Rituals* (1984), the artist is followed as he takes care of his bedridden grandmother, which involves spoon-feeding her and washing her private parts. The series of works *Correcting Devices* (1994–2000), which reveals Libera's own mix of conceptualism and pop, confronts consumerist society head-on. Mutated or altered toys and other devices are used to combine libidinal excess with notions of regulation and control.

Lego Concentration Camp (1996) is the key work of *Correcting Devices*. Imitating real Lego sets through the use of actual Lego blocks and packaging, this seven-box limited edition of three Lego sets contains a range of different aspects based on standard Holocaust imagery – the barracks, watch towers, the front gates, etc. Turning the Holocaust into a toy, or a commodified memorial, subject to consumption like any other commodity, is clearly a dramatic way of asking how the discourse on and the awareness of the Holocaust may be kept vital and present. But the biggest challenge of Libera's Lego piece is that the photos and scenarios on the Lego boxes are only proposals. It is the consumer who has to turn them into concentration camp scenes.

Libera's recent work *Positives* (2002–4) restages 'positive' versions of iconic photographs. The Auschwitz prisoners behind the fence are depicted well-dressed and well-fed. A happy nude model has replaced the Vietnamese girl running for her life in Nick Ut's napalm photograph. And Che Guevara is shown alive, lustfully smoking a cigarette. Mixing irony with anxiety, play with apprehension, these photographs report on the collapse of memory and knowledge in the processes of canonization and medialization.

JAN-ERIK LUNDSTRÖM

NEPAL, 2003
FROM THE SERIES **POSITIVES**
PHOTOGRAPH
120 X 170 CM (47¼ X 66⅞ IN.)

Zaraza z Hongkongu coraz bliżej • Blue Café - pogromcy Ich Troje

PRZE KRÓJ

Nr 15 / 3016 • 13 kwietnia 2003 • cena 3,70 zł
/w tym 7% VAT/

TO NIE ZDARZYŁO SIĘ NAPRAWDĘ! *To tylko*

SEN BUSHA

ODWAŻNA PROWOKACJA POLSKIEGO ARTYSTY

s. 74

LIBERATION (BUSH'S DREAM), 2003
FROM THE SERIES **POSITIVES**, PUBLISHED IN PRZEKRÓJ, 13.4.2003
C-PRINT, 180 X 120 CM (70⅞ X 47¼ IN.)

LIBERATION (BUSH'S DREAM), 2003
FROM THE SERIES **POSITIVES**, PUBLISHED IN PRZEKRÓJ, 13.4.2003
C-PRINT, 120 X 180 CM (47¼ X 70⅞ IN.)

LIBERATION (BUSH'S DREAM), 2003
FROM THE SERIES **POSITIVES**, PUBLISHED IN PRZEKRÓJ, 13.4.2003
C-PRINT, 120 X 180 CM (47¼ X 70⅞ IN.)

ZBIGNIEW LIBERA 265

NATE LOWMAN

born in 1979 in Las Vegas, USA
lives and works in New York

WWW.MACCARONE.NET WWW.RITTERZAMET.COM

In the media-saturated culture of North America, where the borderline between image and reality has become increasingly indistinct and indeed the image often appears the more real, it seems totally in keeping for an artist like Nate Lowman to mix his own and other people's pictures indiscriminately and, by changing their surfaces, then to call them his own. Lowman picks out images from the mass media, and breaks up their even surfaces, which purport to show things as they really are, by photocopying them, photographing them again, scanning them or reproducing them as silk-screen prints. Having thus smudged these images, he combines them with photos and drawings of his own in wall-covering installations whose rough-and-ready texture is reminiscent of the DIY aesthetics of punk fanzines, but also of such masters of image appropriation as Andy Warhol, Sigmar Polke and Richard Prince.

Lowman achieved fame with his *More or Less* (2001–3), a wall installation about bearded men, which deals with the symbolism and iconography of men's facial hair in the 20th century. His father was the starting-point for the project, which also included Jim Morrison, Charles Manson, Jerry Garcia, Tom Cruise, Kurt Cobain and American terrorist Theodore Kaczynski (aka the Unabomber) and the so-called 'American Taliban'. The beard is shown as a paradoxical symbol of direct opposites: wisdom and madness, authority and marginality, well-groomed masculinity and unkempt depravity. With this installation, Lowman turns the spotlight on the extremes of the American male image, though he does not pass any judgment; the observer can interpret this collection as a political statement or as a display of pop culture.

Lowman's work constantly revolves around sex and violence, the classical themes of American culture, which seem tailor-made for his effectively crude *modus operandi*. In *Thug Love* (2003) he placed photocopies of the corpses of Bonnie and Clyde, taken from family snapshots, opposite the Washington DC snipers, linking them with a line – a misquotation – from a rap song by Ja Rule: 'Baby say yeah would you kill for me'. In *History of the SUV/No Blond Jokes* (2003), he combined car stickers like 'In Goddess We Trust' and 'Denial Works for Me' with photocopied portraits of famous female murder victims, and a painted portrait of Linda Tripp – a key figure in the Monica Lewinsky scandal – and finished the whole thing off with a handwritten aphorism: 'Blond jokes not in style'. With his mixture of pop and politics, irony and nihilism, Lowman has obviously touched a contemporary nerve, at a time when economic booms and terrorism, protracted wars and globalized utopias are all going on simultaneously.

MARTIN JAEGGI

Moss's lucrative deals end after cocaine allegations

H&M boss with strict moral code took 'only decision possible'

COMEBACK KATE?, 2006
ALKYD ON LINEN
40.6 X 50.8 CM (16 X 20 IN.)

FALLON, 2005
FROM THE SERIES **OIL RIGS**
DIGITAL C-PRINT, SINTRA
129.7 X 280.5 CM (51 X 110½ IN.)

KRYSTLE, 2005
FROM THE SERIES **OIL RIGS**
DIGITAL C-PRINT, SINTRA
129.7 X 280.5 CM (51 X 110½ IN.)

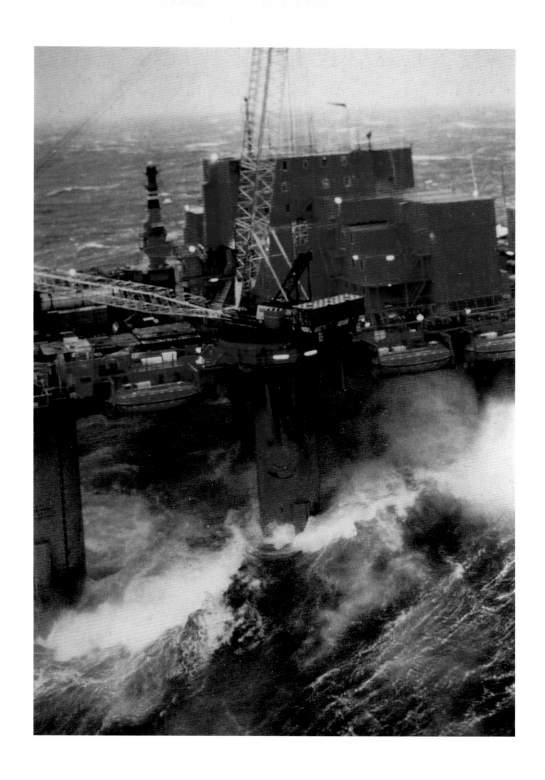

BLAKE, 2005
FROM THE SERIES **OIL RIGS**
DIGITAL C-PRINT, SINTRA
280.5 X 129.7 CM (110½ X 51 IN.)

FLORIAN MAIER-AICHEN

born in 1973 in Stuttgart, Germany
lives and works in Cologne and Los Angeles, USA

WWW.303GALLERY.COM WWW.BLUMANDPOE.COM

Florian Maier-Aichen's photographs hark back to the 19th-century Hudson River School of landscape painting which included such artists as Frederic Edwin Church, Thomas Cole and Albert Bierstadt. Representatives of the school shared a sense of wonderment at the sheer grandeur of the American landscape and captured nature in all its glory in realistic, detailed and, at times, idealized paintings. Maier-Aichen has put his own spin on the photographs, carefully using digital manipulation to dramatize scenes. Many of his works are aerial shots, which effectively amplify the scale of the landscapes through their oblique angles, but the artist also heightens their visual impact by adjusting the luminosity, colour tones and contrasts. The results combine a sense of spectacle with strong emotive charges.

American artist Barnett Newman voiced the idea of the contemporary sublime in the late 1940s. Maier-Aichen continues the tradition and cranks it up a notch by generating the sublime effect of these photographs, thus creating a sub-genre which could be labelled 'the constructed sublime'. Eerily illuminated horizons in night-views of seemingly endless landscapes give us the impression that we are hovering around the fringes of those mega-cities that are prevalent in the seminal sci-fi tales by Philip K. Dick (*Blade Runner*) or William Gibson (*Neuromancer*). In other images, the haloes of light that surround the trees in a mountainous landscape are reminiscent of Caspar David Friedrich's sublime paintings.

These spectacular photographs are ultimately paradoxical in nature. Their immense scale, while revealing more of the landscapes they represent, actually shows less of their detail and, in effect, distances the viewer from their realities, heightening their potential for fantasy and invention – the viewer's imagination is set free, incited by the surreal effects that Maier-Aichen has digitally introduced. The sky and sea become empty voids, their stages set for the nemesis of apocalyptic events to sweep through in a traumatic interface between the controlled chaos of a post-industrial culture and the entropic chaos of its cathartic end times. In these beautiful images, the romantic and the apocalyptic rub shoulders in an uncomfortable fusion of promise and threat – windows into the unpredictable and the unfamiliar. Using a combination of traditional analogue photography and computer imaging, Maier-Aichen tempts the viewer to weave his or her own futuristic pseudo-narratives into these eerily impressive landscapes.

ROY EXLEY

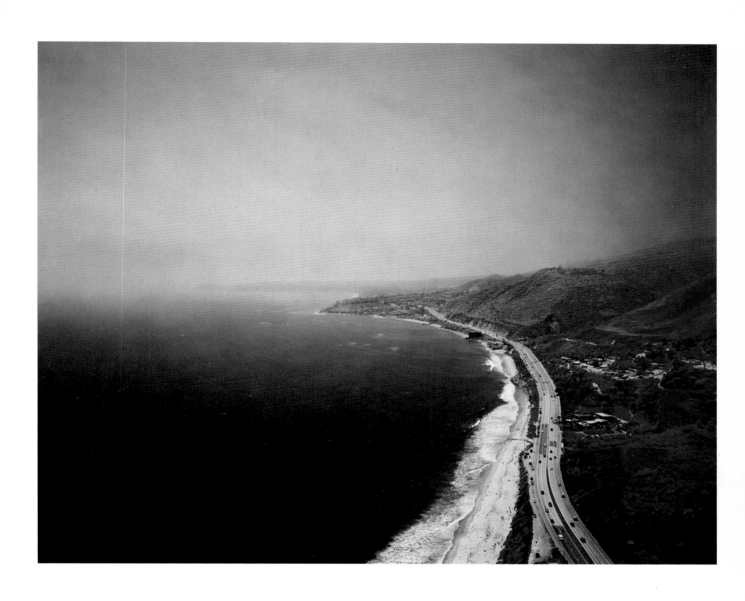

UNTITLED, 2005
C-PRINT
182.9 X 229.9 CM (72 X 90½ IN.)

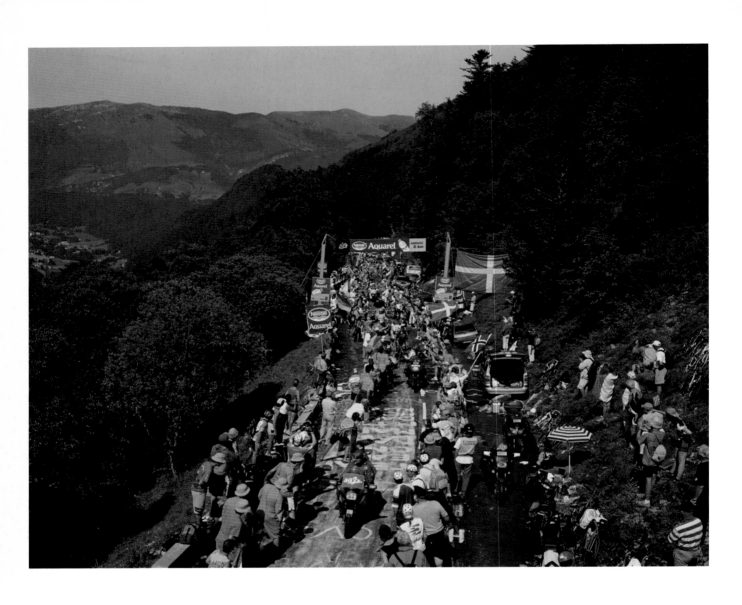

LE TOUR DE FRANCE DANS LES PYRÉNÉES, 2005
C-PRINT, 100 X 119.4 CM (39⅜ X 47 IN.)

UNTITLED, 2007
C-PRINT, 78.1 X 103.5 CM (30¾ X 40¾ IN.)

FABIAN MARTI

born in 1979 in Freiburg, Switzerland
lives and works in Zurich

WWW.FABIAN.MARTI.NAME

It's as if we were standing at a window looking into a distant galaxy just at the moment when a gigantic rock crystal shatters as it hurtles through the perpetual night. With his 152 x 111 cm, vertical-format Inkjet print *Kristallmethode I* (2007), Fabian Marti shows us what photography really is: construction and imagination of reality. The rock crystal has not been photographed with a camera, but has been brought into the picture using a scanner. But just like a camera, the scanner is a piece of equipment which generates pictures in accordance with its own principles of construction: if you leave the cover of the scanner open, as Marti does, not only is the crystal translated into two dimensions, but the terrestrial light gets sucked into the machine, forming a galactically dark, spatial depth within the flat picture. The scan is thus a digital equivalent of the photogram.

Marti, a graduate of the photography department at the Hochschule für Gestaltung und Kunst in Zurich, also works with an analogue 35 mm camera and with sculptures. His works often allude very subtly to art history. In *Head Square* (2007), shot with an analogue camera, he not only inverts Kasimir Malevich's *Black Square* (1915) by placing a white square on a black background, but also inserts the protruding nose of an antique figure, so that the square becomes nothing but a socle seen from below. The fact that the nose belongs to Apollo, the god of order and light, who is hiding behind his pedestal and thereby giving the scene a dimension of mystery, is only one aspect of the combination. The ancient and the modern, the figurative and the abstract, sculpture and photography are all linked together in the simple form and complex substance of this picture, with an added mixture of the serious and the comic. In exhibitions too, Marti – whose works have been shown in such places as the Kunstmuseum Bern, the Swiss Institute in New York and the Stadtmuseum in Munich – combines sculpture and photography. Pictures such as *Der gespiegelte Kater* ('The Reflected Tomcat', 2006), *Hundhund* ('Dogdog', 2006), *UHU* (2007) and *Komposition für einen Rhombus* ('Composition for a Rhombus', 2007), taken with an analogue camera and then scanned, also play with superimpositions, doublings and reflections of their subjects. Another feature worth mentioning is the fact that Marti never touches up specks or streaks of dust. Thus we can see another level above that of the picture, which also serves to demonstrate that the image is a construction – a product of the imagination.

NADINE OLONETZKY

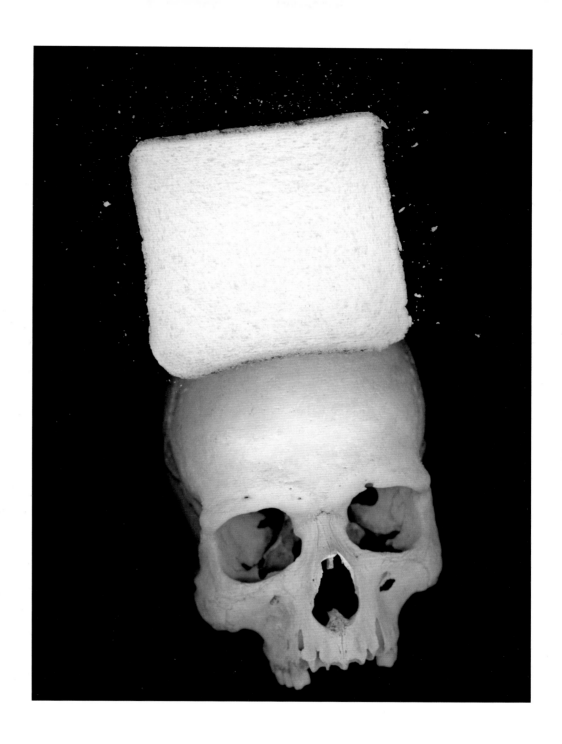

BROT & TOD, 2005
INKJET PRINT
134 X 97.5 CM (52¾ X 38⅜ IN.)

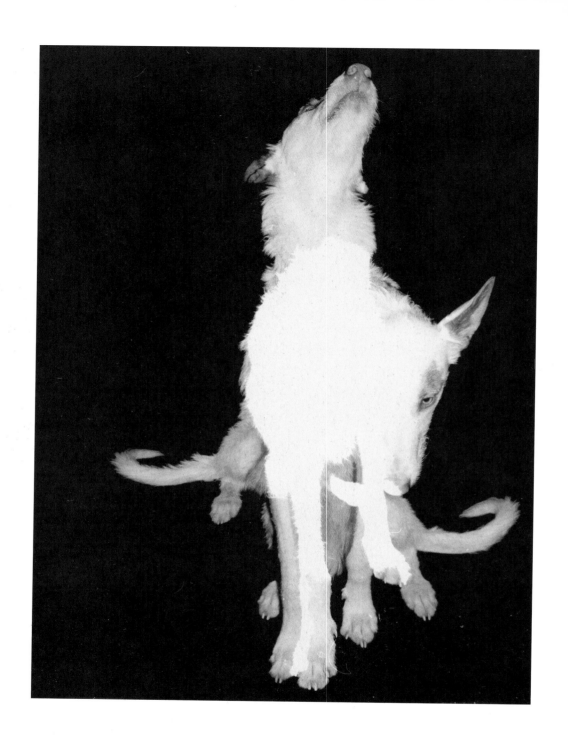

HUNDHUND, 2006
INKJET PRINT
181.7 X 110 CM [71½ X 43¼ IN.]

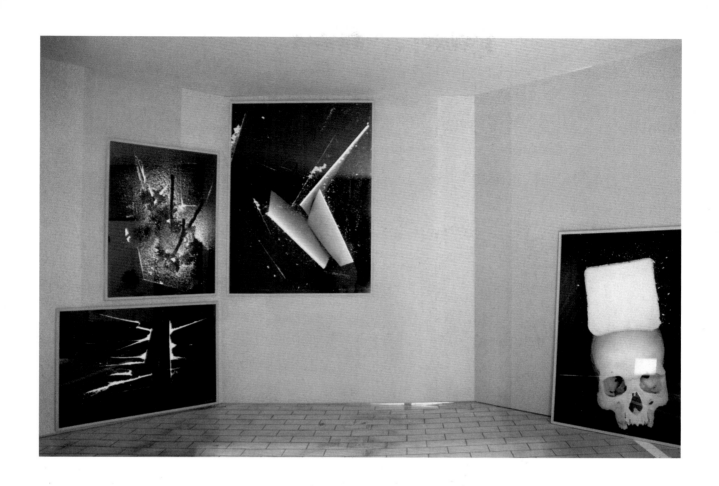

EXHIBITION VIEW AT THE HOCHSCHULE
FÜR GESTALTUNG UND KUNST, ZURICH, 2006

ABOVE LEFT: **WHITE POWER II**, 2006
INKJET PRINT

BELOW LEFT: **WHITE POWER I**, 2006
INKJET PRINT

CENTRE: **UNTITLED**, 2006

RIGHT: **BROT & TOD**, 2005
INKJET PRINT

TAIJI MATSUE

born in 1963 in Tokyo, Japan
lives and works in Kanagawa

WWW.LAGALERIE.DE WWW.TARONASUGALLERY.COM

We might not readily recognize the landscapes in Taiji Matsue's photographs. Aerial photographs, often taken at an angle perpendicular to the earth's surface, easily morph into abstract configurations of forms – fields, forests, farms, settlements, towns and cities all displaying divergent and often exotic textural registers. Matsue's early work played with infinite permutations of these landscapes, turned into visual conundrums by their flattened two-dimensional representation. Later he decided to complicate things by using a high-key printing technique which, in effect, irons out the contrasts so that these 'pieces from the surface of the earth' become literally deobjectified. In the two-dimensional photograph these views from above, which we have all surveyed and marvelled at, are transformed from a vision of reality into a complex series of visual patterns which, like camouflage, tend to confound our interpretive efforts.

Matsue's early images were executed in stark black and white, giving them a distinctly documentary feel, but with his JP-22 series (2005) he moved on to colour. Commissioned by the regional government of Shizuoka Prefecture in southern Honshu, Matsue took a series of eighty-three images from a helicopter. The extremely fine detail of these high-resolution images far surpasses what the eye can see and, although this level of detail might seem superfluous, the complex textures achieved here serve to tease and intrigue the viewer's gaze. It is often stated that all artworks should raise questions in the viewer's mind – to a greater extent than the perfunctory 'why?', of course, which is often used as a pejorative statement when viewers simply don't understand works. Matsue's work challenges our ability to give our full attention to something that is neither informative, decorative nor sensational. In the age of the byte, we have all become visual byte-surfers, anticipating the next eye-candy before the current fare has been fully digested. Matsue charms and captures our diminished staying power by visually seducing us while at the same time invoking an awe for the diversity of the earth's surface and the irresistible power of its beauty.

Matsue is a meticulous worker with an unerring attention to detail. The height from which these aerial photographs are shot is precisely calculated to achieve the desired effect, and the lighting is so critical that a whole series of his photographs of cities, shot on different days, were all taken at between 1.40 and 1.45 p.m., when the lighting requirements were at their optimum. Matsue, in his own way, is continuing a tradition – classical Japanese landscape images, whether executed in watercolour or inks, or on lacquer boxes, have always exuded an air of delicacy and mystery, whereby the viewer, romantically distanced from reality, is asked to consider his or her relationship to the environment. In these days of global warming and ecological disasters, Matsue's delicate images of the earth's surface give us a real and timely pause for thought.

ROY EXLEY

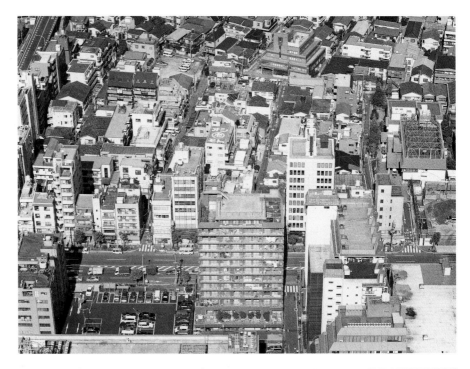

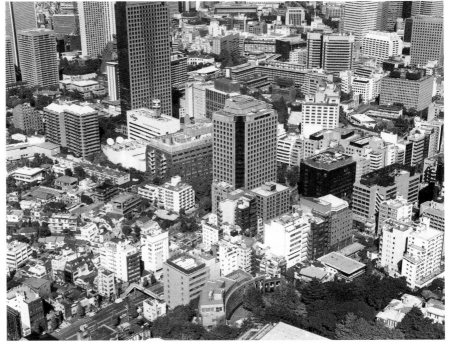

TYO0125, 2001–2
GELATIN-SILVER PRINT
40.1 X 50.5 CM (15¾ X 19⅞ IN.)

TYO0129, 2001–2
GELATIN-SILVER PRINT
40.1 X 50.5 CM (15¾ X 19⅞ IN.)

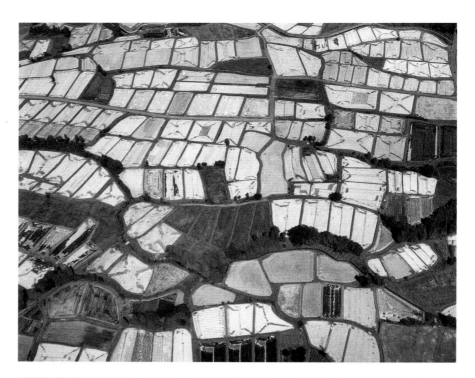

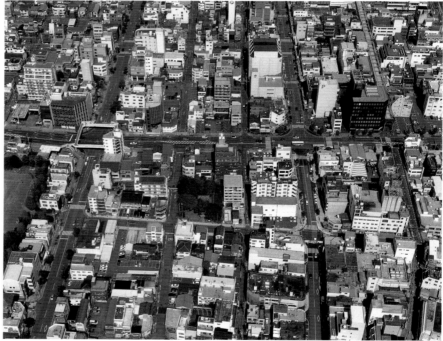

27, 2005
FROM THE SERIES **JP-22**
C-PRINT, 50 X 61 CM (19⅝ X 24 IN.)

50, 2005
FROM THE SERIES **JP-22**
C-PRINT, 50 X 61 CM (19⅝ X 24 IN.)

35, 2005
FROM THE SERIES **JP-22**
C-PRINT, 50 X 61 CM (19⅝ X 24 IN.)

23, 2005
FROM THE SERIES **JP-22**
C-PRINT, 50 X 61 CM (19⅝ X 24 IN.)

HELLEN VAN MEENE

born in 1972 in Alkmaar, Netherlands
lives and works in Heiloo

WWW.HELLENVANMEENE.COM

Since 1994 Hellen van Meene has been creating portraits of adolescent girls and occasionally boys. Her photographs reflect the uneasy period of transition when a girl becomes a woman and a boy turns into a man, and maybe they don't feel quite right in their own skin. The physical and emotional strain of growing up is reflected in small details: pimples and bruises on delicate skin, or plasters taped to nipples. The models show no aggression towards this hostile world, but there is an inner stirring, a secret longing for something unknown. In the silence of their room or the corner of a garden, girls are cocooning, waiting for the moment of metamorphosis. Hope and melancholy are expressed in their faces. Underneath the innocence shimmers female sensuality.

Van Meene developed her highly personal style at the Gerrit Rietveld Academy in the early 1990s, when she was barely a woman herself. At this time, the intimite portrait was an important genre at the school and was practised by famous ex-students and teachers such as Koos Breukel, Rineke Dijkstra, Celine van Balen and Dana Lixenberg. Empathy and a deeply personal engagement (rather than a sociological approach) are what they all have in common. In the first few years of her career, van Meene worked with teens in the Noord-Holland area. In 2000 she was invited to Japan where she discovered that, while she could not communicate directly with her subjects, her instincts regarding the universality of adolescent experience were translatable. Since then she has travelled to England, Latvia and Russia to do more portraits of teens.

All of the pictures are a reflection of van Meene's own memories of puberty. She never uses professional models, but 'normal' girls with their own particular characteristics. She tries to recreate a vague image in her mind with a Rolleiflex 6x6, using the available light. In her best photographs, puberty is given an archetypal dimension. Dreamy faces, trees and plants, and the scarcely lit rooms all work as metaphors for the disturbing notion that these youngsters will soon lose their innocence. A fine example is the picture of a girl posing in a typical Dutch polder, facing the frosty light of early spring. Her plump body, wrapped in a dress of faded colours, is positioned in a shadowy vegetable garden where kale – reminiscent of a Dutch children's story which explains where babies come from – is grown. The red lipstick and a distant glance reflect her longing for something new. In another of van Meene's portraits, a Japanese girl facing the camera is depicted in a woollen white coat against a background of cherry trees. The white blossom seems to express happiness, but the girl has her eyes closed. She has other things on her mind which are taking precedence over this explosion of nature.

RIK SUERMONDT

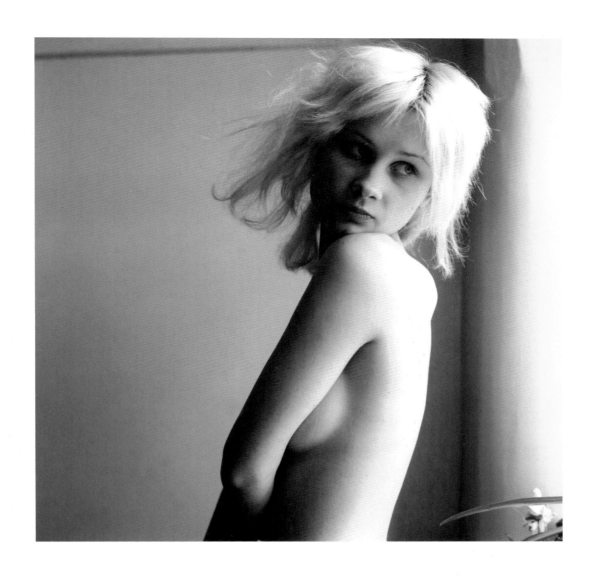

RIGA (LATVIA) – 180, 2004
C-PRINT, 29 X 29 CM (11⅜ X 11⅜ IN.)

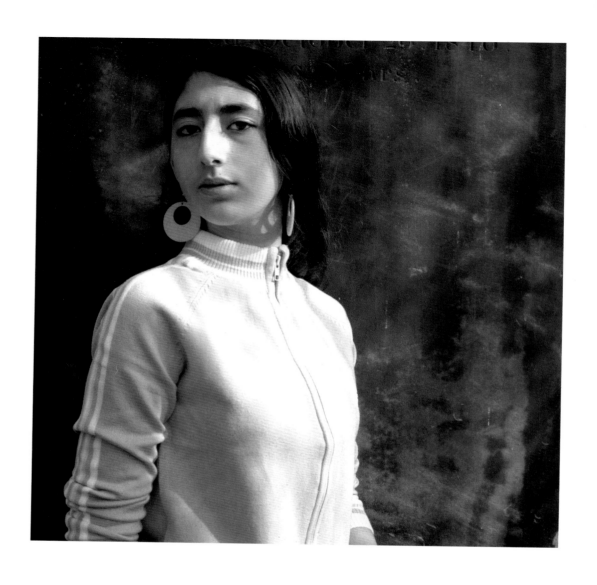

LONDON - 232, 2005
C-PRINT, 39 X 39 CM (15⅜ X 15⅜ IN.)

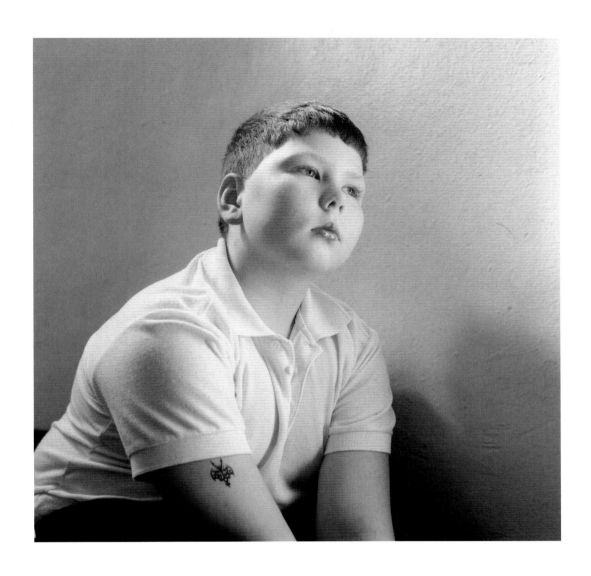

RIGA (LATVIA) – 184, 2004
C-PRINT, 29 X 29 CM (15⅜ X 15⅜ IN.)

JEAN-LUC MOULÈNE

born in 1955 in Reims, France
lives and works in Paris

WWW.CROUSEL.COM

Jean-Luc Moulène's work is generally regarded as a cross between photography and art. The political and media-related implications of his photographs reveal a deep social and political awareness. He exposes the gulf between reality and its reflections by questioning and even eliminating the borders that define the standardized representation of objects. With documentary-style analyses of these objects, or apparently unexciting views of streets, prostitutes or a bottle of ink, he demands a redefinition of our perception, and insists on a personal photographic language and reality.

In the large-format series of colour photographs *Les Filles d'Amsterdam* ('The Girls of Amsterdam', 2005), in which we see almost life-size, naked prostitutes sitting on the floor with open legs, fully frontal, Moulène examines the relationship between the 'object' in the photograph and the observer, just as he does in his *Objets du Louvre* (2005). While his pictures of the Dutch women turn them into objects, those of the objects in the Louvre raise questions about their cultural status: Where did they come from, and how did they get here? Indirectly he is exploring the national identity expressed by these cultural artefacts, since most of them have been plundered from their original homelands. In both series, he clearly attaches great

importance to forms of presentation: the prostitutes are shown in brightly coloured photographs (Ilfochrome), whereas the objects from the Louvre are laid out in a supplement of the daily newspaper *Le Monde* – 'handed back' to a public which itself is made to cross borders. In the play on words 'Le Monde – Le Louvre' ('The World – The Louvre') he contradicts the museum's claim to be the treasure chamber of national culture.

In other series, too, this doctor of philosophy works with the methods of classical photography to analyse specific situations: *Objets de grève* ('Objects of Industrial Action', 1999–2001) and *Produits de Palestine* ('Products of Palestine', 2002–5) are not merely still lifes of objects but also enquiries as to their origins and their political, social and cultural backgrounds. Moulène is constantly delving into history, aesthetics, and the function of illustration and photography in general. By exploring the shifting levels of meaning and also the frontiers of natural and cultural phenomena, he questions and redefines the structures of industry, media and commerce.

Moulène's works, frequently assembled into series, lay emphasis on photography as a system of interactive references. Recently he has also begun to incorporate sculptured objects into his art.

FELIX HOFFMANN

TEMPLE DU SOLEIL, BAALBEK (LIBAN), 2 JUIN 2002, 2007
ILFOCHROME, ALUMINIUM, 122 X 153 CM (48 X 60¼ IN.)

COUPOLE DE DOURIS, BAALBEK, 2 JUIN 2002, 2003
ILFOCHROME, ALUMINIUM, 119 X 151 CM (46⅞ X 59½ IN.)

PATRIS, AMSTERDAM, 03 04 04, 2004
ILFOCHROME, ALUMINIUM
115 X 92 CM (45¼ X 36¼ IN.)

ROXANA, AMSTERDAM, 17 03 04, 2004
ILFOCHROME, ALUMINIUM
130 X 100 CM (51⅛ X 39⅜ IN.)

SIRÈNE, 2005
ILFOCHROME, DIASEC
41.3 X 33 CM (16¼ X 13 IN.)

EROS EPH. VOLANT, 2005
ILFOCHROME, DIASEC
57.5 X 46 CM (22½ X 18⅛ IN.)

LE MONDE – LE LOUVRE
EXHIBITION VIEW, MUSÉE DU LOUVRE, 2005

ZWELETHU MTHETHWA

born in 1960 in Durban, South Africa
lives and works in Cape Town

WWW.ANNEDEVILLEPOIX.COM WWW.JACKSHAINMAN.COM

Visibility and empowerment are at the core of Zwelethu Mthethwa's photographs. Forming an intimate but respectful relationship with his subjects – largely the black inhabitants of Cape Town's townships, other city regions and rural areas – Mthethwa creates large-format, generally full frontal portraits of individuals in domestic interiors. Viewer and subject are in democratic equilibrium, each curiously and empathetically looking at the other. These photographs reflect rich narratives of individuals and culture, but Mthethwa presents them very much as portraits: the majority are taken in the subject's own home or residency, with the individual sitting down and posing for the camera; they are never a snapshot or a mere reflection of unguided circumstance.

Mthethwa's portraits may be posed or staged, in line with the conventions of the genre of photographic portraiture, but they never come close to the studio or the theatre. Gestures are discreet, expressions are low-key, the tone is neutral and yet warm, and the photographs speak of presence and visibility rather than analysis and interpretation. The situation is domestic – relaxing on one's own bed, sitting on a kitchen chair, addressing the camera. This particular focus, the colour-saturated interiors captured by Mthethwa's brand of environmental portraiture, enables a remarkable cultural confrontation. He is speaking about his subjects, speaking to them and with them, but at the same time paying attention to architectural and material detail so that the precise measures and signifiers of class and social status are brought out. The sitters generally have few possessions and little in the way of furniture, and the walls are often covered in advertising posters which absurdly locate these makeshift dwellings in the insipid sea of consumer society.

Extending over a decade, with more recent additions of vocational portraits including miners, as well as delicate still lifes of interiors devoid of their inhabitants, Mthethwa's project narrates the layers of culture, belonging, self-understanding and self-image in black South African society in the new millennium. He masterfully lays bare the social context without victimizing or patronizing his subjects, continually edging closer to the impossible – the art of transforming portraiture into a means of self-representation on behalf of the sitter.

JAN-ERIK LUNDSTRÖM

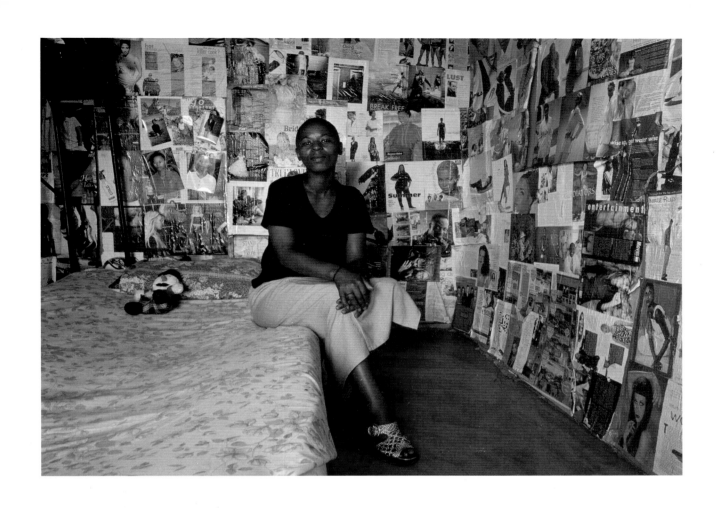

UNTITLED, 2000
C-PRINT, 179 X 241.3 CM (70½ X 95 IN.)

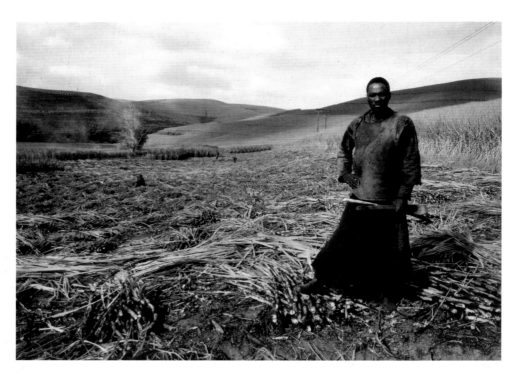

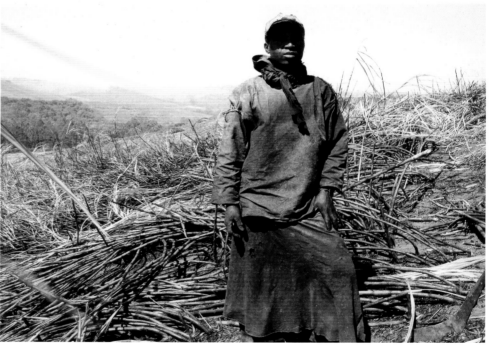

UNTITLED, 2003
C-PRINT, 150 X 194 CM (59 X 76⅜ IN.)

UNTITLED, 2004
C-PRINT, 150 X 194 CM (59 X 76⅜ IN.)

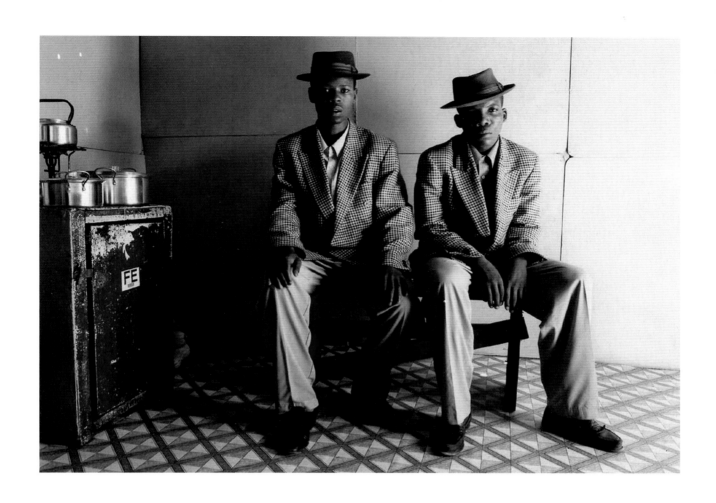

UNTITLED, 2001
C-PRINT, 179 X 241.3 CM (70½ X 95 IN.)

MULTIPLICITY

Agency for territorial investigations
founded in 2000 in Milan, Italy

WWW.MULTIPLICITY.IT

Multiplicity is a collective of architects, artists, photographers, urban planners, geographers, sociologists, economists and activists exploring European and global territories in transition in the search for new modes of behaviour and organization. It has grown from a core group of ten people, including founding member and architect Stefano Boeri, to attract over one hundred members. Participants work on various projects and are chosen for particular areas of investigation according to their local or topical expertise. During the research process, Multiplicity uses multiple systems or modes of analysis, collecting field data from statistics, interviews, photographs and films. The research topic defines the methods; nothing is predetermined. The agency has undertaken substantial field work for case studies in more than fifty sites across Europe and elsewhere, from the West Bank to Helsinki, and from Oporto to Bucharest. Multiplicity works primarily with visual essays (through photographs or films) and various kinds of maps and texts which are presented in a variety of formats including exhibitions, installations, interventions, screenings, lectures, graphs and publications.

Major projects include *USE: Uncertain States of Europe*, *Tokyo Voids*, *Solid Sea* and the ongoing *Border Device(s)*, which looks at the proliferation of borders and boundaries in the modern-day world. *USE: Uncertain States of Europe* focused on the rapidly transforming character of European cities, understanding urban space as a metaphor for contemporary society and as a rich fountain of clues about contemporary life. In *Solid Sea*, Multiplicity describes the Mediterranean as 'a solid space, crossed at different depths and with different vectors by clear and distinct fluxes of people, goods, information and money…, a large continent interposed between Europe, Asia Minor and Africa'. A specific work within *Solid Sea* was *The Road Map*, a two-channel video installation with supporting material, the result of a simple field experiment. Observing that the West Bank in particular is a region '…where an incredible variety of borders, enclosures, fences, checkpoints and controlled corridors are concentrated…,' Multiplicity initiated two taxi journeys, one by a person with a Palestinian passport and another by someone holding an Israeli passport. Even though they covered the same distance from start to finish, the 'Israeli' journey took one hour while the 'Palestinian' trip took five hours. With the *Border Device(s)* project Multiplicity creates a border matrix, a sophisticated analytical grid offering a complex vocabulary and a tool box for the mapping and understanding of the manifold kinds of borders and issues affecting individuals in the contemporary world.

JAN-ERIK LUNDSTRÖM

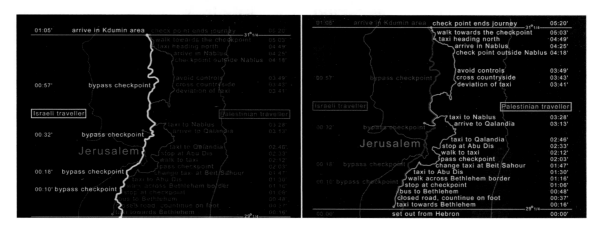

Left map (Israeli traveller):

01:05'	arrive in Kdumin area	check point ends journey 05:20'
		walk towards the checkpoint 05:03'
		taxi heading north 04:49'
		arrive in Nablus 04:25'
		checkpoint outside Nablus 04:18'
00:57'	bypass checkpoint	avoid controls 03:49'
		cross countryside 03:43'
		deviation of taxi 03:41'
	Israeli traveller	Palestinian traveller
		taxi to Nablus 03:28'
00:32'	bypass checkpoint	arrive to Qalandia 03:13'
	Jerusalem	taxi to Qalandia 02:46'
		stop at Abu Dis 02:33'
		walk to taxi 02:12'
00:18'	bypass checkpoint	pass checkpoint 02:03'
		change taxi at Beit Sahour 01:47'
		taxi to Abu Dis 01:30'
00:10'	bypass checkpoint	walk across Bethlehem border 01:16'
		stop at checkpoint 01:06'
		bus to Bethlehem 00:48'
		closed road, continue on foot 00:37'
		taxi towards Bethlehem 00:16'

Right map (Palestinian traveller):

01:05'	arrive in Kdumin area	check point ends journey 05:20'
		walk towards the checkpoint 05:03'
		taxi heading north 04:49'
		arrive in Nablus 04:25'
		checkpoint outside Nablus 04:18'
00:57'	bypass checkpoint	avoid controls 03:49'
		cross countryside 03:43'
		deviation of taxi 03:41'
	Israeli traveller	Palestinian traveller
		taxi to Nablus 03:28'
00:32'	bypass checkpoint	arrive to Qalandia 03:13'
	Jerusalem	taxi to Qalandia 02:46'
		stop at Abu Dis 02:33'
00:18'	bypass checkpoint	walk to taxi 02:12'
		pass checkpoint 02:03'
		change taxi at Beit Sahour 01:47'
		taxi to Abu Dis 01:30'
00:10'	bypass checkpoint	walk across Bethlehem border 01:16'
		stop at checkpoint 01:06'
		bus to Bethlehem 00:48'
		closed road, countinue on foot 00:37'
		taxi towards Bethlehem 00:16'
00:00'		set out from Hebron 00:00'

THE ROAD MAP, 2003
VIDEO STILLS OF AN ISRAELI AND A PALESTINIAN STREET

MULTIPLICITY: STEFANO BOERI, MADDALENA BREGANI,
MAKI GHERZI, MATTEO GHIDONI, SANDI HILAL,
ANNIINA KOIVU, ALESSANDRO PETTI, SALVATORE PORCARO,
FRANCESCA RECCHIA, EDUARDO STASZOWSKY

LEFT: **MAP OF THE ISRAELI STREET**

RIGHT: **MAP OF THE PALESTINIAN STREET**
THE WORKS IN SITU AND THE VIDEO WERE
REALIZED BY SANDI HILAL, ALESSANDRO PETTI
AND SALVATORE PORCARO.

On the image: N 36°25'31" E 14°54'34", Odessa, Istanbul, Portopalo, Peloponnisos, Peiraias, Malta, Cyprus, Antakya, Syria, Alexandria, Cairo

SOLID SEA 01: THE GHOST SHIP, 2002
VIDEO IMAGES OF AN UNDERWATER CAMERA PROJECT BY MULTIPLICITY,
IN COLLABORATION WITH GIOVANNI MARIA BELLU,
FOR DOCUMENTA 11, KASSEL, 2002

MULTIPLICITY: STEFANO BOERI, MADDALENA BREGANI,
FRANCISCA INSULZA, FRANCESCO JODICE, GIOVANNI LA VARRA,
JOHN PALMESINO, MAKI GHERZI, PAOLO VARI

SOLID SEA 01: THE GHOST SHIP, 2002
VIDEO IMAGES OF AN UNDERWATER CAMERA PROJECT BY MULTIPLICITY,
IN COLLABORATION WITH GIOVANNI MARIA BELLU,
FOR DOCUMENTA 11, KASSEL, 2002

MULTIPLICITY: STEFANO BOERI, MADDALENA BREGANI,
FRANCISCA INSULZA, FRANCESCO JODICE, GIOVANNI LA VARRA,
JOHN PALMESINO, MAKI GHERZI, PAOLO VARI

OLIVER MUSOVIK

born in 1971 in Skopje, Macedonia
lives and works in Skopje

WWW.SCCA.ORG.MK/MUSOVIK

In 2002, Oliver Musovik made a photographic record of the courtyard used by the tenants in a block of flats. It was called *Neighbours 2: The Yard*, and was, in his own words, 'a series of photo-with-text layouts, sequel to the similar project about an apartment block in Skopje worker's suburb Dracevo, where I live.' It is not, however, the people that Musovik shows us but the things they leave behind: a bench, for example, constructed out of the stumps of two felled birch trees (chopped down because they had blocked people's view of their parked cars) and a bumper from a lorry; or a pavilion with bus seats. The black-and-white photos are accompanied by texts which explain the backgrounds of each subject, and sometimes they even tell us a complete story. Somewhere between artwork and sociological study, this combination of picture and text offers us an affectionate but perceptive and critical insight into the everyday life and culture of people in Macedonia. Photography is used here as just one of several languages.

In the colour series *Driving* (2006), Musovik has photographed a wide variety of vehicles. From tricycles, scooters and bicycles to motorbikes and cars, we have a whole range of wheeled carriers, once again accompanied by short commentaries. The pictures, nothing spectacular in themselves, build a chronology of human locomotion (almost) from birth to death, starting with vehicles propelled by human force, and finishing with the last of our cars, the hearse. Altogether they present us with a short cultural history of movement on wheels, and once again Musovik reads the sign language of objects. The combination of photography and text in clever installations is also to be seen in a project he undertook with his mother Makdeonka Andonova, herself an artist: *Mama Loves Teleshop* (2003), in which the two of them use and comment on the objects they have bought through teleshopping. Another project was *Weightlifters* (2004), a series on the strange link between hard labour as a punishment and weightlifting as a reward for convicts in prison. In the Inkjet series *The Artist* (2004), Musovik tackles the rules of conduct that an artist should conform to. On the colour self-portraits is an injunction written in red ink: '...has to speak English!' Like his other work, this suggests a delightfully laconic sense of humour. Musovik, whose work has been exhibited internationally, has been awarded grants as artist in residence in New York (2006) and Boswil, Switzerland (1999).

NADINE OLONETZKY

UNTITLED, 2004
FROM THE SERIES **THE ARTIST**
INKJET PRINT, 42 X 30 CM (16½ X 11¾ IN.)

UNTITLED, 2004
FROM THE SERIES **THE ARTIST**
INKJET PRINT, 42 X 30 CM (16½ X 11¾ IN.)

UNTITLED, 2004
FROM THE SERIES **THE ARTIST**
INKJET PRINT, 42 X 30 CM (16½ X 11¾ IN.)

UNTITLED, 2004
FROM THE SERIES **THE ARTIST**
INKJET PRINT, 42 X 30 CM (16½ X 11¾ IN.)

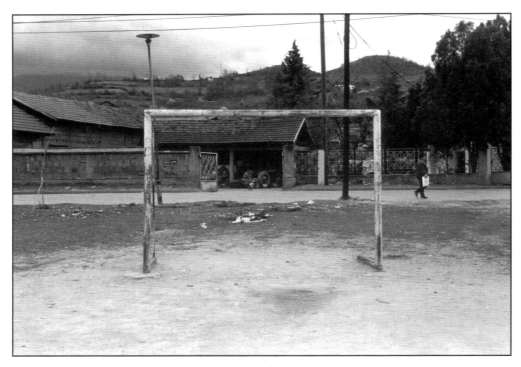

With contributions from all of us from the neighbourhood the old playground was renovated and new goals were erected. But, since we got the new street basketball court, and basketball being much more popular sport in my neighbourhood, the soccer field is literally abandoned, with the goal posts only occasionally being used when beating carpets.

UNTITLED, 2002
FROM THE SERIES **NEIGHBOURS 2: THE YARD**
INKJET PRINT, 70 X 100 CM (27⅝ X 39⅜ IN.)

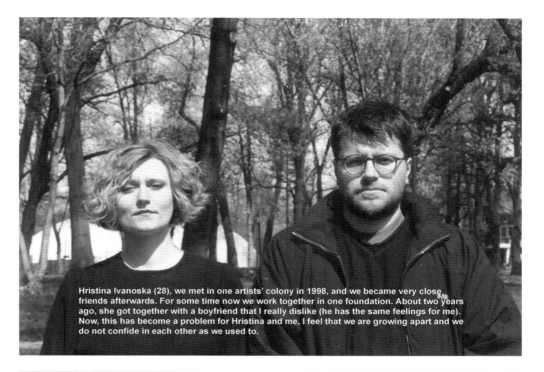

Hristina Ivanoska (28), we met in one artists' colony in 1998, and we became very close friends afterwards. For some time now we work together in one foundation. About two years ago, she got together with a boyfriend that I really dislike (he has the same feelings for me). Now, this has become a problem for Hristina and me, I feel that we are growing apart and we do not confide in each other as we used to.

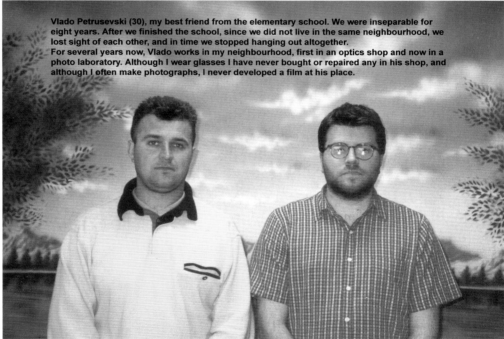

Vlado Petrusevski (30), my best friend from the elementary school. We were inseparable for eight years. After we finished the school, since we did not live in the same neighbourhood, we lost sight of each other, and in time we stopped hanging out altogether.
For several years now, Vlado works in my neighbourhood, first in an optics shop and now in a photo laboratory. Although I wear glasses I have never bought or repaired any in his shop, and although I often make photographs, I never developed a film at his place.

UNTITLED, 2003
FROM THE SERIES **MY BEST FRIENDS**
INKJET PRINT, 28.7 X 41 CM [11¼ X 16⅛ IN.]

UNTITLED, 2003
FROM THE SERIES **MY BEST FRIENDS**
INKJET PRINT, 28.7 X 41 CM [11¼ X 16⅛ IN.]

WANGECHI MUTU

born in 1972 in Nairobi, Kenya
lives and works in New York, USA

WWW.VIELMETTER.COM WWW.SIKKEMAJENKINSCO.COM

Breasts, legs and a torso, extra large eyes with painted eyelashes, a broad grin from a perfectly made-up mouth, a big, fleshy ear with splashes of red that look like blood – the female body in Wangechi Mutu's collages is a hideously beautiful object of different parts that have been patched together. The artist has gathered material from women's, fashion and porn magazines, *National Geographic* and books about Africa. The female humanoids in her series *Pin Up* (2001), *Intertwined* (2003), *Creatures* (2003) and *Crown* (2006) incorporate a wide variety of social and political references. The construction of these fantastic bodies by means of compression, enlargement or reduction of individual body parts is parallel to the sometimes brutal power with which society often forces the human body into specific schemata.

In a similar and emotionally disturbing vein Mutu's collages, wall drawings and installations, which have been exhibited at such prestigious institutions as the San Francisco Museum of Modern Art and the Museum of Modern Art in New York, cast a critical eye on western pictorial culture as well as African myths and history. The female body is her main vehicle of expression because, she says, it gives a clearer picture than the male body of a culture's values, of what it worships and what it denigrates. Mutu, who studied anthropology and art at the Cooper Union in New York and at Yale, is a virtuoso exponent of photography as pictorial memory and as a screen for society's projections. Armed with her scissors, she dissects these worlds of signs, shredding the fragmentary images of the advertising, fashion and porn industries with such savagery that it hurts. With these often large-scale collages, set with great dexterity on Mylar, the sci-fi-esque bodies and faces form a collection that combines glamour and horror. They are as life-enhancing as they are depressing, and as seductive as they are repulsive.

NADINE OLONETZKY

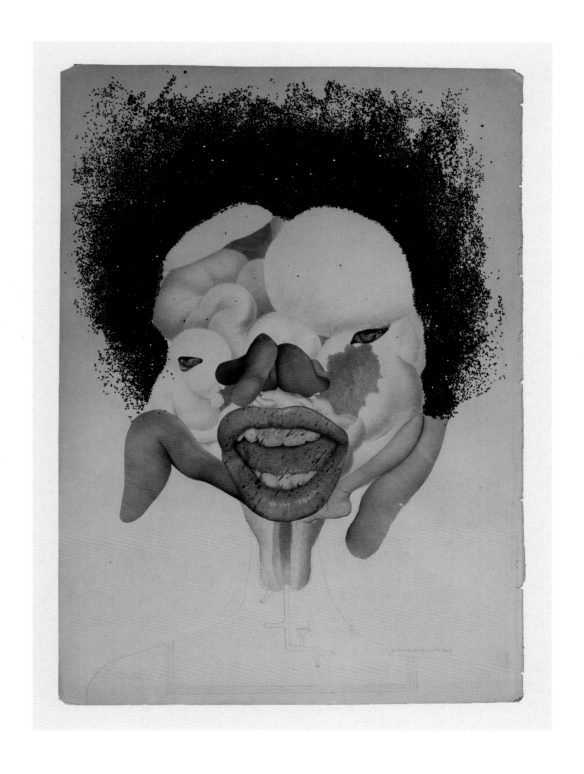

ECTOPIC PREGNANCY, 2005
GLITTER, COLLAGE, INDIAN INK ON FOUND MEDICINE ILLUSTRATIONS
45.7 X 30.5 CM (18 X 12 IN.)

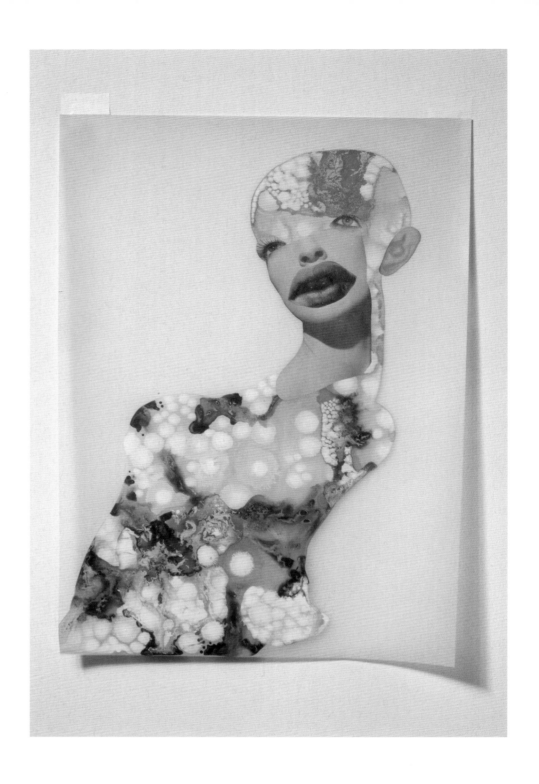

ALIEN AWE III, 2003
INDIAN INK, COLLAGE ON MYLAR
62.2 X 43.8 CM (24½ X 17¼ IN.)

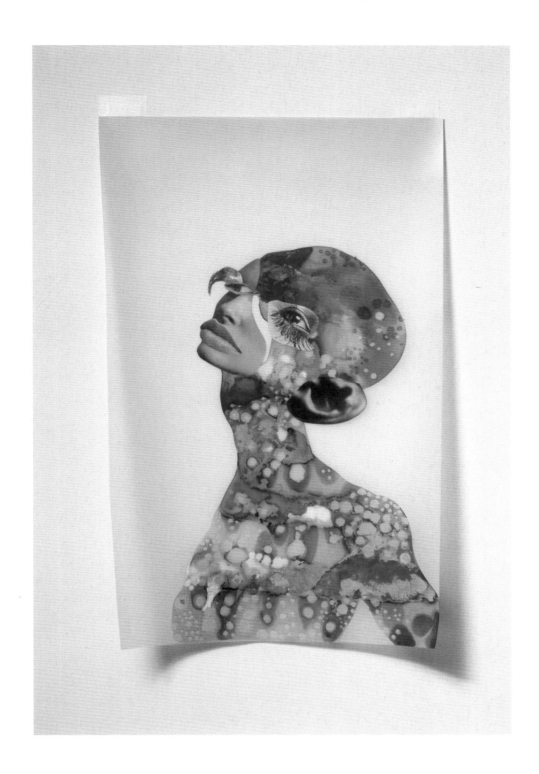

ALIEN AWE II, 2003
INDIAN INK, COLLAGE ON MYLAR
62.2 X 38.1 CM (24½ X 15 IN.)

JEAN-LUC MYLAYNE

born in 1946 in Amiens, France
lives and works in France and all over the world

WWW.GLADSTONEGALLERY.COM

Since the late 1970s, Jean-Luc Mylayne has produced a body of images that not only challenges our notions of art and representation, time and observation, but also fundamental impressions of life through his depiction of wild birds. He makes us question what it is to be human or animal, and how they may relate. Mylayne's wife Mylène, with whom he works, gave him his professional name, a sign of their very special common pursuit. Capturing particular wild birds has meant a demanding, nomadic life: each work may require months, even years, in preparation as it relies on the complicity of the birds themselves and a relationship of trust between artist and model.

Mylayne's photographs, though clearly based on a thorough knowledge of ornithology, have few things in common with ordinary bird photography. For the artist, each photograph is a kind of social, existential and aesthetic accomplishment – not only in the sense that it is premeditated, but also because Mylayne's ideal image reproduces a dynamic encounter and relationship between human and animal, between various life forms and their habitat. He refuses to use telephoto lenses, stop-motion photography or motion sensors in his work; instead he makes sophisticated use of specially designed multi-focal lenses which enable him to incorporate complex scenarios that reflect the close environment and context of the bird in the photograph. Each photograph realizes a pre-conceived script or sketch in which the bird needs to play its part perfectly for the image to work. Describing the bird as the 'actor' and himself as the 'director', Mylayne defines the photograph as a representation of the bird in its natural setting as well as a performance.

Close-ups of birds are just one of several forms of representation in Mylayne's layered works. Sometimes the bird is a small, barely visible spot within the frame, or camouflaged by foliage and difficult to find, having become one with its environment. In other photographs, Mylayne captures it mid-flight, in a kind of physical rendering of the bird and its body. At times, the bird is so near that its portrait blends with a self-portrait of the artist – in the bird's eye there is a clear and precise reflection of Mylayne.

JAN-ERIK LUNDSTRÖM

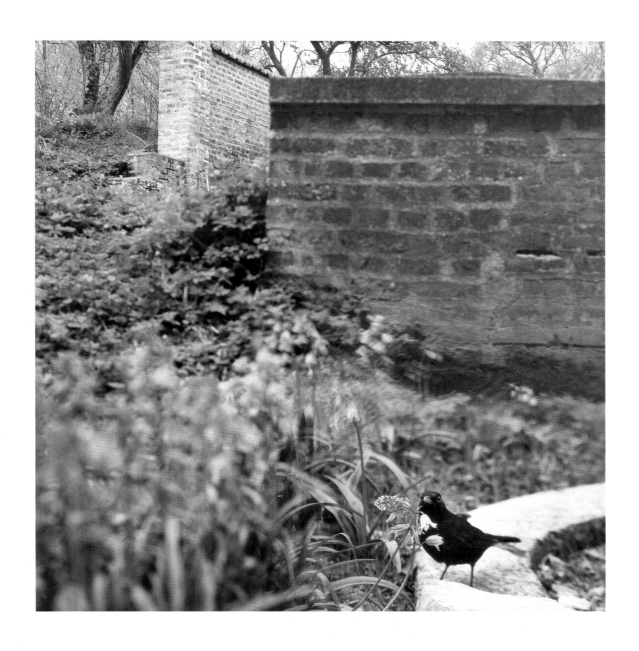

Nº J10 FÉVRIER – MARS – AVRIL – MAI 2001
C-PRINT, 123 X 123 CM (48⅜ X 48⅜ IN.)

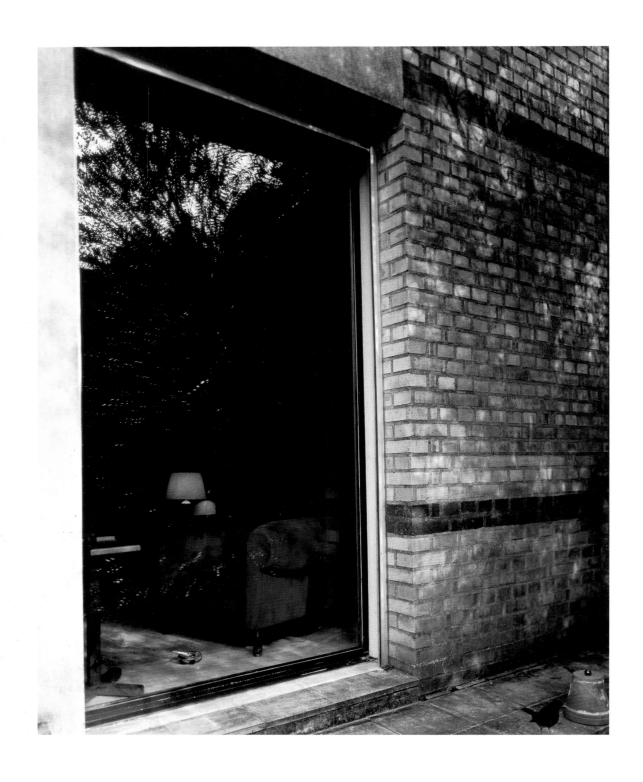

N° B7 NOVEMBRE DÉCEMBRE 2000 – JANVIER 2001
C-PRINT, 153 X 123 CM (60¼ X 48⅜ IN.)

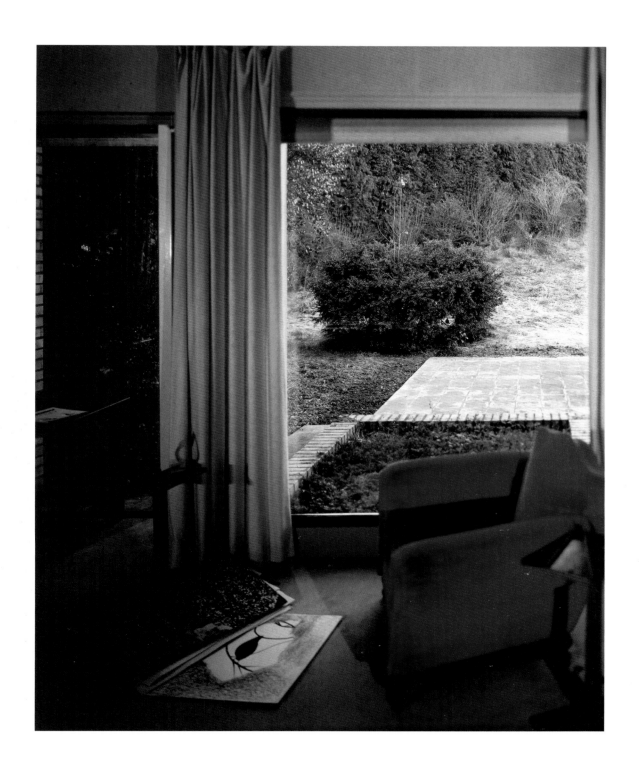

Nº B2 NOVEMBRE DÉCEMBRE 2000 – JANVIER 2001
C-PRINT, 153 X 123 CM (60¼ X 48⅜ IN.)

SIMONE NIEWEG

born in 1962 in Bielefeld, Germany
lives and works in Düsseldorf

WWW.GALERIERUPERTPFAB.COM WWW.GALLERYLUISOTTI.COM

Simone Nieweg was studying under Bernd Becher at the Kunstakademie in Düsseldorf when she started to focus on landscape photography. Since the 1980s she has used depth of focus to produce many colour photographs of what in themselves are unspectacular images of landscapes fashioned by man, be they vegetable or corn fields, fallow and overgrown plots, the edges of forests or allotments. Far removed from any sort of sublimation, Nieweg's *Landschaften und Gärtenstücke* are anything but an idealization or romanticization of the landscape theme: these unpretentious images, though picturesque and well composed, reveal scenes where the structures of manmade fields, forests and allotments interact with the 'disorder' of natural, weather-conditioned plant life, creating an aesthetically autonomous pictorial rhythm of forms and colours. The dominant shades in most of her photographs are green and brown, and they are rarely shot in winter. Sometimes, however, the central tone is set by a colourful object like a blue plastic water butt in someone's allotment, or – as in the photo *Kürbis, Bielefeld* (1990) – an orange pumpkin.

In many of her photographs of fields and forests – including *Getreidefelder, Dormagen* ('Cornfields, Dormagen', 1998) and *Grünkohlfeld, Düsseldorf-Kaarst* ('Kale Field, Düsseldorf-Kaarst', 1999) – the composition and rhythms seem to indicate that the picture has been taken from a standpoint below the level of the horizon. This divides the picture up into foreground, centre and background, and in this regard Nieweg follows a classical tradition which is enhanced by the fact that these subjects are also expanded into large-scale tableaux.

By contrast, the series of allotments often seems to have been photographed from a bird's-eye view. The various subjects fill the picture, but generally in smaller formats. Sometimes with a certain subtle humour, these kitchen gardens are depicted as a modern *locus amoenus*, a private horticultural idyll in which separately planted varieties of fruit and veg vie for attention with the eccentric structures of the garden sheds, as gems of individual design. Taken from different perspectives and under neutral light conditions, Nieweg's pictures are always 'still life' landscapes, on which nature, time and human beings have all left their mark.

BARBARA HOFMANN-JOHNSON

VERSCHNEITES FELD, LIEDBERG, 2003
C-PRINT, 102 X 136 CM (40⅛ X 53½ IN.)

GETREIDEFELDER, DORMAGEN, 1998
C-PRINT, 85 X 116 CM (33½ X 45⅝ IN.)

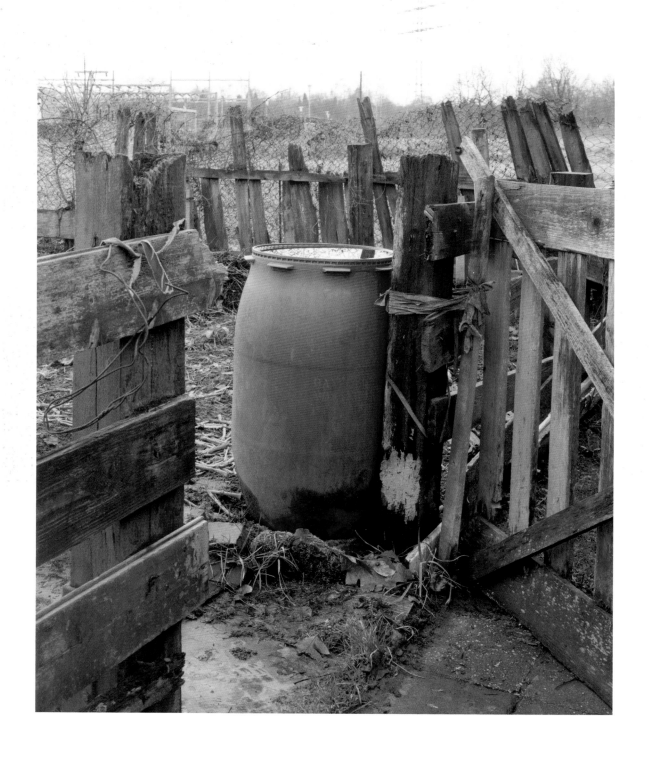

ROTE REGENTONNE, GELSENKIRCHEN, 2004
C-PRINT, 38 X 29 CM (15 X 11⅓ IN.)

KOHLPFLANZEN, MITRY-MORY, 2005
C-PRINT, 29 X 39 CM (11⅜ X 15⅜ IN.)

TOMATEN, CRAVANCHE, 2004
C-PRINT, 30.5 X 40.6 CM (12 X 16 IN.)

GARTENZAUN MIT TEPPICH, GELSENKIRCHEN, 2003
C-PRINT, 29 X 39 CM (11⅜ X 15⅜ IN.)

APFELBAUM, DILLINGEN, 2004
C-PRINT, 101.6 X 152.4 CM (40 X 60 IN.)

MIKA NINAGAWA
born in 1972 in Tokyo, Japan
lives and works in Tokyo

WWW.NINAMIKA.COM

Mika Ninagawa is best known for her dazzling colour-saturated photographs, which veer wildly towards a kitsch aesthetic and include such subjects as flowers, goldfish and fashion. Psychedelic in their colour intensity, these images seem to summon that hyper-reality predicted by Jean Baudrillard to be one of the consequences of the digital age. While Ninagawa's photographs are artworks that have been created to be exhibited and sold in galleries, there is no doubt that they have a strongly commercial look. They almost seem to have stepped out from the world of advertising, without the product or the message. Visually seductive, these works seem to revel in a sort of retrograde iconoclasm: just as, traditionally, avant-garde art shocked by virtue of its coarseness, its transgression of established mores, its challenge to traditional aesthetic sensibilities, Ninagawa's work subjugates the ubiquity of the flawed, slack and regressive aesthetics of much contemporary art, through its excessive and provocative beauty.

In his influential book *The Society of the Spectacle* (1967), Guy Debord explains how the spectacular is used to seduce the consumer and how its tendency is towards escalation – the more we are seduced by material goods, the more we desire seduction, progressively seeking greater spectacle and greater sensation. This is where the world of advertising hunts, seeking out and tempting its prey, the unwitting consumer. The visual seduction employed by advertising agencies on behalf of the producers of consumables is a nexus between art,

psychology and technology, and the adroit production of increasingly seductive eye-candy is one of its front-line weapons. Sophisticated, exotic and usually irresistible, it is this mode of aesthetic that Ninagawa employs in her dazzlingly colourful photographs. How can we resist them? We are assured that beauty is a dire anachronism as far as the contemporary art market is concerned, but who can deny a tingle of pleasure when viewing Ninagawa's unashamedly exotic images. Is she saying that such images should not be product-based, should not be contingent tools used to service the consumer market?

For western viewers to fully understand Ninagawa's work, whose main audience until now has been principally Japanese, we need to appreciate the image bombardment of Japanese society by the media. The image-flow in the Japanese media, while perhaps no more intensive than in the west is, however, visually more lurid and brash, more eye-grabbing and aggressive. It is in this climate that Ninagawa's photographs make their responsive play, staking their claim to a place in the competitively aggressive and continually escalating visual milieu that is the Japanese media. Undeniably seductive, Ninagawa's images offer a provocative challenge to that world and unapologetically so; this is overt overkill but one that we must be thankful for; this is territory that western photographers rarely venture into and, as such, has a refreshingly subversive appeal.

ROY EXLEY

SHOKOL ET MIKANNE, *2007*
C-PRINT, PLEXIGLAS
145.6 X 97 CM (57⅖ X 38⅕ IN.)

EVERLASTING FLOWERS 1
INSTALLATION VIEW, TOKYO WONDER SITE SHIBUYA, TOKYO, 2006

ACID BLOOM, 2003
C-PRINT, PLEXIGLAS
103 X 145.6 CM (40½ X 57⅜ IN.)

EVERLASTING FLOWERS, 2006
C-PRINT, PLEXIGLAS
97 X 145.6 CM (38⅛ X 57⅜ IN.)

LIQUID DREAMS, 2003
C-PRINT, PLEXIGLAS
103 X 145.6 CM (40½ X 57⅜ IN.)

A PIECE OF HEAVEN, 2002
C-PRINT, PLEXIGLAS
96.7 X 129 CM (38 X 50¾ IN.)

ACID BLOOM, 2003
C-PRINT, PLEXIGLAS
103 X 145.6 CM (40½ X 57⅜ IN.)

LIQUID DREAMS, 2003
C-PRINT, PLEXIGLAS
103 X 145.6 CM (40½ X 57⅜ IN.)

ARNO NOLLEN

born in 1964 in Ede, Netherlands
lives and works in Amsterdam

WWW.ARNONOLLEN.COM

With their faded black-and-white tones or colours, as if hidden behind a veil of the past, Arno Nollen's portraits seem to have come from another age. The photos of girls and young women emphasize their vulnerability, but also their sexuality, which is enhanced by the presence of a male onlooker. Minimal light changes, use of colour and angle of vision turn these pictures into a creative, almost filmic art form, particularly when they are part of a series. The body is always in the foreground, though sometimes it may only be the legs or some other part. These women appear in strange clothes or even fancy dress as if taking part in a performance, often wearing nothing but their underwear, or naked apart from their shoes and stockings. The staging, however, is almost shoddy, unlike the glamorized aestheticism of porn, and amateur in style: a hotel room, changing room or boutique serves as the backdrop. And yet Nollen is able to focus directly on the sexuality of his models, while at the same time forcing the observer actively to reflect on the distinction between nudity and licentiousness. The photographs bear witness to the photographer's fascination with the budding femininity of his models, their body language and their expressiveness. Of course, it would take only a few small changes for

fascination with a face to turn into sexual lust, but this is where Nollen opens up the erotic interpretation of his pictures in two directions: he visualizes his and other people's desires, and confronts the male observer of these images with his own voyeurism.

There is nothing anecdotal in these photographs; frequently the subjects are girls Nollen has met in the street, bars or discos. Quite unlike other photographers who link their portrait series to their own or other people's experiences, he tells us nothing about the people he portrays. They function more as a pointer to a personal and also a collective attitude towards the female body. Nollen is one of the younger generation of Dutch portrait photographers who were trained at the Gerrit Rietveld Academy and who have gone on to establish their own photographic style. There is an unmistakable trend towards a particular, intuitive mode of observation that clearly stems from this academy. In addition to his small-format work, commensurate with the intimacy of the subject, Nollen has also created larger, free-hanging installations. The serial character of his work is underlined by the fact that, independently of his photographs, he also makes short films.

FELIX HOFFMANN

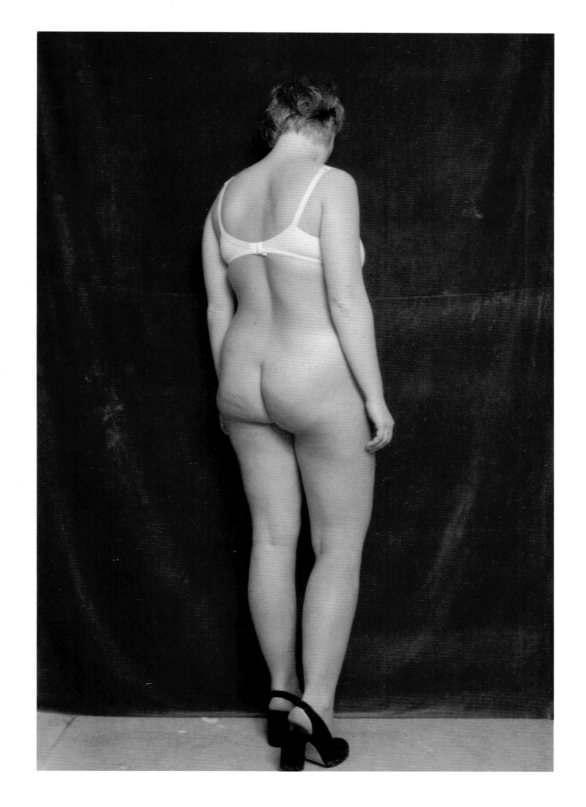

ELKE, 2000
C-PRINT, 170 X 110 CM
(66⅛ X 43¼ IN.)

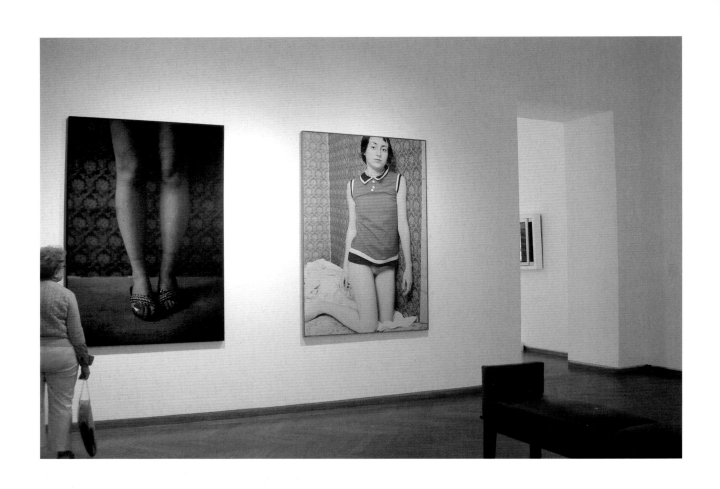

OOSTERPARK, 2000
GELATIN-SILVER PRINTS
110 X 170 CM (43¼ X 66⅞ IN.)

SOPHIE, 2000
C-PRINT, 170 X 110 CM
(66⅞ X 43¼ IN.)

SIMON NORFOLK

born in 1963 in Lagos, Nigeria
lives and works in Brighton, UK

WWW.SIMONNORFOLK.COM

After studying documentary photography in Newport, south Wales, Simon Norfolk became a photojournalist specializing in social themes, but in 1994 he gave up reportage in favour of landscape photography. This led to his first book, *For Most of It I Have No Words: Genocide, Landscape, Memory* (1998), which is significant for two reasons: the shift from a hand-held to a medium or large-format style of photography; and the aftermath of horror as subject-matter. Norfolk deliberately chose the detached style of viewfinder photography to place himself outside photojournalism and opposed to its tactics of sensationalism. The severe, elegant black-and-white images in this book depict a range of symbolic sites that are representative of some of the worst atrocities of the last hundred years – from the Holocaust to Ground Zero to Rwanda. The horrors that history acknowledges are marked by memorials (such as the museum at Auschwitz) whose well-scrubbed interiors yield all traces of their past impassively to the lens. In Vietnam, Norfolk's talent for symbolic details is manifest in a detached image of toy Huey helicopters made of Coke cans.

Norfolk gambled that the impassive presentation of such banal, almost incidental traces would shock viewers from their habituation with images of horror. Instead, he was surprised to find himself criticized for 'aestheticizing' the subject. Perhaps he was most vulnerable to this accusation because of his decision to make photographic memorials of suppressed or denied atrocities (the 1915 slaughter by Turkish troops of one million Armenians, for example, and the firebombing of Dresden by the RAF) where there were none. Some felt that these empty landscapes were too sentimental.

Afghanistan Chronotopia was published in 2002 to great acclaim, largely making Norfolk's reputation as an 'art' photographer of war zones. It is a book of pictures taken in the wake of the war between the US and its allies and the Taliban. Here, again, Norfolk lets high-resolution film record the material evidence of war so that other invisible truths may be inferred. This time colour is deployed allusively to stress analogies between his photography and landscape painting of the past. The debt to American photographers of the 1990s, such as Richard Misrach, becomes clear. In his introduction to the book, Julian Stallabrass describes Norfolk as a latterday Claude Lorrain invoking the ruins of once great civilizations. Norfolk chooses to focus on the 'unofficial' memorials that leave their marks in the towns and landscapes – for instance, piles of unexploded shells or the crater marks that pepper the walls of buildings, left as if for future archaeologists to excavate. Since *Afghanistan Chronotopia* Norfolk has continued to undertake similar projects that deploy a view camera aesthetic to document military landscapes.

DAVID BRITTAIN

SOY UNA RAYA EN EL MAR. DESERT GARBAGE: ME DICEN EL CLANDESTINO, NO DATE
FROM THE SERIES **ARIZONA/MEXICO**
DIGITAL C-PRINT, 127 X 101.6 CM (50 X 40 IN.)

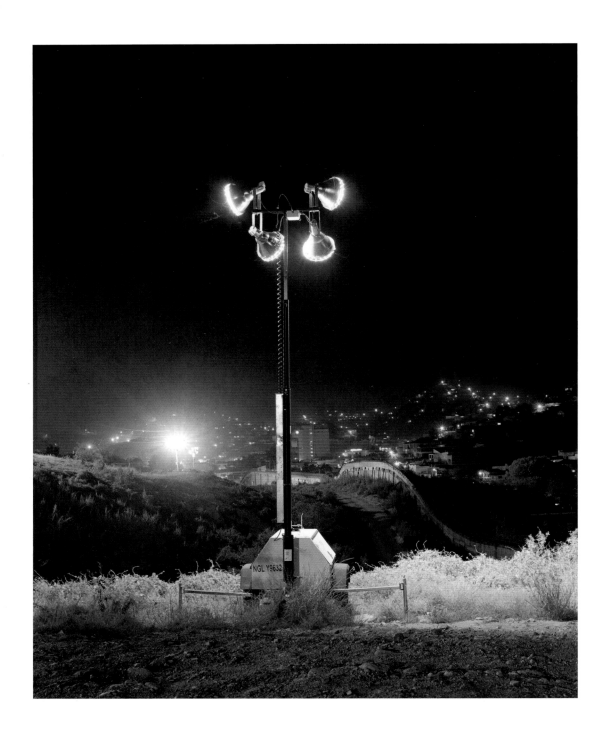

SOY UNA RAYA EN EL MAR. MERCURY HALIDE: PA' UNA CIUDAD DEL NORTE, NO DATE
FROM THE SERIES **ARIZONA/MEXICO**
DIGITAL C-PRINT, 127 X 101.6 CM (50 X 40 IN.)

SUPERCOMPUTERS. THE SUPERCOMPUTER OWNED BY LIVERPOOL UNIVERSITY, UK, NO DATE
FROM THE SERIES **SUPERCOMPUTERS**
DIGITAL C-PRINT, 127 X 101.6 CM (50 X 40 IN.)

SUPERCOMPUTERS. BLUEGENE/L, THE WORLD'S BIGGEST COMPUTER, AT LAWRENCE LIVERMORE
LABORATORY, CALIFORNIA, USA. IT IS THE SIZE OF 132,000 PCS. IT IS USED TO DESIGN AND
MAINTAIN AMERICA'S NUCLEAR WEAPONS, NO DATE
FROM THE SERIES **SUPERCOMPUTERS**
DIGITAL C-PRINT, 127 X 101.6 CM (50 X 40 IN.)

OHIO

founded in 1995 in Cologne, Germany, by Hans-Peter Feldmann, Uschi Huber, Jörg Paul Janka and Stefan Schneider

WWW.OHIOMAGAZINE.DE

Ohio is a magazine art project that has appeared as a VHS, DVD and even a boxed set of photographs. Founded in Germany by Hans-Peter Feldmann, Uschi Huber, Jörg Paul Janka and Stefan Schneider, Ohio got its unusual name because it meant nothing in German. In many ways Ohio was anticipated by Feldmann's work as a producer of photographic artists' pages, Fluxus books and magazines. It began in 1995, and the first issues comprised a bewildering range of vernacular photography taken from the collections of the co-editors – from reproductions removed from mass-market publications to private snapshots. These early editions were appreciated as 'anti-magazines' that deployed counter-intuitive and anti-hierarchical methods of presentation – primarily the eschewal of written texts. One effect was to emphasize the interdependency of text and image in the formation of meaning; another was to locate the 'original' work firmly in the circulating reproduction.

Since 1998, when Feldmann and Schneider left to pursue separate activities, Huber (b. 1966) and Janka (b. 1965) have broadened the activities of Ohio. In the first place they extended the project by issuing compilations of moving images appropriated from a variety of sources – including an institute that records the testing of products. In the iconoclastic spirit of the publication, this material was presented with little evidence of editorial mediation. Issue #8 – a 'slide show' of repetitive amateur grabshots of helicopters – provoked one reviewer to remark: 'For 24 DM you get, in six second intervals, 289 snapshots, one after the other, no text or music added.'

As these projects came to involve more and more negotiations with producers, Huber and Janka came into contact with a whole culture of specialist and eccentric collectors. In July 2004, they invited a group of these amateur archivists to participate in an exhibition for the Kunstverein, Düsseldorf. For the installation 'e.V.' they transformed the gallery into a series of discrete, themed installations that invoked public spaces. E.V. is the abbreviation for the German term *eingetragener Verein*, a small non-profit club or society that promotes good work in local communities. Documentarists from more than twenty such societies in the Ruhrgebiet region were persuaded to donate numerous still and moving images. Material varied from a recruiting video from the society of German chimney sweeps to a remarkable silent Super 8mm record of highlights from a muddy football match between rival sides of steel workers. Care was taken to ensure all contributions (artists and photographers) were given equal importance. Issue #12 of Ohio is an edited version of 'e.V.'

Ohio styles itself as a photography magazine but is certainly different because it challenges authorship and redefines the criteria of worthiness for publication. While it is true that the editors control the context of the photographs they publish (and therefore determine much of their meaning), they argue that Ohio is a collaboration. All photographers are credited, and the editors never crop or otherwise alter the images they use. The aim of Ohio is not to advocate photography – good or otherwise – but to disrupt habituation and force us to question value systems.

DAVID BRITTAIN

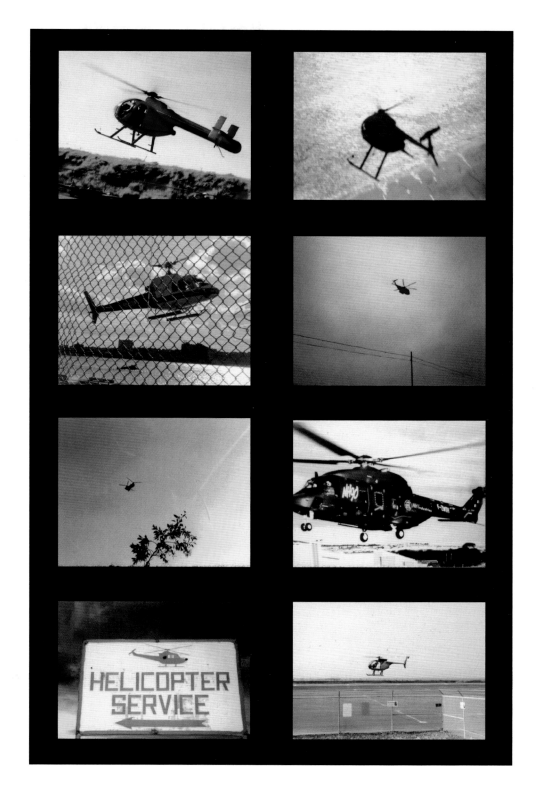

OHIO #8 – HEINRICH DUBELS ERRATISCHE HELIKOPTERPHOTOGRAPHIE, 2000
DVD

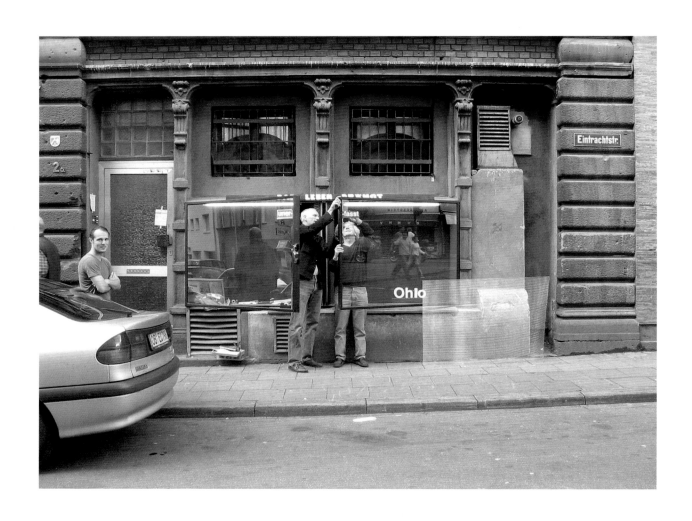

DAS LEBEN DRÄNGT, EXHIBITION OF THE AGENTENKOLLEKTIV
(FRIEDHELM SCHROOTEN & ROBERT BOSSHARD) IN THE OHIO-VITRINE,
COLOGNE, 2003

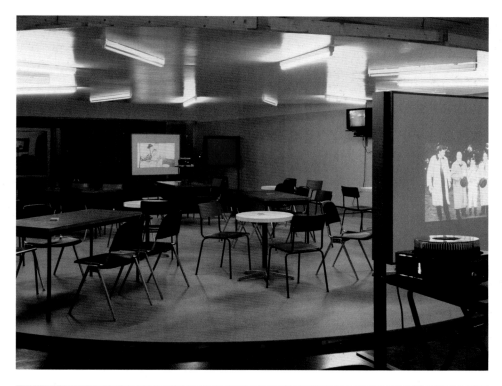

OHIO EXHIBITION **E.V.**
KUNSTVEREIN FÜR DIE RHEINLANDE UND WESTFALEN, DÜSSELDORF, 2004
SLIDES, VIDEOS

OHIO #12 'E.V.', 2004
OFFSET PRINT, DIN A4
OHIO #12 'E.V.', COVER

GÁBOR ÖSZ

born in 1962 in Dunaújváros, Hungary
lives and works in Amsterdam, Netherlands

WWW.GABOROSZ.COM

In 1993, after studying at the Academy of Fine Arts in Budapest, Gábor Ösz attended postgraduate courses at the Fine Arts Academy in Amsterdam and has lived and worked there ever since. Looking at the individual works and projects he has worked on over the past ten years, one is struck above all by his complex conceptual approach and at the same time by the clear and simple way in which he handles his medium. During the making of his photographic and video works (often installations) he puts his thoughts down in writing.

On the Edge (1998), for example, is a fascinating, minimalist video work in which Ösz ventures into a direct study of dimensions. His starting-point is the corner: 'The corner – when taking the geometrical approach to the human habitat – is none other than the home version of a three-dimensional Cartesian coordinate system. The abstract notions of plane and space are represented by the corner, as walls and intersection of the wall. At the intersection of the axes we find the origin, the starting-point in reference to which the position of every element in the coordinate system is defined. The space limited by the walls provides a fundamental division of the world, separating the without from the within and, in a mental sense, the private from the public.' In this context, as far as Ösz is concerned, neither wall nor picture stands alone. Alluding to Malevich and the original positioning of his painting Black Square, Ösz positions his video in the top corner of the room –

where since time immemorial Russians have hung their icons. What we see as a picture on the wall is a complex measured photograph of the surface of the wall itself, almost casually filmed in such a way that it can easily move around. Wall and picture seem at first sight to have the same dimensions, but a closer look reveals that this is an illusion.

This sophisticated approach to picture and space also runs through Ösz's highly original works and projects that centre on the idea of the camera obscura. The starting-point of The Liquid Horizon (1998–2002), for instance, is the Atlantic Wall, the gigantic line of defence erected by the Nazis during the Second World War from the Norwegian coast to France. Initially, it was the (modern) architectural forms of this derelict fortification that attracted him. However, one day, when he was looking out at the landscape through the narrow slit of a bunker and saw the 'liquid horizon', he decided to use the bunker itself as a camera obscura. The surrounding landscape draws (or to be more precise, paints) itself on large sheets of Ilfochrome paper. Because of the long exposure (up to six hours), the forms become softer and the monumental photographs are imbued with a chromatic tenderness and peace. In a similar way, Ösz created Permanent Daylight (2001–4) using a caravan as a camera obscura and taking night photos of the illuminated hot houses in the Dutch region of Westland.

ERIK EELBODE

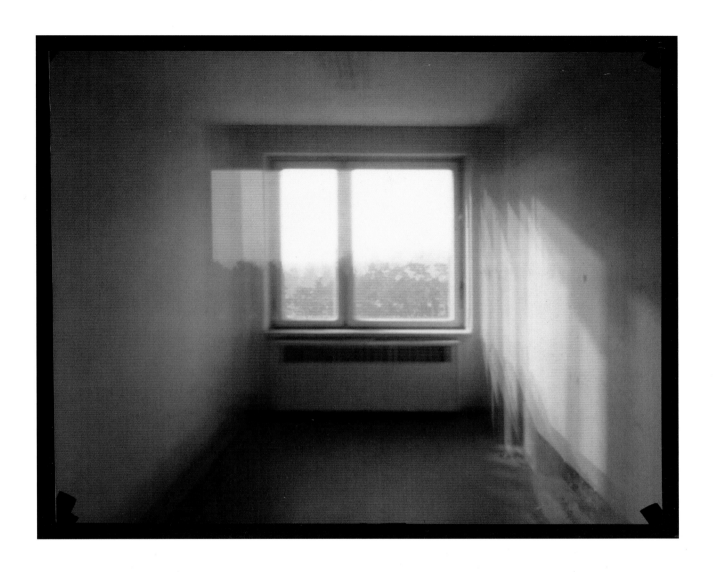

THE PRORA PROJECT, NO.17. 27.9.2002, EXPOSURE TIME 3H, DIVIDED BETWEEN 20 ROOMS, 2002
CAMERA OBSCURA, ILFOCHROME PAPER, 126.5 X 155.8 CM (49¾ X 61⅜ IN.)

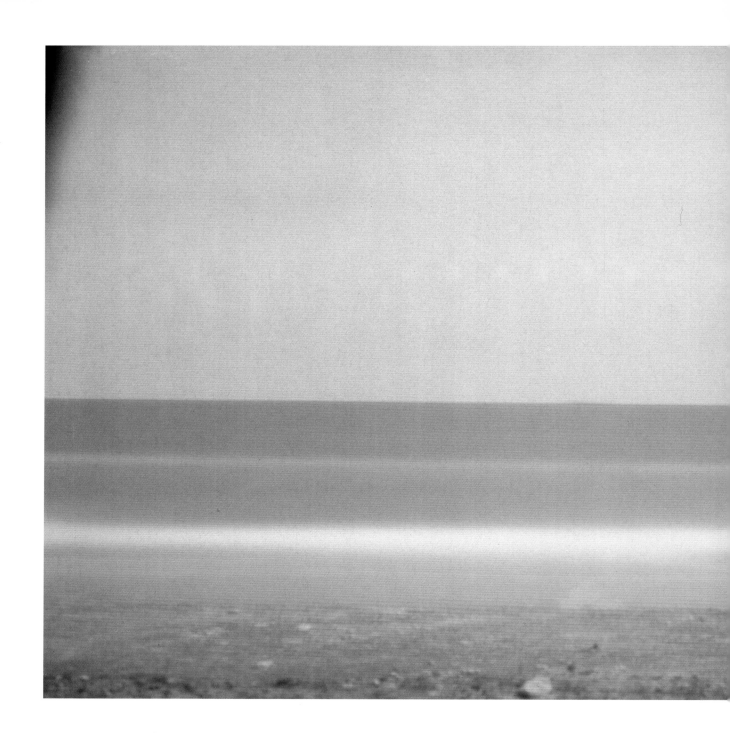

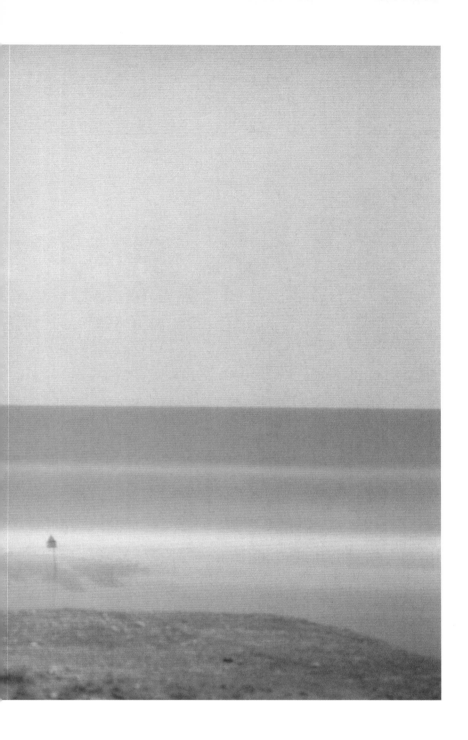

THE LIQUID HORIZON, NO.01. SCHEVENINGEN – 28.6.1999, EXPOSURE TIME 5H, 1999
CAMERA OBSCURA, ILFOCHROME PAPER, 126 X 240 CM (49⅝ X 94½ IN.)

PETER PILLER

born in 1968 in Fritzlar, Germany
lives and works in Leipzig

WWW.PETERPILLER.DE

Peter Piller often sources his material from abandoned image archives, such as those left behind by anonymous commercial photographers and local newspapers, or from the thousands of negatives produced and stored by now defunct businesses. Photographs which, on the face of it, are of no interest to anyone but the most enthusiastic historian of the everyday are given a second life – winding up in Piller's exhibitions and in his A5 format catalogues, where they are interpolated into the history of serial images and photo documentation of conceptual art. Piller takes previously overlooked incidents or the visual characteristics that he discovers in these photographs and makes them the basis for what are often absurd and seemingly random categories, thus producing a new context for their reception. The photographs are arranged in sequences where the element selected by the artist to define the category is present in each image. For example, in a book called *People Touching Cars* multiple examples of people touching cars are grouped together. In the other titles from this series, including *Murder Houses*, *Instant Teller Thieves*, *Construction Sites (and Empty Parking Lots)*, *People Pointing* and *Site Visits*, the selected categories function in a similar fashion. A work called *Tongues* (2002–4) consists of aerial views of neighbourhoods shot by companies which fly over streets and houses taking photographs that they subsequently sell door to door. In Piller's selection, each house has a red textile flying like a flag from its

windows, an unlikely coincidence, no doubt carefully extracted by the artist from hundreds, perhaps thousands of images, and one that seems to liberate a hint of revolutionary fervour from an archive of photographs designed to flatter the sensibility of proud homeowners.

Piller's favoured territory is the small town beat of the local reporter who has an eye for detail and a taste for the banality of provincial life. His images often describe the fringes of the city where residential areas butt up against light industrial estates, bits of pseudo countryside and business parks. If Bernd and Hilla Becher imbue the industrial architecture that they capture and serialize in their work with a sort of a classical elegance, then Piller gives his chosen terrain an element of intrigue and unexpected significance that emerges from the patterns that lie dormant in the everyday. Sometimes there is poignancy or a flash of unexpected beauty in his work, as in the series *Forsythia Blossoms* (1994), a set of photographs taken by the artist himself. These show this hardy, if somewhat forlorn shrub blooming untended amidst the junk and debris, the broken concrete slabs, muddy puddles, discarded items of clothing and rubbish that are strewn across a patch of wasteland. Testimony, perhaps, to the interruption of the poetic that can sometimes occur where it is least expected – in the somewhat abject and mundane corners of the world.

GRANT WATSON

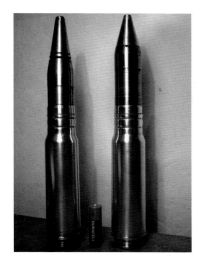

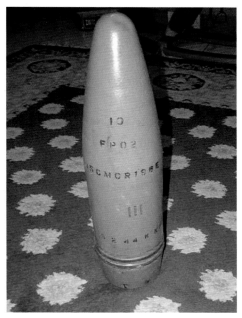

FROM THE SERIES **DEKO UND MUNITION/
DECORATION AND MUNITION**, 2003
C-PRINT, 30.3 X 20.3 CM (12 X 8 IN.)

FROM THE SERIES **DEKO UND MUNITION/
DECORATION AND MUNITION**, 2003
C-PRINT, 30.3 X 20.3 CM (12 X 8 IN.)

FROM THE SERIES **DEKO UND MUNITION/
DECORATION AND MUNITION**, 2003
C-PRINT, 30.3 X 20.3 CM (12 X 8 IN.)

FROM THE SERIES **DEKO UND MUNITION/
DECORATION AND MUNITION**, 2003
C-PRINT, 30.3 X 20.3 CM (12 X 8 IN.)

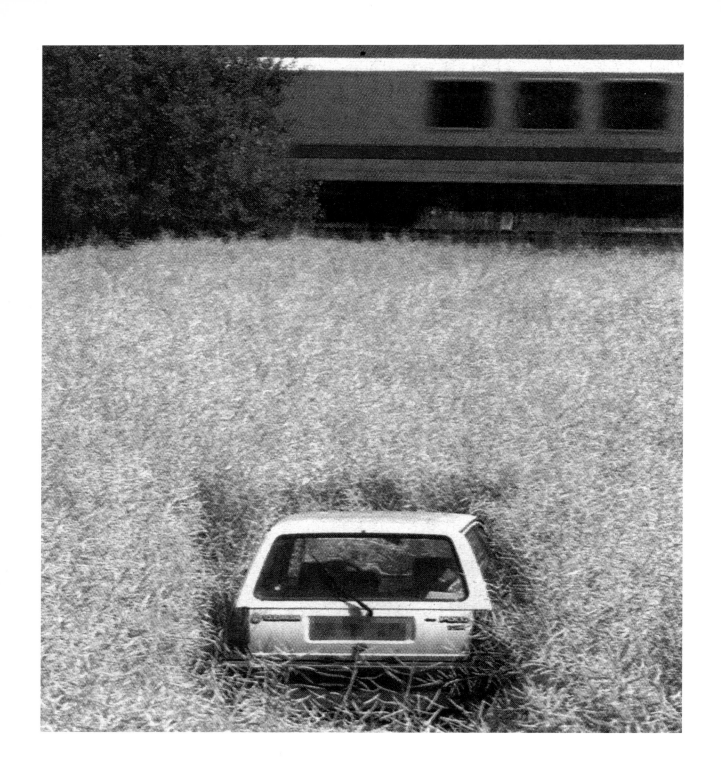

FROM THE SERIES **UNGEKLÄRTE FÄLLE/UNRESOLVED CASES**, 2000–6
INKJET PRINT, 74 X 67 CM (29⅛ X 26⅜ IN.)

FROM THE SERIES **BAUERWARTUNG/CONSTRUCTION EXPECTED**, 2000–6
INKJET PRINT, 43 X 73 CM (16⅞ X 28¾ IN.)

FROM THE SERIES **BAUERWARTUNG/CONSTRUCTION EXPECTED**, 2000–6
INKJET PRINT, 43 X 73 CM (16⅞ X 28¾ IN.)

MARTIN POLAK/
LUKAS JASANSKY

M.P. born in 1965 in Prague, Czech Republic

L.J. born in 1966 in Prague

live and work in Prague

WWW.JIRISVESTKA.COM

Martin Polak and Lukas Jasansky have been working together since the mid-1980s, taking black-and-white photographs of villages, houses, streets and landscapes. Gently differentiated, rather melancholy shades of grey might be a better way of describing the pictures in the series *Czech Landscape* (1998–2000) and *Village* (2001–3), which offer restrained, unpretentious views of various Czech scenes: dusty streets, houses old and new that look a little shabby but also quite romantic, broad landscapes and fields that seem strangely contemporary and yet at the same time are like relics from some long-lost world. It's a world that seems to be a little unsure of itself, made rather pallid by the bright times that have since dawned, but these pictures are not documentary photographs in the classical sense because sometimes they also contain people. In the series *Ignac* (2000–2), for instance, we see a single man – Ignac – standing in the bushes in front of a modern building. In *Czech Landscape* there are tiny figures in the distance, or a group standing in a circle holding hands in a field. They are all doing something, though we don't know exactly what. That makes us curious, but our curiosity is not satisfied by any clear answers. Perhaps they are carrying out some ritual, or staging a performance – an artistic project set in the landscape, culture taken out into nature – but whatever it is eludes our grasp. What seems to be more important is the environment of these people.

Are Polak and Jasansky using black-and-white photography – a medium of the past – in the present as a basis for the future? Certainly their pictures seem to be both contemporary and historical, but also forward-looking. Indeed it is precisely this oscillation between eras that gives expression to the transience of the present and the strangeness of a reality that is not only Czech. The pair's work has been frequently exhibited in Prague and Germany, as well as at the Czech Centre in London (2000) and the 'Nature's Mirror' exhibition in Tokyo (2005).

NADINE OLONETZKY

UNTITLED, 1998–2000
FROM THE SERIES **CZECH LANDSCAPE**
BLACK-AND-WHITE PHOTOGRAPH
87 X 115 CM (34¼ X 45¼ IN.)

UNTITLED, 1998–2000
FROM THE SERIES **CZECH LANDSCAPE**
BLACK-AND-WHITE PHOTOGRAPH
87 X 115 CM (34¼ X 45¼ IN.)

UNTITLED, 2001–3
FROM THE SERIES VILLAGE
BLACK-AND-WHITE PHOTOGRAPH
87 X 115 CM (34¼ X 45¼ IN.)

UNTITLED, 2001–3
FROM THE SERIES VILLAGE
BLACK-AND-WHITE PHOTOGRAPH
87 X 115 CM (34¼ X 45¼ IN.)

UNTITLED, 2001–3
FROM THE SERIES VILLAGE
BLACK-AND-WHITE PHOTOGRAPH
87 X 115 CM (34¼ X 45¼ IN.)

UNTITLED, 2001–3
FROM THE SERIES VILLAGE
BLACK-AND-WHITE PHOTOGRAPH
87 X 115 CM (34¼ X 45¼ IN.)

UNTITLED, 2000–2
FROM THE SERIES **IGNAC**
BLACK-AND-WHITE PHOTOGRAPH
80 X 100 CM (31½ X 39⅜ IN.)

UNTITLED, 2000–2
FROM THE SERIES **IGNAC**
BLACK-AND-WHITE PHOTOGRAPH
80 X 100 CM (31½ X 39⅜ IN.)

MARCO POLONI

born in 1962 in Amsterdam, Netherlands
lives and works in Geneva, Switzerland,
and Chicago, USA

WWW.ROELLINDUERR.COM

It has long been a truism that the contemporary mass of images has helped to shape our social reality. Marco Poloni is one of the artists whose work focuses on images that affect everyday culture. The starting-points of his projects lie in his observation of the role played by images in the perception, evaluation and interpretation of reality. He appropriates familiar pictorial languages and relates them to tried-and-trusted aesthetics in order to confront the observer with the role of pictures in the establishment of meaning, narrative and the significance of events.

In *Permutit: Scenes from a Film* (2005), Poloni creates a (fictional) story using forty-two photographs that are reminiscent of cinema stills, which suggest a kind of chase, as in a thriller. Exploiting a pictorial knowledge which has become part of media awareness in western culture, he is able to explore the conditions under which we interpret images in a particular way and transfer them to reality. The observer is kept dangling between illusion and disillusion, reality and imagination, consistency and paradox.

In *Displacement Island* (2006), Poloni again deals with the question of how we construct reality. In a series of sixty-seven photographs – some taken by the artist, others reproduced from various print media – he shows us the image of a holiday island which has also become a destination for illegal immigrants. The series focuses on the contrast between the two phenomena. Poloni demonstrates how the global problems of mass tourism and illegal immigration, which run parallel and may even intersect, appear on the holiday island as two totally separate worlds. Through the mixture of sources, we are confronted with a subjective version of the situation, but one that clearly shows this separation as a construct of power in which images play a central role. Once again, Poloni exploits the observer's awareness of pictorial language, but here he links it directly to a public image policy and hence to the politicization of public image-making.

REINHARD BRAUN

ALL IMAGES FROM THE SERIES **DISPLACEMENT ISLAND**, 2006
67 INKJET PRINTS, PIGMENT INK ON FIBRE PAPER
DIMENSIONS VARIABLE

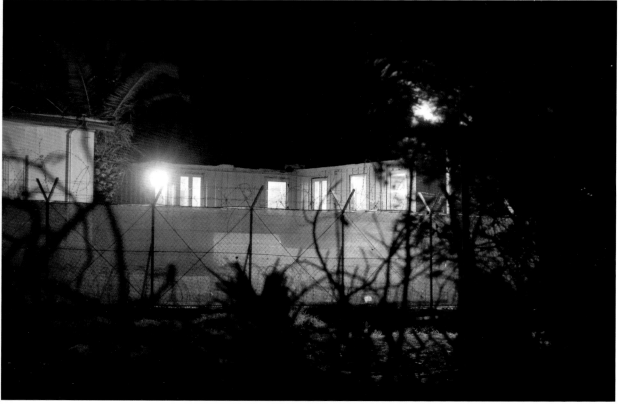

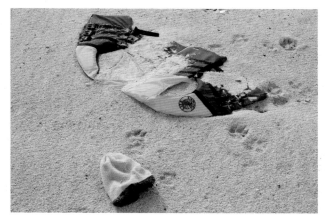

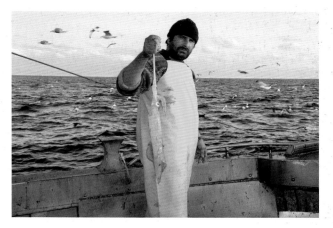

BARBARA PROBST

born in 1964 in Munich, Germany
lives and works in New York, USA, and Munich

WWW.KUCKEI-KUCKEI.DE WWW.SPRUETHMAGERS.COM

The subject of Barbara Probst's series *Exposure* (begun in 2000) is no less than the relation between time, perception, the photograph and reality. She uses several cameras to photograph one and the same moment, one and the same (staged) action, event or situation from different perspectives at the same time. Then she selects and arranges them to make tableaux that are usually in several parts, or diptychs at the very least. Exposure, revelation, discovery, unmasking, the decisive moment, the 'armed' eye – Probst works her way through all these synonyms for photography in her installations. The individual parts of *Exposure* show unmistakably that the reconstruction of meaning, of an event or even of historical processes on the basis of photography is a virtually impossible undertaking. She reminds us of the fact that Walter Benjamin and, later, Victor Burgin wrote that photography is always accompanied by a text, whether explicit or implicit. And she also shows that omissions and contradictions are part of photographic practice itself. *Exposure* demonstrates the fact that an image not only expresses something but also causes something else – an 'other' image – to disappear, precisely when both refer to the same thing or supposedly the same 'reality'.

Probst confronts us with a series of 'other' images, contrasting colour with black and white, or showing the rear view of people performing incomprehensible actions. Again and again, the camera itself figures in these pictures. *Exposure* allows us to reconstruct a possible meaning for the scene, action or event through the gaps between the images, or between the images and the equipment. Thus Probst exposes the hidden 'text' of photography as a space or blank area in the representation, entailing a shift of perception. She involves the observer in different possible ways of reading that text, and so destroys the myth that there is any such thing as photographic 'truth', or a 'reality' captured by photographic representation. *Exposure*, however, is not just a game of perception and image; it amounts to a critique of the current mass media, whose use of images functions politically through forms of selection, omission and exclusion.

REINHARD BRAUN

EXPOSURE #37: N.Y.C., 249 W. 34TH STREET, 11.07.05, 1:13 P.M., 2005
ULTRACHROME INK ON COTTON PAPER, 2 PARTS, EACH 189.2 X 125.7 CM
[74½ X 49½ IN.]

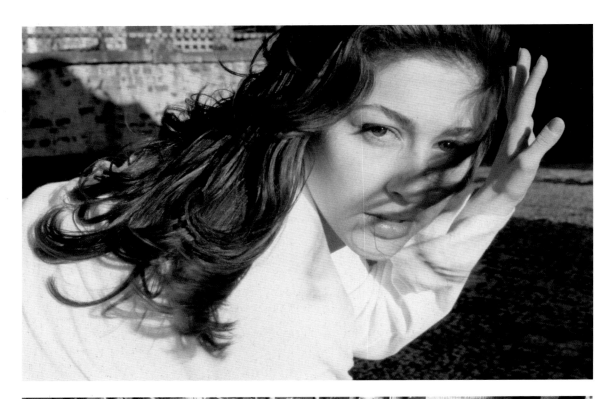

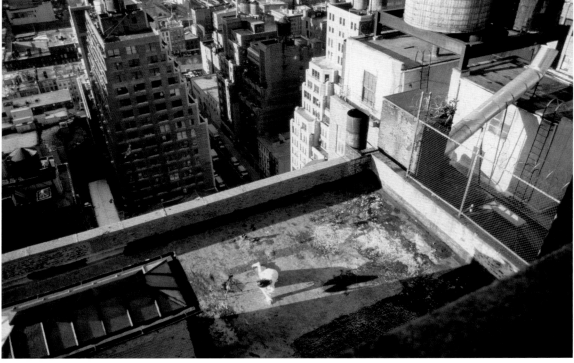

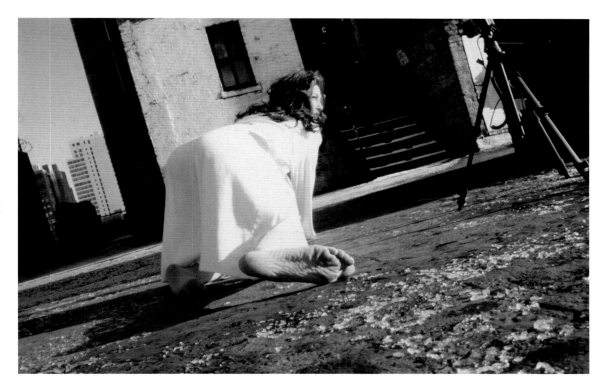

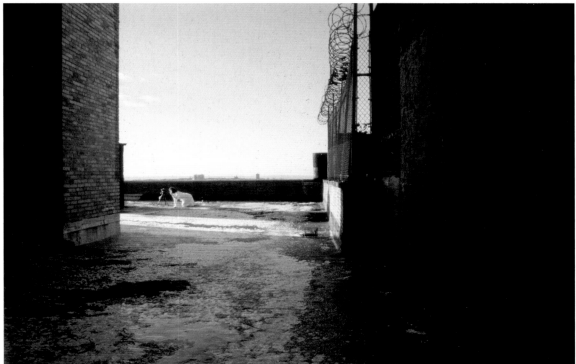

EXPOSURE #5: N.Y.C., 545 8TH AVENUE, 12.20.00, 2:27 P.M., 2000
ULTRACHROME INK ON COTTON PAPER, 4 PARTS, EACH 86 X 130 CM
(33⅞ X 51⅛ IN.)

GONZALO PUCH

born in Seville, Spain
lives and works in Madrid

WWW.PEPECOBO.COM

After initially devoting himself to painting, sculpture and installations, Gonzalo Puch now focuses his artistic talents on photography. Here, too, his generally large-scale tableaux and lightboxes are for the most part staged like theatre sets, offering highly original, richly associative and often humorous representations of cognitive models of the world. Laid out in classrooms, neutral surroundings and sometimes even in his own apartment, his colour photographs contain multiple references to philosophy and the importance of light in subjects such as mathematics, astronomy, geometry, physics, geography, cartography, biology, botany and ecology. These 'all-over' compositions often seem like playful, even comic picture laboratories, in which an eccentric researcher is hard at work. For instance, a cyclist happens to come across a blackboard containing mathematical formulae (*Untitled*, 1999), or a man sits on a stool cutting out large paper numerals and adding them to other numerals on a reddish-orange wall (*Untitled*, 2002). In another photograph, we see a young woman in front of a board covered with formulae, and an illuminated globe surrounded by planetary systems (*Untitled*, 2002). There is an amusing picture of Puch himself lying on the ground, apparently being crushed by a crumpled paper globe (*Untitled*, 2004).

The history of art and culture, which itself has become a meaningful system of human cognition, is also incorporated into Puch's photographic work. In *Hommage an Vermeer* (1994), for instance, there is a room, on the end wall of which hangs a map of the world, and standing in front of this is a burning telescope that is directed towards the window. In this allusion to Vermeer's painting *The Astronomer* (1668) there is no astronomer, but instead the search for knowledge as the picture's subject-matter is transferred to the metaphor of the fire. Apart from these pictorial stagings, carried out in various interiors, Puch has extended his photographic subjects in recent years to rural environments. Here, too, the staged contact between man and world is carried out with playful humour.

BARBARA HOFMANN-JOHNSON

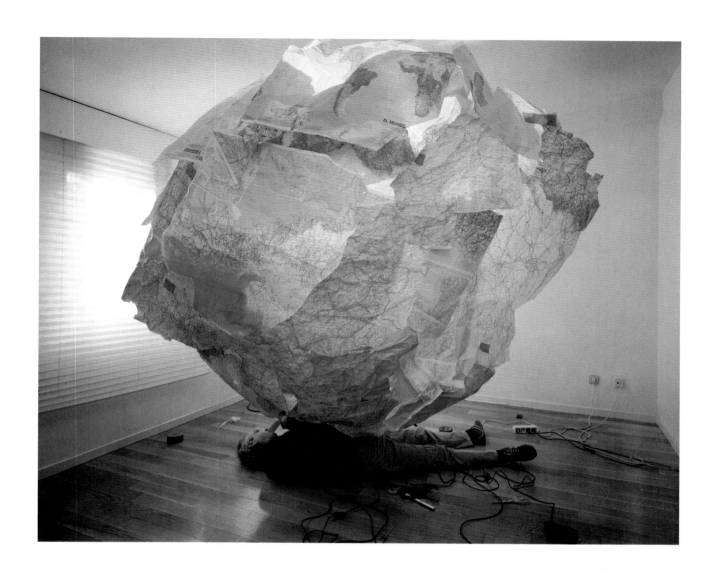

UNTITLED, 2004
DIGITAL COLOUR PRINT
160 X 205 CM (63 X 80¾ IN.)

UNTITLED, 2001
COLOUR PHOTOGRAPH
114.5 X 163 CM (45⅛ X 64⅛ IN.)

CLUNIE REID

born in 1971 in Pembury, UK
lives and works in London

WWW.KEITHTALENT.COM

Clunie Reid completed her studies in painting at the Royal College of Art in 1995 and now teaches at the Wimbledon College of Art, where she herself did a BA in painting. What she does now, however, can hardly be classed as 'painting'. A more appropriate description would be cutting, tearing, collecting, copying and installing. Like many other young artists, Reid seeks to adopt a personal stance in the face of the never-ending and self-perpetuating maelstrom of images that are hurled at us every day by all the different media. She says: 'My work tends to focus on photographic images that already exist in the world and materials and objects that can be used as presentation strategies for these images. I am interested in how images are read, decision-making processes in art production and constructive syntax in sculpture, collage and assemblage.'

Instead of a brush, Reid's most important tool is her scissors. There are enough pictures now, she seems to be saying, and so let's stop adding more to the pile. She therefore 'reinvents' existing pictures by cutting them up and sticking them together. Or, to quote Claire Mitchell in *The List*, she reappropriates 'a visual language pilfered from tabloid, celluloid, pulp and fashion – flickering, bite-size imagery that holds our easily-distracted modern gaze for just long enough before something prettier, uglier, funnier or scarier comes along. Reid makes this point in a highly charged way – completely covering walls with recurring photocopied images ripped straight out of tabloid culture, the sense of such intense repetitious overload obliterating the effect of the original image.' What today is an 'original image'? And can images generally have any impact at all? These are just two of the questions that are thrown up in the course of Reid's photographic protest marches.

Of course, for us, the image-consumers of the western world, what Reid confronts us with is completely familiar – been there, seen it all before. Or have we? No one can see it all. The flood of printed images alone is endless and chaotic. Reid places herself at the edge of the chaos, dams up the flow, and tries to establish visual connections that will extend beyond the surface of the images. Fortunately, she does so with a healthy dose of humour and irony. In the words of Michael Paulson: 'Clunie Reid's brash xerox diptychs...seem to ask, isn't it horribly shocking that I did this, even though it's really not that shocking, but you're shocked anyway, or are you? Reid has found a convincing way to delve into the contemporary relationship between originality and absolute cynicism.'

ERIK EELBODE

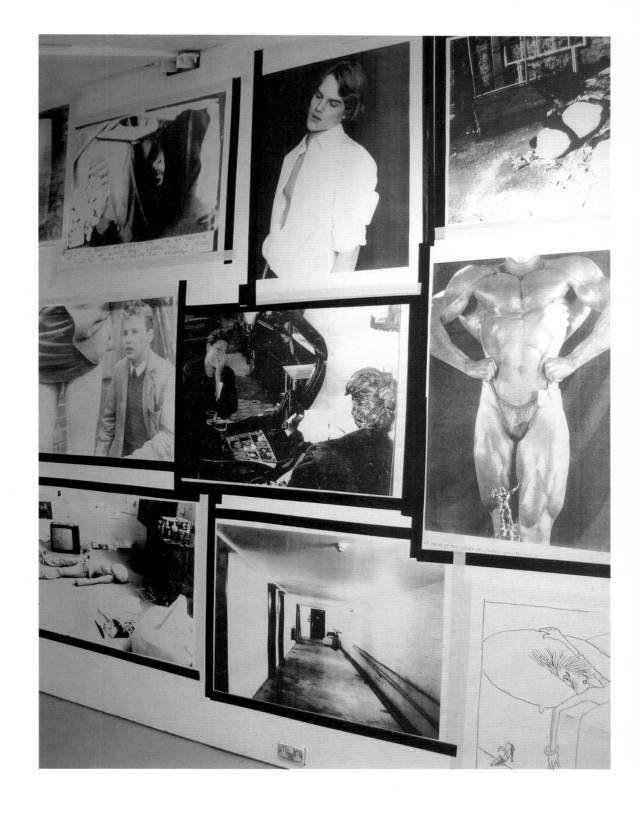

INSTALLATION VIEW, KEITH TALENT GALLERY, LONDON, 2006

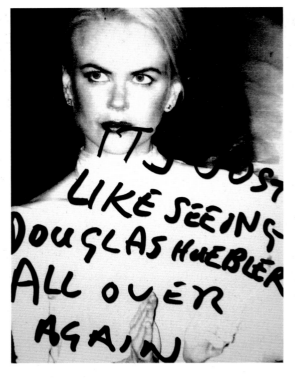

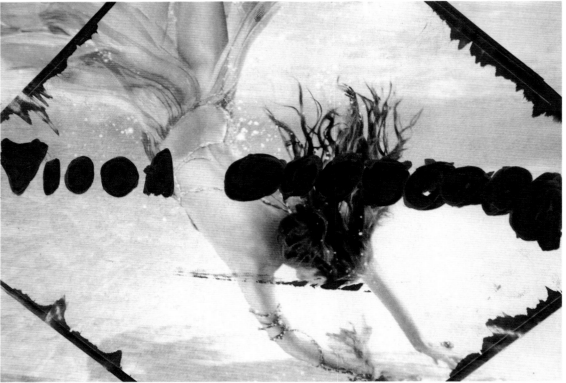

IT'S JUST LIKE…, 2007
PHOTOCOPY, 30 X 21 CM (11¾ X 8¼ IN.)

UNTITLED (DIVER), 2007
FELT TIP ON PHOTOGRAPH, 13 X 18 CM (5⅛ X 7⅛ IN.)

IT'S JUST LIKE…, 2007
PHOTOCOPY, 30 X 21 CM (11¾ X 8¼ IN.)

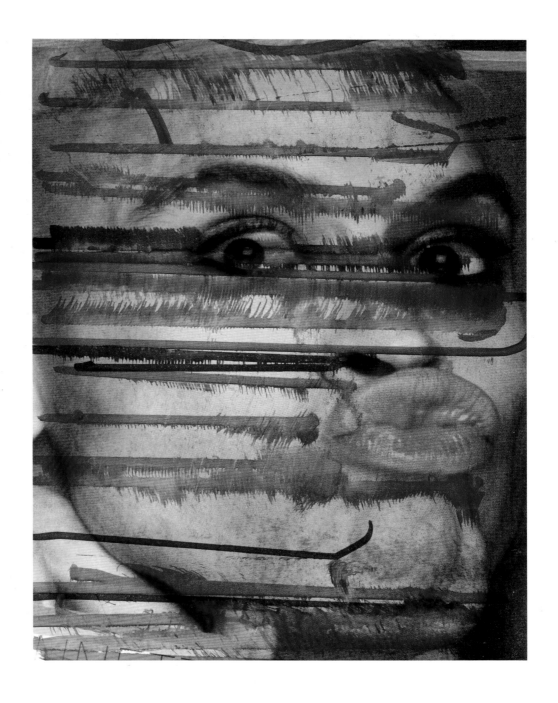

UNTITLED, 2007
FELT TIP ON PHOTOGRAPH
20 X 15 CM (7⁷⁄₈ X 5⁷⁄₈ IN.)

ROSÂNGELA RENNÓ

born in 1962 in Belo Horizonte, Brazil
lives and works in Rio de Janeiro
WWW.GALERIAVERMELHO.COM.BR

In spite of her encyclopedic approach to photographs and the photographic medium, conceptual artist Rosângela Rennó seldom engages the camera directly in her vast and predominantly photography-based oeuvre. Rather, Rennó is an explorer, analyst, collector and caretaker of found, acquired, appropriated or commissioned photographs – from private sources, media and popular culture, institutions and authorities, and the commercial scene. She is dedicated to not only accessing large bodies of photographs from the social realm, but also to ordering, classifying, categorizing, rearticulating, modifying and transforming them, often bringing out unexpected or forgotten nuances of meaning or expression. At times her artistic practice is concentrated on the physical reality of photographs; she might print or project them on atypical materials – on steel, plastic or a smoke screen, for example – emphasizing their ephemeral or fleeting qualities. Other times she looks into the way photographs are circulated in society, addressing forms of presentation such as family albums, passport photos, studio portraits and framing, and often recasting those images that have been marginalized, 'lost' or forgotten by history or society. Rennó also explores the political, social and cultural systems of codification, classification and control in her examination of the following: the meaning of photographs, their distribution and circulation, their role in constructing identities, and their contribution to the collective memory and world-making.

Bibliotheca, a massive project begun in 1992, is a fine example of Rennó's work with an extensive archive. Slides and prints from various private or studio collections are sorted, organized and displayed in a variety of ways. In painted display cases, Rennó presents digital photographs, maps, slide boxes, negatives and photo albums; a colour-coding system is also included, identifying the origin and fictitious narratives of the images on display, making comparisons and juxtapositions, and unravelling undercurrents of meaning and use. *Red Series* (2001–3) takes ordinary photographs of men in uniform or boys in imitation uniform, and rearticulates them as large-format, red prints which are difficult to read. *The Daily Mirror* (2002) focuses on media stories about women who share the artist's name, producing a marathon piece in which Rennó restages 133 Rosângelas who reflect a remarkable cross-section of Brazilian society. For *The Last Photo* (2006), Rennó gave a camera from her own collection to ten photographers and asked them to take one photograph each of Rio de Janeiro's emblematic Christ the Redeemer. The results were presented with the camera used for each picture (the camera is sealed after the photograph has been taken, hence the title), raising a series of interlinked questions about meaning and copyright (the original sculptor, the owner of the statue, the innumerable tourist snapshots of the same motif, the commissioned photographers, the artist…), among other things.

JAN-ERIK LUNDSTRÖM

UNTITLED (OLD NAZI), 2000
FROM THE SERIES RED SERIES, 2000–3
DIGITAL C-PRINT ON FUJI CRYSTAL PAPER
180 X 100 CM (70⅞ X 39⅜ IN.)

MENOS VALIA, 2005
DIFFERENT PHOTOGRAPHIC MATERIALS ON PVC AND WOOD,
EACH 187 X 105 X 15 CM (73⅜ X 41⅜ X 5⅞ IN.) TRIPTYCH, DETAIL

BIBLIOTHECA (GENERAL VIEW), 2002
37 DISPLAY CASES WITH PHOTO ALBUMS AND DIGITAL COLOUR PHOTOGRAPHS,
PLEXIGLAS, CARD AND STEEL, DIMENSIONS VARIABLE

DEBORA ENGEL, GRADOSOL, 2006
FROM THE PROJECT **THE LAST PHOTO**
COLOUR PHOTOGRAPH AND GRADOSOL CAMERA
PHOTO: 83 X 83 X 9.5 CM (32⅜ X 32⅞ X 3¾ IN.)
CAMERA: 17.3 X 24.5 X 9.5 CM (6⅞ X 9⅝ X 3¾ IN.)
DIPTYCH

ZÉ LOBATO, ROLLEIFLEX, 2006
FROM THE PROJECT **THE LAST PHOTO**
COLOUR PHOTOGRAPH AND ROLLEIFLEX AUTOMAT 4
PHOTO: 67.8 X 67.8 X 12.4 CM (26¾ X 26¾ X 4⅞ IN.)
CAMERA: 19.6 X 17.4 X 12.4 CM (7⅞ X 6⅞ X 4⅞ IN.)
DIPTYCH

ROSÂNGELA RENNÓ, RICOH 500, 2006
FROM THE PROJECT **THE LAST PHOTO**
GELATIN-SILVER PRINT AND RICOH 500
PHOTO: 82.8 X 55 X 9.4 CM (32½ X 21⅞ X 3¾ IN.)
CAMERA: 18.9 X 16.5 X 9.4 CM (7½ X 6½ X 3¾ IN.)
DIPTYCH

XAVIER RIBAS

born in 1960 in Barcelona, Spain
lives and works in Brighton, UK, and Barcelona

WWW.XAVIERRIBAS.COM

Xavier Ribas presents a discreetly perceptive, carefully considered and yet mildly subversive aesthetic in his photographs, which often maintain a certain friction in the play on absence and presence; this is matched with a persistent scrutiny of a type of *terrain vague* – spaces that are neither city nor suburb, neither countryside nor wilderness. In their precise but open-ended mapping of otherwise hidden or unseen spaces, his images are a cautious but rich renewal of the topographic tradition of 20th-century landscape photography. Moreover, they are often grounded in a clear-sighted understanding of traces and marks as signs of human activity, reflecting Ribas' background in anthropology. His discriminating eye organizes the visual world in this way: unpeopled photographs point to human influence through what has been left behind in the landscape.

Observing contemporary culture's obsession with leisure, Ribas became interested in the self-regulated use of unexploited or undefined areas at the edges of the city – spaces that are regularly used for picnics, swimming and other outdoor pursuits at the weekend or during holidays. His *Barcelona Pictures* (1994–97) ingeniously record these pastimes: the photographs seem to have been organized casually but they capture human actions (or their residue) precisely, redefining spaces by bringing them out of their wasteland slumber and reorganizing them as unofficial public leisure grounds.

Rooms (1997–2000), *Flowers* (1998–2000), *Stones* (2000) and *Sanctuary* (2002) are all photographic series devoted to observing human presence through its absence.

Again, the spaces are nondescript, unremarkable and yet shudder with meaning. In *Flowers*, for example, the absence is doubled: the roadside flower, a small visual explosion amid the dust and gravel, most plausibly denotes a loss, the details of which are known only to a handful of people. In *Stones*, the trace is more tentative, less obvious semantically: large stones have been placed next to a tree, but do they indicate a place of rest, a particular encounter or debris from a construction site? Here, precise interventions have an imprecise meaning. Temporal disctinctions are both pinned down and upturned in Ribas' works. The past marks the present, and the future will be defined by the present.

In two recent series, temporality, the visible and the invisible, memory and oblivion are given an even greater role. *Invisible Structures* (2006) presents small sections of seemingly undifferentiated rainforest, with no visible horizon and no distinguishing features. And yet one cannot help feeling that they are hiding something else – the sign of another temporality or even reality. For this jungle grows on the ruins of an ancient Maya city, more powerfully present in its invisibility than through the actual fragments or simulated representation. *Mud* (2006), on the other hand, tragically remaps the theme of loss and mourning. The bland and uneventful photographs of a muddy landscape or hillside, few of which bear signs of human presence, are in fact images of a mass grave: the Guatemalan village Panabaj, which was buried in a vast mudslide in 2005.

JAN-ERIK LUNDSTRÖM

UNTITLED (BERLIN #7), 2003
FROM THE SERIES CITIES
C-PRINT, 120 X 94 CM (47¼ X 37 IN.)

UNTITLED, 2001–2
FROM THE SERIES LONDON
C-PRINT, 130 X 100 CM (51⅛ X 39⅜ IN.)

UNTITLED, 2001–2
FROM THE SERIES LONDON
C-PRINT, 130 X 100 CM (51⅛ X 39⅜ IN.)

UNTITLED, 2001–2
FROM THE SERIES LONDON
C-PRINT, 130 X 100 CM (51⅛ X 39⅜ IN.)

UNTITLED, 2001–2
FROM THE SERIES LONDON
C-PRINT, 130 X 100 CM (51⅛ X 39⅜ IN.)

UNTITLED (INVISIBLE STRUCTURES #12), 2006
C-PRINT, 155 X 120 CM (61 X 47¼ IN.)

JOHN RIDDY

born in 1959 in Northampton, UK
lives and works in London

WWW.FRITHSTREETGALLERY.COM WWW.GALERIES.NL/ANDRIESSE

John Riddy studied painting at London's Chelsea School of Art and began taking photographs to document other painters' canvases and sculptures. Space is Riddy's subject, and for him the task is to resolve the complexities he finds in the built environment and in landscapes. He first came to critical attention in the early 1990s with his functional black-and-white pictures of unpopulated architectural spaces. An iconic work from this period is *New York 1994*, which depicts a monumental hall in Grand Central Terminal – made strangely memorable due to the presence of a chandelier. Such work encouraged inevitable comparisons with the 'straight photography' of Eugène Atget, Bernd and Hilla Becher, and Walker Evans, who all to some extent made the cultural vestige their subject. In fact, Riddy's work of that time bears closer resemblance to that of the poetic photographer of buildings and interiors, Edwin Smith.

In 2000 Riddy found new challenges in the work of literary adaptation or interpretation. His key book and touring exhibition *Praeterita* takes its name from the autobiography of the Victorian art critic John Ruskin. The project, which comprises twenty-eight photographs, involved travelling to some of the landscapes, cityscapes and interiors encountered by Ruskin. Each picture refers to a passage from the book in which Ruskin movingly recaptures memories from his life. The sequencing of images in Riddy's work demonstrates his conceptual sophistication. The *Praeterita* pictures are characterized by the detached –

Riddy once called it 'reticent' – approach of earlier work. Number 21 in the series, titled *The Feasts of the Vandals*, is a view of a deserted English beach at that time of day when shadows lengthen. The eye is led to the middle of the horizon where the row of beach huts and the shoreline converge. Before our eyes, countless sets of footprints are preserved by the sand, stretching to infinity. Somehow one can't imagine Riddy intruding into the scene to leave his own trace for the record. The stillnesses, absent presences and contradictions of place continue to be his theme. Since 2004, with the exhibitions 'Recent Places' and 'Skies', Riddy has been taking colour pictures. Again, this encompasses landscapes and cityscapes. Buildings, some photographed at night, are represented as deserted and as if there was something artificial about their appearance of permanence.

While Riddy has benefited from the recent revival of interest in 'styleless' photography, he lacks (and has no use for) the self-reflexive irony of much of it. By contrast, it could be said that his work aspires to something utopian: a purity or innocence that is outside art and outside time. In an interview of 1996 Riddy confessed to a romantic sensibility, 'if "romantic" means believing you can transform reality through representing it'. David Ryan sums up Riddy's achievement as 'allowing a free play of correspondences and connections to occur' between either side of the viewfinder.

DAVID BRITTAIN

UTRECHT, 2004
DIGITAL C-PRINT
47 X 59 CM (18½ X 23¼ IN.)

SHIN-FUJI (DINER), 2005
DIGITAL C-PRINT
47 X 59 CM (18½ X 23¼ IN.)

SHIN-FUJI (CROSS ROADS), 2005
DIGITAL C-PRINT
47 X 59 CM (18½ X 23¼ IN.)

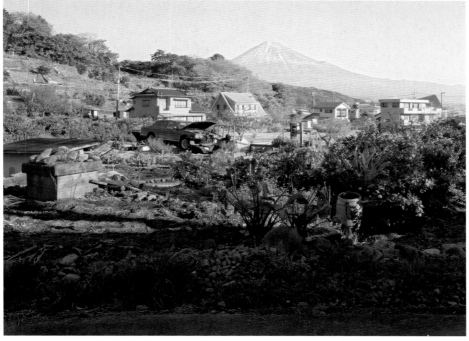

SHIN-FUJI (GARDEN), 2005
DIGITAL C-PRINT
47 X 59 CM (18½ X 23¼ IN.)

SHIN-FUJI (HILLSIDE), 2005
DIGITAL C-PRINT
47 X 59 CM (18½ X 23¼ IN.)

TORBJØRN RØDLAND

born in 1970 in Stavanger, Norway
lives and works in Hafrsfjord

WWW.RODLAND.NET

In one of his early series, *In a Norwegian Landscape* (1993–95), Torbjørn Rødland depicted native woodland scenes at different times of the year. Some of the pictures focused on particular details, such as snow-covered pines which seem too obtrusively oversized to represent the concept of well-balanced beauty. Other pictures in this series centre on a young man with long blond hair, posing casually in sunglasses; sometimes he is carrying a plastic bag, a succinct means of associating him with contemporary youth culture and consumer society. This project clearly alludes to the tradition of allegorical seasonal paintings as well as Romanticism and the theme of the wanderer, prompting a philosophical contemplation of nature; and yet there are elements of imperfection which, together with the figure of the young man and his links to the everyday world, strip these images of any idyllic pathos.

The young man is Rødland himself. In this early series, he explored the possibilities of contemporary perception and representation of nature and landscape, placing himself as protagonist at the centre of the picture. 'The photographer,' he writes, 'entered (and completed) the composition to make the exposure from within. The viewer (standing before the image) was mirrored (by the *rückenfigur* in the image): the landscape had already been seen.'

In his later work too, the Norwegian forest acts as a framework or even as the central motif in the subtly ironic presentation of highly original pictorial worlds that encapsulate the clash between allegory and banality, between Romantic traditions and the worn-out clichés of yesteryear. Though present in a handful of individual photographs, it is mainly seen in series such as *Close Encounters* (1997), *Nudists* (1999) with its distinct touch of soft porn, and *Priests* (2000). In recent years, Rødland's work has also featured series of portraits and still lifes, with particular reference to elements of music and popular culture. He shows us music cassettes, signed baseballs, and still lifes with typical examples of the food culture common to young people all over the world. With these subjects, Rødland relativizes the ability of photography to represent any particular moment, whatever its genre: with subtle humour and aesthetic sensitivity, he seizes on a few of the many possibilities and arranges them into atmospheric pictorial worlds of his own choosing.

BARBARA HOFMANN-JOHNSON

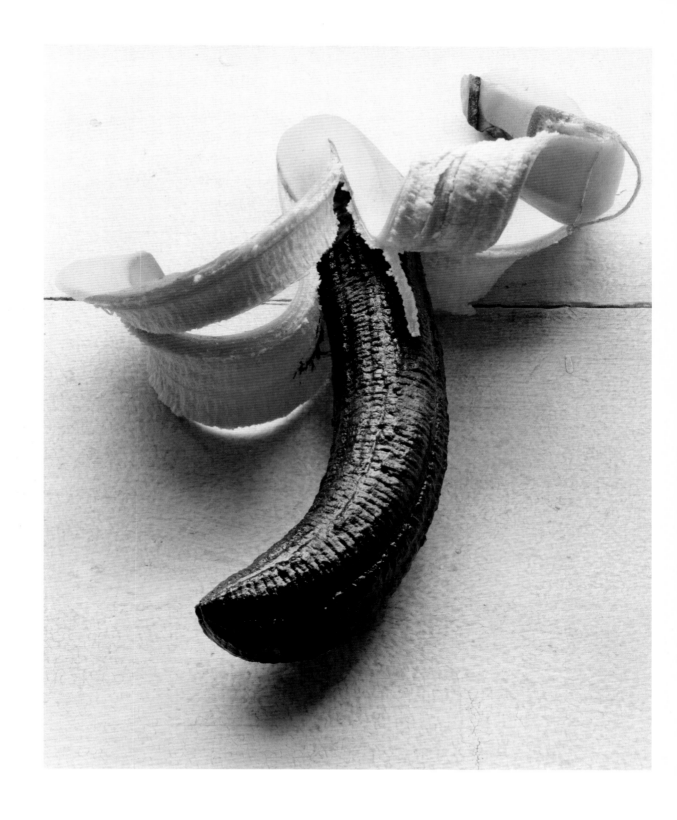

BANANA BLACK, 2005
C-PRINT, 50 X 40 CM (19⅝ X 15¾ IN.)

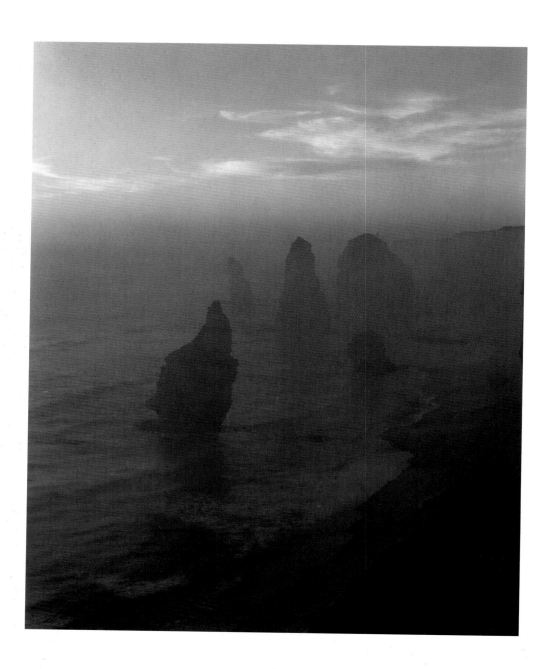

FIVE, 2000
C-PRINT, 105 X 80 CM
(41⅜ X 31½ IN.)

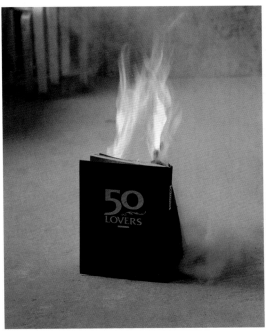

THE MORNING AFTER, 2005
C-PRINT, 140 X 110 CM
[55⅛ X 43¼ IN.]

BURNING BOOK, 2006
C-PRINT, 76 X 60 CM
[29⅞ X 23⅝ IN.]

THE NEW ARTIST, 1998
C-PRINT, 50 X 40 CM
[19⅝ X 15¾ IN.]

PRIEST NO. 2, 2000
C-PRINT, 76 X 60 CM
[29⅞ X 23⅝ IN.]

RICARDA ROGGAN

born in 1972 in Dresden, Germany
lives and works in Leipzig

WWW.EIGEN-ART.COM

In just a few words, Ricarda Roggan sums up her own method: 'Basically the principle is always the same: A substance is dug out of the deposits of history, carried into a particular room, and there looked at in the light.' What Roggan is indicating in this laconic description is not just her artistic programme, but also a shift of perspective within her work from the staging to the representation of rooms.

As with a number of the young artists who trained at Leipzig's Hochschule für Grafik und Buchkunst in the late 1990s, Roggan discovered a broad area of exploration in the many relics of history. In early work such as the series *Stuhl, Tisch und Bett* ('Chair, Table and Bed', 2001–2), she developed a working method which combined the tracking procedures of the installation artist with the precise image-making of the photographer. Roggan collected items of furniture and other objects which she had found in abandoned factories, left over from the defunct German Democratic Republic, and transplanted them just as she had found them into empty rooms, some of which she had created for this purpose. In the large-format photographs of these compositions, the objects – thanks to their spatial isolation and reduction – take on an enhanced presence and display their true essence.

Roggan's work from 2005 and 2006 focuses on empty rooms whose functional architectural forms are still redolent of their former collective nature. Neither the dark photos of floors in the series *Attika* ('Attic'), nor the claustrophobic chambers in the series *Schacht* ('Shaft') contain objects that reveal anything about their individual histories. Any obtrusive marks or disturbing elements seem to have been eradicated. Through such deliberate interventions, the artist progressively changes these old rooms into places of abstraction, where the structural network of wooden beams or the open spaces of the bricked-in windows or cemented floors take on a metaphorical aspect: the past does not lie visibly before our eyes, but its history remains an image to be constructed. Taken with a large, special purpose analogue camera, which in effect acts as a darkroom, these photographs are essentially architectural since their subject is the representation of the rooms themselves. It is not by chance that the network of threads in Roggan's *Stall* is reminiscent of the focusing screen of a camera. The processes of emptying and reducing, together with the artistic staging carried out beforehand, are the link that binds all her works and, in this age of digital 'realities', endows them with their special quality. Indeed, it may be said that this interweaving of conceptualization and authenticity, of cool detachment and personal engagement, with the existing objects and architectures left over from our own time, give her a special place in the contemporary ranks of constructive photographers.

FLORIAN EBNER

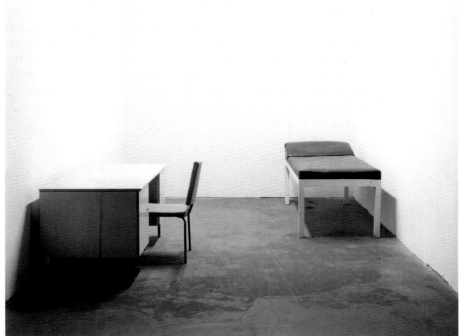

DREI STÜHLE UND EIN TISCH, 2002
C-PRINT, 100 X 125 CM (39⅜ X 49¼ IN.)

STUHL, TISCH UND LIEGE, 2002
C-PRINT, 100 X 125 CM (39⅜ X 49¼ IN.)

ATTIKA 1, 2005
C-PRINT, 160 X 194 CM (63 X 76⅜ IN.)

SCHACHT 3, 2006
COLOUR PHOTOGRAPH
142 X 162 CM (55⅞ X 63¾ IN.)

GUADALUPE RUIZ

born in 1978 in Bogotá, Colombia
lives and works in Zurich, Switzerland

WWW.LUPITA.CH

Guadalupe Ruiz's photographs are heavily influenced by her homeland of Colombia and her family, but also reflect the western European environment in which they are taken and the mass-media clichés of Colombia and Latin American culture that most observers bring with them when they look at her work. She often leaves onlookers in a state of uncertainty as to whether these are representations of their own preconceptions or of things as they really are. This is particularly striking in her numerous portraits of men and women. For many people, Latin America is the epitome of macho culture. At first sight, Ruiz's pictures seem to confirm this notion: the women look hot-blooded, and the men hard-nosed. On closer inspection, however, one realizes that these images have clearly been staged and the poses, far from conveying any natural expression, are in fact almost caricatures. What exactly constitutes reality or artificiality is simply not certain, and so the observer is left alone with his questions, which then force him to focus on his own modes of perception.

Even Ruiz's family portraits straddle this grey area between document and fiction, between neutral observation and targeted staging. Those that are obviously posed alternate with others that may well have been taken spontaneously. The photographs hint at stories without ever following a coherent narrative thread, and the unquestionable authenticity of individual images is undermined by the overall structured nature of the series. Even with her cityscapes of the notorious drug centres of Medellín and Cali, the observer can't be quite sure of what he is looking at. Is she showing us a luxurious new, postmodern building simply because it corresponds to our idea of a drug baron's residence? Who else might be living in such a place? Unexpectedly, we find ourselves confronted by our uncertainties over what is real and what is not, because we can only think of these places in terms of the drug trade, along with vague images of massive social contrasts.

Ruiz's photographs show us how, in our globalized, media-saturated world, the borderlines between fiction and reality are becoming increasingly indistinct. We think we know our planet, but in fact all we do is faithfully swallow the images and scraps of information that are fed to us. Her work is, as much as anything, a commentary on the ambivalent role of images in the postcolonial present, and on our supposed familiarity with foreign realities which these images seek to inculcate into us.

MARTIN JAEGGI

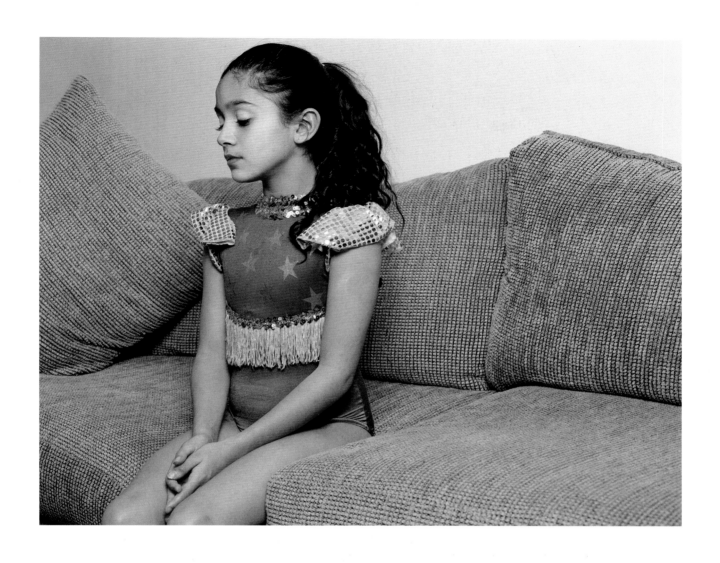

LUISA, 2006
FROM THE SERIES **HAZARDOUS REACTIONS**
COLOUR PHOTOGRAPH, 19.5 X 24.5 CM (7⅝ X 9⅝ IN.)

NIGGA NEVER NOW, 2006
FROM THE SERIES **HAZARDOUS REACTIONS**
COLOUR PHOTOGRAPH, 24.5 X 19.5 CM (9⅝ X 7⅝ IN.)

COLOMBIAN_CHIKA@YAHOO.COM, 2006
FROM THE SERIES **HAZARDOUS REACTIONS**
COLOUR PHOTOGRAPH, 24.5 X 19.5 CM (9⅝ X 7⅝ IN.)

PAN-AMERICAN CALEIDOSCOPE, 2006
FROM THE SERIES **HAZARDOUS REACTIONS**
COLOUR PHOTOGRAPH, 24.5 X 19.5 CM (9⅝ X 7⅝ IN.)

DON ALFONSO, 2007
FROM THE SERIES **LA BELLA SUIZA**
COLOUR PHOTOGRAPH, 25 X 20 CM (9⅞ X 7⅞ IN.)

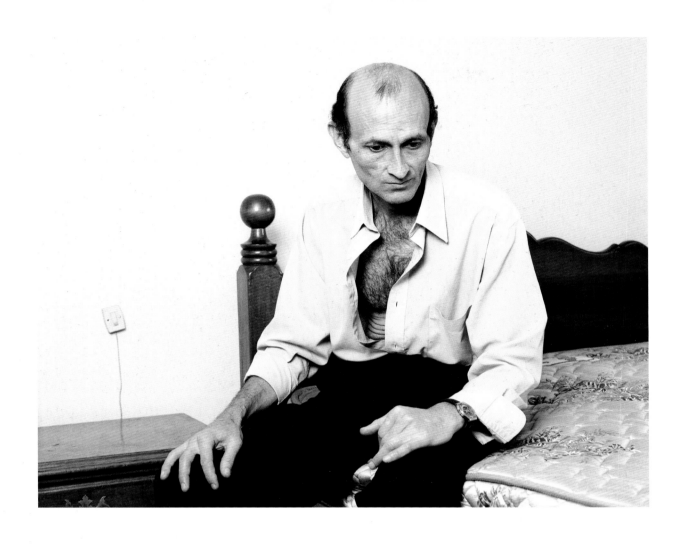

GONZALO DESGUALETADO, 2005
FROM THE SERIES **MISCELLANEOUS**
COLOUR PHOTOGRAPH, 19.5 X 24.5 CM (7⅝ X 9⅝ IN.)

ANRI SALA

born in 1974 in Tirana, Albania
lives and works in Berlin, Germany, and Paris, France

WWW.GHW.CH WWW.JOHNENGALERIE.DE

Is Anri Sala a documentarian or a video artist? While the young Albanian boasts an award-winning career as both (having taken the prize for best documentary at the 2000 Williamsburg Brooklyn Film Festival and the Young Artist Prize at the 2001 Venice Biennale), his work veers between fact and fiction, between perception and feeling, inhabiting a perpetual state of being neither here nor there. His 2004 survey exhibition for the Musée d'Art Moderne de la Ville de Paris was entitled 'Entre chien et loup' in French, and 'When the Night Calls it a Day' (literally 'between dog and wolf') in English, referring to that stage at dusk when perception and recognition break down. In the catalogue, the artist described his wish 'to extend this moment of time that normally lasts 15 minutes to the whole time of the exhibition, hour after hour and day after day'.

Sala's work is often filmed in half-light or near-darkness, as in *Ghostgames* (2002), in which a handheld camera follows the dizzying trajectories of translucent ghost crabs as they are chased up a beach in North Carolina by young boys with flashlights. The game involves the creatures vainly trying to flee the bright lights, only to be diverted through the legs of the opponent, resulting in a hushed exclamation of 'Goal!' The sweeping, strobing yellow light that disturbs the black screen is Sala's own sophisticated visual Morse code, switching between reality and abstraction as quickly as between light and dark. Similarly, occasional bursts of fireworks light up the eight-minute video

Mixed Behaviour (2003), in which a DJ plays music from a rooftop for a New Year's celebration in the Albanian capital. While the timing of the pyrotechnics display seems controlled by the choice and rhythm of the music, the shadowy figure could just as easily be a soldier or a journalist, sheltering from the rocket bursts above the rooftops.

Sala's political agenda is half-hidden, too, often obscured by the medium of language rather than shadow. In an earlier documentary film, *Intervista: Finding the Words* (1998), Sala attempts to restore the lost soundtrack to an old reel of film showing his mother at a 1970s Communist Youth of Albania rally. His mother's incredulity at her younger self's militant diatribe and idealistic babble lead her to believe that ultimately the words 'say nothing' to her. She urges her son to 'always question the truth'. In *Làkkat* (2004), which was shot in Senegal, it is especially clear that thoughts and words cannot easily be translated across different languages, cultures and times. Enveloped in semi-darkness, one of two African schoolboys hesitantly repeats unfamiliar words enunciated by his teacher in their native tongue, Wolof. Although some words sound French, there is ultimately no discernible meaning and the subtitles are futile. Instead, the rhythmic sound and captioning lend the film a staccato, abstract poetry. As with much of Sala's work, the experience is one of trying to make out shapes through patterned glass.

OSSIAN WARD

UNTITLED (TREE I), 2003
BLACK-AND-WHITE PHOTOGRAPH ON BARYTA PAPER
106 X 74 CM (41¾ X 29⅛ IN.)

NO BARRAGAN NO CRY, 2002
COLOUR PHOTOGRAPH
157.7 X 224.8 CM (62½ X 88½ IN.)

UNTITLED (SILENCE SINCE), 2002
BLACK-AND-WHITE PHOTOGRAPH ON BARYTA PAPER
110 X 157 CM (43¼ X 61¾ IN.)

FRANK VAN DER SALM

born in 1964 in Delft, Netherlands
lives and works in Rotterdam

WWW.FRANKVANDERSALM.COM

With an interest in the urban environment, modern buildings and public spaces of transition (such as metro stations, parking lots and check points), Frank van der Salm craftily transforms three-dimensional architecture into radiant, almost otherworldly images. His mostly unpeopled pictures evidence human intervention and exodus, but without any documentary pretence. Indeed, it is almost impossible to locate his pictures precisely, as he includes only the barest hints of specificity. Commissioned work is a notable exception, such as his pictures of Seattle Public Library, designed by Rem Koolhaas for the Office for Metropolitan Architecture.

One of the first things that strikes you when looking at van der Salm's photographs is his variety of styles. The collection of his work is like a photography sampler which could well be used as a teaching aid on the technical capabilities of the camera, making it possible to read his work in the broader context of other photographers who have explored architecture in recent decades. His photographs alternately recall the soft-focus lyricism of Uta Barth and Jörg Sasse, as well as Thomas Ruff's explorations of buildings by Mies van der Rohe; the compressed architectural density in images by Barbara Crane and Michael Wolf; the cool, clinical precision of Candida Höfer and Thomas Struth; and the model-like effects achieved with shallow depth-of-field in the work of Esteban Pastorino Diaz and Toni Hafkenscheid. Van der Salm's innovation lies in his willingness to allow all of these styles to exist side-by-side. Like the many modernist architects who promoted a privileged consideration of the particular requirements and characteristics of a project and its materials over the habitual application of a formal agenda, van der Salm approaches each subject as a new challenge and renders it in a way that highlights its dominant and unique characteristics. He seems to revel in photography's ability to aestheticize and uses his technical choices like a box of tools, achieving variously pleasing effects in images of buildings that hint at the utopian origins of their design. In this way he honours the architecture. His photographs do not strictly record but often flatter, and make even ordinary places seem important and appealing.

Like architecture, a photograph is a kind of threshold: to stand in front of its flat surface and read it as inhabitable space requires an unanchored mind. A picture provides a particular translation of space, one that we do not physically move through but our imaginations are able to roam. Like a building, a photograph, when experienced, is not an empty vessel – it is not inert. Since they do not allow us to settle on one mood or idea, van der Salm's pictures illustrate that photographs are highly selective interpretations of reality. They ultimately shift our attention away from the photograph as an object and toward our own perceptual process.

KAREN IRVINE

BLOOM, 2006
KODAK ENDURA LAMBDA PRINT,
PERSPEX, DIBOND
150 X 120 CM (59 X 47¼ IN.)

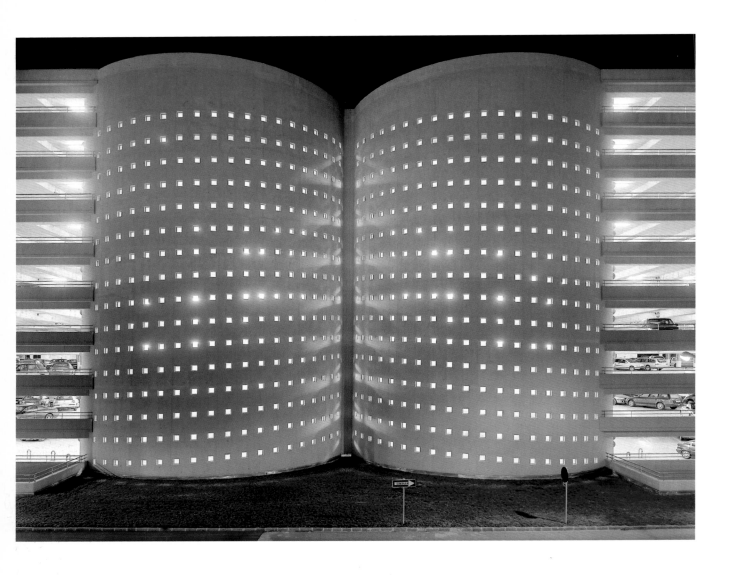

PARK, 2002
KODAK ENDURA LAMBDA PRINT,
PERSPEX, DIBOND
120 X 150 CM (47¼ X 59 IN.)

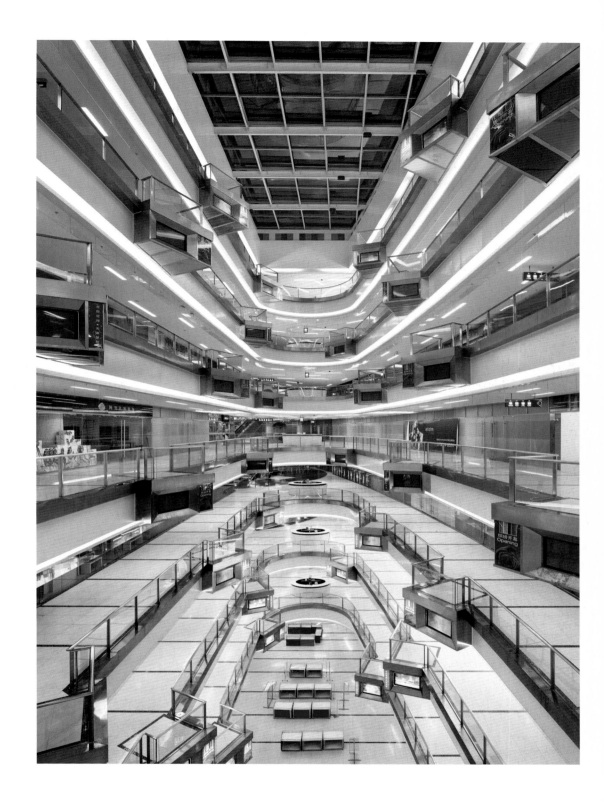

ARCADE, 2006
KODAK ENDURA LAMBDA PRINT,
PERSPEX, DIBOND
170 X 120 CM (66⅞ X 47¼ IN.)

DIANA SCHEUNEMANN

born in 1975 in Germany
lives and works in London, UK, and Zurich, Switzerland

WWW.DIANASCHEUNEMANN.COM WWW.SCHEUNEMANNART.COM

As one might gather from her two websites, there would appear to be two versions of Diana Scheunemann: one is the successful fashion, lifestyle and advertising photographer, working for such high-profile clients as *Elle*, Levi's, Sloggi, *The Face* and Rank; the other is the young woman with a slightly diffident approach, who with her photo and video projects tries to make sense of the most intimate aspects of her own life and that of the people around her. Although the two Scheunemanns are of course inextricably linked to each other, they do seem to speak a different language. Most texts tend to repeat the anecdote reported by the Zurich journalist Christof Moser in the monograph published by Damiani: 'I've booked a couple of guys in a hotel room. They're going to wank while I take their picture. Great idea, don't you think?' Generally, however, in her advertising photos, portraits of celebrities, fashion and lifestyle pictures and books, her tone is a little more moderate, and she explicitly distances herself from pornography: 'There's a huge difference between the pictures I shoot and porn, even if my models sometimes do sexy stuff and are naked. Pornography is only about sex and sexual organs. I take pictures that show life and fun and energy.'

Scheunemann has certainly had a good look at the photographic scene, not only during her training at the Hochschule für Gestaltung und Kunst in Zurich, but also (and particularly) during the time she worked as production coordinator and assistant to other professional photographers. She knows the classic exponents of fashion and glamour, Guy Bourdin and Helmut Newton; she knows Terry Richardson, Richard Kern and many others, and she admires the snapshot technique of Wolfgang Tillmans. Among her most successful works are the photos in which she combines these influences and then reworks them in her own style.

Scheunemann explains her projects on www.scheunemannart.com. If you are looking for sex talk, you won't find it. She describes herself as a conceptual artist, though a sensual, life-loving, not too serious one. In her project *Behind My Face* (1999 onwards), for instance, she takes one self-portrait every day, generally using the same technique, dating each one and putting each year's portraits in a book – rather like On Kawara. In another ongoing *View Project*, as well as in a video diary, she explores the intimacy associated with photographing friends. 'With this strategy I like to explore the dichotomy between performance and reality, the staged and the improvised.' Since 2005, she has been working on *I Was Here*. These are also self-portraits, but she does not figure in the pictures, in contrast to *Remember Me* (1996), where she photographed herself in a photo booth in Zurich, duplicated the pictures, and made a memory game out of them. '[This] playfully symbolises my fear of loss. The idea is that you could add to it as much as you wanted to.' This might be a good summing-up of an oeuvre that is bursting with the artist's *joie de vivre*.

ERIK EELBODE

CLOWN LICKING, 2006
DIGITAL C-PRINT, ALUMINIUM
100 X 72 CM (39³⁄₈ X 28³⁄₈ IN.)

Old Wanker 2 Has Come

I like to show my naked body. I like being absolutely naked, that's why I go to a specialist and have my pubic hair removed.
Sometimes I work as a naked cleaner.
I just love to be naked in front of people who understand and appreciate that. I like to do what they want me to do.

Funny Wanker With A Hard On

BEFORE
I would like to do the shoot with you. But I have no idea how I will react.
When we take the pictures I hope a woman will be attracted by the sound of the camera and the flashes. Carefully she will open the curtain of the fitting room and look inside, stunned! Watching me play with my body.
After a while she relaxes and starts to take her clothes off. You continue taking pictures as we start to touch each other softly. In between the flashes of your camera we enjoy the intimacy and the sex.

AFTER
I really enjoyed doing the shoot. I was quite nervous about being naked in a fitting room and you being in there with me did not help. I had butterflies in my stomach and enjoyed the moment....

OLD WANKER 2 HAS COME, 2002
DIGITAL C-PRINT, ALUMINIUM
100 X 71 CM (39⅜ X 28 IN.)

FUNNY WANKER WITH A HARD ON, 2002
DIGITAL C-PRINT, ALUMINIUM
100 X 76 CM (39⅜ X 29⅞ IN.)

Old Wanker On A Couch After Coming

I found it fascinating that you came into the
hotel room with me, a complete stranger
and took pictures whilst I was enjoying the
loveliest, nastiest thoughts.
I know a nice, very clean and sympathetic
swingerclub...
just one mail is enough...and I'll be there with
you...smile!
Oh while we are chatting, guess what? I would
just love to give a man a blow job. Would you
shoot it? Could you find the man?

A MONTH LATER
I would just love to meet you now in my office
for a glass of wine. If you like I would serve you
naked. Or how about I drink my glass out of
your pussy? ;-))

Baby Wanker In His Bed

Do you like my waterbed?
Are you thinking about having sex on it?
I want to get your clothes off while making the
pictures, and then you are as naked as me and I
touch and stroke you all over until your nipples are
rock hard. I lick your pussy with my pierced tongue.
Are you shaved? I want to shave you in the bath.
Ohhh it's excellent that you are nude now.
Unfortunately this is just a fantasy. Let's do it again!

OLD WANKER ON A COUCH AFTER COMING, 2002
DIGITAL C-PRINT, ALUMINIUM
100 X 73 CM (39⅜ X 28¾ IN.)

BABY WANKER IN HIS BED, 2002
DIGITAL C-PRINT, ALUMINIUM
100 X 76 CM (39⅜ X 29⅞ IN.)

BRUNO SERRALONGUE

born in 1968 in Châtellerault, France
lives and works in Paris

WWW.BRUNOSERRALONGUE.COM

For nearly fifteen years, Bruno Serralongue has recorded political events and social situations, using a documentary approach that seeks to circumvent the machinery of the mass media, whose images now represent a kind of global currency even though they do not correspond to reality. A starting-point of his work is the *fait divers* – the news that appears under 'miscellany'. For the photographs in this series (1993–95), he sought out the scenes of events reported in the local section of the daily newspaper *Nice-Matin*. His large-format photographs of the empty settings create a sharp contrast to the rhetorical sound and fury of the news items themselves. For two other projects, he exchanged the view through his special purpose camera, which he uses for most of his work, for the first-hand view of a reporter, taking on a role at the newspapers *Corse-Matin* (1997) and *Jornal do Brasil* (1999) for a short period. The artistic yield from these enterprises consists of heterogeneous prints singled out by the papers for publication.

In the second half of the 1990s, Serralongue independently developed an approach which might be called an extension of the documentary style, but his exploration of specific national or local cultures is here expanded into a global perspective. At his own expense, and without any press accreditation, he travelled to such events as the transportation and burial of Che Guevara in Cuba (*Homenaje*, 1997) and the Zapatista summit in the Chiapas Region (*Encuentro*, 1996). These wide-angled scenic photographs have very little in common with the semantically charged works of photojournalism; they depict events from a different perspective and interweave them with on-the-spot social structures, incorporating the vast apparatus of the media that has been hurriedly put into place.

Serralongue's more recent works highlight shocking scenes that we almost take for granted. The common thread here is his unyielding focus on the almost identical weekly demonstrations of illegal immigrants on the Place du Châtelet in Paris (2001), or the fences holding refugees in the transit camp at Sangatte, in northern France (*Risky Lines*, 2007), or the fate of a Korean worker in France who was trying to track down the head of the bankrupt car manufacturer Daewoo. From such single events emerged the series *Corée* ('Korea', 2001) and the art book *Rapport de Forces* (2004), a collection of photographs and articles on South Korea during an age of maximized profit-making.

Perhaps it is because of the combination of conceptual elements with an emphatically slow and old-fashioned method of working, plus visual irritants such as blurring, *contre-jour* and dark shadows, that Serralongue is now able to adopt an authentic documentary approach which is, in the best sense of the word, critical. In many of his works, he has brought the classic subject of the 'event' back into focus, not as a decisive moment but as a political and social category.

FLORIAN EBNER

GROUPE (CANTONNIERS ET VILLAGEOIS, 12.08.2004), 2004
FROM THE SERIES **GROUPE DE TRAVAIL**
ILFOCHROME, 40 X 50 CM (15³/₄ X 19⁵/₈ IN.)

GROUPE (CNHTC, VOLVO TRUCK, JINAN, 13.08.2004), 2004
FROM THE SERIES **GROUPE DE TRAVAIL**
ILFOCHROME, 40 X 50 CM (15³/₄ X 19⁵/₈ IN.)

JUDGE NOT, SUPPORT SEXUAL PREFERENCE, WSF MUMBAI 2004, 2004
FROM THE SERIES **WSF MUMBAI**
ILFOCHROME, 125 X 156 CM (49¼ X 61⅜ IN.)

LUNDI 24 AVRIL 2006. ETAT DE MEXICO. MEETING DU DÉLÉGUÉ ZERO AU COLEGIO
DE CIENCIAS Y HUMANIDADES DE NAUCALPAN, 2006
ILFOCHROME, 156 X 125 CM (61 ⅜ X 49 ¼ IN.)

SHIRANA SHAHBAZI

born in 1974 in Tehran, Iran
lives and works in Zurich, Switzerland

WWW.BOBVANORSOUW.CH

Shirana Shahbazi's work explores the impact of pictorial representation in the construction of culture, religion and identity. Her work is based in photography but extends across various media, drawing extensively from her roots in both western and eastern cultures. In the well-received project *Goftare Nik/Good Words* (2000–1), which launched her career, she takes the city, surroundings and people of Tehran as her subjects and explores transcultural attitudes and habits in present-day Iran, focusing especially on where they collide – and blend – with symbols of traditional Islamic culture: a family of four enjoys candyfloss in an amusement park, a little girl wearing jeans and a T-shirt rollerblades, a bride wearing a western-style dress strikes a clichéd pose next to a flowering tree. An empty soccer stadium, with portraits of the Ayatollahs Khomeini and Khamenei looming above the stands, demonstrates the omnipresence of the ruling regime, while images of construction sites and new developments capture the rapid growth and modernization of the city.

Within the *Goftare Nik/Good Words* installations, Shahbazi incorporates painted copies of her photographs made by Iranian billboard painters whom she has hired precisely for this purpose. By subjecting her vision of ordinary people and scenes to the hyper-real language of billboard propaganda, which is normally used to endorse commercial products or celebrate religious martyrs, Shahbazi offers an alternative iconography. Combined with her photographs, these paintings poignantly explore the complexities of representation as they deconstruct officially sanctioned imagery and celebrate everyday heroes. Recently, Shahbazi has taken photographs

during her travels around the world – in Shanghai, Berlin and New York – as well as Switzerland. These pictures expand the issues her work raises about representation across cultures and continue to include diverse photographic subjects and styles, including tourist snapshots, street photography and travel photos. Within the installation of these works, Shahbazi often still includes translations of her images made by Iranian billboard painters. Current work includes a series of classically beautiful portraits and still lifes with natural subjects such as flowers, fruit and insects, shot against a plain black backdrop. She has had some of these images woven into wool and silk carpets by Iranian rug makers. Like her collaborations with the billboard painters, these unconventional prayer rugs continue her strategy of probing traditions of visual representation by placing images of ordinary people and scenes in places where pictures are usually used to communicate grand themes.

The title *Goftare Nik/Good Words* comes from the Zoroastrian tenet 'good thoughts, good words, good deeds'. Like words, Shahbazi's images are constructed bearers of meaning. By keeping her images varied and ambiguous, translating them into different media, and displaying them as floor-to-ceiling mosaics, she encourages viewers to make their own connections and demonstrates that meaning is always unstable. In her work Shahbazi lays bare the image's ability to construct identity, and to both undermine and reinforce cultural stereotypes. She thus creates an auspicious opportunity to investigate the trappings of our visual and cultural codes.

KAREN IRVINE

STILL LIFE-11-2006, 2006
FROM THE SERIES **FLOWERS, FRUITS AND PORTRAITS**
C-PRINT, ALUMINIUM, DIMENSIONS VARIABLE

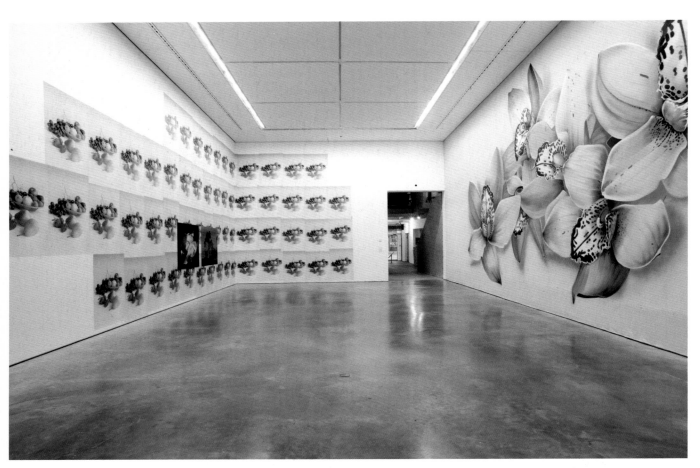

EXHIBITION VIEW **SHIRANA SHAHBAZI**,
MILTON KEYNES GALLERY, 2006

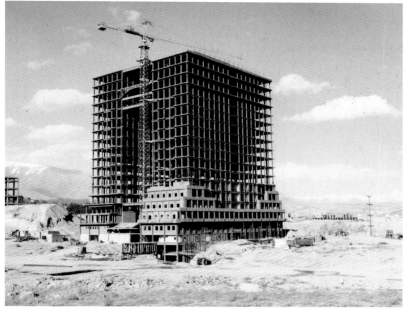

WOMAN-01-2004, 2004
FROM THE SERIES **PAINTED DESERT**
C-PRINT, ALUMINIUM, DIMENSIONS VARIABLE

TEHRAN-03-2000, 2000
FROM THE SERIES **GOFTARE NIK/GOOD WORDS**
C-PRINT, DIBOND, DIMENSIONS VARIABLE

ANN-SOFI SIDÉN

born in 1962 in Stockholm, Sweden
lives and works in Berlin, Germany

WWW.BTHUMM.DE WWW.CHRISTINEKOENIGGALERIE.COM

Tackling issues of violence, control, surveillance and the breakdown of reason, Ann-Sofi Sidén's work is orchestrated through spatial and sculptural installations, and videos. Her kaleidoscopic oeuvre, which cannot be sorted into a neat, thematic order, nevertheless suggests some notion of a system to be present: a real or fictitious system against which a protagonist struggles, often the artist herself.

Codex (1993–2005) investigates and re-enacts, through staged photographs, historical forms of punishment against women. *It's by Confining One's Neighbor that One is Convinced of One's Own Sanity* (1995), the first work to be generated out of the artist's encounter with psychiatrist Alice E. Fabian, is a video piece which reconstructs the paranoid state of control that this psychiatrist maintained while living under isolated conditions in the middle of New York City. As an accompaniment, Sidén produced the suggestive installation *Would a Course of Deprol Have Saved van Gogh's Ear?* (1996), based exclusively on advertisements for psychopharmacological drugs in Dr Fabian's vast collection of psychiatry magazines.

Sidén's video installation *Who Told the Chambermaid?* (1998) imposes visual surveillance throughout all the rooms in a single hotel, transmitted and managed via seventeen CCTV cameras. Here, a documentary pretence is seamlessly integrated with fiction: in some rooms genuine events are captured as they unfold; in others,

activities are staged. But there is nothing to distinguish the former from the latter. Although its precise origins are unknown, it is usually suggested that *Queen of Mud* (since 1988) was also born out of the Fabian experiences, since the Queen of Mud (aka QM) is first discovered under the bed of a female psychiatrist. This creature, smeared in mud, appears in several videos as a kind of societal subconscious, an uncontrollable and wild anti-queen who always challenges norms and is known for her ability to 'move into people's dreams'. The character is finally honoured in *QM Museum* (2004), a collection of videos in which her life is (incompletely) narrated.

Warte mal! (1999), consisting of filmed interviews with prostitutes and additional video material from a Czech town close to the German border, may be Sidén's most straightforward documentary work, but it is also her most complex meditation on issues of power, gender, control and freedom. Landing in the heart of the prostitution industry, *Warte mal!* is a remarkably layered and multifaceted report on the living conditions and systems surrounding prostitution today. In *3MPH* (2003) the artist returns as protagonist. It features a 25-day horseback ride through Texas, USA, and examines the complex social and cultural realities of the southern state.

JAN-ERIK LUNDSTRÖM

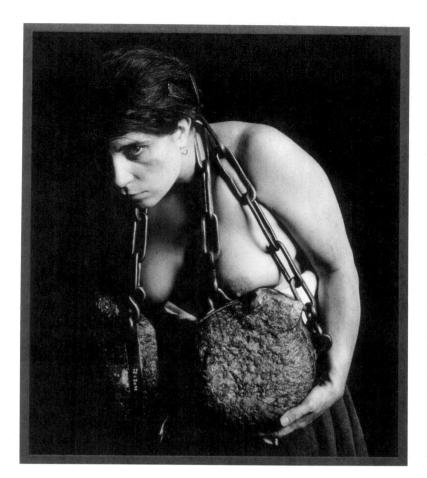

THE CITY STONES

*The city stones were used to punish wom•n who committed
adultery. With the stones around her neck, the convicted
woman was led around the city and to the city gates, where
she was expelled forever.*

** The stones and chain weigh 26 kilos (57 lbs.)*

THE CITY STONES (STADTSTEINE), 1993–2005
FROM THE SERIES **CODEX**
GELATIN-SILVER PRINT AND TEXT PANEL
PICTURE: 90 X 75 CM (35⅜ X 29½ IN.)
TEXT PANEL: 120 X 37 CM (47¼ X 14⅝ IN.)

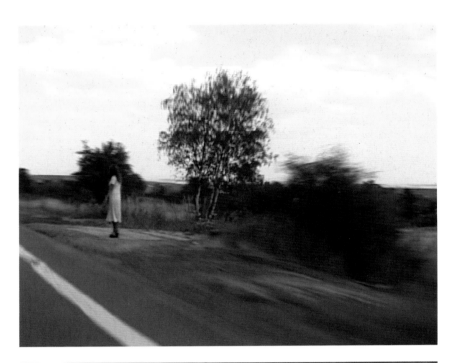

PINK ANGEL, 1999
VIDEO STILL FROM **WARTE MAL!**

SUMMER CURVE, 1999
VIDEO STILL FROM **WARTE MAL!**

TWO GIRLS, 1999
VIDEO STILL FROM **WARTE MAL!**

4 SUMMER GIRLS, 1999
VIDEO STILL FROM **WARTE MAL!**

SANTIAGO SIERRA

born in 1966 in Madrid, Spain
lives and works in Mexico City, Mexico

WWW.SANTIAGO-SIERRA.COM

Santiago Sierra's thought-provoking work in film, photography and performative sculpture courts danger, invites criticism and has made the artist something of an art world pariah. Since enjoying a sustained period of global success and attention, culminating in his work for the Spanish Pavilion of the 2003 Venice Biennale, Sierra seems to have been pushing the boundaries of taste and acceptance ever further. In *245 Cubic Meters* (2006) he invited visitors to don gas masks and enter a synagogue near Cologne that he had filled with noxious smoke from six car engines. In 2007 he installed four running motors in a Venezuelan gallery and pumped their exhaust fumes outside (*Four Black Vehicles with the Engine Running Inside an Art Gallery*). These seemingly opposing pieces were both viscerally interactive installations, one reminding us of the Jews exterminated in Nazi death chambers during the Holocaust, and the other highlighting our current assault on the environment.

Beyond Sierra's desire to 'create difficult art to deal with painful episodes in history', his work has always tackled controversial socio-political subjects, many of which reflect harshly on contemporary society as well. Indeed, his earliest architectural pieces involving footbridges, walls and containers created similarly suggestive spaces, encompassing such broad issues as the illegal movement of people, the cramped and unfair working conditions of minimum-wagers, as well as the general conditions of showing art in a museum or a public place. These works co-opted the aesthetic of Minimalism, but incorporated the process and stages of their making, often in titles such as *The Wall of a Gallery Pulled Out, Inclined 60 Degrees from the Ground and Sustained by 5 People* (2000).

Sierra's much-maligned 'exploitative' tactics are entirely necessary for the work's success, because remunerating Chechen refugees, unemployed junkies or prostitutes to sit in boxes, masturbate or have a line tattooed across their back would not sufficiently highlight the plight of their economic substrata were it not for the presence of the artist's camera. However, he always documents his installations or happenings in respectful black-and-white photographs or on grainy film, both to ensure the work's gravitas and align his practice with the early conceptual and performance artists of the 1970s such as Robert Smithson, Bruce Nauman and Vito Acconci. In fact, these art-historical precedents place Sierra in a long line of artists that have portrayed the human body in various states of distress. His unflinching provocations of human endeavour have involved incessant acts of begging, standing, labouring, walking and chanting, but never acting. His performances are powerfully real, but by their very nature can only ever exist in the memory or in images of time past, documents that are not trophies but memorials.

OSSIAN WARD

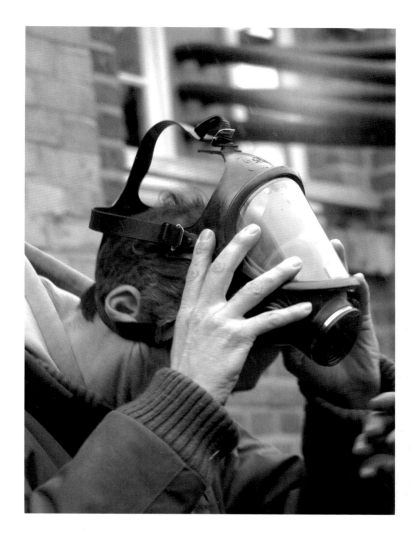

245 CUBIC METERS. STOMMELN SYNAGOGUE,
PULHEIM, GERMANY. MARCH 2006
PHOTOGRAPHS DOCUMENTING THE ACTION IN
8 LARGE-FORMAT FRAMES, EACH C. 30 X 21 CM
(11¾ X 8¼ IN.) OR 21 X 30 CM (8¼ X 11¾ IN.)

245 CUBIC METERS. STOMMELN SYNAGOGUE,
PULHEIM, GERMANY. MARCH 2006
PHOTOGRAPHS DOCUMENTING THE ACTION IN
8 LARGE-FORMAT FRAMES, EACH C. 30 X 21 CM
(11¾ X 8¼ IN.) OR 21 X 30 CM (8¼ X 11¾ IN.)

EL DEGÜELLO, BATTERY PARK. NEW YORK, UNITED STATES. OCTOBER 2003
BLACK-AND-WHITE PHOTOGRAPH, 220 X 150 CM (86⅝ X 59 IN.)

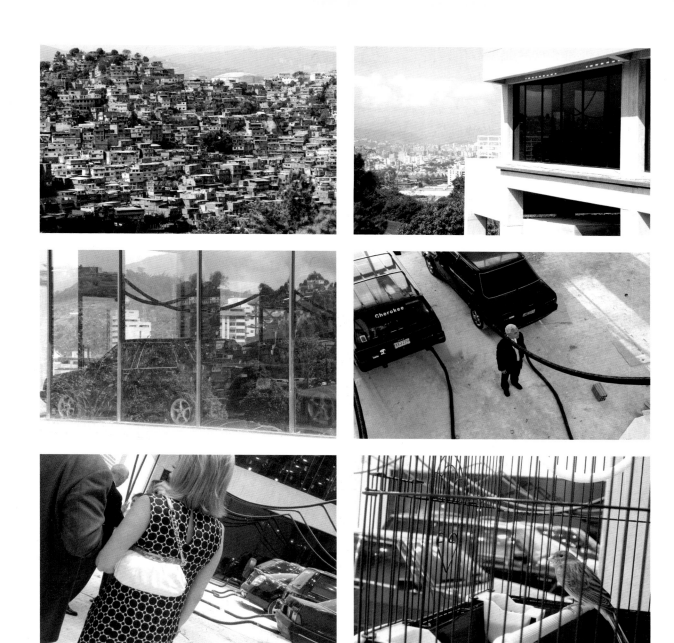

FOUR BLACK VEHICLES WITH THE ENGINE RUNNING
INSIDE AN ART GALLERY. SALA MENDOZA. CARACAS,
VENEZUELA. FEBRUARY 2007
PHOTOGRAPH
DIMENSIONS UNKNOWN

ALEC SOTH

born in 1969 in Minneapolis, USA
lives and works in Minneapolis

WWW.ALECSOTH.COM

Between 1999 and 2004, Alec Soth made several trips by car southwards from Minnesota along the Mississippi to Louisiana, and he photographed the people and landscapes that he saw on the way. The result was a precise, but at the same time very personal and poetic photographic travelogue. The myths surrounding the banks of the longest river in North America have inspired many other artists, writers, filmmakers and musicians over the years. With his *Sleeping by the Mississippi*, Soth offers us a subjective view of the places and their inhabitants. With lyrical fragments bound together by the flow of the river, this first comprehensive collection gives a refreshing new impetus to the tradition of travel photography. In a similar fashion, a second major project called *Niagara* (2006) depicts the region around the great waterfall on the Canadian border as the setting for collective desires. For generations, this has been the dream destination of honeymooners, and he shows us the lovers, but also the run-down motels and neglected industrial landscapes, in stark contrast to the might of the cascading waters. Within this series, Niagara itself

acts as a metaphor for love and passion, but also a symbol of its death throes and its transience.

With part narrative and part documentary background, Soth's long-term studies develop an aesthetic and artistic language of their own. As a member of Magnum (since 2004), Soth is a typical example of the interdisciplinary expansion of the medium that rejects the traditional distinction between 'applied' and 'artistic' photography. Born and raised in Minnesota, he attended the Sarah Lawrence College with a view to becoming a painter, but after hearing a lecture by the photographer Joel Sternfeld, he turned his attention exclusively to photography. His colour photos have been published in *Fortune* and in *The New Yorker*, and show the clear influence of American social reportage, as well as being reminiscent of the work of Walker Evans and Robert Frank. Among other exhibitions, his pictures have been shown at the Whitney Biennial in New York and the Bienal de São Paolo, and they are also handled by internationally prestigious galleries in Berlin and New York.

FELIX HOFFMANN

MELISSA, 2005
DIGITAL C-PRINT
127 X 102 CM (50 X 40⅛ IN.)

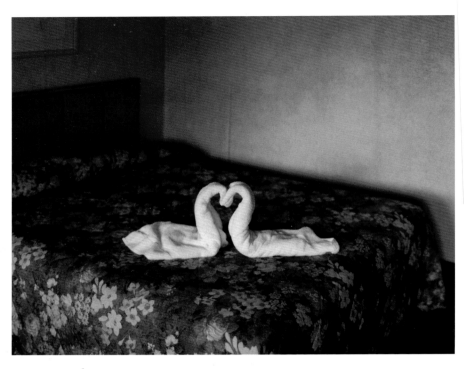

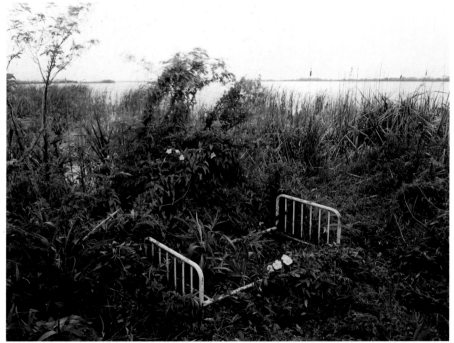

TWO TOWELS, 2004
DIGITAL C-PRINT, 61 X 76 CM (24 X 29⅞ IN.)

VENICE, LOUISIANA, 2002
C-PRINT, 102 X 127 CM (40⅛ X 50 IN.)

CHARLES, VASA, MINNESOTA, 2002
C-PRINT, 127 X 102 CM (50 X 40⅛ IN.)

HEIDI SPECKER

born in 1962 in Damme, Germany
lives and works in Berlin

WWW.HEIDISPECKER.DE

It might be argued that a building is a building, but a building that is viewed through Heidi Specker's lens becomes a series of subtle variations on the themes of surface texture, form and colour. Through her digital manipulation of large-format images, Specker translates modern edifices into soft-focus, impressionistic simulations of their tough and hard realities. The cladding and windows lose their utilitarian solidity and become webbed or meshed patterns, much more gentle than the geometrically conceived structural elements from which they derive. Like fantasies snatched from a dream, these dematerialized images of modernist tower blocks, offices, banks and apartments take on a new existence. Developing new identities under Specker's influence, they suggest narratives that have no parallels in the commerce of the city from which they sprang, and might seem more at home in a scene from William Gibson's *Neuromancer*.

Grids, tessellations, meshes and optical patterns dominate the visually dynamic images from Specker's series *The Theory of Particles* (1998). This exhaustive visual tour of the façades of newly emerging buildings in post-Wall Berlin, with their divergent architectural vocabulary, is in no way documentary but rather a fantasia on the theme of 'the architect's dream'. Here, the viewer becomes lost in a dazzling and visually beguiling sequence that seems to pay homage, from a distance, to the vision of constructivist photographer Alexander Rodchenko and his idiosyncratic images. Grainy patterns, twisting one way then another, fill the image like insect-eye views of the world. The objectivity of reality has been manipulated and warped, shifting us into a parallel world where an obsession with the rectilinearity of urban space finds its hypnotic visual consummation.

In the series *Concrete* (2002–3), Specker brings us crashing to earth as we are confronted by harsh and unforgiving textures in the Brutalist architecture of the Queen Elizabeth Hall on London's South Bank, and the main lecture hall at Cologne University. The repetitive rectilinear patterns are still here, but instead of the gentle impressionistic colours and soft edges of Specker's earlier work, we witness bleak monochrome greys and the rugged and pitted surfaces of raw concrete. In places the concrete has spalled off, exposing the reinforcing steel beneath: dilapidation and decay rule, contradicting the apparent indestructibility of these monolithic structures. These images reveal an alternative view of modern architecture. Whereas Specker's Berlin images are lively, light, colourful and airy, displaying a choreographic dance of grids and lines, these images of Brutalist concrete are dark, drab and heavy, weighed down by their own gravity and the ravages of time.

ROY EXLEY

D'ELSI – ELSI 1, 2007
PIGMENT PRINT
ON FINE ART PEARL
85 X 62 CM (33¹/₂ X 24³/₈ IN.)

D'ELSI – ELSI 2, 2007
PIGMENT PRINT
ON FINE ART PEARL
85 X 62 CM (33¹/₂ X 24³/₈ IN.)

D'ELSI – BERG 1, 2007
PIGMENT PRINT
ON FINE ART PEARL
85 X 56 CM (33¹/₂ X 22 IN.)

D'ELSI – BERG 2, 2007
PIGMENT PRINT
ON FINE ART PEARL
85 X 56 CM (33¹/₂ X 22 IN.)

D'ELSI – EIS 1, 2007
PIGMENT PRINT
ON FINE ART PEARL
85 X 62 CM (33¹/₂ X 24³/₈ IN.)

D'ELSI – EIS 2, 2007
PIGMENT PRINT
ON FINE ART PEARL
85 X 62 CM (33¹/₂ X 24³/₈ IN.)

D'ELSI – EIS 3, 2007
PIGMENT PRINT
ON FINE ART PEARL
85 X 62 CM (33¹/₂ X 24³/₈ IN.)

BANGKOK II, 2005
PIGMENT PRINT ON FABRIANO, 4 PARTS,
EACH 26.7 X 20 CM (10½ X 7⅞ IN.)

BANGKOK VI, 2005
PIGMENT PRINT ON FABRIANO, 3 PARTS,
EACH 26.7 X 20 CM (10½ X 7⅞ IN.) (DETAIL)

JULES SPINATSCH

born in 1964 in Davos, Switzerland
lives and works in Zurich

WWW.JULES-SPINATSCH.CH

Since the late 1920s, photographic theory has raised questions about the cognitive value of what we see. What can a simple photograph of an event teach us when reality itself is infinitely more complex? Since those times, the world has become even more difficult to grasp. Among the many attempts to grapple with this problem, Jules Spinatsch's collection *Temporary Discomfort* (2001–3) has taken up a special position of its own. The project documents five political summits, held by the leading powers of the modern world. In contrast to the pictures conveyed by the mass media, Spinatsch does not show us the clashes between anti-globalization demonstrators and security forces; he is more interested in the tactics that enable the powers-that-be to hold such protests at arm's length. There is a ghostly quiet in the apparently deserted, militarized winter landscape of Davos, and in the barricaded streets of New York. In Part IV of *Temporary Discomfort* Spinatsch introduces a new category of images showing areas that would usually be closed off to public view: at three places in Davos he erected digital network cameras which, from a raised perspective, were able to scan the security areas in small sections. These fragments of time and space, assembled throughout the duration of the summit conference, eventually produced panoramic views, and thus state surveillance itself became the object of artistic supervision.

Temporary Discomfort is a central work which provides the link between Spinatsch's earlier and later series. For example, the slumped drivers in *We will never be so close*

again (1997–98) recur in the figures of the waiting chauffeurs and bodyguards. On the other hand, the representation of landscape to be seen in the pictures of a fenced-in Davos is the subject of an extensive project carried out in 2003. The nocturnal photographs and videos of the Alps in *Snow Management*, partly lit by the headlights of a snowcat, show nature under complete domination, a totally stylized object of our event-orientated culture, following the photographic tradition of the 'socially altered landscape'.

Spinatsch has also been continuing his work with digital panoramas. For *Heisenbergs Abseits* ('Heisenberg's Offside', 2006), he installed his webcam in Berne's Wankdorf Stadium for a World Cup qualifier. The resultant images did not represent the game itself, but the overall spectacle – the architectural framework, the reporters, the crowd and individual players. The vividness of this collection of 3,003 sharply defined individual images could never have been matched by earlier forms of photography. What Walter Benjamin termed the 'optical unconscious' of the photographic medium has now lost its magic, and has been replaced by the pragmatic task of visual registration. The fact that Spinatsch's works can also be said to assume a documentary dimension is due partly to the targeted selectivity of his vision, partly to his use of digital equipment, and also to the manner in which he is able to exploit the political potential of that equipment.

FLORIAN EBNER

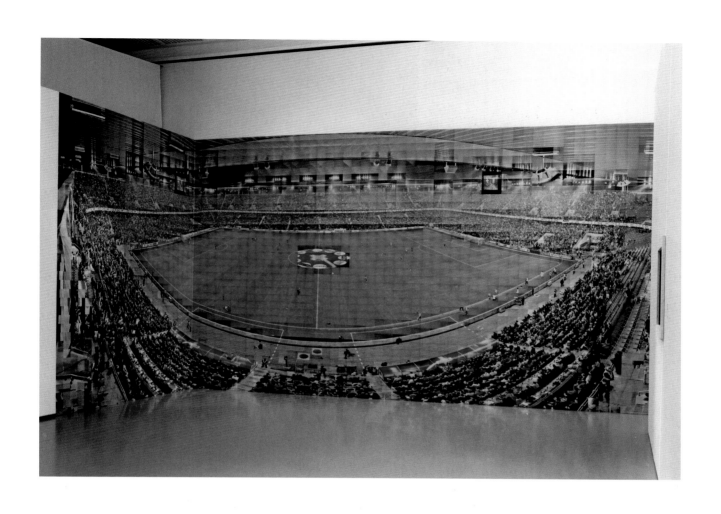

HEISENBERGS ABSEITS, SCHWEIZ–FRANKREICH 1:1 (0:0), WM-QUALIFIKATIONSSPIEL,
STADE DE SUISSE, BERN WANKDORF, 8. OKTOBER 2005, 2005–6
INKJET PRINTS GLUED TOGETHER TO FORM WALLPAPER, 3.5 X 9.3 M (11½ X 30½ FT)
PANORAMA INSTALLATION USING 3,003 PICTURES OF THE STAND TAKEN WITH AN INTERACTIVE CAMERA,
EXHIBITION VIEW OF **EXPANDED EYE**, KUNSTHAUS ZÜRICH, 2006

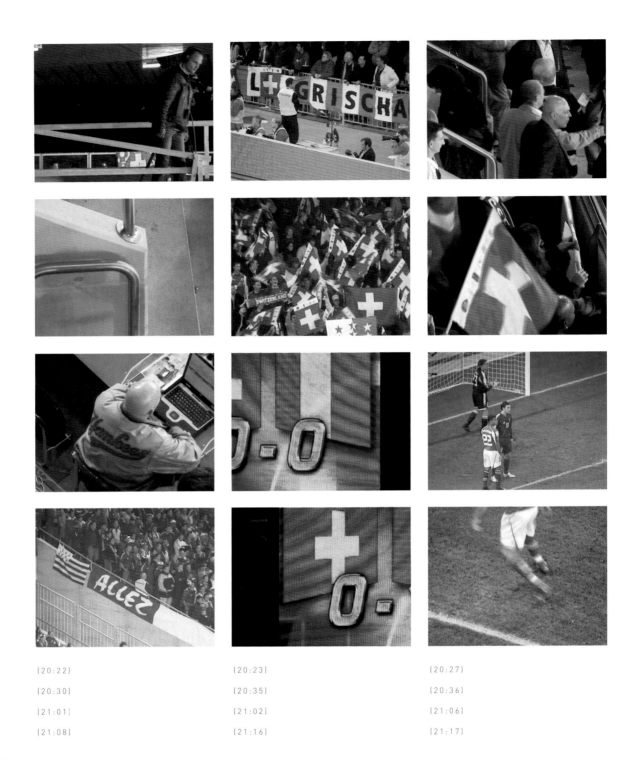

(20:22) (20:23) (20:27)

(20:30) (20:35) (20:36)

(21:01) (21:02) (21:06)

(21:08) (21:16) (21:17)

SCHWEIZ–FRANKREICH
1:1 (0:0), WM-QUALIFIKATIONSSPIEL

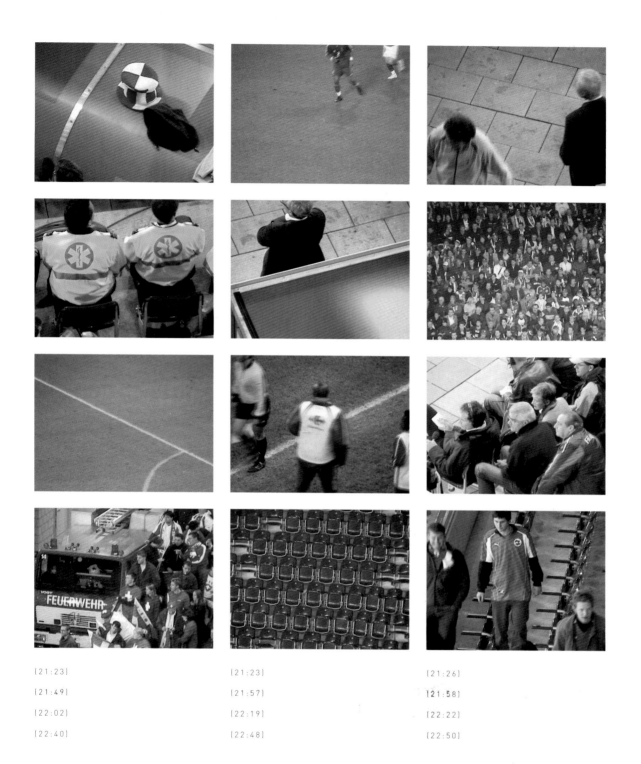

(21:23)

(21:23)

(21:26)

(21:49)

(21:57)

(21:58)

(22:02)

(22:19)

(22:22)

(22:40)

(22:48)

(22:50)

SCHWEIZ–FRANKREICH
1:1 (0:0), WM-QUALIFIKATIONSSPIEL

ERIK STEINBRECHER

born in 1963 in Basel, Switzerland
lives and works in Berlin, Germany, and Basel

WWW.STAMPA-GALERIE.CH WWW.GALERIEBARBARAWEISS.DE

Erik Steinbrecher works with a variety of different materials, depending on the place and the project: he uses rubber, synthetic resins or aluminium for objects, piping and wooden fencing for installations, and both assembles existing pictures and takes photographs. He studied at ETH Zurich from 1983 until 1990, and has presented his work at many international one-man and group exhibitions, as well as Documenta X. A continually renewed collection of pictures forms the basis of his work, from which he composes particular fields of meaning, arranging the images by analogy in a kind of visual alliteration. Thus the motif of the fence recurs in many installations, as well as in the newspaper format publication *Arabesque à Gogo* (2003). In this pseudoscientific pictorial essay, Steinbrecher explores aspects of enclosure and exclusion, violation and protection by the fence, without articulating any judgment: scepticism towards any clear statement of 'truth' is central to all his work.

Photo art in the 1980s enjoyed an unparalleled boom with pictures in wall-sized format. Steinbrecher's photographs have none of the pathos of those large-scale works. He chose photography, instead, as the most suitable medium for visual meditation, and articulated this in precise collages and art books. In *Gras* ('Grass', 1993–2002) people who have been overcome by sleep are laid out on stretches of grass in urban parks, which are divided up by bushes, shadows and paths. They had looked for a suitable place for their nap and then stretched out, not just anywhere but on one particular spot in the whole wide world. Steinbrecher documents this one spot: the pictures reveal the view of the walker, the voyeur looking down on the sleepers from eye level and noting in passing how they have positioned themselves in this public space. Their bodies may be seen both as the subject of a sociological-cum-photographic field study and as sculpture. Whether Steinbrecher takes photos, compiles collections or assembles installations, what is represented is the unmistakable and meaningful expression of pleasure in the sheer existence of objects and people. This pleasure – sometimes overt, sometimes implicit – is present, with anarchic energy, in everything. Even in grass.

NADINE OLONETZKY

OK POSTER #99, 2005
C-PRINT, 65 X 45 CM (25⅝ X 17¾ IN.)

UNTITLED, 2004
COLLAGE (DETAIL)
297 X 209 CM
(116 7/8 X 82 1/4 IN.)

UNTITLED, 2004
COLLAGE (DETAIL)
297 X 209 CM
(116⅞ X 82¼ IN.)

EVE SUSSMAN

born in 1961 in London, UK
lives and works in Brooklyn, USA
WWW.ROEBLINGHALL.COM

Eve Sussman's early installations *Ornithology* and *How to Tell the Future from the Past* (both 1997) present closed but generative systems of representation, such as live footage of pigeons in an airshaft streamed into the gallery space, or the combination of live footage and narratives from the past. The viewer is asked to piece together elements from disparate times and places in order to make out the whole. The video *89 Seconds at Alcázar* (2004), which brought Sussman worldwide attention, is also immersed in the conditions and concerns of temporality. Here, Sussman imaginatively reconstructs Diego Velázquez's famous painting *Las Meninas* (1656), itself a fissure in the history of representation, by representing the movements of those involved in the painting at the moment of its conception. *89 Seconds* allows the instant of the painting, captured 200 years before the invention of photography, to expand, unfold and linger, creating a miniature performance in which every gesture and movement relates to and ultimately recreates *Las Meninas*. The experience of the painting coming to life is stunning, as is the very realization of such complex and layered configurations, emerging as they do out of a single, painted, historical moment.

In Sussman's most recent and ambitious piece to date, *The Rape of the Sabine Women* (2005), her involvement with the moving image is taken to yet another level. Produced in collaboration with the Rufus Corporation, an ad hoc group of performers brought together by Sussman, history again marks the artistic point of departure. The Roman legend of the abduction of the Sabine women has been painted and interpreted by many artists throughout history, including Giambologna, Nicolas Poussin and, most famously, Jacques-Louis David. Sussman, however, uses the legend as a mere stepping stone for a complex five-part 80-minute film, by several critics termed a video-opera. This is a dense, layered and copious work, including an extraordinary musical score by Jonathan Bepler. Insistently self-reflexive – actors are seen preparing in the dressing room, cameras and musicians appear on screen – *The Rape* dissects both real and filmic time, often restarting, jumping back, slowing down, speeding up, or shifting between black-and-white and colour. Finally, in the midst of splendour and abundance, *The Rape* shifts the Sabine legend to a 1960s laissez-faire context, to become a fine meditation on love, hate, violence and desire.

JAN-ERIK LUNDSTRÖM

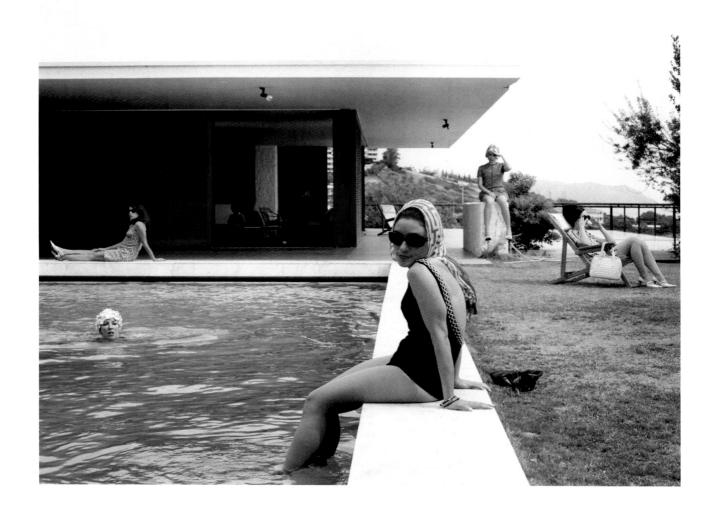

GIRLS AT THE POOL, 2005
DIGITAL C-PRINT, 125 X 199 CM (49⅛ X 78⅜ IN.)
STILL FROM **THE RAPE OF THE SABINE WOMEN**
PHOTO BY BENEDIKT PARTENHEIMER

UNTITLED (TEMPELHOF), 2005
DIGITAL C-PRINT, 97 X 190 CM (38⅛ X 74¾ IN.)
STILL FROM **THE RAPE OF THE SABINE WOMEN**
PHOTO BY BOBBY NEEL ADAMS

PHILIPPE TERRIER-HERMANN

born in 1970 in Paris, France

lives and works in Brussels, Belgium, and Paris

WWW.GALERIE-POLLER.COM

Philippe Terrier-Hermann explores power, beauty, success and perfection with a sort of calculated brazenness – his way of attacking the often hypocritical fringe-group romanticism of snapshot photographers: 'The role that artists like Nan Goldin and Richard Billingham play in relation to the market is hugely hypocritical. They defend this trashy aestheticism, which at first sight appears to be political, while they themselves are covered head to foot in designer clothing, and live in five-star hotels after they've sold the deaths of their friends from AIDS in the guise of art. My work is heavily influenced by this indignation.... I always want to portray power, with a strong leaning towards classical art.... I want to show globalization and the *nouveaux riches*, following the examples of the great masters: mixing in a certain dose of cynicism – planting a bit of subversion into an academic image.'

Terrier-Hermann's cynical academicism was first expressed in *Intercontinental* (1996–2000), a series of one hundred stylized representations of the world of high finance. The manner of representation, which could not be classified either as documentary or fiction, seems to spring directly from the artificiality of the ivory towers of those depicted. Paradoxically, the artifice of these pictures begins to take on an authenticity of its own, so that they emerge as the only adequate way of representing this reality.

Terrier-Hermann's cult of beauty in *Fascination* (2000–1) has an even more subtle effect. This series of portraits of Italian men – including a minister, a boxer and a porn star – represents the subjects in a highly mannered fashion combining classicism, sophisticated conservatism and homoeroticism with Fascist undertones. Beneath the beautiful, smooth surface one finds the skeleton of a rotten society which Terrier-Hermann both celebrates and criticizes. In *Philosophy à la mode* (2005), he shows women shopping in the fashionable streets of big cities, reduced to their existence as consumers, and living in their globally standardized, luxury biotopes.

Terrier-Hermann's desire and search for beauty also permeates his landscapes and cityscapes. For *Beautés japonaises* (2003) he asked a hundred Japanese people living in Paris what they considered to be the most beautiful places in Japan. He then visited and photographed them as a kind of treasure hunt, carried out with all the tricks and techniques of a marketing campaign. Here, too, he shows himself to be a worthy successor to the dandies and idlers of the *fin de siècle*, who knew even then that amoral aestheticism as an artistic method offers very serviceable access to truth.

MARTIN JAEGGI

PHILOSOPHY À LA MODE, 2005
C-PRINT, 60 X 60 CM [23⅝ X 23⅝ IN.]

Beauté japonaise N° 73 日本の美N.73

Rivière Shiratani, Île de Yaku, Kagoshima 白谷川 屋久島 鹿児島県

Recommandée par Monsieur Toshifumi Ando - Directeur adjoint de l'office national 推薦 国際観光振興会パリ観光宣伝事務所次長 安藤 利文
du tourisme japonais à Paris

Beauté japonaise N° 26 日本の美N.26

Tradition et modernité, Hama-cho, Tokyo 伝統と現代 浜町 東京都

Recommandée par Madame Chieko Clément - Directrice administrative de Japan 推薦 日本航空株式会社パリ支店総務　広報部担当　千恵子クレモン
Airlines France, Monsieur Haruki Kibe - Directeur de Kintetsu International Express 推薦 近鉄国際列車ディレクター　木部　春樹
France, Monsieur Toshifumi Ando - Directeur adjoint de l'office national du 推薦 国際観光振興会パリ観光宣伝事務所次長　安藤　利文
tourisme japonais à Paris et Monsieur Kenzo Takada - Styliste - Paris 推薦 スタイリスト　高田　賢三

Beauté japonaise N° 91 日本の美N.91

Takenoko-zoku, Harajuku, Tokyo タケノコ族 原宿 東京都

Recommandée par Monsieur Kenzo Takada - Styliste - Paris 推薦 スタイリスト高田 賢三

Beauté japonaise N° 105 日本の美N.105

Kobe, Hyogo 神戸 兵庫県

Recommandée par Monsieur Shigeatsu Tominaga - Président de la fondation 推薦 笹川日仏財団理事長 富永 重厚
franco-japonaise Sasakawa à Paris

FROM THE SERIES **BEAUTÉS JAPONAISES**, 2003
C-PRINT, ALUMINIUM, 30 X 30 CM AND 10 X 30 CM
(11¾ X 11¾ IN. AND 3⅞ X 11¾ IN.)

FROM THE SERIES **BEAUTÉS JAPONAISES**, 2003
C-PRINT, ALUMINIUM, 30 X 30 CM AND 10 X 30 CM
(11¾ X 11¾ IN. AND 3⅞ X 11¾ IN.)

FROM THE SERIES **BEAUTÉS JAPONAISES**, 2003
C-PRINT, ALUMINIUM, 30 X 30 CM AND 10 X 30 CM
(11¾ X 11¾ IN. AND 3⅞ X 11¾ IN.)

FROM THE SERIES **BEAUTÉS JAPONAISES**, 2003
C-PRINT, ALUMINIUM, 30 X 30 CM AND 10 X 30 CM
(11¾ X 11¾ IN. AND 3⅞ X 11¾ IN.)

Beauté japonaise N° 25

Tradition et modernité, jardin de Hama Rykyu, Tokyo

Recommandée par Madame Chieko Clément - Directrice administrative de Japan Airlines France, Monsieur Haruki Kibe - Directeur de Kintetsu International Express France, Monsieur Toshifumi Ando - Directeur adjoint de l'office national du tourisme japonais à Paris et Monsieur Kenzo Takada - Styliste - Paris

日本の美N.25

伝統と現代　浜離宮　東京都

推薦　日本航空株式会社パリ支店総務；広報担当　千恵子クレモン
推薦　近鉄国際列車ディレクター　木部　春樹
推薦　国際観光振興会パリ観光宣伝事務所次長　安藤　利文
推薦　スタイリスト　高田　賢三

FROM THE SERIES **BEAUTÉS JAPONAISES**, 2003
C-PRINT, ALUMINIUM, 30 X 30 CM AND 10 X 30 CM
(11¾ X 11¾ IN. AND 3⅞ X 11¾ IN.)

ANA TORFS

born in 1963 in Mortsel, Belgium
lives and works in Brussels

WWW.IBKNET.BE/PERSON/PHP?LA=EN&P=1&PP=&ID=35

Look and read. Look again. Read again. There are very few works today in the fine arts that provide such a close-knit weave between text and picture. In Ana Torfs' recent installation, *Anatomy* (2006), we see once more a sharp eye for texts and a deep sensitivity in her use of the written word. *Anatomy* is a tragedy in two acts, distilled from the Berlin trial records of the murders of Rosa Luxemburg and Karl Liebknecht – founders of the German Communist Party – in 1919. In a conversation with Els Roelandt, Torfs explains how 'texts are divided up over and over again, and during the subsequent *mise-en-scène* with actors, they are set in a new light and given new life.' For *Anatomy* she filmed twenty-five actors performing an uncompromising selection of statements by the witnesses, including the accused and some bystanders. 'Out of these 25 versions of the "truth" emerges a fragmented, constantly shifting picture of the last thirty minutes in the lives of Liebknecht and Luxemburg.' In addition to the colour videos, *Anatomy* contains 120 black-and-white slides – a performance by seventeen German actors photographed in Berlin's Anatomisches Theater, which Torfs regards as 'a general metaphor for my work…. The dissecting room, where there are no bodies but where the reading material is dissected and analysed.' The German commentaries in the video section are simultaneously translated by an English interpreter – yet another 'interpretation' that shows just how flexible language is. There is also a book to accompany the installation, but this is not just an historical essay, for the voice of the artist is also to be heard. Torfs' books are not mere catalogues. In terms of form and content, they are all independent works.

Torfs analyses another trial text (that of Joan of Arc) in a slide installation and a book, *Du mentir-faux* (2000). The 35 mm film *Cycle of Trifles* (1998) and the accompanying book *Beethoven's Nephew* derive from the notebooks of the deaf composer. For *The Intruder* (2004), an installation with slide projections, Torfs adapted a play by Maurice Maeterlinck, for which she commissioned an English translation. The video installation *Il Combattimento* (1993) revolves around an opera libretto, and in the web project for the Dia Art Foundation *Approximations/Contradictions* (www.diaart.org/torfs, 2004) Bertolt Brecht's lyrics for Hanns Eisler are given an inimitable interpretation. The ways in which a book may actually come into being provides the basis for the complex installation *Elective Affinities/The Truth of Masks & Tables of Affinities* (2000–2).

Torfs' preoccupation with words and her passionate involvement with ambiguous texts – 'working on association and suggestion, the sequence of affinities and connections, instead of a strict, rational structure' – have given rise not only to work of richly varied content, but also to a timeless pictorial language. In the words of Jean Torrent, referring to a series of black-and-white photos entitled *à…à…aaah!* (2003), 'Ach, I'll only write a few words about them, but Ana Torfs' pictures are silent. That is to say, they are full of expression.'

ERIK EELBODE

ANATOMY, 2006
INSTALLATION WITH SLIDE PROJECTIONS
AND VIDEO ON TWO MONITORS,
WIRELESS HEADSET, DIMENSIONS VARIABLE

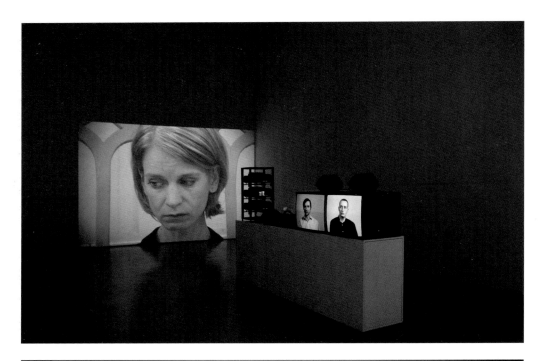

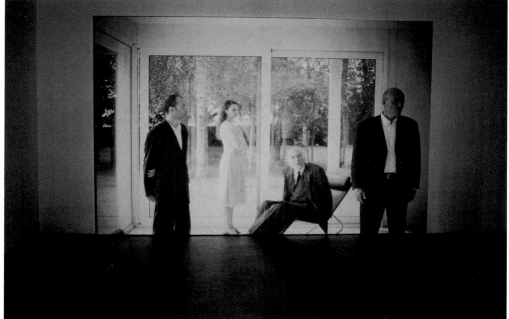

ANATOMY, 2006
INSTALLATION WITH SLIDE PROJECTIONS AND VIDEO ON TWO MONITORS,
WIRELESS HEADSET, DIMENSIONS VARIABLE
INSTALLATION VIEW, DAADGALERIE, BERLIN, 2006

THE INTRUDER, 2004
INSTALLATION WITH SLIDE PROJECTIONS ON BLACK PROJECTION SCREEN,
AUDIO, DIMENSIONS VARIABLE
INSTALLATION VIEW, ROOMADE, BRUSSELS, 2004

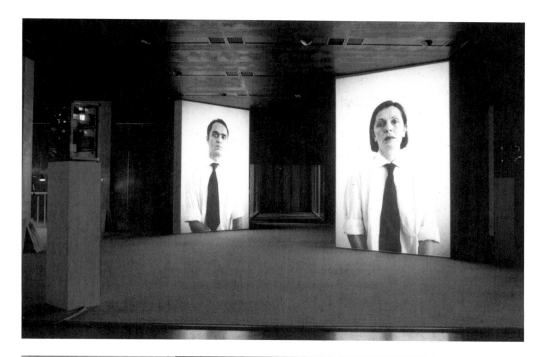

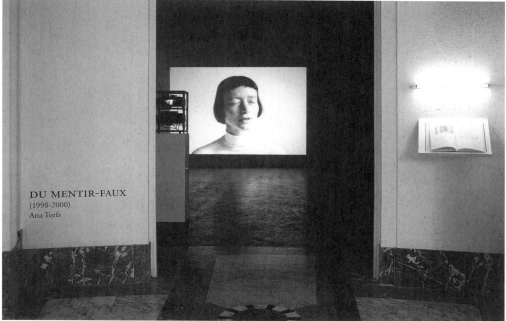

ELECTIVE AFFINITIES/THE TRUTH OF MASKS, 2002
INSTALLATION WITH SLIDE PROJECTIONS, DIMENSIONS VARIABLE
INSTALLATION VIEW, FORWART, BRUSSELS BIENNIAL, 2002

DU MENTIR-FAUX, 2000
INSTALLATION WITH SLIDE PROJECTIONS, DIMENSIONS VARIABLE
INSTALLATION VIEW, PALAIS DES BEAUX-ARTS, BRUSSELS, 2000

JANAINA TSCHÄPE

born in 1973 in Munich, Germany
lives and works in New York, USA,
and Rio de Janeiro, Brazil

WWW.JANAINATSCHAPE.NET

In Janaina Tschäpe's images there are always reminders that everything could have been different. Her work seems to suggest that the possibility of gradual change and melding is always present: an elusive and at the same time obvious convergence between bodies and landscapes, masks and mirror images, present and past. There is often a connection to a specific place, where unsuspected narratives surface, as in *Camaleoas* (2002), in which Tschäpe follows the four women Claudia, Cristal, Fatima and Jani, who live in a favela in Rio de Janeiro. The tone of the video work and the photographs is both ordinary and extravagant. Cristal says: 'It was like this: I was living with a man, I started dating him when I was eleven years old, I stuck with him until I was 22, he beat me a lot, he watched me, cursed me, I lost all respect, you know, because he beat me, I didn't have any limits for anything, I accepted whatever he did to me. He tried to kill me lots of times. The accident that I had, naturally it was because of a fight we had at home. So in the car, after I came out of the coma, I started to stop to think about my life. That was when I quit doing cocaine, thank God, the best thing that I ever did in my life, but the reason I stopped was to think about the things that women let go, you know, women today, the majority of women are very submissive, I think that they've forgotten that we're strong, you know?'

In the series *Botanica* (2005), photographed in Tschäpe's own garden, place and memory also have great meaning. John Hanson Mitchell's notion of 'ceremonial time' is about just this: the past and the future exist in the present, time must be regarded as a continuous fabric. Each place has a ceremonial time, and therefore cannot die, except as a memory, or by never coming into existence as a memory. Body and identity, too, are recurring themes in the works of Tschäpe. Her images confront the viewer with sculptural, cocooned and naked figures, verging on architecture in an unceasing exploration of human limitations. Tschäpe tells fables about the thin shells of bodies, and about a different awareness.

JOHAN SJÖSTRÖM

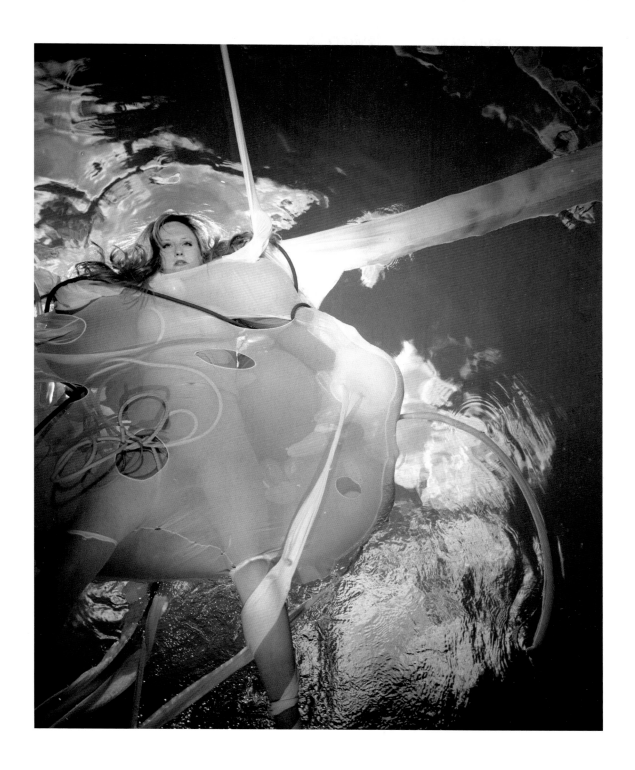

VOLVA, 2004
FROM THE SERIES **BLOOD, SEA**
FLEXPRINT, 127 X 102 CM (50 X 40⅛ X IN.)

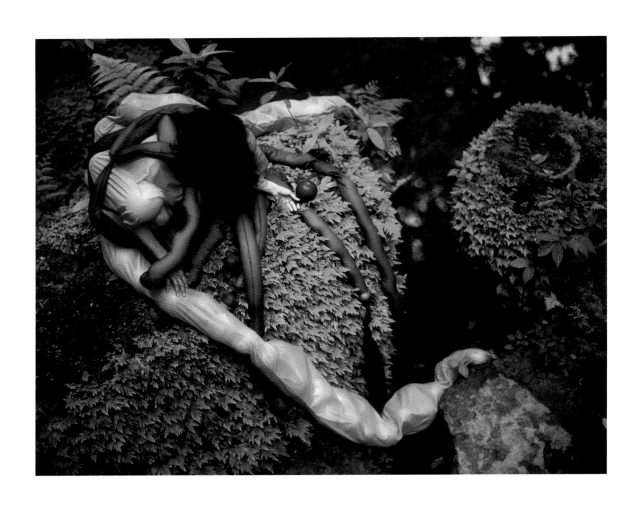

GLANDULITERA MARIS, 2005
FROM THE SERIES **MELANTROPICS I**
GLOSSY C-PRINT
127 X 102 CM (50 X 40⅛ IN.)

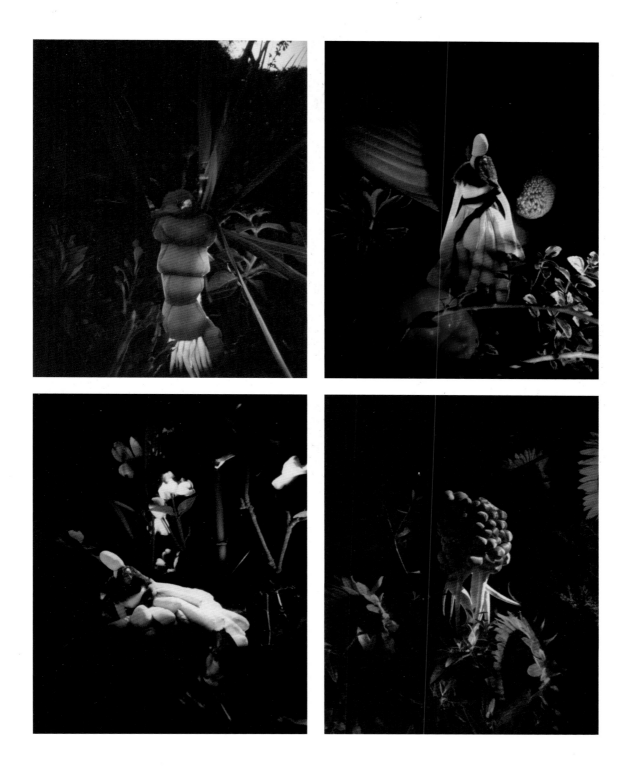

A BOTANIST'S DREAM 16, 2006
POLAROID, 27.5 X 21 CM (10⅞ X 8¼ IN.)

A BOTANIST'S DREAM 20, 2006
POLAROID, 27.5 X 21 CM (10⅞ X 8¼ IN.)

A BOTANIST'S DREAM 22, 2006
POLAROID, 27.5 X 21 CM (10⅞ X 8¼ IN.)

A BOTANIST'S DREAM 14, 2006
POLAROID, 27.5 X 21 CM (10⅞ X 8¼ IN.)

JENS ULLRICH

born in 1968 in Tukuyu, Tanzania
lives and works in Düsseldorf, Germany

WWW.VAN-HORN.NET

On Jens Ullrich's bookshelves you will find hardly any photography or contemporary art books. This is not necessarily a symbol of defiance, nor does Ullrich want simply to be different. The truth is he finds much more of interest in books about wood-carving in the rural districts of Germany, for example, and he is just as reticent about the fact that he studied at the Kunstakademie in Düsseldorf, that he sometimes assists and collaborates with Thomas Ruff, and that he has connections with the Becher School.

Ullrich works almost exclusively with found materials: newspaper photographs or Internet records of things which have already passed into history and which, in his own words, he 'has changed a little', as in the series *Masken* ('Masks', 2004). In these black-and-white photographs of everyday scenes in Africa, he has replaced all the faces with traditional masks taken from catalogues of African art. People who live in the present day are seen effortlessly wearing items from their past in artefacts that have been conserved in the museums of the western world for years. Returned to the country of their origin, these masks stir the souls of those who wear them, the descendants of those who created them, although Ullrich makes it clear that this is just one of many interpretations. You might also read into these crude montages a ghostly awakening as the masks come to life – a life that bears an astonishing similarity to 'their' (and our) everyday life. Such scenes that are so closely bound up with place and culture suggest something both fantastic and

timeless. Ullrich's masks thus take on a variety of meanings, from a critical commentary on colonial history to a charming reinterpretation of the influence of African art.

Ullrich creates an additional dimension through his presentation of the photographs in passepartouts in low-budget installations of white-painted, untreated wood. Each of his series is also accompanied by a simple, riveted booklet. In the *Masks* booklet, the rather poor reproductions are accompanied by a 1915 text by Carl Einstein and a stimulating, experimental piece by Ullrich, in which he discusses the original captions with personal, semi-ironic associations and the obligatory clichés about African art.

The booklet and picture series *Trophäen* (2007) and *Welcoming Community* (2005) are a partly biographical study of the meaning and essence of so-called 'direct action', as Ullrich's parents are passionate peace activists. In black-and-white press photos of demonstrations, the slogans on the placards have been replaced with ornamental and meaningless Letraset stick-on letters, which were popular in the pre-digital era. Any concrete message conveying a specific opinion has been eradicated, without destroying the dynamism of the demonstrators, who now protest with a 'work of art'. This, suggests Ullrich, may be the role played by the artist, who must fight to be understood, and thus endow the world with some meaning. Then, the world might also be 'changed a little'.

ERIK EELBODE

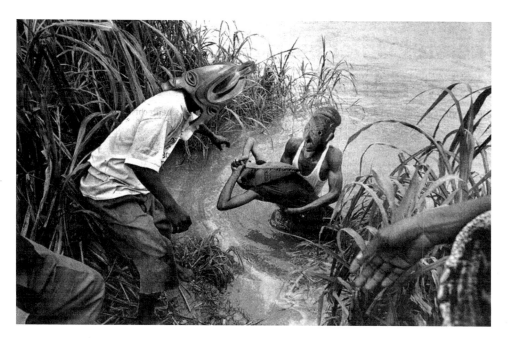

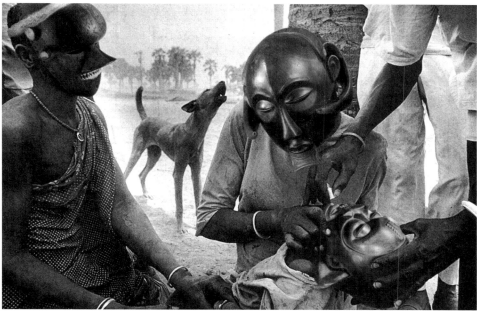

010 (SEEUFER), 2004
FROM THE SERIES **MASKEN**
C-PRINT, 39 X 47 CM (15³/₈ X 18¹/₂ IN.)

030 (HUND), 2004
FROM THE SERIES **MASKEN**
C-PRINT, 39 X 47 CM (15³/₈ X 18¹/₂ IN.)

006, 2006
FROM THE SERIES **PLAKATE** (WELCOMING COMMUNITY)
INKJET PRINT, 60 X 40 CM (23⅝ X 15¾ IN.)

WELCOMING COMMUNITY, 2006
30 C-PRINTS AND ORIGINAL POSTERS
BY MARGARET ULLRICH
INSTALLATION VIEW OF **MEDIA BURN**,
L2 – TATE MODERN, LONDON, 2006–7

007, 2006
FROM THE SERIES **PLAKATE**
(WELCOMING COMMUNITY)
INKJET PRINT, 60 X 40 CM (23⅝ X 15¾ IN.)

017 (1880), 2007
FROM THE SERIES **TROPHÄEN**
INKJET PRINT
114 X 100 CM (44⅞ X 39⅜ IN.)

USEFUL PHOTOGRAPHY

founded in 2002 in Amsterdam, Netherlands,
by Hans Aarsman, Claudie de Cleen,
Julian Germain, Erik Kessels and Hans van der Meer

WWW.USEFULPHOTOGRAPHY.COM

Useful photography is the generic term for the millions of photographs that are used for a designated purpose every day: pictures in sales catalogues, instruction manuals, police files, packaging, etc. The photographer is usually anonymous and the lifespan of the images short. In 2000 Dutch artists and photographers Hans Aarsman, Claudie de Cleen, Julian Germain, Erik Kessels and Hans van der Meer founded the magazine *Useful Photography*, united in a shared interest in 'applied' photographs without artistic or cultural meaning. Six issues appeared, all dedicated to different kinds of functional photography. As editors they operate in the footsteps of conceptual artists such as Christian Boltanski, Hans-Peter Feldmann or Maurizio Cattelan and Dominique Gonzalez-Foerster. These early pioneers collected and reanimated 'found' photographs in new artistic and social contexts. The Dutch five show the same interest in deadpan, repetitive serial presentations of existing images. What sets them apart from their predecessors is the focus on the typical photographic registration-method of the packshot, so despised by art-school photography departments since the medium became accepted as a major art form twenty years ago.

Useful Photography #002 (2002) shows, for example, the surprising creativity of amateur photographers in 'down and dirty packshots' of personal items sold through eBay. Photographs of second-hand clothes, ashtrays, toys and other nicknacks are taken with a digital camera, using the home as a studio. In his analysis Gerry Badger concludes that the 250 photos read like 'an archaeological report from the future, investigating a twenty-first-century midden heap and listing the discarded detritus of our civilization'. A special edition on *War* (2003) examines the varying patterns of camouflage from different countries. Again, the images were found on the Internet and have the simplicity and no-nonsense styling of packshots. 'Can you tell from the various patterns which country is trying to hide from you?' reads an announcement. *Useful Photography #005* (2005) contains a collection of standardized photos of cows, all descendants of the breeding bull Lord Lily, who stars on the cover. The cows are presented on full spreads in a variation of the centrefold format made famous by *Playboy*. The dry humour stimulates the reader to ponder the absurd idea that one bull can produce tens of thousands of offspring and raises questions about serious topics such as mass production, efficiency and (animal) cloning. *Useful Photography #004* (2004) is the most politically orientated issue to date, showing Palestinian posters found and photographed by Dutch photojournalist Ad van Denderen. These 'heroic' portraits of dead suicide bombers, militants and intifada fighters killed in the conflict with Israel – a mixture between Islamic culture and Hollywood billposting design – are born out of a documentary necessity. Collected and edited as straightforward pictures in an artists' magazine, they show the provocative side of the editors.

RIK SUERMONDT

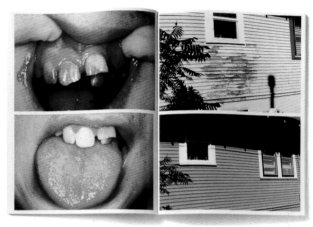

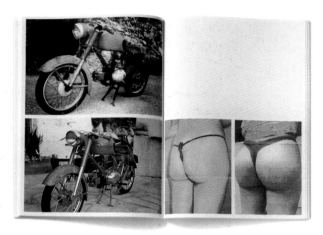

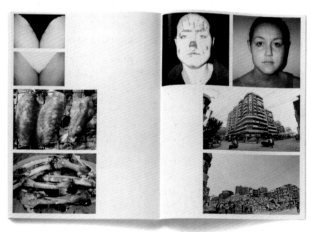

USEFUL PHOTOGRAPHY #002, 2002
EACH PAGE 29.7 X 21 CM (11¾ X 8¼ IN.)
ANNUAL MAGAZINE WITH THIS TITLE
(SERIAL NUMBER CORRESPONDS TO THE YEAR OF PUBLICATION)

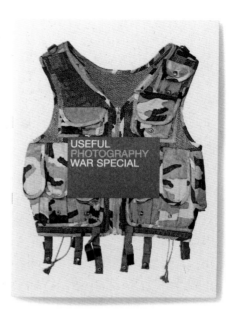

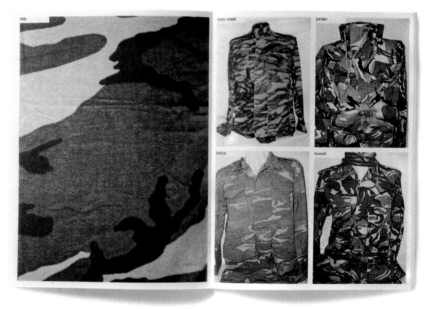

USEFUL PHOTOGRAPHY #003, 2003
EACH PAGE 29.7 X 21 CM (11¾ X 8¼ IN.)
ANNUAL MAGAZINE WITH THIS TITLE
(SERIAL NUMBER CORRESPONDS TO THE YEAR OF PUBLICATION)

USEFUL PHOTOGRAPHY #003, 2003
EACH PAGE 29.7 X 21 CM (11¾ X 8¼ IN.)
ANNUAL MAGAZINE WITH THIS TITLE
(SERIAL NUMBER CORRESPONDS TO THE YEAR OF PUBLICATION)

SANTOS R. VASQUEZ

born in 1962 in Los Angeles, USA
lives and works in Los Angeles
WWW.MEZZANINGALLERY.COM

Santos R. Vasquez uses photography to explore the jungle of everyday signs. His work demonstrates dense networks of meaning in apparently commonplace objects and situations. For example, to make *Springtime for Tony Williams* (2000), he photographed the cover of a record made by the jazz drummer Tony Williams, and enlarged it to almost wall size. The commercial art in light and dark blue suddenly takes on the tones of a minimalist painting, and begins to suggest the dimensions of a landscape. The piece is supplemented by two more photographs which show details from the inside of the folding cover – the hands of the drummer and a drumstick – representing the pictorial language used by the mass media to underline the individuality and authenticity of the artist.

For *Two Sets of Twins* (1997) Vasquez photographed in different shades photocopies of the title page of Claude Lévi-Strauss's *The Elementary Structures of Kinship*. The title itself becomes an ironic commentary on the easily distinguished pictures, which show copies of a book cover featuring a photograph of Lévi-Strauss. Each copy gives birth to another until the original simply gets lost.

In *Capitol Never Sleeps* (1999), Vasquez shows pictures of the citrus district in Los Angeles where, during the night, lorries are loaded with fruit to be delivered to food shops. He photographed this area around lunchtime, when people had stopped work, and the shining, deserted streets are reminiscent of paintings by Edward Hopper or Giorgio de Chirico. The hackneyed expression in the title here has a surprising twist: sleep is not necessarily bound up with the night, and the modern working world follows its own rhythms, which no longer coincide with those of nature. In one of his more recent works, Vasquez casts a critical eye on the clothing brand American Apparel, which has achieved worldwide success in the last few years, partly thanks to clever advertising campaigns in which model working conditions are linked to trendy, streetwise eroticism. Vasquez's photographs show details taken from American Apparel's advertisements for women's underwear, on which he draws speech bubbles that point to the sex organs of the model and contain statements like 'There are moments when one must distinguish between good taste and clear conscience'. Vasquez takes to extremes the link between political correctness and eroticism that underlies American Apparel's approach, and unmasks their ethical pretensions as a skilful marketing strategy. As always, he refrains from taking an overtly didactic, moralizing political stance, but sweetens his approach with clever pictorial wit, at the same time throwing up important questions regarding the status of images in our society.

MARTIN JAEGGI

SPRING: LANDSCAPE FOR TONY WILLIAMS, 2000
C-PRINT, 121.9 X 243.8 CM (48 X 96 IN.)

SPRING (2): SEASCAPE FOR TONY WILLIAMS, 2000
C-PRINT, 121.9 X 243.8 CM (48 X 96 IN.)

SPHINX 1: ANNA K, 2004
PRINTED MATTER, C-PRINT
121.9 X 169.3 CM (48 X 66⅝ IN.)

FAR FROM VIETNAM 1: MARINA, 2004
PRINTED MATTER, C-PRINT
121.9 X 167.8 CM (48 X 66 IN.)

HOMAGE: WASHING MACHINE, 2004
PRINTED MATTER, C-PRINT
23 X 17.8 CM [9 X 7 IN.]

LIDWIEN VAN DE VEN

born in 1963 in Hulst, Netherlands
lives and works in Rotterdam

WWW.GALERIES.NL/ANDRIESSE

Lidwien van de Ven is an anti-journalist. Heavily interested in politics and religion, she naturally takes her photographs in the same places as the press, but her pictures flout the conventions of the mass media. She describes her attitude towards reportage photography as follows: 'There are bound to be certain journalistic procedures in my work. I do a great deal of research in advance in order to keep up to date with information and discussion concerning the subjects I'm interested in. But it is quite a different matter when I take my photographs.... The readability and direct recognition of images are not particularly important for me.' She radically rejects the aesthetics of directness that characterize the news media. Her often black-and-white pictures, which at first sight seem unimpressive or maybe cryptic, are the size of posters, and she gives them a kind of aura which forces the observer to reflect on the gentle-seeming puzzle confronting him.

White March (2001), for instance, looks down onto a crowd of demonstrators in Belgium, outraged at the slow progress of criminal proceedings against the paedophile Dutroux. What we cannot tell is whether van de Ven is giving expression to the people's anger, or is drawing our attention to the danger of such mass assemblies which might at any moment turn into a lynch mob. *NATO, Brussels, 10 April 1999* (2001) shows a TV broadcasting van outside NATO headquarters at the point when discussions were being held over the war in Kosovo. Could this picture be pointing to the role of the media in the Yugoslavian conflict, and the ever closer links between politics, the media and the military?

In the Jordanian capital Amman, van de Ven used public advertising spaces to display seemingly innocuous photos of border crossings in the Near East (*Amman Meeting Points*, 2004), pictures that simultaneously tell us nothing and everything about the Middle East conflict, and precisely because of their ambiguity caused many a passer-by to stop and look. Unlike most media images, van de Ven's photographs do not purport to capture any hard and fast – or even relative – 'truths'. They tend, instead, to ask questions for which there are no answers, and in this way they create the possibility of detachment which in turn leads to reflection.

In her FRAC exhibition, 'Ile de France' (*Espace experimental*, 2005) and with her contribution to Documenta 12 (including *document*, 2007), van de Ven's works were even more radical. During the exhibitions themselves, she frequently rehung her photographs, and even painted some of them over. Each time, the observer had just one momentary sight of the work, the essence of it being that it was part of a process. It is in this insistence on uncertainty and on the independent interpretative activity of the observers – even though they would doubtless prefer a clear statement – that van de Ven's radicalness lies.

MARTIN JAEGGI

PROMISED LAND/PALESTINE, 2003
GELATIN-SILVER PRINT ON PAPER, ALUMINIUM,
8-PART SERIES, 100 X 125 CM (39⅜ X 49¼ IN.) (DETAIL)

PARIS, 11/02/2006, 2007
DIGITAL PRINT ON PAPER
135 X 200 CM (53⅛ X 78¾ IN.)

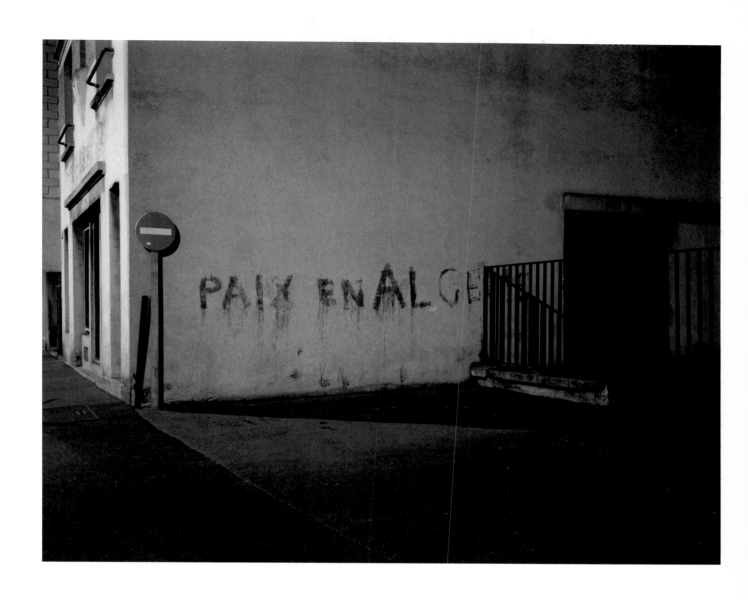

NANTERRE, 07/11/2004, 2005
GELATIN-SILVER PRINT ON PAPER, ALUMINIUM
120 X 150 CM (47¼ X 59 IN.)

QINGSONG WANG

born in 1966 in Heilongjiang Province, China
lives and works in Beijing

WWW.WANGQINGSONG.COM

Qingsong Wang started his artistic career painting tortured, suffocating self-portraits, and has continued to depict and involve himself in his photographic output. His first work from the late 1990s saw him take various roles as soldier, prisoner and holy figure, being both constrained and freed by the influx of western consumerism, as symbolized by Marlboro or Coca-Cola, and even on occasion by being physically branded with a McDonald's logo. In 2000 Wang began to combine references from ancient Chinese folklore with western art history, referencing female nudes from Ingres, Velázquez and Manet to Allen Jones and Eric Fischl or Japanese photographer Nobuyoshi Araki. However, Wang's work is more than just a dichotomy of East against West. His *Fotofest* (2005), which depicts five naked women comically recreating Matisse's *The Dance* for hundreds of camera-wielding onlookers, could be read both as an indictment of our culture's obsessive use of sex to sell everything from newspapers to works of art, and as a commentary on China's continuing intolerance of nudity in all forms.

Wang now specializes in these meticulously staged photographic tableaux, some of which are stitched together digitally, while others that seem improbable are in fact real scenes involving hundreds of extras posing in over-the-top fantasy dioramas. His complex composite photographs include panoramic works such as *Romantique* and *China Mansion* (2003), which were shot in a Beijing movie studio against highly theatrical, heavenly backdrops. Ordinary Chinese women were given the roles of famous muses or frolicking nymphs,

as if to ingratiate themselves to an international audience and somehow prove their new-found openness. The often grim facial expressions of the paradise-dwellers and the ever-present threat of a terracotta-style warrior waiting in the wings hints at the repressive hand that follows any such attempts at westernization. A much harsher vision of Chinese oppression is *Sentry Post* (2002). A ragbag of bandaged militia trying to cross a barbed-wire border are kept at arm's length from the riches of rampaging capitalism presumably being built on the wasteland beyond, much as western corporations are desperate to gain access to this nation and set up their own barracks. *Dormitory* and *Night Patrol* (2005) also focus on the cruel totalitarian aspects of Communist rule, showing citizens being forced into ever smaller, more squalid and uncomfortable life situations.

Wang's most ambitious work so far, *The Blood of the World* (2007), returns to the subject of war in a dramatic restaging of battles ancient and modern, including recognizable scenes from the history of painting such as Goya's *The Third of May: The Execution of the Defenders of Madrid* and Delacroix's *Liberty Leading the People*. His epic, cinematic sensitivity is nevertheless part of a drive towards verisimilitude rather than a path to artifice – Wang wants us to believe in his catastrophic photographs, because, as he says, 'You feel everything you're seeing is possible, death really is possible. The one certainty of war is that people will die.'

OSSIAN WARD

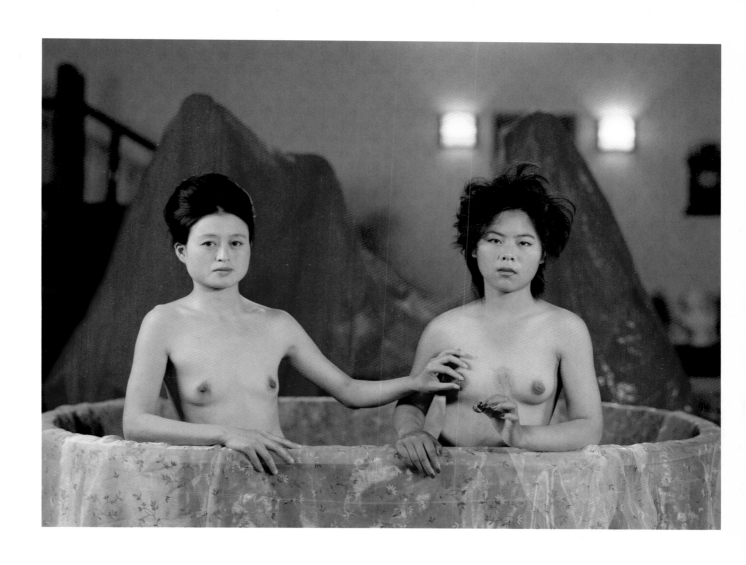

DUPOND & DUPONT, 2003
C-PRINT, 120 X 160 CM
(47¼ X 63 IN.)

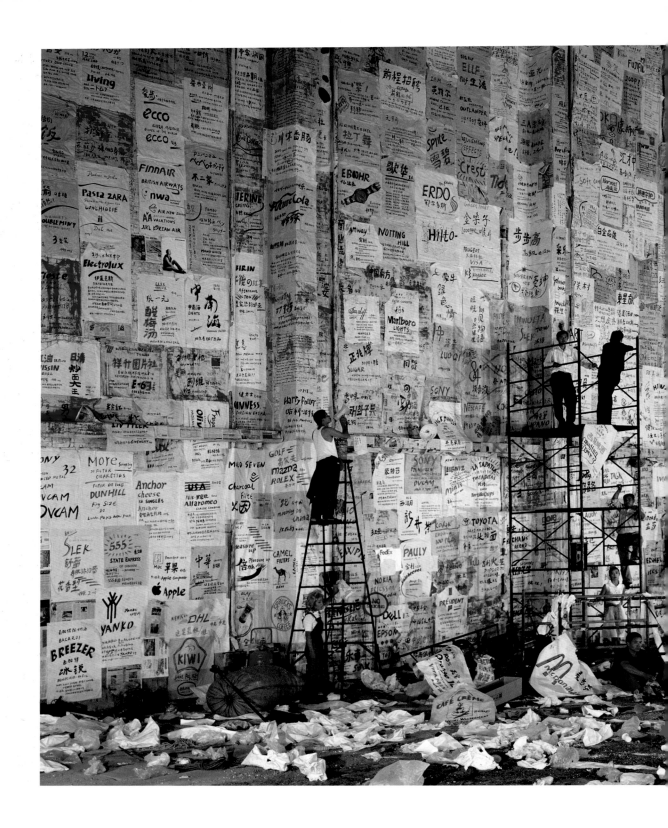

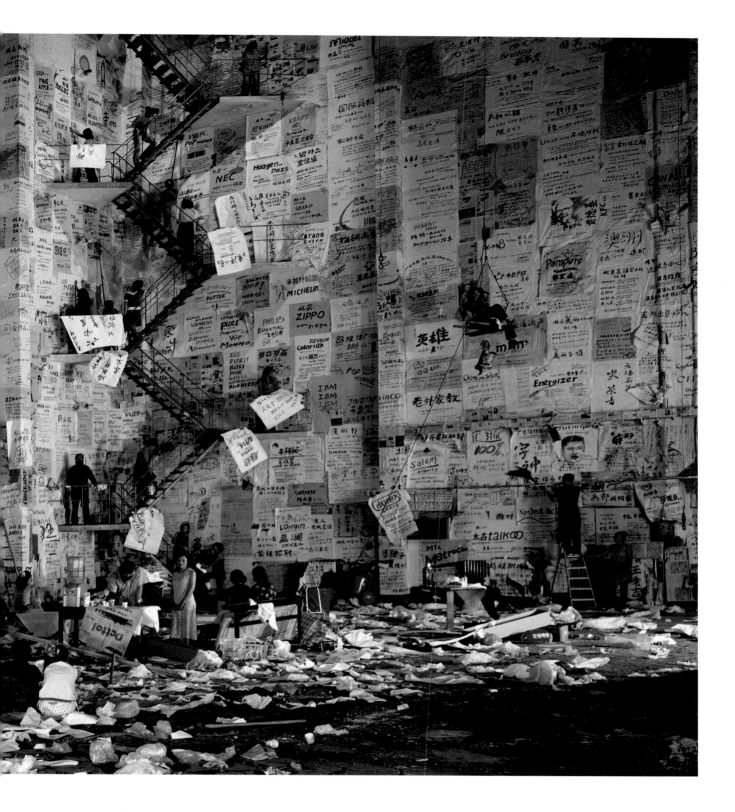

COMMERCIAL WAR, 2004
C-PRINT, 170 X 300 CM
(66⅞ X 118⅛ IN.)

MICHAEL WESELY

born in 1963 in Munich, Germany
lives and works in Berlin

WWW.WESELY.ORG

Michael Wesely has spent years exploring the visual signatures of cities, with their distinctive architectural forms, configurations and complexes. Far from being a documentary photographer, however, he is an inveterate experimenter, constantly pursuing new ways to express the infinitely divergent modes of perceiving our environment. The staggering realization that no two people experience the world in the same way offers powerful encouragement to exploring the ways in which we can represent photographically not only the spatial permutations and conundrums thrown up by the complexities of our environment and our perception of it, but also the temporal implications of our varying modes of attention and memory in relationship to those complexities.

Wesely's principal mode of experimentation has been the use of extremely long camera exposures, such as in his renowned series of photographs *Potsdamer Platz* (1997–99), showing this square in Berlin during its reconstruction. Some of these images required phenomenally protracted exposures of twenty-six months. This series resulted in a commission by the Museum of Modern Art (MoMA) in New York to photograph its own building project. The resulting series, *Open Shutter* (2001–4), was subsequently exhibited at MoMA to great acclaim. In a departure from his photographs of urban scenes, and using another unorthodox approach which transforms familiar, iconic landscapes into geometric, semi-abstract forms, Wesely began in 1999 to use a custom-built camera with a narrow, vertical aperture. Panning across a landscape, this camera translates the scenery into a series of horizontal strips which reflect its subtle and unique colour tones and even preserve a sense of its depth, but at the same time obliterate any identifying forms and features.

Another equally inventive project resulted from Wesely's collaboration with the audio artist Kalle Laar (beginning in 2000), in which his long-exposure pictures of cities such as Los Angeles have been paired with audio recordings made at the same sites by Laar. Wesely's techniques for recording time visually are sympathetically reinforced by the inherently time-defined audio recordings, the camera and microphone being set up adjacent to each other for the same duration. The combination of these two media creates a stretched slice of time that offers parallel but uncannily disjointed experiences of the same events.

Ultimately, Wesely's restless experimentation with new modes of perceiving and representing our world gives us the sobering realization that the perception of our surroundings is singularly one-dimensional. On the whole, our visual dialogue with our environment is tempered by habit and convention, governed by contingency. Wesely, with his intriguing, unorthodox images, leads us to realize how such oblique representations of our world can offer new insights into the way we look at it. Just as Alice was thrown into ontological confusion in Wonderland after drinking spatially distorting elixirs, so in looking at Wesely's work and its visual and temporal distortions, and interpreting the resultant confusions, can we too experience fresh, new ontological insights.

ROY EXLEY

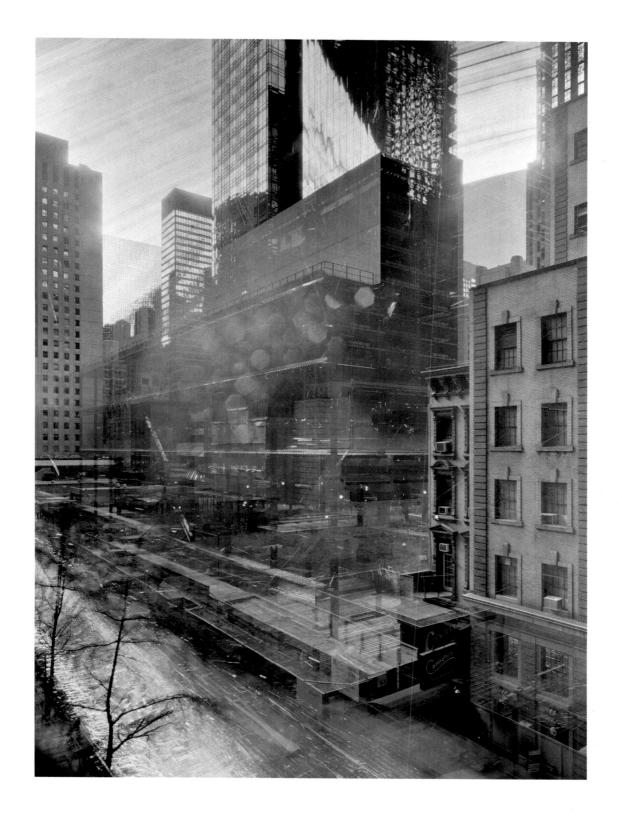

9.8.2001–7.6.2004 THE MUSEUM OF MODERN ART, NEW YORK, 2003
C-PRINT, DIASEC, 175 X 125 CM (68⅞ X 49¼ IN.)

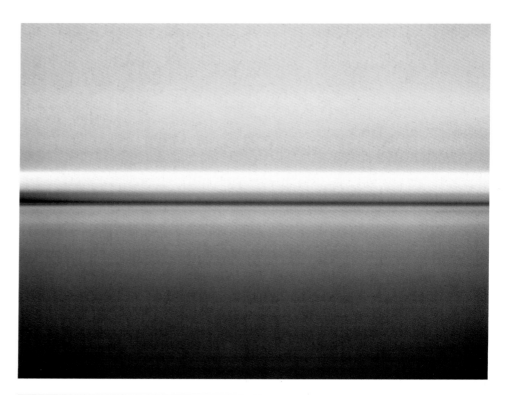

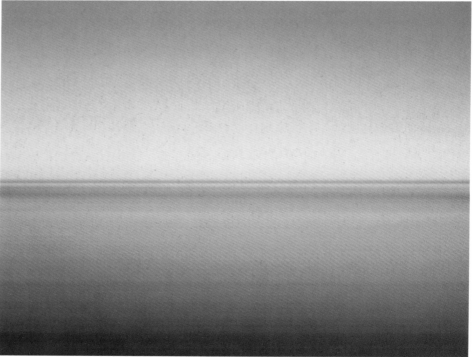

DIE ELBE BEI ARNEBURG, 2004
C-PRINT, DIASEC, 110 X 140 CM (43¼ X 55⅛ IN.)

NORTH KOREA NEAR JAYOURO II, 2005
C-PRINT, ALUMINIUM, DIBOND
180 X 240 CM (70⅞ X 94½ IN.)

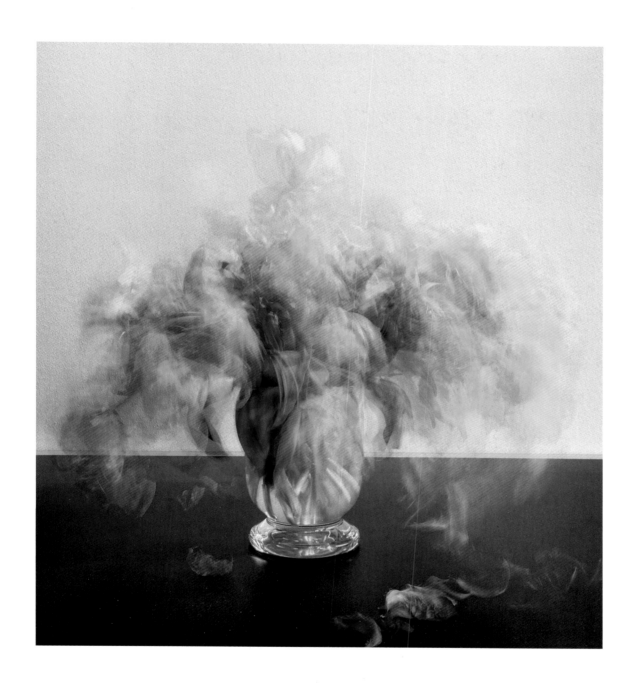

9.5.–17.5.2005, 2005
C-PRINT, 200 X 180 CM
[78¾ X 70⅞ IN.]

YANG FUDONG

born in 1971 in Beijing, China
lives and works in Shanghai

WWW.SHANGHARTGALLERY.COM

Yang Fudong initially studied painting at the China Academy of Fine Arts in Hangzhou before turning to photography and filmmaking in the late 1990s. He belongs to the generation of young Chinese who have experienced first-hand the radical changes that have taken place in their country. A recurrent theme in his work is the loss of emotion and the inability to relate which have marked this generation. He frequently portrays people in their late twenties and early thirties who seem to be strangely suspended between the past and the present. His works embody – often with much irony – the way in which the rapid, western-influenced modernization of Maoist China has played havoc with traditional culture. With great skill, he balances these contrasts, composing images of classical beauty and strange timelessness.

At the 2007 Venice Biennale, Yang exhibited all five parts of his recently completed black-and-white film *Seven Intellectuals in Bamboo Forest* (2003–7). This acclaimed work, with its underlying melancholy, is a modern interpretation of a traditional Chinese tale from the 3rd century, in which seven wise men retreat into a bamboo grove to escape from the confusion of the world around them; there they drink, play games and tell tales in their search for self-fulfilment.

In the colourful and provocative video and Lambda prints *Honey* (2003), the action is driven by the pursuit of pleasure: luxuriously clothed men and women are shown indulging in secret, ambiguous deeds that smack of a cool world-weariness. However, Yang's works rarely contain a narrative thread; they are visual impressions ranging from close-up to panoramic. Some are reminiscent of *tableaux vivants*, while others recall the aesthetics of New Wave cinema or unforgettable scenes from the films of Jim Jarmusch.

At the start of his career, Yang focused on intellectuals. In the early photographic triptych *The First Intellectual* (2000), we see a young man standing in ragged, bloodstained clothing in the middle of a multilane highway; in his raised hand he is holding a brick, which he is about to throw. The picture achieved global recognition through the Internet and inspired new images, possibly because it appealed to the collective unconscious of modern Chinese people – a symbol of the inviolable sanctity of each individual.

UTA GROSENICK

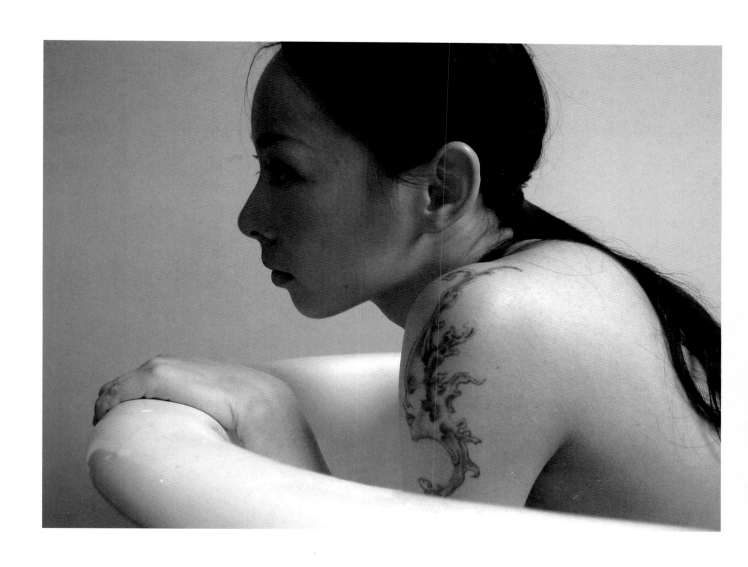

SEVEN INTELLECTUALS IN BAMBOO FOREST, 2004
C-PRINT, 86 X 114 CM (33⅞ X 44⅞ IN.)

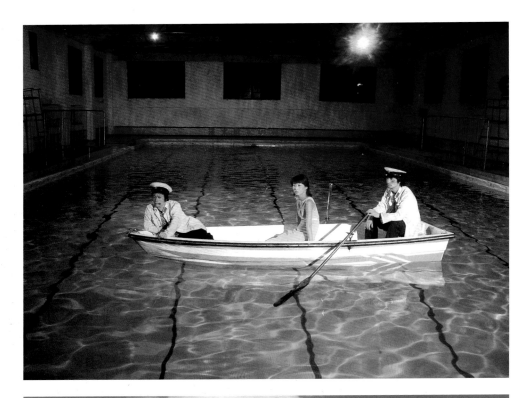

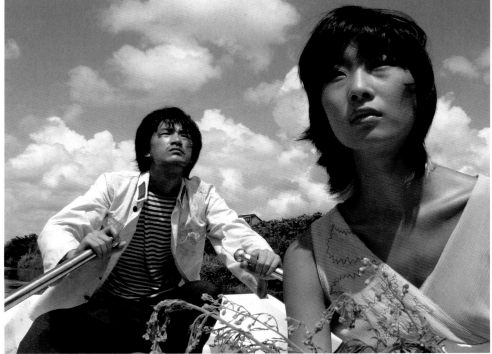

LOCK AGAIN NR. 3, 2004
C-PRINT, 86 X 114 CM
(33⁷/₈ X 44⁷/₈ IN.)

LOCK AGAIN NR. 1, 2004
C-PRINT, 86 X 114 CM
(33⁷/₈ X 44⁷/₈ IN.)

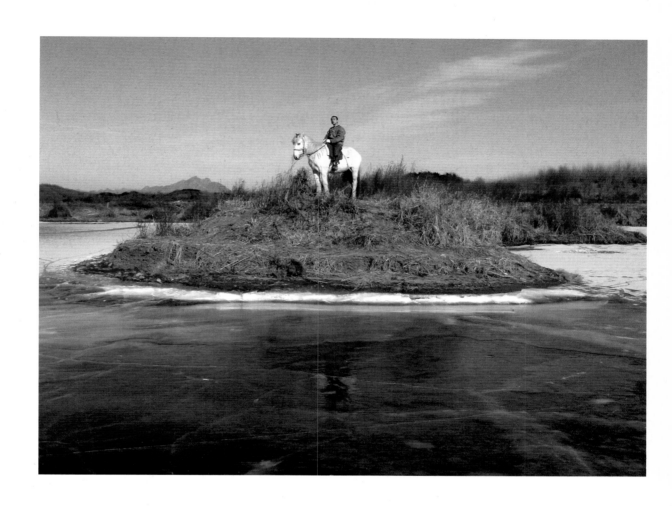

REVIVAL OF THE SNAKE, 2005
VIDEO STILL

TAKASHI YASUMURA

born in 1972 in the Shiga Prefecture, Japan
lives and works in Tokyo
WWW.OSIRIS.CO.JP WWW.YOSSIMILO.COM

At first sight, Takashi Yasumura's pictures seem simple – a drawer containing carefully folded plastic bags, a pink stapler, a rolled-up garden hose beside a bonsai. It seems difficult to see the 'scandal' associated with these elegantly straightforward still lifes in the series title *Domestic Scandals* (1998–2004). Prosaic, cleanly lit, precise – they could be pieces of evidence gathered from a crime scene. But these everyday objects are not linked to any crime or scandal; rather, they are themselves the scandal. Yasumura photographed them in the house of his middle-class parents. They all point to the erosion of Japanese tradition by the global triumph of the western consumer world, with its promise of an easy modern life. Each of the objects shown is a metaphor for a conflict engendered by this cultural transformation, liable to flare up at any given moment. The obtrusive ghettoblaster stands for teenager consumerism unleashed by pop culture; the plastic cruet symbolizes changes in eating habits. But the strict ordering of space, the precise arrangement of the objects and the absolute cleanliness all betray an aesthetic sensitivity that has so far managed to escape the clutches of westernization. This mixture of western products and Japanese feeling for space delineates a no-man's-land between East and West, an intermediate zone in which more and more people are now living. Dispassionately, and free from the shadow of cultural depression, Yasumura simply grasps in these pictures the contradictions inherent in a globalized world.

His more recent work, *Nature Tracing* (2000–4), is also characterized by a sophisticated ambiguity. It contrasts representations of nature in private homes – a sunset on a TV screen, a traditional Japanese watercolour, a statue of an eagle – with pictures of nature in the wild, such as a waterfall, a rugged coastline, a river running through a forested valley. From the interplay between these images, questions arise about the way culture shapes our perception of nature. When we look at the countryside, our perception is always accompanied by those human representations of nature that we have seen and internalized. Unexpectedly, the landscape pictures in *Nature Tracing* begin to take effect, and we perceive them as images whose contact with reality is uncertain, because they constantly refer to other images. 'Nature' now emerges as a cultural product. Here, too, Yasumura reveals himself to be a master of controlled ambivalence, a sharp-eyed cultural critic, whose focused and dispassionate images open up many hidden depths.

MARTIN JAEGGI

A PAIR OF SLIPPERS, 1997
C-PRINT, 88.9 X 119.4 CM
(35 X 47 IN.)

JAPANESE ORANGES, 2002
C-PRINT, 88.9 X 119.4 CM
(35 X 47 IN.)

OLD NEWSPAPERS, 2005
C-PRINT, 119.4 X 88.9 CM
(47 X 35 IN.)

KIMIKO YOSHIDA

born in 1963 in Tokyo, Japan
lives and works in Paris, France

WWW.KIMIKO.FR

'My self-portraits are still lifes.... You immediately see what it's all about: being and nothingness, the vanity of the image, life and death, and especially getting beyond narcissism,' says Kimiko Yoshida. And she also claims: 'Art is what transforms.' Indeed, metamorphosis and transformation are key words in the art of Yoshida. The series of self-portraits that constitute the heart of her oeuvre is a seemingly infinite chain of variations, alterations and transmutations, all of them involving the face of the artist presented straight on. The basic ingredients of a Yoshida image are easily recounted. The (made-up) face and torso, a monochrome studio background, an object – like a mask, a veil, a headdress – held in front of the face. The make-up stems from the Japanese technique of *doran*, a covering or levelling of the face rather than embellishing it. Yoshida emphasizes that she does not use filters, nor does she apply any digital post-production. Only lighting, make-up and the treatment or colouring of her hair are used to enhance the final image.

Yoshida's photography abounds in polarities, combining a disciplined but inventive formalism – in its consistent application of reduction and repetition – with an exuberant, even Baroque, conceptualism, in one lustful, infinitely resourceful embrace of a kaleidoscopic range of cultural references. Every body of work engages with a spectrum of sources including African, Asian and European cultures, or Greek, Nordic and Asian myth, while remaining strictly organized through the predefined programme of a very particular aesthetic – the face, the object, the chromatic field. Another polarity would be the juxtaposition of austere minimalism – no expression, no gestures – with a radical realism: 'this is being performed in front of the camera, this is recorded live, this is analogue.'

Two themes manifest themselves in Yoshida's vast, dense oeuvre. First is the assumption of different identities, traversing a completely transhistorical and transcultural spectrum. The actual face and torso of Yoshida are what is registered by the camera, but they are always changing. 'I am many,' says the artist. Second is the exploration of language's relation to identity and death. Letters, treated as objects, are juxtaposed against the face. *Respiration Piece: Red Comma* (2005) presents a comma, the smallest element of written language, a resting point between words, here made from hand-blown glass at Murano in Venice and using the historical Bodoni font from 1788, positioned in front of the face. *Tombeau* (2005–6) shows the words *Pulvis, Cinis et Nihil* (Dust, Ashes and Nothing) against an expressionless face with closed eyes. Situated between figuration and abstraction, between identification and death, the work of Yoshida proposes that 'identity is a fantasy...a thumbing through of a succession of borrowed identities.... All that's not me, that's what interests me.'

JAN-ERIK LUNDSTRÖM

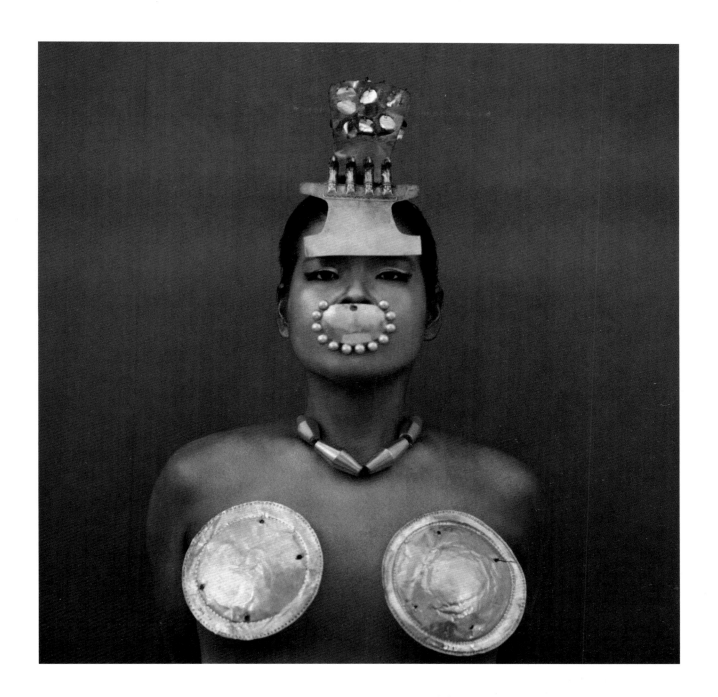

THE EL DORADO BRIDE (GOLD PECTORAL, MACARACAS, AZUERO, PANAMA, 1,100–500 BEFORE PRESENT; NOSE & NECK GOLD ORNAMENTS, MOCHE, PERU, 1,900–1,700 BEFORE PRESENT; GOLD HAIR ORNAMENT, LAMBAYEQUE, PERU, 1,100–900 BEFORE PRESENT). SELF-PORTRAIT, 2005
FROM THE SERIES ETHNICS
C-PRINT, ALUMINIUM, ACRYLIC, 120 X 120 CM (47¼ X 47¼ IN.)

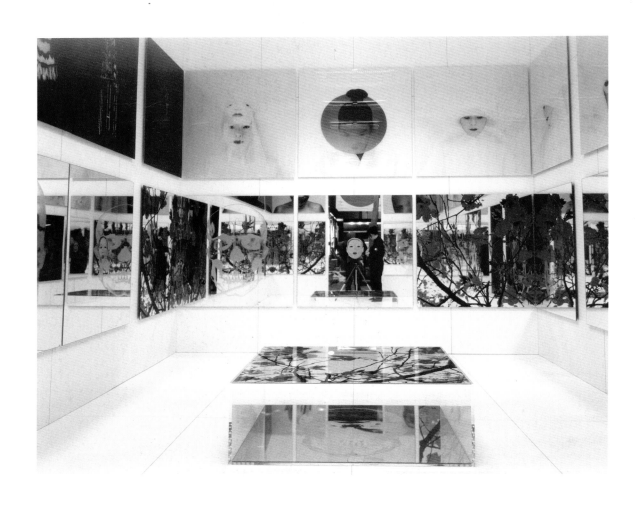

SILVER PAVILION, 2004
PHOTOGRAPHS, SCREENPRINT, MIRROR GLASS
INSTALLATION VIEW OF **INTÉRIEUR 04,
19. BIENNALE POUR LA CRÉATIVITÉ DANS
L'HABITAT**, COURTRAI, BELGIUM

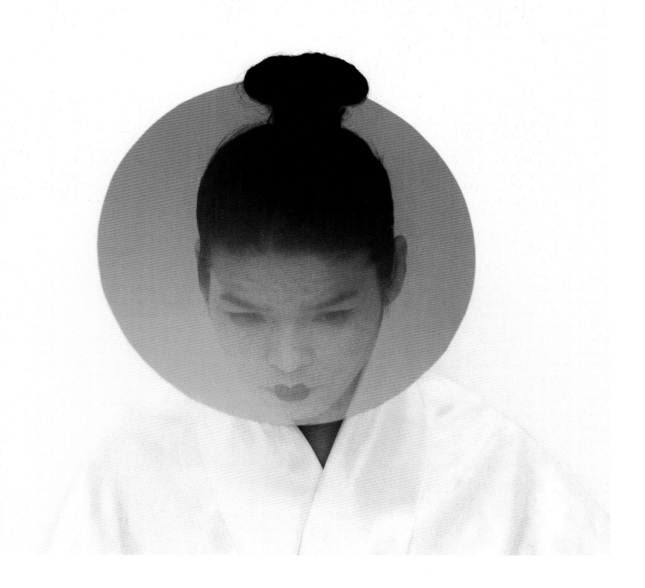

THE JAPANESE BRIDE. SELF-PORTRAIT, 2003
FROM THE SERIES **WHITE**
C-PRINT, ALUMINIUM, PLEXIGLAS
120 X 120 CM (47¼ X 47¼ IN.)

BIOGRAPHIES OF AUTHORS AND EDITORS

PAOLO BIANCHI organizes exhibitions, is guest editor of the magazine *Kunstforum International*, and teaches at the Hochschule der Künste in Zurich. He lives in Baden, near Zurich. Exhibitions: *Schaurausch, Kunst in 50 Schaufenstern*, OK Offenes Kulturhaus, Linz, 2007; *Augenzeugen: Bilder von Krieg, Globalität und Blogs*, Seedamm Kulturzentrum, Pfäffikon/SZ, 2007; *Paradoxe Freundschaft: Kunst-Dialog zwischen Italien und der Schweiz*, Centro Culturale Svizzero, Milan, 2005–6. Themed issues of *Kunstforum*: 'Das Neue Ausstellen', 2007, vol. 186; 'Die Kunst der Selbstdarstellung', 2006, vol. 181; 'Müllkunst', 2004, vol. 168; 'Kunst ohne Werk', 2000, vol. 152.

REINHARD BRAUN is an author and curator. Since 1990 he has written many articles and lectures, researched photography and media history and theory, and has worked on projects with artists in the field of the media and telecommunications. In 1999 he founded MiDiHy Productions/Medien. Theorie. Kunst. Kultur. From 2003 to 2006 he was editor of *Camera Austria*. Since 2007 he has been curator of fine arts at the Steirischer Herbst Festival. He lives and works in Graz, Austria. http://braun.mur.at

DAVID BRITTAIN is an author, critic and curator. Between 1991 and 2001 he edited the magazine *Creative Camera*, London, was responsible for the relaunch of *Creative Camera* as *DPICT*, and published the book *Creative Camera: 30 Years of Writing* (Manchester University, 2000).

In 2006–7 he curated the exhibition 'Found, Shared: the Magazine Photowork', at CUBE, Manchester, and the Photographers' Gallery, London. Brittain writes regularly for the magazines *Source*, *Photoworks*, *Next Level* and *Eye*, and was guest editor for an edition of *Afterimage* (Rochester, NY, 2007). He currently holds a research fellowship at Manchester Metropolitan University/MIRIAD.

FLORIAN EBNER is a photographer and author, and lives in Leipzig. He studied photography at the École Nationale Supérieure de la Photographie in Arles, and history and art history at the Ruhr-Universität Bochum. From 2000 to 2006 he taught at the Hochschule für Grafik und Buchkunst Leipzig, as an assistant to Timm Rautert. In collaboration with Manuel Reinartz, he produced the artist's book *P>S* in 2007. His writings on modernist and contemporary photography have been widely published.

ERIK EELBODE is a photography critic. He lives and works in Ghent, Belgium, as an editor, curator and translator, and he is a member of the Association Internationale des Critiques d'Art (AICA): erikeelbode@skynet.be

ROY EXLEY is a freelance critic and curator, specializing in photography. He writes for *Portfolio*, *Photoworks*, *Camera Austria*, *Next Level*, *Flash Art* and *Blueprint*. Since 2000, he has curated nine exhibitions, including

Amplifying Silence/ Magnifying Stillness at the Fondation
d'Art Contemporain Daniel & Florence Guerlain in
Les Mesnuls, France, and *multicomplexificationalities* at
The Nunnery in London. He was a jury member for
'Photosynkiria' in Thessaloniki, Greece, and for the BOC
Emerging Artists Award in the UK. He lives in London.

UTA GROSENICK has organized exhibitions at the
Deichtorhallen in Hamburg and the Bundeskunsthalle
in Bonn, and was a curator at the Kunstmuseum in
Wolfsburg. She edited *Art at the Turn of the Century* (1999),
Women Artists (2001), *Art Now* (2002) and *Art Now, Vol. 2*
(2005). Since 2006 she has been managing editor at
DuMont Buchverlag, for whom she co-authored
International Art Galleries: Post-War to Post-Millennium
(2006). Her most recent publications include *China Art
Book*, a survey of eighty contemporary Chinese artists.

FELIX HOFFMANN is an expert on art and culture, and
is currently head curator at the C/O in Berlin. In 2003
and 2004 he held the photography curator's fellowship
of the Alfried Krupp von Bohlen and Halbach Collection
at the Fotomuseum in Munich, the Kupferstichkabinett
in Dresden, and the Folkwang Museum in Essen.
He is the author of many essays on historical and
contemporary photography, and as a curator has
designed many exhibitions.

BARBARA HOFMANN-JOHNSON studied art history,
German literature, theatre, film and television, and now
lives in Cologne as a freelance art historian and curator.
In recent years she has curated and co-curated many
solo shows and themed exhibitions of contemporary
art with the emphasis on photography both from
Germany and elsewhere. As well as writing articles for
monographic catalogues, she has written a number
of pieces on the UBS Art Collection, and she also works
freelance for the Photographische Sammlung/SK
Stiftung Kultur in Cologne.

KAREN IRVINE is curator at the Museum of
Contemporary Photography, Columbia College,
Chicago, where she also teaches. She gained her Master
of Fine Arts at FAMU in Prague, Czech Republic, and is
currently pursuing a masters degree in art history at the
University of Illinois, Chicago.

MARTIN JAEGGI studied film and new media in New
York and San Francisco. He is now living and working
as a freelance publicist and translator in Zurich. He
holds teaching posts at the Hochschule für Gestaltung
und Kunst, Zurich, and the F&F Schule, Zurich. He
has published many articles about photography and
contemporary art in books, newspapers (*Tages-Anzeiger*,
Weltwoche) and magazines (*Art Review, Exit, Aperture*, etc.).

JAN-ERIK LUNDSTRÖM is director of the BildMuseet at the University of Umeå, Sweden. Among his more recent exhibitions were: *Politics of Place, Society Must Be Defended* (1st Thessaloniki Biennale 2007), *Killing Me Softly, Projects for a Revolution, Double Vision* (Prague Biennale 2005), *Carlos Capelan: onlyyou* and *Same, Same, but Different*. He was also head curator of the Berlin Photography Festival 2005. He has written a large number of books, including *Nordic Landscapes, Tankar om fotografi, Irving Penn* and *Horizons: Perspectives on a Global Africa*, and also writes for magazines such as *Glänta, European Photography, Paletten* and *tema celeste*. Lundström also holds visiting professorships at HISK in Antwerp, Belgium, and at the Art Academy in Oslo, Norway. Together with Johan Sjöström he is due to curate the next Bucharest Biennale in May 2008.

NADINE OLONETZKY is a freelance author, and writes on photography, art and culture for magazines such as *Du, NZZ am Sonntag* and *Photonews*, as well as contributing to books. She has held assistantships at the Kunsthalle, Vienna (1994), and the Fotomuseum, Winterthur (1995–96). From 1997 until 2001 she worked for the Kulturstiftung in the Swiss canton of Thurgau. She is a member of the studio commune Kontrast (www.kontrast.ch), and lives and works in Zurich.

ARNE REIMER lives and works as an artist and photographer in Leipzig. After taking his diploma in photography at the Hochschule für Grafik und Buchkunst, Leipzig, studying under Timm Rautert, he was awarded a Fulbright Scholarship in 2001, and completed his Master of Fine Arts at the Massachusetts College of Art, Boston, in 2005. After a short period spent teaching at Wellesley College, since 2006 he has been employed in the photography department of the Hochschule für Grafik und Buchkunst in Leipzig.

MANUEL REINARTZ lives and works as an artist and photographer in Berlin and Leipzig. From 1995 until 2000 he studied theatre and philosophy in Leipzig and communications design in Potsdam. In 2000 he began to study photography at the Hochschule für Grafik und Buchkunst, Leipzig, finishing in 2006 under Timm Rautert, whose master classes he is now attending. In 2007 he co-authored the artist's book *P>S* with Florian Ebner.

THOMAS SEELIG studied photography at the Fachhochschule in Bielefeld, and then trained at the Jan van Eyck Academy in Maastricht to be a curator. He has worked as a freelance curator and editor for exhibitions and publications on contemporary photography. He lives in Winterthur, Switzerland, and since 2003 has been a curator at the Fotomuseum Winterthur.

JOHAN SJÖSTRÖM has been curator of the BildMuseet at the University of Umeå, Sweden, since 1998. He has been invited as lecturer, curator or critic to countless photographic events, including the Rencontres d'Arles, France; FotoFest, Houston; FotoFest, Beijing; Rhubarb Rhubarb Festival, Birmingham, UK; Artphoto Image Festival, Bucharest; Bratislava Month of Photography, Slovakia; and Skábmagovat, Inari, Finland. He has contributed to magazines such as *ArtPhoto*, *FotoMagazin* and *Paletten*, as well as being editor of various publications, including *Lara Baladi – Kai'ro*, *The Politics of Place*, *Mats Hjelm: Trilogy*, *Mirror's Edge* and *Head North*. Together with Jan-Erik Lundström he is scheduled to curate the next Bucharest Biennale in May 2008.

RIK SUERMONDT studied art history at Utrecht University. Since 1987 he has worked as a freelance historian of photography, and teaches the history of photography at the Hogeschool voor de Kunsten Utrecht and at the AKV/St. Joost in Breda. Since 1999 he has been curator of FotoFestival Naarden. Suermondt writes regularly for art and photography magazines, and is also co-author and editor of several books, including *Photography Between Covers: The Dutch Documentary Photobook After 1945* (1989), *Frits Weeda: In de schaduw van de welvaart* (2005), *Plaats Delict Amsterdam* (2006) and *Paul de Nooijer fotograaf* (2007). www.riksuermondt.nl

OSSIAN WARD is arts editor for *Time Out* in London, and has written many articles on contemporary art. He contributes to magazines such as *Art in America*, *Art + Auction*, *Modern Painters* and *Monopol*, and has written for newspapers that include *The Evening Standard*, *The Guardian*, *The Observer*, *The Times* and *The Independent*. He is former editor of *ArtReview* and the *V&A Magazine*, has worked for *The Art Newspaper*, and edited *The Artists' Yearbook 2008/9* for Thames & Hudson.

GRANT WATSON studied curating and visual culture at Goldsmiths College in London. He lives in Antwerp, and is curator of the Museum van Hedendaagse Kunst Antwerpen (MuHKA), where he arranges exhibitions and organizes events. Prior to that, he was curator of Visual Arts at the Project Arts Centre in Dublin, where the programme included exhibitions by artists such as Gerard Byrne, Martha Rosler, Goshka Macuga, Sheela Gowda, Enrico David, Seamus Harahan, Klaus Weber, Sarah Pierce and General Idea. He also organized the group exhibition 'Communism and Enthusiasm' for the Frieze Art Fair, London. Recently he co-edited the book *Make Everything New: A Project on Communism*, published by Book Works, London, and was guest curator for *Documenta 12*.

GLOSSARY

Florian Ebner, Arne Reimer, Manuel Reinartz

Cross-references to other glossary entries are in *italics*.

AMATEUR PHOTOGRAPHY (SNAPPERS vs AMATEUR PHOTOGRAPHERS)

What is an amateur photograph? Even if the term seems straightforward at first sight, it's actually far from clear. What is generally called an amateur photo is often not the work of an amateur photographer. The wide field of amateur photography dissociates itself from those at 'the top', i.e. the professionals, but has its own inner hierarchy that distinguishes between the snapper and the amateur photographer, who has technical and artistic ambitions in his or her use of the medium. Snappers, on the other hand, take their pictures for a variety of reasons, all of which boil down to the desire to capture an image in order to recall it later. The ordinary amateur photo can therefore be defined in terms of private usage and an untrained exponent – which links it more closely to the snapper than to the classic amateur photographer, who will generally try to emulate his professional counterpart. One must also mention the category of autodidacts (a dwindling group) who may be recruited from this field and who have made photography their artistic profession.

The culture of amateur photography, which has expanded massively thanks to the invention of cheap and easy-to-use pocket cameras, has a history that goes back over nearly 120 years and has developed a vast range of customs and rituals, modes and forms of presentation. These include the photo album (together with *slideshows*, clipframes, posters etc.) which plays a central role in assembling individual histories. In the age of digital photography, the practices of amateur photography have changed fundamentally: mobile snapshots are to be found on home pages, the world of eBay has spawned a new culture of specialist photographs, and images as stores of memories have now become flexible, capable of new combinations, and at the same time placeless, while one press of the Undo button is enough to make them all disappear.

The relation between art photography and amateur photography is uneven and hierarchical, not dissimilar to that which once existed between painting and photography. While amateurs always tried to emulate the great masters, as for instance German photo clubs looked up to the work of Otto Steinert in the 1960s and 1970s, today it is only with hindsight that the importance of amateur photography has been recognized as having provided a repertoire of forms for the photographic avant-garde. Back in the 1970s, young artists paid close attention to the pictorial world of the amateurs, and their modern counterparts are also using snapshots and applied photography to discover the potential of 'authorless' photography, whose images – precisely because of their anonymity – can tell us so much about ourselves, about photography, and about the way it generates cultural values.

APPROPRIATION (APPROPRIATION ART/ FOUND FOOTAGE)

The term 'appropriation art' in the art world was initially associated with a group of young American artists of the 1980s. For a long time now, however, it has become widely recognized as a multi-faceted principle

of artistic creativity. In the first instance, 'appropriation' indicates a shift of context carried out by the artist: he takes an element from another field and integrates into his own work, or simply calls it art, just as it is. Marcel Duchamp's ready-mades fall into this category of appropriation. From an art-historical point of view, this concept has now been taken a great deal further in terms of both timescale and content. As well as concrete objects and images, sights and subjects from outside the realm of fine art have also been appropriated. In this respect, Cindy Sherman's famous series of *Untitled Film Stills* (1977–80) may be regarded as an appropriation of trivial images from the world of the cinema. Sherman's artistic use of these images creates an interplay between entertaining performance and deconstruction, from which emerge the underlying clichés relating to the role of American women.

Appropriation, in its narrower sense of processing existing material, began in the field of photography with the avant-garde of the 1920s, in the form of *photomontages* by artists such as John Heartfield and Hannah Höch. Since the 1960s, American artists in particular have worked in a similar vein, taking material from popular culture and from the media – the most prominent being Andy Warhol and John Baldessari. In contrast to the manner in which these and others transform the material (through screen prints, montages etc.), Richard Prince and Sherrie Levine – prime exponents of 'appropriation art' – restrict themselves to the method of re-photography, i.e. photographing existing pictures. Richard Prince focuses on stereotypes from advertising and amateur photography, sometimes taking details and combining them in series, while Sherrie Levine goes in the opposite direction, from top to bottom, by reproducing photographic masterpieces from modern times and claiming authorship of these copies.

The forms of appropriation to be found in the works of Hans-Peter Feldmann and Christian Boltanski since the 1970s have as their subject the sociological, historical and narrative potential of amateur photography, as they constantly draw on the form of the *archive*. What these works have in common is a desire to use this medium as 'non-art' – as a social medium and as a form of 'low culture'.

Today, with a heightened awareness of history and with the opening up of all kinds of analogue photographic archives, together with all the new pictorial worlds available through the Internet, the many artistic practices that are based on found and appropriated material ('found footage', as it is known in film terminology) have found a new lease of life. In an image-saturated world, artistic analysis of existing material is often more interesting than the production of yet more photographs.

ARCHIVE

Over the last thirty years, there has been much discussion on the interrelationship between archives and photography. The archive as a structure of accumulation and classification of knowledge that has helped to define our modern age seems to have found its ideal form in photography, which provides a rich store of visual images relating to visible reality. The

second half of the 19th century produced a huge variety of photographic collections and archives on such subjects as clouds and stars, monuments and tourist attractions, animal species and national 'types'. Indeed, this normative and hence political aspect of the archival system of classification has had a lasting influence on theoretical discussion right through to the present day.

For photographers themselves, and especially the out-and-out realists among them, archiving is an indispensable way of organizing their work internally, but the selected categories and principles of organization already reveal something about their modus operandi as well as about their personal view of the world. Many documentary approaches centre on the concept of the archive and the need to create such records. Processes of historical transformation seem especially to trigger this activity, as exemplified by Eugène Atget's photographs of *Vieux Paris* in decline, or Bernd and Hilla Becher's systematic documentation of a vanishing industrial culture. Interestingly, these two archival landmarks in the history of photography both stand at points of intersection in the changing artistic view of the medium.

Since the 1970s, artists have used the photographic archive in a variety of ways. Photography's quest to cover the whole range of objects (Hans-Peter Feldmann) is accompanied by the cultural and historical functions fulfilled by the photographic archives of the 19th century (Joan Fontcuberta, Jochen Lempert). What many of these works have in common is a markedly ironic approach, which is not meant to denote the disposition of the artist, but acts rather as a way of analysing our pictorial heritage (see *Appropriation*). This approach also exposes the seemingly grotesque elements of the media culture, which we take for granted, as well as its suppressed or apparently purposeless images (Peter Piller).

In the last fifteen years, the nature of photographic archives has radically changed. The traditional stores of prints and negatives, kept forever in a single place, are gradually being replaced by digital image banks. Private archives have suddenly become public thanks to the Internet, while the public images of our collective memory are now available for commercial exploitation. This new and seemingly uncontrollable explosion of images has already generated a variety of artistic responses, and will certainly continue to do so.

ART PHOTOGRAPHY/AUTEUR PHOTOGRAPHY

Volker Kahmen's *Fotografie als Kunst* (Photography as Art) (1973) was the first major book to be published on this subject. It contains an impressive collection of 442 photographs, bringing together historical and contemporary works, including some by then up-and-coming artists like Bruce Nauman and Gilbert & George. The comprehensive photographic section is structured according to formal analogies, and Kahmen's juxtaposition of the photographs allows for surprising comparisons between images taken from very different contexts. He focuses especially on the documentary achievements of the medium.

From then onwards, however, the paths of photography and art tended to diverge rather than converge. In Germany in the 1970s and 1980s, there

emerged a species of artist who worked almost exclusively with film. He used the medium to construct, stage and perform scenes for the camera, with which he then recorded them. The images, filtered and divided up into grids, served as raw material which was transformed into large-format photographs. He saw himself as an artist, not as a photographer, he had come from art college, and frequently he went back there to teach. Looking back, we talk of this as 'art photography', and typical West German exponents were Dieter Appelt, Anna and Bernhard Blume, Rudolf Bonvie, Jürgen Klauke, Astrid Klein and Katharina Sieverding; also worthy of note was Thomas Florschütz from East Germany. In coining the term 'auteur photographer' in 1979, Klaus Honnef sought to create a concept – rather like that of the cinematic auteur – which from an historical as well as an artistic point of view would endow the photographer, who was bound to a documentary approach as well as a personal vision, with the status of (artistic) authorship without having to actually classify him as an artist, a label which was not considered suitable at the time. Even today, the term 'art photographer' for those who work on projects of personal interest is still regarded by some as an unwarranted ennoblement of the activity. But work in these two fields has long since converged, and in many cases it is difficult to guess whether the auteur has been trained as an artist or as a photographer. In Germany this is due in no small measure to the success and influence of the teachings of the *Becher School*, and to the self-confident emergence of photography at art colleges such as the Hochschule für Grafik und

Buchkunst in Leipzig, where it is far from unusual for students to be encouraged to work on hybrid forms.

THE BECHER SCHOOL
(THE DÜSSELDORF SCHOOL)

In 1976, Bernd Becher – who worked in artistic partnership with his wife Hilla – was offered the professorship of photography at the Kunstakademie in Düsseldorf. It was a good choice. Their work, firmly rooted in the German tradition of August Sander, had already received international recognition. The choice seems even more inspired when one considers the success achieved in the art market during the 1980s by their first batch of students – including Thomas Struth, Candida Höfer, Axel Hütte, Thomas Ruff, and later Andreas Gursky and Jörg Sasse. The label of the Becher School or Düsseldorf School, also used for subsequent generations of students, denotes an objective approach with a degree of detachment that clearly distinguishes it from the journalistic or documentary practices of other German photographers, who tend to use a far freer pictorial language. During the 1990s, the Düsseldorf School was seen from the outside as an extension of *New Objectivity*, and even as synonymous with German photography itself. However, in further developing the Becher School between 2000 and 2006, Thomas Ruff had already shifted the emphasis from objectivity to experimental, digital work, in keeping with his own experiments. In this respect, the term 'Becher School' is now somewhat shadowy, since it reduces the very varied range of its long established artists to what they learned during their studies; on

the other hand, it is a useful label to identify an important seedbed of photographic art during the 1970s and 1980s.

BLACK-AND-WHITE PHOTOGRAPHY (GELATIN SILVER, CHLOROBROMIDE, SILVER BROMIDE, FB PAPER, BARYTA, PE/RC PAPER)

A conventional black-and-white photograph can (still) be printed as an enlargement or contact print of a negative onto monochrome, industrially produced developing paper. The light-sensitive photographic emulsion is generally based on either silver bromide (for a cooler shade of black) or chlorobromide (for a warmer tone). Another not inconsiderable influence on the tone is the choice of paper. Papers can be divided into FB paper (fibre-based), which is coated in a baryta (barium hydroxide) layer that holds the emulsion, and RC (resin-coated) or PE (polyethylene) paper, which is coated in a thin layer of polyethylene. Although PE paper greatly accelerates the processing, many photographers prefer FB paper as being the 'original' and, in terms of picture quality and durability, much better quality.

The classic gelatin-silver papers which in the 1920s took over from the printing-out papers of the 19th century, and whose cool, clear shades helped to bring the medium into the modern age, shrank after the 1980s to a small selection of photographic papers, and recently Agfa Photo (as a result of insolvency) and Kodak have ceased production of their black-and-white papers altogether, while Durst ended production of their enlargers in 2006. The demise of the black-and-white darkroom also entails the end of a special photographic culture which for many photographers provided an initiation into the medium as a whole. At the same time, many black-and-white works now have the somewhat conservative image of handmade, 'fine art prints'. A growing market in *Inkjet* papers is trying to rescue classic black-and-white by bringing it into the digital age, but for many artists who for various reasons – including conceptual – still cling to classical black-and-white photography, this is not an attractive compromise. Young photographers are often more interested in experimenting with black-and-white laser prints or photocopies.

BOOKS (INCLUDING PHOTOBOOKS, ARTIST'S BOOKS, EXHIBITION CATALOGUES AND LIMITED EDITIONS)

In the last fifteen years, there is scarcely a single subject on the broad photographic scene that has come so far out of the shadows of the private domain and into the glare of the public gaze as the relationship between photography and books. Long regarded by historical research as a minor matter, the photobook is now experiencing an extraordinary boom. Countless anthologies are appearing on the market, including recently the two-volume *The Photobook: A History* by Martin Parr and Gerry Badger. A substantial public is now leafing through the new illustrated book culture, which had previously attracted mainly – though admittedly numerous – collectors and photographers themselves. Long before the concept of multimedia

came into being, the photobook was already practising it, creating a work that combined photography, text, typography, graphic design and the art of printing. The great diversity of these books reflects the social and discursive contexts in which photography is used, and it is no small achievement that this new interest has given rise to not just one but many cultural variations of the genre. Who, other than the *cognoscenti*, could have guessed that the photobook would become so important for Japanese photography? Without wishing to embark on a list of all the important early works, we can at least make the following observations.

Generally we think of the photobook as a combination of printed text and pictures, the beginnings of which are generally traced back to the 1920s, when mass production became possible thanks to improved printing techniques. But in terms of time, this would cut its history in half, for it began as far back as William Henry Fox Talbot's *The Pencil of Nature* (1844–46) and the carefully compiled travel books and scientific compendia of the 19th century, which included photographic prints.

There are a few small but rigid formal principles that apply to all photobooks: firstly, the relationship between the pictures, which form a sequence of individual pages or double spreads. This may seem obvious, but in the course of time it has become apparent that different photographic approaches fit in with certain styles of narration. One might perhaps describe these approaches in terms of sequence, combination and formal consonance, which in most books overlap and influence one another. August Sander's famous *Antlitz der Zeit* (Face of Our Time) (1929) is a selection from his great collection of German portraits, arranged in an order of 'civilized' precedence, according to the author's own personal perceptions. William Eggleston's *Guide* (1976) is a carefully composed, somewhat ironic guide to the American states of Alabama and Mississippi, with a rhythmic sequence of colourful consonances and dissonances provided by his seemingly casual photography. Photobooks, whether they insist on a purist presentation of their individual photos or, conversely, adopt the image-filled layout of magazines, are very often narratives compressed between two book covers and describing the world, society, a particular place or a particular group of people. That distinguishing feature is the narrative, and linked to this is the flow of images.

If we look more closely at the wide range of photobooks, we can distinguish different categories that do not correspond to the classical concept – for instance, *artist's books*. The prototype of the modern artist's book goes back to the 1960s and 1970s, when countless artists discovered photography as a simple, straightforward democratic medium that enabled them to compile unpretentious little volumes printed in small quantities. A legendary example is Ed Ruscha's fourteen books, which he published between 1963 and 1971. As an ideal medium for conceptual art, they were both statement and manifestation of an artistic approach, conceived as little multiples – book objects rather than actual books. Narrative plays a less important role in these artist's books; they are often characterized by different forms of collection, inventory

and formal comparison, and it is not unusual for the materials to have emerged from an act of *appropriation*. The tone is often one of detachment or irony (especially towards the forms of traditional narrative), and their basic quality, apart from the very simple design of their pages, is the *serial format* as a defining feature of modernity. From a contemporary point of view, the borders are fluid: many small or even well-established publishing firms invite photographers as well as artists to publish artist's books. It is therefore difficult to draw a line between the artist's book and the photobook, but if there is a distinction, it will stem less from the authorship – whether artist or photographer (and here too it is difficult to distinguish) – and more from the different narrative approach. Both types of publication can be produced as special editions – signed copies, limited print runs, and containing an original work by the photographer or artist.

Last but not least, the exhibition catalogue represents another particular form, even if strictly speaking it is not a photobook simply because of its purpose. Exhibition catalogues represent a selection from an artist's work, made specially for a particular place and occasion. The fact that they are published by a museum, contain a list of the exhibits at the end, or an explanatory, art-historical essay at the beginning is an unmistakable indication of their purpose. Nevertheless, exhibition catalogues can be composed just like photobooks, according to a structured sequence. The best example of this is the above-mentioned *William Eggleston's Guide*, the MoMA New York edition of which has an introductory essay by John Szarkowski.

THE BOSTON SCHOOL

In the mid-1970s, a group of young photographers in Boston, who were studying at the School of the Museum of Fine Arts and at the Massachusetts College of Art, decided that their own lives should be the focal point of their art. Influenced by Larry Clark's book *Tulsa*, they began to photograph their own private world and that of their friends, complete with its characteristic sex and drugs. Their work combined the method and approach of the amateur photographer – the pictures depicted their own chosen 'family' – with the visual intensity of *photojournalism*, supplemented by scenes that had been staged for and in front of the camera (see *Families*). Under the collective title 'The Boston School', and curated by Lia Gangitano and Milena Kalinovska, an exhibition was mounted by the Institute of Contemporary Art Boston in 1995, bringing together for the first time the work of David Armstrong, Philip-Lorca diCorcia, Nan Goldin, Mark Morrisroe, Jack Pierson, Tabboo! (Stephen Tashjian) and Shellburne Thurber.

CAMERA TYPES

The word 'camera', referring to an instrument that technically registers images, originates with the camera obscura. Since the Renaissance at the very latest, it has been known that in a dark room (the literal meaning of *camera obscura*), light falling through a small hole will project an image of the outside world onto the opposite wall. This basic principle of the camera remains as valid today as it has always been. But in the course of the centuries, the simple hole has been replaced by

increasingly complex lenses, while the observing eye or the drawing hand has given way to the photographic film or the digital sensor.

There are three main types of camera: view camera, rangefinder camera, and reflex camera (single or twin lens). The most widely used are the rangefinder and single-lens reflex types, and most small- and medium-format cameras fit one of these categories. With a rangefinder camera, the photographer looks at the subject through a viewfinder that is separate from the lens. Single-lens reflex cameras, on the other hand, project the image seen through the lens onto a 45° sloping mirror, then onto a focusing screen. The image reproduced on the screen is the wrong way round, but in most small-format cameras, it is restored to normal by an additional prism. A view camera is much the same as the earliest camera prototypes: its basic construction is very simple, with a front standard, holding a lens, linked by flexible bellows to a rear standard, containing a ground glass that is used to focus the image. The photographer sees the image projected directly from the lens onto the ground glass, but it is upside down. Initially, the bellows served only to focus on the image by adjusting the distance between the two standards. But due to the adjustability of the lens and standards, new effects became possible. Tilting the standards in relation to each other changes the details of the picture, and tilts the axis of the lens away from the centre. So long as the image delivered by the lens is bigger than the detail fixed by the format, it is possible with a central perspective projection to 'correct' objects that protrude beyond the image,

without tilting the camera and so without creating any distortion in the perspective – i.e. the converging lines that are particularly prevalent in architectural photography. By using the so-called Scheimpflug Principle – discovered by the Austrian officer and cartographer Thomas Scheimpflug (1865–1911) – it is also possible to change the plane of sharp focus. In traditional cameras, the film level is always parallel to the lens level, which leads to the plane of sharp focus also being parallel. But if the angle of the lens plane is tilted in relation to the film plane, the plane of sharp focus will also be tilted. The three levels always meet at a common point of intersection or running along a straight line. Thus the photographer can focus sharply on all the points that are on one level, independently of the size of the aperture, or he can deliberately focus on unfocused areas in the image. This is the method used, for example, by Olivo Barbieri, Miklos Gaál and Marc Rader.

Apart from the measurements and angles that are made possible by its mechanical construction, and the quality of its film loading, a camera – or rather its casing – has little influence on the overall nature of the image. This depends first and foremost on the qualities of the lens. But a top-quality, fault-free image may not necessarily be the aim of the photographer or artist. By using simple, cheap cameras with correspondingly primitive imaging systems, some art photographers deliberately incorporate defects into their works as a stylistic device, such as loss of focus and brightness towards the edges, or inaccurate colour reproduction (e.g. Stephen Gill).

CIBACHROME *SEE* ILFOCHROME

COPYRIGHT/PICTURE COPYRIGHT/
COURTESY

Everyone knows that in any publication, the © sign
followed by a name and a date indicates the copyright
which an author or institution has claimed, thereby
informing any potential user that use of the material is
restricted. Owing to the fact that, until 1989, copyright
in the US, unlike in the UK and Germany, did not give
automatic protection to intellectual property from the
moment of its creation, it became common practice for
the copyright sign to be marked on photographs that
were due to be published. Recently, there have been
international agreements to strengthen the right of
authors and photographers to protect their work
against, among other things, duplication, exhibition,
reproduction and adaptation. Picture copyright –
not to be confused with the rights of the person being
photographed – governs the photographers' right to
protect their work. The word 'courtesy' refers to the
person or institution (e.g. museum or gallery) that has
'kindly' made the work available for reproduction or
exhibition, but is not necessarily the copyright holder.

C-PRINT/C-TYPE PRINT, ANALOGUE AND
DIGITAL (CHROMOGENIC PRINT, COLOUR
COUPLER PRINT)

The vast majority of colour prints made with analogue
exposure of a negative and chemically developed are
C-prints. C stands for chromogenic, and refers to print
material that contains three layers of light-sensitive
silver salts; each of these is sensitized or 'coupled' to
a primary colour: blue, green or red. Industrially, the
chromogenic process was developed as a subtractive
method by Agfa and Kodak for colour film in the 1930s
and for colour paper in the 1940s. Since the beginning
of the 1950s chromogenic prints have been standard in
colour photography. There is also a distinction between
larger format prints hand-made with an enlarger (either
by the photographer or in a photo lab) and machine-
made prints in various standard sizes. Since the 1970s
chromogenic colour paper has been made on *PE paper*
(see *Black-and-white photography*), and large laboratories
can now mass-produce these colour prints very cheaply.
This simple form is also popular for conceptual artworks.

Thirty years ago, in catalogues of contemporary art,
the cheap and simple image of the colour photo was
still associated with the abbreviation C-print – in
contrast to the black-and-white gelatin-silver print
(see *Black-and-white photography*) and the more
expensive but more durable processes of *dye transfer
prints* and Cibachromes (see *Ilfochrome*), while today
the analogue C-print – against a background of digital
technology – is considered a traditional photographic
process. By comparison, C-prints from the 1970s
and 1980s seem considerably softer than the current
generation of prints (partially caused by different
films and development processes).

In the 1990s, the firm of Durst developed the hybrid
technology of digital C-prints, which combined the
new possibilities of *digital photography* with the now
improved chromogenic process. Instead of a negative,
a digital picture file is exposed onto the chromogenic

paper using red, green and blue lasers; the exposed paper is then processed in the traditional RA-4 method, the same as an analogue C-print. In recent years, the colour papers made by the major companies Kodak (Kodak Endura Ultra) and Fuji (Fuji Crystal Archive) have been optimized for digital exposure. The terms used for these prints are taken from the product names given to them by the manufacturers; a technical distinction is also made between digital exposure that uses lasers (e.g. Lambda or LightJet prints) and exposure that uses LED (Epsilon prints). Many specialist laboratories also offer digital exposure on *Ilfochrome* and even on black-and-white baryta paper (see *Black-and-white photography*). The photographic world is currently split by a heated debate as to whether the new *Inkjet prints* are as good as those exposed on photographic paper with regard to the homogeneity of their texture, or are in fact superior because of their greater durability.

DIGITAL IMAGE FORMATS

Raster graphics are a format used for storing digital photographic images. The image is built up like a mosaic of dots in the form of a grid. The grid has a fixed resolution which is set by the number of dots upwards and across. The smallest unit of the image is therefore the individual dot or pixel, each of which has a particular colour value.

The most commonly used formats are TIFF/TIF, and JPEG/JPG. The JPEG format is named after the Joint Photographic Experts Group, the committee which developed the standard in 1992. It allows for very small file sizes in relation to the resolution of the image. The compression process that it uses, however, is 'lossy', meaning that the more the file is compressed, the more obtrusive become small errors (known as compressing artefacts), and these are perceived visually as a reduction in the sharpness of the image. The JPEG format is also the basis for the *moving picture* formats MPEG-1 and MPEG-2, which are used for DVDs and HD videos. TIFF (Tagged Image File Format) was developed by Aldus and Microsoft in order to separate the colours of raster graphics for the printing industry. The TIFF format is a complex one that allows data to be stored in a lossless format, avoiding the lack of sharpness of the JPEG format. With a maximum size of four gigabytes, TIFF files can store images at a very high resolution, but this size is still insufficient for some scientific applications, e.g. in astronomy.

For professional and semi-professional use, the RAW image format is becoming increasingly prevalent. A RAW image file contains just the data generated by the image sensor in a camera or scanner and has not yet been extensively corrected or processed. All necessary corrections can be made by the photographer, using image editing software with appropriate add-ons. Because fine adjustments to details such as brightness and colour are done manually, in accordance with the photographer's own visual judgment, we can call this – as with analogue film – a true 'developing' process. Adobe have now introduced a royalty-free RAW format called DNG or Digital Negative, which they hope will become a standard.

DIGITAL PHOTOGRAPHY

Digital photography simply means the direct electronic storage of a photographic image by means of a sensor that is either integrated into or adapted to the camera. Long eclipsed by the current revolution in the global market which it triggered, theoretical debate over the digitalization of photography began in the early 1990s and is still going on in photographic circles. On the one side is the argument that basically nothing changes with regard to how people receive and evaluate the relevance and realism of a photographic image, even if it no longer has a material existence but is only stored as a digital code. In the eyes of the opposition, however, digital images as pure abstractions have no soul, and without some physical link to their subject (in the form of a negative) they cannot be called photographs. The first approach emphasizes the continuity of the medium, based on the unchanging combination of the photographer and camera on the one hand and the real-life present subject on the other. Those who see digitalization as the end of photography, however, wish to cling to the chemical traces created by light on silver bromide film – or in other words, to the traditional, tangible imprint of reality.

If we disregard theoretical arguments, there can be no doubt that the practical side of digital photography has brought about great changes in the production and accessibility of photographic images. For example, the camera display makes it possible simply to delete any unsatisfactory image. We can therefore expect one whole category of photograph to disappear – namely, the failure – though for many photographers and theorists this can be an interesting field. It is, after all, only by protracted study of a supposed error that one can learn from one's mistakes. In applied photography, the removal of the time delay required to develop analogue materials, and the immediate accessibility of the image in the camera or on a monitor often leads to an increase in the art director's influence on the production of the image. The photographer's expert input is therefore considerably reduced, and in extreme cases he may become little more than a technician.

DOCUMENTARY PHOTOGRAPHY (SOCIAL DOCUMENTARY PHOTOGRAPHY/ DOCUMENTARY STYLE)

Hair-splitting colleagues will tell you that photographs have always been documentary, and you just have to look for the right message. After all, each one is a sort of visual witness to its time. But this is not what is meant by documentary photography, though the vagueness of the term certainly gives the concept a degree of vitality and adaptability. It is not a photographic genre like, say, architectural photography, but applies more to the approach and also to a certain aesthetic. The term 'documentary' in photographic language goes back to the early 1930s, and denotes the different views afforded by a precise, objectively recording camera, as in Eugène Atget's archival documentation of old Paris. The great boom in documentary photography, if measured by its public effect, came in the period that followed the Great Depression. Between 1935 and 1942, the Farm Security Administration (FSA), a US government organization, commissioned a group of

photographers to give a public face to the dire poverty of rural communities in America. Since then, the term has been especially associated with the depiction of social injustice; earlier studies such as Jacob Riis' photos of the New York slums and Lewis Hines' photos of working children appear in this context to constitute social documentary photography *avant la lettre*.

Along with a more personal approach which found a following in combination with *photojournalism*, documentary photography also developed as an art form to record society. Along with August Sander, Walker Evans ranks as one of the most important exponents of this form, for which Evans himself coined the term 'documentary style', in order to avoid an over-simplification of the documentary concept. His photographs should not be seen as straightforward eyewitness records; the artistic approach transforms the documentary style. This style finds expression through the photographer's technique, which in Evans's case consists of a sharp, usually frontal view, a mode of operation that works well for series and typologies, and an interest in the everyday culture of particular societies – what we would call 'the vernacular'. How influential Walker Evans' approach was to the documentary field can be gauged from the large number of photographers from subsequent generations who, in their own individual ways, have followed on from his work, whether by continuing to dissect American society (from Robert Frank through Lee Friedlander to William Eggleston), or adopting the detached, objective approach (see *The Becher School*). Until the 1980s the documentary style was one of the leading aesthetic elements in art photography – one thinks of representatives of the *New Topographics*, or the French documentary project DATAR (a kind of inventory of the French countryside by twenty-nine photographers). With hindsight, one might even say that recognition of photography as an art form was due not only to the fact that it was used as a medium by artists during the 1970s, but also in no small measure to the aesthetic and conceptual dimension of this approach that began with Sander and Evans.

Contemporary documentary photography is exhibited in galleries and museums, and published in photobooks, but its long-form journalistic outlet – the magazine photo essay – has for the most part disappeared. And while the documentary is enjoying an artistic boom in combination with other media (video, image plus text, etc.), documentary photography actually finds itself in the paradoxical position of having found its way out of the crisis in which the concept of authenticity had landed as a result of the debate on digital and media images. Today works are more likely to be judged according to their success in finding images that capture the complex meanings of events. Paths to this kind of success vary from deliberately slow and anachronistic working methods, through appropriation of new media perspectives, to the (re-)construction and staging of images – a category which in fact is the exact opposite of the documentary style: namely, fiction. But this anomaly may well simply be evidence of the flexibility of the documentary format itself.

THE DÜSSELDORF SCHOOL
SEE THE BECHER SCHOOL

DYE TRANSFER PRINTS

Dye transfer, as a photographic printing process, was introduced to the market by Kodak in 1947. Three separate negatives are produced by photographing a colour negative through red, green and blue filters. A mould is made from each of these negatives, and then these are transferred very precisely onto gelatin-coated paper, so that the dye seeps into the gelatin layer.

Dye transfer prints are notable for their glowing colours, are very light-resistant, and during the production process the strength and contrast of the colours can be corrected. Initially, they were used mainly in the commercial sector, but in the 1970s they began to be used in exhibition work, for instance by William Eggleston. Kodak ceased industrial production in 1993, but the process is still being used by some laboratories worldwide.

EDITIONS/ARTIST'S PROOFS/ EXHIBITION PRINTS

One quality that photography shares with graphic art is its reproducibility – the ability to make multiple copies of a work. However, when the art market first began to take a gradual interest in contemporary photography, the advantage of being able to produce an unlimited number of copies suddenly posed a problem. If one wanted to preserve the status of an 'original' photograph (see *Vintage*), there could hardly be unlimited copies of it. From the 1970s onwards, more

and more artists and photographers therefore began to set an artificial limit on the number of prints. It is now common practice in the art market to produce numbered editions. Although naturally the strategy followed by each individual photographer and gallery will vary according to the nature of his work, the following observations are generally true: the number of copies printed will be in inverse proportion to the format of the work – the larger it is, the fewer and therefore the more expensive the copies will be. Currently, the chosen number tends to vary between three and ten prints. Young artists especially like to stagger the prices of their work, in order to provide an incentive for young and enterprising collectors. Very well-known works will run into several editions, often in very different print runs – a typical example being Rineke Dijkstra's *Beach Portraits* (1992–96). As well as the limited edition, there is the A.P. or *Artist's Proof*, of which there are usually only one or two copies which belong exclusively to the artist. Sometimes these may be made available for exhibition, or a special set of prints may be produced for this purpose – known as *exhibition prints*.

Certificates are hardly ever issued for photographic prints of this kind – the artist's signature guarantees their authenticity, and the gallery vouches for the correctness of the details in the sales contract. The situation is rather different, though, with works like Wolfgang Tillmans' Inkjet prints, which are fragile and easily damaged. The 'originals' exist as digital data (on a CD, for example), and so the print-outs are not signed but can be reproduced if necessary. For works that entail performance (e.g. films and videos), which are

also distributed in different storage formats and require an authorized data source, certificates do have to be issued, specifying the manner of presentation and the reproduction rights permitted.

EXHIBITIONS

An exhibition is the art of placing pictures in a space in such a way that they will produce the desired effect. This may seem commonplace, but it is a constant challenge; the curator must devise a syntax that will suit these particular pictures, not only as individual works but also as part of a whole. He or she must consider such matters as sequence and juxtaposition, formal consonance and dissonance, even if it means that wandering visitors may gain a different physical and synoptic impression of the works than they would if leafing through a book, for instance. Photographs, whether framed or unframed, have their own materiality; the manner of presentation will depend on the ever-changing aesthetic trend of the time (see *Photographs as material objects*). The classic way to hang framed pictures is alongside one another in a row, and this is especially common in exhibitions with an historical thread. The linearity of this presentation suggests a logical development, or an affinity between the pictures, and it generates a progressive pattern which is ideal for any kind of *series* or sequence. A strict arrangement on the wall requires a *typology* of pictures, no matter whether they are hung in blocks, or laid out in a grid with spaces between the frames. This recalls the botanical origins of typology, and the table or chart in which the categorized specimens were collectively displayed.

Over the last fifteen years the more traditional display styles have been joined by scrapbook-like arrangements in which individual images of different formats and materials are scattered at different heights over the complete surface of the wall, often arranged into rhythmic groups. This form, which is particularly favoured by young artists like Wolfgang Tillmans (see *Families*), determines the whole layout. The overall visual effect of the combined individual elements even has priority over the editing of the subject-matter with all its internal references. The exhibition of photographs in such room-filling displays has given the medium the same status as it enjoyed between the 1920s and the 1950s, although in those days the photographers and their works were connecting with a very different set of political, ideological and economic conditions.

FAMILIES/FUSION

In an article for *Zeit* magazine written in 1997, the young but already famous Wolfgang Tillmans expressed his admiration for the US artist Nan Goldin; the text was accompanied by Tillmans' terse portrait of Goldin (who was fifteen years older than him) in a field. What linked them at the time in the eyes of the general public was the style of the photograph, which dispensed with all the falsity of bourgeois conventions, and was devoted entirely to the representation of one's own life and one's own 'family' – as the American photographer called her friends. Goldin's tremendous slideshow *The Ballad of Sexual Dependency* (from the mid-1980s) consists of more than 700 photographs depicting her

passions and sorrows, and her experience of drugs, AIDS and death in the Bohemian society of New York. In the 1990s, these visually poetic and haunting photographs had an electrifying effect on many young photographers in the US as well as in Europe. The interior view as a documentary style to capture one's own life and surroundings swiftly became the new photographic paradigm. Seen from a distance now, ten years after this 'summit conference', the difference between Nan and Wolfgang seems far greater than it did then. Although Tillmans also works within the familiar world of his family and makes no secret of his homosexuality, his photographs are imbued with a strange ambivalence, which somehow gives the intimacy an abstract quality without sacrificing the bond between himself and the people he portrays – and this in spite of, or perhaps even because of their use in magazines (see *Photojournalism*), for which he has been working since the early 1990s. His 1992 series with Alex and Lutz for the avant-garde magazine *i-D* has become the stuff of legend. The term 'fusion', which he himself once used to describe the intimacy of his group portraits of young men, might also be applied to the quality of his approach: Tillmans' work cannot be pinned down – it seems fluid, and with even-handed familiarity it interweaves the images of his friends with portraits of stars and celebrities, the layout of a magazine transferred to the wall of a gallery, the still life on a windowsill with appropriated material from an artist's book, his own life with political engagement. This Turner Prize winner has long since emancipated himself from his earlier image as an exponent of the

rave culture, and more than virtually every other photographer of the present day, he works non-stop with the materials of his medium, beginning with his photocopies from the late 1980s right up to his experimental work on photographic paper. The fusion of his photographic practices with the authenticity of his approach makes Wolfgang Tillmans one of the leading artists of his generation.

FILM FORMATS

There are and always have been many different formats of photographic film. In the early days, photographers themselves coated their daguerreotypes, paper negatives and glass plates with light-sensitive emulsion, but by the second half of the 19th century there were already standardized processes of production. The formats ranged from 'ninth-plate' tintypes (2 x 2½ in.) to the so-called double format.

An important practical advance for photography, and hence for its massive expansion among the general public, was the invention of flexible photographic film. In the late 1880s Eastman Kodak launched the roll film, which is still in use today, and at the same time they launched the first Kodak box camera. 'You press the button, we do the rest' was the sales slogan of these universally usable products, which were aimed mainly at the ever growing market of *amateur photographers*.

Since the mid-20th century, the most popular film formats have been 135 film, measuring 24 x 36 mm; medium-format roll film, which depending on the camera can produce photos in aspect ratios including 6 x 4.5, 6 x 6, 6 x 7 and 6 x 9 cm; and large-format sheet

film in sizes including 4 x 5, 5 x 7 and 8 x 10 inches or larger; the same camera can generally be fitted with several different sizes of film holder. Due to the drop in sales caused by the advance of digital technology in the professional field, most major manufacturers have now stopped making large-format film, and some sizes, such as the 5 x 7 inch, have disappeared completely.

Together with the greater resolution that accompanies an increase in size, film formats are important for another reason, which is connected with optics. The angle of view of a lens, and hence its perspective, is determined by its focal length in relation to the format of the photograph. A lens with a focal length of 150 mm in a small-format camera has a narrow focus; with a format of 4 x 5 inches the focal length appears normal, and 8 x 10 inches produces a strong wide-angle effect. But since the focal depth using the same aperture is determined solely by the focal length of the lens, this is automatically reduced by increasing the format of the photograph. This need not necessarily be a disadvantage, and it may even open up new possibilities for the photographer. As the sensors in digital cameras and digital backs (a way to convert analogue cameras to digital) produce considerably smaller formats than the analogue film that they replace, they also produce images which on close inspection have a different appearance and make a different aesthetic impact. Creating a slightly hazy effect in a digital image therefore requires later image editing or retouching.

THE HELSINKI SCHOOL

In the early 1990s, there were no major photography collections or galleries in Finland, and so in 1995 the University of Art and Design in Helsinki (UIAH) commissioned Timothy Persons to set something up for the new generation of photographers. Together with Jorma Puranen, he founded the TaiK Gallery (Taideteollinen Korkeakoulou) as part of the university, where the work of the students and later also of the graduates and teachers could be exhibited. Since 2005, a group exhibition has been touring Europe, and two catalogues have been produced. In many photographs exhibited by TaiK, the Finnish landscape plays a central role, as does a preoccupation with identity. The impact of these young Finnish artists is not only testimony to their own vitality, but is also a sure sign of a flourishing programme of training and support that has been built up over a very short period of time.

ILFOCHROME (ORIGINALLY CIBACHROME)

The two (synonymous) names of this colour process, which is used for analogue exposure and enlargement of slides onto colour photographic paper, go back to the development of the material by the Swiss firm Ciba (now known, after two mergers, as Novartis), and its further development by Ilford. Today it is marketed solely as Ilfochrome Classic. From a technical viewpoint, Ilfochrome is a dye destruction process: azo dyes inside an emulsion layer on the paper are bleached out during processing. Unlike the chromogenic process (see *C-print*), in which the image is created by colour couplers during the development process, the image

only becomes visible after bleaching and removal of the silver halides in the fixing bath. The advantage of dye destruction prints is that they are more faithful to the original slides, as well as being less sensitive to light and therefore considerably longer-lasting. Large-format slides for *lightboxes* are therefore enlarged onto transparent Ilfochrome Classic film, and it is also ideal for printing digital images.

Since the mid-1970s, many professional photographers from a variety of commercial and artistic fields have used Ilfochrome for their enlargements, despite its high price, because they like the sharpness and the vivid colours – especially the glowing reds. Others, though, who find the rich tones and metallic surface too garish, prefer to use the softer style of chromogenic prints (see *C-print*).

IMAGE EDITING/COMPOSITING

Digital image editing is the manipulation of stored image files using specialized software such as *Photoshop*, Gimp, Corel Photo Paint, etc. These cover most of the processes that traditionally took place in the darkroom, e.g. dodging and burning, retouching, colour correction and montage (compositing). Image editing software has now made all these processes much faster and more efficient. For example, it is possible to put together a seamless montage of details from different sources, and to change colours and masks with a precision that analogue processes simply could not match except at a prohibitive cost.

In the world of art, the potential of digital image editing was very quickly spotted by artists such as Jeff Wall and Andreas Gursky. Jeff Wall compiled montages with photographs taken either in the studio or outside, creating homogeneous pictures like *The Stumbling Block* (1991) and *Dead Troops Talk* (1992), while Andreas Gursky extracted particular details from his photos of real places, as in the picture *Rhein* (1999), or combined parts from a sequence of photos of the same place to form a single picture, as in *Montmartre* (1993).

INKJET PRINT

The term is used to denote prints produced by printers that propel jets of ink onto paper. Other names are used, generally not denoting any technical difference but simply based on the product specifications of individual manufacturers. Iris prints, for instance, are made on equipment manufactured by Iris Graphics, whose first printer, the Model 3024, was introduced in 1987. These machines were meant primarily for the production of trial prints for the printing industry, i.e. proofs that could be checked before the material was handed over for final printing. Since the early 1990s, Iris printers have been used in the art world to print large numbers of reproductions and also digital photographs. The term 'Giclée print' (from the French *gicler* – to spray) was coined by Jack Duganne, who in 1991 printed a limited edition of Diane Bartz's work for Nash Editions. The aim of such terms was to avoid using words like 'computer' and 'digital', since these had negative connotations in the context of art, and also to emphasize the care and craftsmanship that went into the printmaking, as opposed to the industrial-scale mass-production of Iris prints. Modifications of

printing inks and extensions to the range of colours – some printers today work with six or more – have considerably expanded the spectrum. With the introduction of pigmented dyes, modern prints, created under laboratory conditions, can have a lifespan of a hundred years or more, which puts them on a par with, if not ahead of, traditional colour prints (see *C-print*).

LIGHTBOX

A lightbox is a construction made from a flat, box-shaped, opaque frame with a front of glass or Plexiglas. Inside it are lights, generally fluorescent tubes that illuminate the picture, which is mounted either on or behind the transparent pane. The picture carrier is usually an Ilfochrome print (see *Ilfochrome*) on transparent film.

The particular fascination of lightboxes lies in the fact that the picture itself is a light source, rather than – as with traditional pictures – light falling on it from outside and being reflected by it. Lightbox images share this charm with projected images, such as those seen in the cinema. The advertising industry has been using lightboxes for a long time and on a huge scale, as can be seen in every big city at night. The Canadian artist Jeff Wall is a great believer in lightboxes, and all his colour works are presented in this manner.

LOOP

A loop is a continuous playing of a film, video or slideshow at an exhibition or public performance. It may be a pragmatic decision, based on the needs of a particular situation, to keep repeating a work that has a fixed beginning and end, or it may be a deliberate conceptional device for purely artistic reasons. An example of the latter use of loops can be found in works by Theresa Hubbard and Alexander Birchler: these are filmic pieces which have actually been produced as loops and have no precise beginning or end.

MOVING PICTURES

For many young artists today, experimenting and exploring the potential of both photographic and cinematic images are integral to their work. There have always been photographers who were also filmmakers (Paul Strand, Robert Frank, William Klein, Raymond Depardon), but new perspectives have now been created by the potential of multimedia, and through intensive scrutiny of the cinema by the fine arts. Countless photographic works have appropriated the narrative patterns of films or have staged their own images in a filmic style, and in innumerable films (as well as in hybrid artworks), the cinematography reflects awareness of the distinction between still and moving images (with techniques like the fixed shot, the moving camera, panning, etc.). On a computer screen and in the displays of many digital cameras, the once separate image-bearers – photography and film – are similar sources of information, and the borderline between still and moving images has become blurred.

Currently the most commonly used medium for moving pictures is digital video, which is available in several formats and which will soon have completely replaced the old analogue formats (VHS, S-VHS, Betacam, etc.). In recent years, the HDV format (high

definition video) with a higher resolution and an aspect ratio of 16:9 has been competing with the conventional DV tape formats that have an aspect ratio of 4:3. As a storage medium the DVD has already established itself as a standard, and HD-DVD for higher resolution images is beginning to follow suit. As well as the classic mode of video presentation on monitors or wall-mounted flatscreens, the latest means of presentation is the video projector. With its large projected image and the darkened projection room, it gives a cinematic feel. The intimacy that this creates in many large-scale art installations is even more apparent with classic analogue film formats like 16 mm and 35 mm. References to the amateur films and home movies of the 1960s and 1970s is, however, most apparent in Super-8 films. Last but not least, the medium of the *slideshow* also uses moving pictures in the form of a sequence of stills which, as in film, rapidly succeed one another to create the impression of motion.

NEUES SEHEN (NEW VISION)/
NEUE SACHLICHKEIT (NEW OBJECTIVITY)

In German photography, from the late 1920s onwards, *Neues Sehen* and *Neue Sachlichkeit* took over the position which until then had been occupied by the pictorialist style of art photography. There were also similar movements in the US, the Soviet Union, France, Italy and Japan.

Often regarded as opposites – in fact there are no clear distinctions between these two concepts – their common ground lies in their rejection of painterly photography in favour of a specifically photographic,

technique-based approach. *Neues Sehen* gave a central role to photographic experimentation. In 1925, the constructivist artist and Bauhaus teacher László Moholy-Nagy published his revolutionary manifesto *Painting Photography Film*, in which he brought together the various forms of photography: photograms, photomontages, unusual perspectives, journalistic and scientific photos, amateur dabblings and filmstrips. The new, unfettered aesthetic aimed to create a new form of vision for the modern age. Although *Neues Sehen* lost its public impact in the early 1930s, after 1945 it once more became an important theoretical reference point for experimental photography.

Conversely, the photographic exponents of *New Objectivity*, whose precise vision fitted in perfectly with the realistic, figurative movement sparked off in 1925 by G. F. Hartlaub, enjoyed great popularity during the 1930s and 1940s, particularly in book form. The dynamism and unconventionality of *Neues Sehen* was counterbalanced by the concentration and technical perfection of *New Objectivity*. Its main characteristics were its focus on the form and nature of the subject, close-ups, clear composition and precise detail. Its favourite themes were architecture and landscapes, as well as particular objects. Albert Renger-Patzsch, whose book *Die Welt ist schön* (The World is Beautiful) (1928) became the epitome of *Neue Sachlichkeit* photography, Karl Blossfeldt and Hans Finster were among its most influential exponents. Also notable in this context is the portrait work of August Sander, whose systematic approach is still regarded as a milestone in the history of German photography.

'NEW'

In 20th-century photography, the adjective 'new' was prefixed to many different approaches which, following on from major exhibitions or publications, laid claim to having invented some original photographic vision. The term is a rhetorical indication of modernity, whether this consists in a break with existing aesthetic conventions or in a view of a world which itself has changed. This all too common attribute also reflects the task which even today photography has imposed on itself: to show images of new worlds.

NEW COLOR

In 1981, Sally Eauclaire curated an exhibition at the Everson Museum of Art in Syracuse, New York; it was called *The New Color Photography*, and it displayed the work of forty-seven photographers. This exhibition was in fact a retrospective covering the period since the late 1960s when colour first made its way into art photography, having previously been mainly confined to advertising and amateur photography. 'Colour photography is vulgar' – so said Walker Evans, echoing the opinion of many of his colleagues, who considered abstract black-and-white far more suitable for the intellectual and aesthetic aspects of their medium. And yet this very 'vulgarity' ('superficiality' might be the term we would use today) could lead to an increased realism: Evans went on to say that if an image is concerned with vulgarity or a man-made – not God-made – colour subject, then colour film alone is the right choice. This applies in a particular way to the photographic world of William Eggleston, who in 1976 at the Museum of Modern Art in New York put on one of the first (and highly controversial) exhibitions to be devoted exclusively to colour photography. He was certainly one of the great champions of New Color. Other exhibitors included Stephen Shore, Joel Meyerowitz, William Christenberry, Mitch Epstein, Len Jenshel, Joel Sternfeld and Adam Bartos. Today, when one considers the omnipresence of colour photography, the controversy over the artistic status of colour that went on twenty years ago in the photography departments of many European universities seems like an echo from a distant age.

NEW DOCUMENTS

In 1967 John Szarkowski, who from 1962 until 1991 was director of the photography department at the Museum of Modern Art in New York, exhibited the work of Diane Arbus, Lee Friedlander and Garry Winogrand under the title *New Documents*. Through these three artists, the exhibition propagated a different form of *documentary photography*, which in contrast to the harmonious, poetic vision of the humanist photographers of the 1950s (such as Edward Steichen's exhibition *Family of Man*, 1955) focused more on the centrifugal forces and political tensions within American society of the 1960s, whether through street images or interiors, adopting an emphatically subjective, critical and even sarcastic tone; 'In the last ten years, a new generation of photographers has taken the documentary approach in a personal direction. Their aim is not to reform life, but to get to know it' (John Szarkowski).

NEW TOPOGRAPHICS

In 1975 William Jenkins curated an exhibition at the Museum of Photography at George Eastman House, Rochester, New York, with the title *New Topographics: Photographs of a Man-Altered Landscape*; at the time it was the most radical rejection of a photographic tradition that had always placed the unspoiled magnificence of the (American) landscape at the forefront. The pictures exhibited by the nine photographers examined the social landscape as a combination of nature and culture, on which the industrial and infrastructural exploitation of the countryside, and the expansion of the urban sprawl, had left their indelible marks. The vision conveyed by these images, however, is detached and reduced, without any obtrusive judgment, but seen with a sharp and unromantic eye. Taking part in this exhibition were Robert Adams, Lewis Baltz, Joe Deal, Frank Gohlke, Nicholas Nixon, John Schott, Stephen Shore, Henry Wessel and the German couple Bernd and Hilla Becher (see *The Becher School*). The term 'topographics' and the critical approach that it embodied set the tone for the younger generation of photographers in the 1980s and 1990s.

PHOTOGRAPHS AS MATERIAL OBJECTS

If a photograph is taken to mean simply a print on paper or on some other substance, it is apparent that since the earliest days of this medium there have been countless different modes of presentation that have enhanced this two-dimensional image carrier and its visual information by giving it the three-dimensional quality of an object (like a daguerreotype in its case).

But aside from the great photography exhibitions of modern times and of the 1950s, such as *Family of Man* or the *Photokina* shows, the most common form of photographic display has long since been the framed print under glass, as normally used with most graphic works. Since the end of the 1970s, however, beginning with the reception of conceptual art and its photographic positioning, there has been an increasingly experimental approach to the matter of presentation, which has led to such varied exhibition formats as systematic *typology*, the unpretentious *serial format*, the large-format print, the *lightbox*, the *slideshow*, and the wall or room installation (see *Exhibitions*). During the 1990s, as a counter to the rather stuffy, conventional museum presentation, and particularly connected with contemporary photography, new forms were developed which seemed to offer more direct access to the pictures. Prints or print-outs were stuck directly onto the walls, either with nails or with tacks, while others were attached to solid materials like aluminium, or fixed in light but stable sandwich panels made of capa, dibond or alucubond. While the coating prevents the picture layer from being damaged, this frameless presentation, which originated at trade fairs, gives the image a specifically photographic sense of immediacy. A different aesthetic effect is created through the technique of lamination, which also improves protection of the photographic surface. On the contemporary art scene, the combination of the print with a screen of acrylic glass, known under the trade name of Diasec, has become extremely popular,

although it gives anything but an impression of directness. Under acrylic glass, whether glossy or matt, the image seems to be some distance away, as if it were under a layer of dark ice. With this kind of hermetic processing, and set on a firm carrier within their sandwich panels, the often large-format, framed photographs seem not only to be pictures indicating a reality hidden beneath, but also to demand attention as autonomous objects, a valid part of the exhibition in themselves.

PHOTOJOURNALISM/MAGAZINE PHOTOGRAPHY

Irving Penn, who more than any other photographer defined the image of the American magazine *Vogue*, made the following remark: 'The modern photographer ...works for publication. ...The end product of his efforts is the printed page, not the photographic print.' For a long time, this seems to have been the guiding principle for many young photographers who still hoped to change the world or at least improve the taste of their contemporaries. If one looks back today on the history of photojournalism, and measures the effect it has had on the public, there may seem to have been a downhill turn over the last fifty years, following the golden age in newspapers and magazines between the 1920s and the 1950s. National Socialism and Fascism in Europe did less damage to the medium itself – photography, after all, was an important instrument of propaganda – than it did to the lives of many talented photographers and editors, who had to flee from Europe or face ruin and even death.

For the dwindling influence of photojournalism since the 1960s, people generally tend to blame television, but its recent history is not solely to be judged by its (quantitative) loss of public impact. If we look back, for example, at the situation in West Germany during the 1970s, the launch of *Zeit* magazine (1970) and *Geo* (1978) brought about a particular kind of social reportage which contributed to the structural changes that took place in the Federal Republic at that time. The student demonstrations of the late 1960s and the politicization of a whole generation also gave the photojournalist a special status. During Otto Steinert's teaching career, the Folkwangschule in Essen became an important training centre for photojournalism. Following on from this tradition, in the 1980s people began to react against the dominance of television by countering this intrusive info-entertainment through photoreportage and self-referential criticism of the media circus. In the 1990s, magazine photography received a further boost from the input of students who had studied under Professor Angela Neuke in Essen, Dieter Hinrichs at the Fotoschule in Munich, and others at the Fachhochschulen in Bielefeld and Dortmund. The range of their approaches and pictorial languages was wide, extending from contemporary versions of the documentary style (see *Documentary photography*) through atmospheric subjectivity to the far from classical and highly experimental 'youth photography', which dealt with purely autobiographical subjects (see *Contemporary German Photography*, ed. Markus Rasp). In the field of contemporary pop and subculture, from the early 1990s it was the vibrant British scene which,

through magazines such as *i-D*, *Arena* and *The Face*, provided the impetus for new approaches to magazine photography (see *Families*) which completely unhinged the traditional relationship between applied and artistic photography. In Germany, the magazine of the *Süddeutsche Zeitung*, at least during the first ten years of its existence (1990–2000), provided a forum for contemporary art photography (see *Art photography*), often containing long and original sequences of photos. This kind of pictorial narrative, which in the heyday of photojournalism would be compiled in collaboration with an author and picture editor, is one of the defining features of genuinely authorial photography in the field of photojournalism. However, in the last few years, the pictorial narrative has become a rarity, many formats have disappeared again, and outlets for such photography are scarce. Even if a section of magazine culture does keep reinventing itself, thanks to a crossover between youth and art, it would seem that photojournalism as an expression of individual authorship may soon be a thing of the past. Back in the 1990s, renowned photojournalists such as Timm Rautert were already changing tack and teaching different subjects in their art colleges. We might have to reverse Irving Penn's comment as quoted earlier: the photographic image has once more replaced the printed page, although the latter is still immensely important in the culture of the photobook (see *Books*).

PHOTOMONTAGE

The golden age of photomontage goes back to the avant-garde between the two world wars. Initially, it was Dadaists like Raoul Hausmann and Hannah Höch who, immediately after the First World War, appropriated the games that amateurs played with photographic and typographic material, and developed them into a provocative form of artistic expression. The term 'montage' originated in the world of engineering, and their use of it underlined their rupture with the bourgeois, anti-technological concept of art. In many ways, the fragmentary nature of photomontages corresponds to the situation at that time: a discredited social order, the experience of multiple, simultaneous sensory experiences in the big cities, and also, from a pictorial point of view, the Cubist technique of collage. During the 1920s and 1930s, many artists from different sections of the avant-garde – John Heartfield, Alexander Rodchenko, László Moholy-Nagy and Max Ernst, to name but a few – used the constructive potential of this new and revolutionary narrative mode. Simultaneously modernist and (photo)realist, it was also able to shatter the established (visual) order radically, ironically and poetically. The basic material came from appropriated images (see *Appropriation*), cut from newspapers or magazines or even from their own photographs, stuck together, overlapped or deliberately double-exposed, and these in turn seemed to take on the dynamism of *Neues Sehen*.

Although the time between the wars was a peak period for photomontage, the practice of creating new pictures from different photographs was in fact much older, and had already been used in various contexts during the 19th century and at the beginning of the 20th. Montages and postcards were made by studios

and by amateurs, who for entertainment or simply as a pastime stuck big heads onto little bodies, but while some distortions were obvious, there were also ambitious, artistic attempts to create synthetic images from multiple photographs – the famous seascapes by Gustave Le Gray being a prime example. These various traditions and practices have continued right through to the present. The artistic influence of Hannah Höch and John Heartfield can be discerned, for instance, in Martha Rosler's series *Bringing the War Home* (1967–72), or in Thomas Ruff's *Plakaten* (1996). Even *image editing* software, which has been hailed as creating a brand new form of photography – as used in the work of Jeff Wall or Andreas Gursky – has its structural roots in earlier forms of photomontage and in the necessary process of retouching, although this once demanded a great deal of painstaking work to create the illusion.

PHOTOSHOP

Adobe's image editing software Photoshop is the undisputed market leader in the field of professional prepress and photo editing and has set the standard for the whole industry. In 1987 Thomas Kroll began to devise a software program for digital image processing, and in the same year he and his brother John completed an early version under the name 'Display'. In 1988 he teamed up with Adobe, and in 1990 Photoshop 1.0 was released. Since then, each new release has been improved and expanded. A major advance occurred in 1994 with version 3.0, which introduced so-called 'layers', enabling the user to place different sections of the image on top of one another, and to work on them separately. The widespread use and dominance of Photoshop has led to the fact that the word itself is often used as a synonym for *image editing* of any kind.

POLAROID

The term 'Polaroid' has become a synonym for instant photography. This process has now lost its unique status of immediacy in the digital age, but it is still sometimes used today by professional photographers who are still working with analogue, to produce a test image in order to check exposure and focus. The earliest Polaroid cameras used a roll film, containing a roll of negative film, which was exposed, and a roll of positive paper, on which the image was developed inside the camera. This was later replaced with pack film, which the photographer had to pull out of the camera to develop; the negative layer was then peeled off and discarded, leaving the positive image behind. The technique was first marketed by its inventor Edwin Herbert Land and his Massachusetts-based company Polaroid in 1948, initially in black and white, but from 1963 onwards in colour. Ten years later, the company went one better by producing integral film, in which the negative and positive layers are kept together inside a white plastic frame (picture size 3 x 3⅛ in.; frame 3½ x 4¼ in.). This version quickly became very popular among *amateur photographers*, as well as with artists like Andy Warhol and David Hockney, and it is above all the SX-70 original format that enjoys a legendary reputation even today. Owing to its high cost and the advent of digital cameras, instant photography is now threatened with extinction, if indeed it has not

died out already. In 2006, the Polaroid Company announced that it was ceasing production of SX-70 film.

SCHOOLS

The fact that a 'school' may have a decisive influence on a young photographer or artist almost goes without saying, and yet the importance of this is often underestimated. The institution itself – and the vast majority of contemporary art photographers have graduated from photography or art colleges (and even here, the distinction is important) – is a forum for a particular approach to photographic traditions, with individual teachers, likeminded colleagues, and also the unique social and urban features of the town where it is situated. An increasingly important factor is getting the right degree from a particular college, or earning a masters degree under a particular teacher, so that one can go out into the world armed with plenty of credit to help gain entrance to the art market. The following schools are historical and contemporary examples of those that have made their mark, starting out from a single class right through to a group of artist friends who speak the same language – i.e. in the historical sense of school as a group sharing the same ideas: *The Becher School, The Boston School, The Helsinki School, The Vancouver School, The Yale School.*

SERIES/SERIAL FORMAT

Absage an das Einzelbild (No to the Single Picture) was the title of an influential exhibition held in the Folkwang Museum, Essen, in 1980. Although many conceptual artists of the 1970s had raised people's awareness of serial-format photography and its significance, the fact is that working methods based on a large number of photographs go a long way back in the history of the medium, and their capacity for classification and documentation has been widely exploited in the fields of science and criminology. The *carte-de-visite* photographs of the 19th century also formed series of portraits, and in the 1930s publications such as Heinrich Freytag's *Fotoserien/Serienfotos* alerted a wide audience of *amateur photographers* to the narrative potential of multiple images.

A series is often defined through an identical or repeated theme that links the photographs together and relates them to one another in terms of time, space, form or subject. A photographic series can be a single reportage put together in a short time, or it can be a protracted, ongoing study of a particular genre, or the *typological* representation of a particular category of objects. It may be exhibited as a group, in which different, smaller units are brought together, or a row, which lays more emphasis on the comparability or equality of the photos, as well as the spatial presentation in a straight line along the wall. A further differentiation among these 'serial' techniques is that of the chronological sequence, which indicates progression over time, and often implies a narrative of some kind. Another important distinction is that between a collection of individual images and a true multi-part work that must only be viewed as a whole.

Prototypical examples of series are Cindy Sherman's *Untitled Film Stills* (1977–80), Helmar Lerski's *Verandlungen durch Licht* (Transformations Through

Light) (1936), and Nicholas Nixon's year-by-year collection *The Brown Sisters* (begun in 1975). Wolfgang Tillmans' book *Concorde* (1997) consists almost exclusively of sequences of planes taking off, while in the field of journalism Eddie Adams' images of a Vietcong prisoner being shot (1 February 1968) are also a sequence, and in an artistic context so are the picture narratives of Duane Michals. Examples of looser groups are August Sander's portfolios, and Jeff Wall's *Young Workers* (1978–83), which the artist revised in 1983 and which can also be seen as an eight-part work.

SLIDESHOW

The projection of photographic images is almost as old as the medium itself. The first exhibition of photographs on glass took place in the 1850s, but the projection of painted images dated back another two hundred years, in the form of the Magic Lantern. In the course of its history, the slideshow has fulfilled a variety of functions, often accompanying either a lecture or a performance: it is used for education, for club meetings (e.g. of amateur photographers), for commercial presentations, and from the 1960s to the 1980s was very popular at parties and family gatherings. In the digital age, the mechanical projection of slides now seems old-fashioned, and in many institutions is regarded as an outmoded method of lecturing; on the other hand – and possibly for this very reason – it has maintained its appeal in the art world; indeed it has become even more admired for the formal beauty of the square Kodak Carousel projector and its circular 35-mm slide tray.

Slideshows are often performed rather neutrally, with the projector firmly rooted to the floor and images being projected in a continuous, automatic sequence onto the wall or screen (see *Loop*), but sometimes they are staged like theatrical performances, together with text and music, as in Nan Goldin's famous piece *The Ballad of Sexual Dependency* (see *Families*). The slideshow seems to have a close affinity with narrative and film sequences (see *Moving pictures* and *Series*) as well as with *typological series*. In addition to the analogue miniature and the less common medium-format projector, the function of the slideshow can now be fulfilled by a range of software applications, using a digital projector to display the photographs.

STAGED PHOTOGRAPHY/CINEMATIC PHOTOGRAPHY/PERFORMATIVE PHOTOGRAPHY/ CONSTRUCTIVE PHOTOGRAPHY

There are many sets of opposites in photography. For instance, there is the distinction between 'straight photography' – an image defined at the moment when it is taken – and 'synthetic photography', which entails some form of later alteration, whether in the darkroom, through retouching techniques (or digital editing), montage, collage, etc. Another distinction, which only affects the category of straight photography, is that between documentary or objective and *staged* photography. Looking back over the history of the medium, we can see that the notion of photographer as director, and the studio as theatre, are omnipresent in portraits, genre scenes, nudes, still lifes and more. However, the term 'staged photography' is not

generally applied to these basic applied and artistic forms; it is an umbrella term which, with a vagueness rather like that of its counterpart *documentary photography*, covers a wide range of artistic practices which began in the 1960s and 1970s to question the alleged reality of photographs as documents through the 'reality' of photographs that had been set up especially for the camera. The form extends from Duane Michal's *Photostories* through Cindy Sherman's disguises to the constructed pictorial worlds of the 1980s, with their made-up characters, created by such artists as Sandy Skoglund, Bernard Faucon and Henk Tas. It is, however, a far broader field than can be described here, and also encompasses the solitary approach of Joel-Peter Witkin and precursors such as Hans Bellmer.

In the last few years, a closer inspection of what goes on in front of the camera – whether it be invented, constructed or staged – reveals another distinction, which with hindsight shows up the continuity, the fragmentation and the further development of this photographic trope. For his elaborate stagings since the late 1970s, the Canadian artist Jeff Wall coined the initially somewhat disliked term *cinematic photography*, although in fact that is an accurate description of his own procedure and could also be applied to the work of some of his contemporaries (Gregory Crewdson, Philip-Lorca diCorcia). The equally paradoxical coinage *performative photography*, which covers interactive processes involving play and costume that go together with various forms of picture staging, can also be a useful term. Underlying the apparent simplicity of

Erwin Wurm's improvised *One Minute Sculptures* is a highly intelligent concept of sculpture extended by photography. Nikki S. Lee's excursions into different strata of American society and their respective pictorial cultures, to which she both exposes and adapts herself in her staged self-portraits, reveal much more complex examples of the interaction between the photographer and her immediate surroundings. By comparison with these relatively outward-looking variations on conceptual photography, many staged photographs by artists of the 1970s were more concerned with the physical experience of the self, or embarked on a sometimes ironic and sometimes intensive search for their own identity (Urs Lüthi, Arnulf Rainer, Joe Spence, Hannah Wilke).

Constructing objects, situations and spaces, or intervening in those that already exist, in order to translate them through the eye of the camera into a particular image, can be both a serious and a playful facet of an artistic form which, to borrow from Siegfried Krakauer's phrase 'reality as a construction', we might call *constructive photography*. Many artists of the 1980s created fantastic, dreamlike worlds, but contemporary artists such as Thomas Demand, Oliver Boberg and Ricarda Roggan are more interested in the status of images as simulacra, in media afterimages of the collective memory, or the latent presence of history in the legacies of our culture. They deliberately refuse to compose their images digitally, but instead use straight photography in order to charge their spaces with the photographic phantasm of what is at least a real image of a 'possibility of reality' (Arno Gisinger).

TYPOLOGY/TYPOLOGICAL SERIES/ COMPARATIVE PHOTOGRAPHY

Typology represents the densest form of *serial-format* photography. Typology itself as a form of scientific presentation is of course far older than the medium of photography, and was already in use during the 18th century for the comparative morphology of plants. While the practices of some photographers in the 19th and 20th centuries explored typological approaches – e.g. Eugène Atget's collection of Parisian horse carriages – in Walker Evans' work during the 1930s and 1940s we find innumerable series which were photographed in highly standardized compositions that were the result of a deliberate artistic plan. August Sander's portrait sequence *People of the 20th Century* was also based conceptually on a classification of social types. It is generally acknowledged that these two founders of the documentary style (see *Documentary photography*) were also precursors of comparative photography, which was Bernd and Hilla Becher's exclusive working method when, with the highest possible degree of homogeneity and using the same objective frontal approach, they compiled their *Typologies of Industrial Buildings* (winding towers, blast furnaces, water towers, gas tanks etc.). Although the golden age of typology – which in the 1980s and 1990s was not merely confined to the *Becher School* – is now over, it remains established as a particular way of looking at things (Charles Fréger). For many young photographers, typological work may have lost its attractions – it may seem too authoritarian, impersonal and reductive – but the idea of a comparative approach still lives on as a specific form of photographic perception, not least in the often typological method of hanging pictures in blocks or grids on the gallery wall (see *Exhibitions*).

THE VANCOUVER SCHOOL

Vancouver is outstanding as a centre of intellectual, critical discussion which has had a deep influence on many of the photographers based there. The starting point of its two most important representatives, Ian Wallace and Jeff Wall, was a theoretical and historical confrontation with art, parallel to which, during the 1970s, they produced their own photographic works that drew on conceptual art as well as on the history of art and photography. With his use of large-format lightboxes towards the end of that decade, over the next ten years Jeff Wall became one of the best-known photographers in the world. Younger representatives of the Vancouver School, such as Stan Douglas, Ken Lum, Rodney Graham, Roy Arden and Mark Lewis, share the same reflexive and also semiological interest in photographic and cinematic images, as well as in theory. Their many working methods include text-and-image combinations, found photographs, staged (and also documentary) photography, video and film. Vancouver, where large numbers of artists continue to live, teach and practise, is often the setting for their work, which focuses on the many political, social and postcolonial aspects of this modern city in the north-west of Canada.

VINTAGE/ORIGINAL/REPRINT/ MODERN PRINT/REPRODUCTION

In the language of an historian or collector, a vintage print is one that is believed to represent the definitive version of the photograph as intended by its creator. As a rule, it will have been produced immediately after the photograph was taken, and will have been processed either by the photographer or by a chosen technician. In the context of photographic history and the art market, it was not until the 1960s that the term took on any significance, when people seriously began to question the concept of an 'original' photograph. One is bound to come closest to the photographer's vision and period through contemporary prints, especially as in most cases it is not possible to make prints later on. But the very idea of an 'original', which is so sacrosanct to collectors and historians alike, is dubious when one considers the different historical uses of photography, which were rarely confined to their value as exhibition pieces. Far more useful than the label 'vintage' would be information – if available – about when the print was made and what it was used for (contact print, test print, press photo, enlargement for an exhibition, artwork, commercial portrait, etc.), for it was not unusual for photographers to produce several different enlargements of their images for different purposes. In print genealogy, a print that has obviously been made much later from a surviving negative is known as a *reprint* – if a known original exists – or a *modern print*.

Experimental works, like photograms or photocollages, are in themselves unique, and it is not possible either to make even reasonably accurate prints of complicated montages consisting of many different negatives. Then the only choice left is usually the *reproduction* – a photograph of an original, if the negative has disappeared or never existed. Sherrie Levine had a very different intention, however, in 1979 when she appropriated Walker Evans' originals (see *Appropriation*), because among other things, this was meant to be seen as a critique of the veneration accorded to photographic originals. For photographs that were mass-produced in the 1970s and later sold in galleries (see *Editions*), the term 'vintage' had lost all meaning.

THE YALE SCHOOL

Until his death in 1975, Walker Evans (see *Documentary photography*) was director of the photography department at the Yale School of Art, which is one of the most prestigious teaching institutions in the US. In 1979, the successful photographer and teacher Tod Papageorge took over the department. Especially between 1980 and 2000, under Papageorge a succession of important artists emerged from this department, including Philip-Lorca diCorcia, Gregory Crewdson, Justine Kurland, Anna Gaskell and Katy Grannan; of these, Crewdson and diCorcia have actually returned to Yale to teach. Their photographic work is permeated by a staged, hyper-real world of images, the plots of which are clearly derived from the cinema ('fictional narrative'). In the foreground is the visual opulence of the staging, which does not fight shy of creating pictorial patterns of sheer perfection.

PICTURE CREDITS

Our great thanks to all the artists, galleries and others who have supplied us with picture material and information for this book.

Unless otherwise stated, copyright for the reproduced works belongs to the photographers themselves.

ROY ARDEN
Courtesy of the artist
Portrait, p. 13 © Scott McFarland

THE ATLAS GROUP/WALID RAAD
Courtesy Anthony Reynolds Gallery, London

SEUNG WOO BACK
Courtesy of the artist

OLIVO BARBIERI
Courtesy Brancolinigrimaldi Arte Contemporanea, Rome, and Yancey Richardson Gallery, New York

YTO BARRADA
Courtesy Galerie Polaris, Paris

VALÉRIE BELIN
© VG Bild-Kunst, Bonn 2007
Courtesy Fiedler Contemporary, Cologne
Portrait, p. 9 © Lisa Roze

RICHARD BILLINGHAM
Courtesy Anthony Reynolds Gallery, London

SABINE BITTER/HELMUT WEBER
Courtesy of the artists
Photos of *Live Like This! Did that building do that to you? Or did you do that to the building?*, p. 61 © Pez Hejduk

RUT BLEES LUXEMBURG
Courtesy of the artist and Union, London

ANUSCHKA BLOMMERS/ NIELS SCHUMM
Courtesy TORCH Gallery, Amsterdam

SONJA BRAAS
Courtesy Fiedler Contemporary, Cologne

DIRK BRAECKMAN
Courtesy Zeno X Gallery, Antwerp

SERGEY BRATKOV
Courtesy Galerie Anita Beckers, Frankfurt, and Regina Gallery, Moscow

ADAM BROOMBERG/OLIVER CHANARIN
Courtesy of the artists

ELINA BROTHERUS
Courtesy Galerie Wilma Tolksdorf, Frankfurt/Berlin
Portrait, p. 9 © Lars Schwander

STEFAN BURGER
Courtesy Freymond-Guth & Co., Fine Arts, Zurich, and Galerie Marion Scharmann, Cologne

GERARD BYRNE
Courtesy Green On Red Gallery, Dublin, and Lisson Gallery, London

CLAUDE CLOSKY
Courtesy Laurent Godin Gallery, Paris, Mitterrand+Sanz Gallery, Zurich, Enrico Fornello Gallery, Prato, and Galerie Mehdi Chouakri, Berlin
Portrait, p. 10 © Photomaton
Installation shot, p. 99 © Joséphine de Bère

COLLECTIF_FACT
Courtesy collectif_fact

KELLI CONNELL
Courtesy of the artist

NATALIE CZECH
© VG Bild-Kunst, Bonn 2007
Courtesy Jette Rudolph, Berlin

TACITA DEAN
Courtesy of the artist,
Frith Street Gallery, London, and
Marian Goodman Gallery, New York/Paris

LUC DELAHAYE
Courtesy Ricco Maresca Gallery, New York

CHARLOTTE DUMAS
Courtesy Galerie Paul Andriesse, Amsterdam

LUKAS EINSELE
Courtesy of the artist

RUUD VAN EMPEL
Courtesy Flatland Gallery, Utrecht, and
TZR Galerie Kai Brückner, Düsseldorf

JH ENGSTRÖM
Courtesy Galerie VU, Paris

ROE ETHRIDGE
Courtesy Andrew Kreps Gallery, New York

CHARLES FRÉGER
Courtesy Galerie Kicken, Berlin

STEPHEN GILL
Courtesy of the artist
Portrait, p. 8 © Tina Boles

ANTHONY GOICOLEA
Courtesy Aurel Scheibler, Berlin

MARNIX GOOSSENS
Courtesy Aschenbach & Hofland Galleries, Amsterdam

G.R.A.M.
Courtesy Christine König Galerie, Vienna

ANETA GRZESZYKOWSKA
Courtesy Raster, Warsaw

BEATE GÜTSCHOW
© VG Bild-Kunst, Bonn 2007
Courtesy Produzentengalerie Hamburg and
Barbara Gross Galerie, Munich

MARIA HAHNENKAMP
Courtesy Galerie Krobath Wimmer, Vienna
Portrait, p. 10 © Robert F. Hammerstiel
Installation shot, p. 172 © Christian Wachter

JITKA HANZLOVÁ
Courtesy Jiri Svestka Gallery, Prague
Portrait, p. 13 © H. Spuhler

NAOYA HATAKEYAMA
Courtesy L.A. Galerie – Lothar Albrecht, Frankfurt

ANNIKA VON HAUSSWOLFF
Courtesy of the artist
Andréhn-Schiptjenko, Stockholm,
Air de Paris, Paris, and
Casey Kaplan Gallery, New York

JOSÉ ANTONIO HERNÁNDEZ-DIEZ
Courtesy Galería Elba Benítez, Madrid

TAKASHI HOMMA
Courtesy Galerie Claudia Delank, Cologne

JUUL HONDIUS
Courtesy of the artist and
Galerie Akinci, Amsterdam

MARINE HUGONNIER
Courtesy of the artist and
Max Wigram Gallery, London

MICHAEL JANISZEWSKI
Courtesy of the artist and
Michael Michlmayr

SANNA KANNISTO
Courtesy Galerie Wilma Tolksdorf, Frankfurt/Berlin

IZIMA KAORU
Courtesy Kudlek van der Grinten Galerie, Cologne

RINKO KAWAUCHI
Courtesy of the artist,
FOIL Gallery, Tokyo, and
Galleria Carla Sozzani, Milan
Portrait, p. 13 © Lorenzo Camocardi

PERTTI KEKARAINEN
Courtesy Galerie Anhava, Helsinki

JEAN-PIERRE KHAZEM
Courtesy of the artist and
Sperone Westwater, New York

IOSIF KIRÁLY
Courtesy of the artist

JOACHIM KOESTER
Courtesy Galleri Nicolai Wallner, Copenhagen
Portrait, p. 11 © Ann Lislegaard/Nicolai Wallner

AGLAIA KONRAD
Courtesy FREHRKING WIESEHÖFER, Cologne

JUSTINE KURLAND
Courtesy TORCH Gallery, Amsterdam

LUISA LAMBRI
Courtesy of the artist,
Galerie Paul Andriesse, Amsterdam, and
Studio Guenzani, Milan

AN-MY LÊ
Courtesy Murray Guy, New York
Portrait, p. 11 © John Pilson

PAUL ALBERT LEITNER
Courtesy Galerie Fotohof, Salzburg

JOCHEN LEMPERT
© VG Bild-Kunst, Bonn 2007
Courtesy Sabine Schmidt Galerie, Cologne

SZE TSUNG LEONG
Courtesy Yossi Milo Gallery, New York

ZBIGNIEW LIBERA
Courtesy Raster, Warsaw

NATE LOWMAN
Courtesy Maccarone, New York, and
Ritter/Zamet, London

FLORIAN MAIER-AICHEN
Courtesy of the artist
Portrait, p. 9 © Stephanie Hin

FABIAN MARTI
Courtesy Galerie Peter Kilchmann, Zurich
Portrait, p. 12 © Annette Amberg and Lena Thüring

TAIJI MATSUE
Courtesy L.A. Galerie – Lothar Albrecht, Frankfurt

HELLEN VAN MEENE
Courtesy Yancey Richardson Gallery, New York

JEAN-LUC MOULÈNE
Courtesy of the artist and
Galerie Chantal Crousel, Paris
Portrait, p. 10 © Florian Kleinefenn

ZWELETHU MTHETHWA
Courtesy Jack Shainman Gallery, New York

MULTIPLICITY
Courtesy of the artists

OLIVER MUSOVIK
Courtesy of the artist

WANGECHI MUTU
Courtesy Susanne Vielmetter Los Angeles Projects,
Culver City
Photo of *Ectopic Pregnancy*, p. 303 © Joshua White
Photos of *Alien Awe II* and *Alien Awe III*, pp. 304–5
© Gene Ogami

JEAN-LUC MYLAYNE
Courtesy Gladstone Gallery, New York

SIMONE NIEWEG
Courtesy of the artist

MIKA NINAGAWA
Courtesy Tomio Koyama Gallery, Tokyo

ARNO NOLLEN
Courtesy Van Zoetendaal Gallery, Amsterdam
Portrait, p. 9 © Koos Brenkel

SIMON NORFOLK
Courtesy of the artist

OHIO
Courtesy of the artists

GÁBOR ÖSZ
Courtesy Kudlek van der Grinten Galerie, Cologne

PETER PILLER
© VG Bild-Kunst, Bonn 2007
Courtesy FREHRKING WIESEHÖFER, Cologne, and
Barbara Wien, Berlin, ProjecteSD, Barcelona, and
Andrew Kreps, New York
Portrait, p. 13 © Albrecht Fuchs

MARTIN POLAK/LUKAS JASANSKY
Courtesy Jiri Svestka Gallery, Prague

DIANA SCHEUNEMANN
Courtesy of the artist

BRUNO SERRALONGUE
Courtesy Air de Paris, Paris, and
Galerie Baronian Francey, Brussels
Portrait, p. 9 © Pierre Even

SHIRANA SHAHBAZI
Courtesy Galerie Bob van Orsouw, Zurich, and
Milton Keynes Gallery, Milton Keynes
Portrait, p. 12 © Pierre Fantys
Installation shots, p. 400 © Chris Webb

ANN-SOFI SIDÉN
© VG Bild-Kunst, Bonn 2007
Courtesy Christine König Galerie, Vienna,
Galerie Barbara Thumm, Berlin, and
Galeria Pepe Cobo, Madrid

SANTIAGO SIERRA
Courtesy of the artist and
Galerie Peter Kilchmann, Zurich

ALEC SOTH
Courtesy Gagosian Gallery, New York
Portrait, p. 10 © Donna Kelly

HEIDI SPECKER
© VG Bild-Kunst, Bonn 2007
Courtesy Fiedler Contemporary, Cologne

JULES SPINATSCH
Courtesy Galerie Luciano Fasciati, Chur

ERIK STEINBRECHER
© VG Bild-Kunst, Bonn 2007
Courtesy STAMPA, Basel
Portrait, p. 13 © Erika Barahona

EVE SUSSMAN
Courtesy of the artist,
Rufus Corporation, New York, and
Roebling Hall, New York
Portrait, p. 13, photo by Bobby Neel Adams © Rufus
Corporation
Girls at the Pool, p. 427, photo by Benedikt Partenheimer
© Rufus Corporation
Untitled (Tempelhof), pp. 428–9, photo by Bobby Neel
Adams © Rufus Corporation

PHILIPPE TERRIER-HERMANN
Courtesy Galerie Poller, Frankfurt/New York

ANA TORFS
Courtesy of the artist

JANAINA TSCHÄPE
Courtesy Galeria Fortes Vilaça, São Paulo

JENS ULLRICH
Courtesy VAN HORN, Düsseldorf

USEFUL PHOTOGRAPHY
Courtesy KesselsKramer Publishing, Amsterdam

SANTOS R. VASQUEZ
Courtesy Galerie Mezzanin, Vienna

LIDWIEN VAN DE VEN
Courtesy Galerie Paul Andriesse, Amsterdam

QINGSONG WANG
Courtesy of the artist and
Albion, London

MICHAEL WESELY
© VG Bild-Kunst, Bonn 2007
Courtesy Fahnemann Projects, Berlin, and
The Columns, Seoul
Portrait, p. 12 © Lina Kim

YANG FUDONG
Courtesy ShanghART Gallery, Shanghai

TAKASHI YASUMURA
Courtesy Yossi Milo Gallery, New York

KIMIKO YOSHIDA
Courtesy the Israel Museum, Jerusalem,
Galerie Metropolis, Paris, and
Galerie Albert Benamou, Paris